"Alice and Tom are pioneering the entrepreneurs. This book is an invitatic forts and build a robust creative entrepreneur ecosystem ... gion. If you are wondering why the creative economy is explosive, this book answers all your questions."

- **Professor Tom Byers**, Stanford Technology Ventures Program, Stanford University, Palo Alto, California U.S.

"Alice Loy and Tom Aageson are wise and experienced in what to expect, what to do and how to achieve your personal and company challenges. Everyone starting-up would benefit tremendously from reading this book."

- **John Howkins,** Author, *The Creative Economy: How People Make Money From Ideas,* London, U.K.

"I have read many books that sing the praises of the creative economy. *Creative Economy Entrepreneurs* is different. This book will take you on a creative ride beyond 2018 and will have you reconsidering your priorities, as you reflect on a world beyond the disruption of technology, and post the next 'big thing.' I recommend this book to anyone with an interest in the future..."

- **Frances Valintine**, Founder, Tech Futures Lab, Auckland, New Zealand

"*Creative Economy Entrepreneurs* gives people the tools, the new thinking skills, and the practical know how to meet challenges of the new economy and invent and innovate the future."

- **John M. Eger**, Zahn Director and Professor of Creativity and Innovation, Creative Economy Initiative San Diego State University, San Diego, California, U.S.

"In this book, Alice Loy and Tom Aageson introduce us to creative entrepreneurs and their stories. In a refreshing contrast to the cloudy concepts and macroeconomic statistics that leave most people baffled about the creative economy, they shine a light on the creative and cultural industries, down on the ground, all around the world."

- **David Parrish**, Author of *T-Shirts and Suits: A Guide to the Business of Creativity*, London, U.K.

"*Creative Economy Entrepreneurs* is a unique blend of broad content knowledge and ethnographic research into some of their most successful enterprises. I highly recommend it for anyone pursuing a venture in the creative economy."

- **Robert G. DelCampo, Ph.D.**, Executive Director, Innovation Academy, University of New Mexico, Albuquerque, New Mexico, U.S.

"Buckle your seatbelt for a round-the-world tour of creative ventures that are solving the world's biggest challenges. When you land at home, you'll be inspired to build the creative economy in your community—and you'll have learned a lot about how to do it. This book makes a clear-eyed business case for why leaders need to embrace the melding of culture and economics to build resilient, prosperous communities."

- **Randall Kempner**, Executive Director, Aspen Network of Development Entrepreneurs (ANDE), Washington, D.C., U.S.

"Loy and Aageson in *Creative Economy Entrepreneurs* spell out for the first time the distinctive needs and practices of creative entrepreneurs in this innovation system. Through a series of fascinating case studies they show how U.S. analyses of tech entrepreneurship to date have missed a big trick by neglecting the importance of creativity."

- **Hasan Bakhshi**, Executive Director, Creative Economy and Data Analytics, Nesta, London, U.K.

"The book makes a compelling argument that if communities and economic development professionals overlook the potential of the creative economy, they might risk missing out on future growth and resilience. Highly recommend reading it!"

- **Jeffrey A. Finkle**, CEcD, President & CEO, International Economic Development Council (IEDC), Washington, D.C., U.S.

"I am delighted to bring a world of support to this book and the work carried out by Alice Loy and Tom Aageson...This book gives a meaningful contribution to promote creative entrepreneurs and sustainable business."

- **Edna dos Santos-Duisenberg**, Director and main-co-author of the United Nations' *Creative Economy Reports* (2008 and 2010). Advisor, United Nations for Training and Research (UNITAR), Rio de Janeiro, Brazil

"*Creative Economy Entrepreneurs* is an invaluable testament to the power of the creative economy. It is full of insight into the transformational potential of creativity, and it shows us how the intersection of art and business is changing the world."

- **Kim Chestney**, Founder of the Creative Industries Network and the CREATE! Festival Pittsburgh, Pennsylvania, U.S.

"The stories in this book illustrate how the challenges faced in developing an ecosystem to support and grow a Creative Economy can be tackled. The book is suitable for everyone. But in particular, I encourage leaders in the public and private sectors to read it. The stories will inspire you. I sincerely hope they will motivate you to take affirmative action to support the Creative Economy."

- **Professor Graeme Britton**, President and CEO, Raffles University, Iskandar, Johor, Malaysia

"What Richard Florida did for the creative class, this book could do for the ecology of creativity! It is as much an overview as it is about details, it is as much about real life as it is about vision, it supports structure as well as inspiration. For me, it is agenda setting and a must-read for politicians and practitioners."

- **Bernd Fesel**, Director, European Creative Business Network, Rotterdam, Netherlands

"Here's a book I've been waiting for. . . I just didn't realize it. It would...be good to get a copy of the book in the hands of every social and economic development professional who fails to see the full potential of the creative economy and look again at their own role in supporting its development."

- **Gail McClure**, Ph.D, Senior Advisor, Education and Human Resources, National Science Foundation, St. Paul, Minnesota and Fort Myers, Florida, U.S.

"A first hand testimony on the impact of creative entrepreneurship on the economy and communities. It reads like a user's manual for policymakers to build a working creative ecosystem."

- **Phillippe Kern**, CEO, KEA European Affairs, Brussels, Belgium

"Tom and Alice carve out a new pathway forward for economic development everywhere, in an area many others had overlooked or neglected. Now, with this book, they share their journey and lessons so creative entrepreneurship can continue to spread. I plan to put this book into the hands of every policymaker I meet."

- **Dane Stangler**, Chief Policy Officer, Startup Genome, Oakland, California, U.S.

"This book is essential reading for policymakers looking for new approaches to solving some of the big challenges of the 21st century."
- **Peter Tullin**, Co-Founder, CultureLabel.com & REMIX Summits, Melbourne, Australia

"Forward-thinking venture firms are investing in creative industry startups and this book explains why."
- **Rashid Sultan**, Founder and Partner of Messilah Ventures, Kuwait City, Kuwait

"Leadership in creativity has been one of America's great strengths, and we must continue to nurture that vital advantage."
- **Douglas Brown**, Dean of Anderson School of Management, Retired, University of New Mexico, Albuquerque, New Mexico, U.S.

"Far away from the current literature on the creative industries, this refreshing book puts the spotlight on project-specific examples supporting entrepreneurship and economic development from a diversity of geo-cultural perspectives. *Creative Economy Entrepreneurs* is an indispensable reference tool for the next generation of entrepreneurs and decision makers involved in the creative economy."
- **Indrasen Vencatachellum**, Former Director of UNESCO Division for Creative Industries, Paris, France

"Anyone worried about what the age of robots will do to society will feel much relief after reading this book. The role of the creative entrepreneur shows where humans will thrive and any aspiring entrepreneur with an eye to the future should read this book."
- **Darryn Melrose**, CEO and President, New Media School, Auckland, New Zealand

"In this insightful new book, Alice and Tom spell out how the success of the creative community is tied directly to the success of the local economy...It's time for our leaders to invest in the impact that creatives have in promoting diversity and innovation."

- **Jan Ryan**, Director, Creative Entrepreneurship & Innovation, College of Fine Arts, University of Texas, Austin, Texas, U.S.

"Creative Startups has created a movement for entrepreneurs in the Creative Economy, and this text will hopefully inspire generations to come in how to support creative people in their business endeavors. This book should have its place in university entrepreneurship curriculum a long time."

- **Jason Schupbach**, Director, The Design School, Herberger Institute for Design and the Arts, Arizona State University, Phoenix, Arizona, U.S.

"This book lays a path for those who are driven to a build a more vibrant creative economy. It gives readers a framework and practical tools for creating economic opportunities and developing a robust startup ecosystem."

- **Tina L. Seelig**, Professor of the Practice, Management Science and Engineering, Faculty Director, Stanford Technology Ventures Program, Stanford University, School of Engineering, Palo Alto, California, U.S.

"If you want a perceptive glimpse under the hood of a powerful force for good in 21st century business, give this a read."

- **Iain Bennett,** FRSA, Director, Fifth Sector, Manchester, England

"The gift of creativity is more than just talent; it's a form of survival that can change lives and add value if well-supported."

- **Vuyo Mahlati**, DedaniCollection.com, Johannesburg, South Africa

"Across the globe we see how the unleashing of creativity results in the creation of value, and meaningful and gainful employment. This new book by Creative Startups is a perceptive analysis of the learning and experiences of some of the world's most exciting creative enterprises, with useful lessons and insight for those committed to developing the ecosystems which will help creative businesses and creative ideas thrive."

- **Caroline Norbury**, CEO, Creative England, Bristol, England

"The book aides current and future creative entrepreneurs in understanding the profound and unequivocal value they bring their respective societies, national economies and the families of those they hire. Alice Loy and Tom Aageson have created a seminal text that will hopefully inspire generations of creative and arts entrepreneurs to take action and realize the tremendous value they do and can offer."

- **Jim Hart**, Professor of Practice and Director of Arts Entrepreneurship, Southern Methodist University, Meadows School of the Arts, Dallas, Texas, U.S.

CREATIVE
ECONOMY
ENTREPRENEURS

Creative
ECONOMY
Entrepreneurs

FROM STARTUP
TO SUCCESS

HOW ENTREPRENEURS IN
THE CREATIVE INDUSTRIES
ARE TRANSFORMING THE
GLOBAL ECONOMY

ALICE LOY & TOM AAGESON

CREATIVE ECONOMY ENTREPRENEURS

First edition: September 2018

Creative Economy Entrepreneurs: From Startups to Success; How Startups in the Creative Industries are Transforming the Global Economy / Alice Loy and Tom Aageson

ISBN 978-0-692-11879-5 (pbk)

ISBN 978-0-692-11880-1 (ebook)

Cover and interior designed by Ginny Sterpka

Text set in Minion Pro and Fututa PT

Creative Startups

Santa Fe, NM

www.creativestartups.org

Printed in the U.S.A.

.TO OUR FAMILIES.

*who supported us as we launched
and built Creative Startups.*

CONTENTS

FOREWORD ... xvii

PREFACE ... xxi

1 Leading Creative Futures 1

2 Solutions for Uncertainty 20

3 Challenges, Ecosystems, and Themes 42

4 New Work That Works 63

5 Creativity for Resilience 92

6 Innovative Investment 115

7 Unleashing Diversity 147

8 Going Global Staying Local 172

9 Empowering Youth Engagement 206

10 Developing Unique Regional Identities 238

11 No Fear of the Future 266

12 Practical Tips for Developing
Your Creative Entrepreneurial Ecosystem 288

ENDNOTES .. 315

ACKNOWLEDGMENTS .. 359

INDEX ... 361

ABOUT THE AUTHORS ... 378

FOREWORD

The Disruption of Creative Entrepreneurs

Today you are an entrepreneur—or you risk being irrelevant.

That's not to say that the times require you to think of yourself as someone about to launch the next Google, Apple, Amazon, or Facebook. What you are required to do is to think of yourself—your passions, your skills, your unique way of seeing the world, your gifts—and find a way to create from those attributes something that is meaningful to you and valuable to the world. Otherwise you will be irrelevant—and that's not much fun. Fortunately, we're in a time when it's better and better to be an entrepreneur—especially a creative entrepreneur.

Here's what's happened in the last 25 years: Entrepreneurship—the force that sooner or later disrupts every industry—has itself been disrupted. Twenty-five years ago, if you were to talk about someone who was an entrepreneur and their fascinating new idea, most people could make a few safe assumptions about what you were talking about: It involved technology, it was digital, it had something to do with the internet, it was designed to get big fast, it involved traditional venture capital financing—and more often than not, truth be told, it involved well-educated white men who had MBAs from a handful of top-notch business schools.

Slowly at first, and then all at once, almost all of those operating assumptions about entrepreneurs and entrepreneurship have been disrupted.

We've seen the whole notion of "entrepreneurship" splinter into myriad pieces, breaking apart what was once a one-size-fits-all economic and business category. Today we've got social entrepreneurs, cultural entrepreneurs, civic entrepreneurs, urban entrepreneurs—in fact, if you ask Google, "How many different kinds of entrepreneurs are there?" you'll get answers like, "The 10 types of entrepreneurs," "the 8 types of entrepreneurs," "the 6 types of entrepreneurs," "the 5 types of entrepreneurs," "the 4 types of entrepreneurs"—try it yourself and you'll see.

This book is about creative entrepreneurs—a category that I believe has unlimited potential to change the fabric of economies, the trajectory of communities, and the future of industries. As you read this book and encounter the cast of creative entrepreneurs and their compelling stories, you'll begin to see the Venn diagram that makes creative entrepreneurship so powerful—and also so fragile.

Creative entrepreneurship lives in the overlapping zones of technology, experience, entertainment, and design thinking. It is more likely to be a verb than a noun, a way of being or doing or thinking or experiencing than a single product or service. It defines who we are and what we value much more than what we buy or own or consume. It springs from a creative urge—to make, to tell, to show, to fashion, to perform. It rarely comes about because of a four-box matrix that reveals an open space in the competitive landscape. It almost never is born from a consultant's assessment of untapped market potential. Unlike far too many entrepreneurial startups in Silicon Valley, it doesn't tack on to an existing successful idea one new little twist or feature: "You know, it's Twitter, but with 10 more characters!"

Which is one reason why creative entrepreneurship has been so slow to gain recognition: It isn't something you can pigeon-hole. And it's why creative entrepreneurs so often have had a hard time getting a fair hearing from investors—it's a true category buster. And it's why creative entrepreneurs sometimes have a hard time even knowing that they're entrepreneurs—they're so deep into their own creativity, they haven't gotten to the entrepreneurship part.

But those days are over, as this book makes abundantly clear. Creative entrepreneurship is not only finding important expressions in the marketplace where technology, experience, entertainment and design thinking come together. Creative entrepreneurship is on its way to transforming established fields like health and medicine, education and teaching, banking and finance, travel and transportation—and more.

Any place where a verb is more important than a noun, you'll find a creative entrepreneur. Any place where experience is valued over ownership, you'll find a creative entrepreneur. Any place where meaning and purpose are elevated above status and celebrity, you'll find a creative entrepreneur.

In other words, any place where you'd like to find yourself—and increasingly where all of us want to find ourselves if we've got our heads screwed on right—you'll find a creative entrepreneur. There's a name for that place.

It's called the future.

Alan Webber
Co-founder, *Fast Company* magazine

PREFACE

This book is intended to fuel the global Creative Economy movement, energizing leaders—like you—who strive to build resilient economies, engage youth, create jobs, and spark wealth formation. Our vision for this book is to highlight the creative entrepreneurs often bypassed by traditional "tech" accelerators, economic development strategies, and private sector investors. With this book, we place creative industries entrepreneurs at the center of economic development strategies that are not only effective, but essential.

There is a lack of Creative Economy publications focusing on the role and value of entrepreneurship. Often, related books and articles address the macro-economic view of the Creative Industries, providing policy frameworks and discussions regarding the structural formation of industries. While these works are useful analyses of established creative economy ecosystems, they don't provide leaders with practical advice on how to start or expand a creative economy ecosystem.

Our experiences building creative ecosystems from Kuala Lumpur to Kuwait, Baltimore to Brisbane, tell us that entrepreneurs are the visionaries, the do-ers, the risk-takers essential to successful economic development. Without entrepreneurs, there simply is no economy in your city, your region. We hope this book will encourage more leaders to invest in Creative Economy entrepreneurs, and more regions to support creative ventures—from startups to scaleups.

Alice and Tom
Albuquerque and Santa Fe, New Mexico

1

LEADING *Creative* FUTURES

Not A Refried Corporate Amusement Park

Before the giant robot and his daisy, there was a bowling alley. Silva Lanes, to be exact, which opened in the late 1970s in Santa Fe, New Mexico. Silva Lanes was a good five miles from the town's famed tourist-bubble plaza of turquoise and adobe, and it served a working class and family-dense neighborhood. In 2009, Silva Lanes met a sad end, bankrupted by competition from casinos and a dicey reputation that stemmed from a shooting victim dumped in the parking lot and a hit-and-run committed by an out-of-state magazine salesman.

The 33,000 square foot building, with its desert grey arches and wooden *viga* tails jutting out from the portals, sat abandoned for several years, serving as a familiar symbol of a common story: town struggles as jobs move elsewhere, middle class slumps, youth leave, local family entertainment evaporates, and the ex-bowling alley withers into a fenced off lot.

In northern New Mexico, we're no stranger to this narrative. Our state has the nation's second highest unemployment.[1] We are experiencing steep declines in the extractive industries that have backboned our economy for decades. In Santa Fe, our state's capital

city, the number of residents under the age of 55 has declined by
13% over the last three decades.[2] In shuttered building after shut-
tered building, we see this struggle manifested.

But then something surprising happened at Silva Lanes.

A collective of enterprising underground artists—dump-
ster-diving upcycling sculptors, laser-rigging theatre nerds, gog-
gle-sporting sound designers, and programmers-turned-weld-
ers—completed at the last minute an application for an innovative
accelerator program called Creative Startups. These artists had a
vision for a new kind of family entertainment experience, and they
had their eye on Silva Lanes as a place to build it. At the Creative
Startups Accelerator, they learned key startup concepts, met other
emerging creative entrepreneurs, and were mentored by individu-
als who had themselves built successful businesses. On the last day,
they pitched their idea to accredited investors and came out on top,
taking home $25,000[3] (USD unless otherwise noted). The artists
had become entrepreneurs, and Santa Fe would never be the same.

The initial seed capital the collective garnered through the Ac-
celerator helped them convince *Game of Thrones* author George
R.R. Martin to buy Silva Lanes and rent it to them, so they could
repurpose it into an innovative experience never before seen in
Santa Fe—or arguably anywhere else in the world. With galleries,
a music venue, a maker space, and a two-story Victorian mansion
where the refrigerator serves as a portal into a neon blue control
room straight out of *Star Trek*, Silva Lanes is now home to global
phenom Meow Wolf.

Meow Wolf's mansion is called the House of Eternal Re-
turn, and it's an immersive, interactive exhibit with a sci-
fi backstory and over 70 rooms of "explorable worlds."[4]

Kids and adults spend hours crawling through fireplaces, playing pink dinosaur bones like a marimba, peering into a gerbil-powered mine diorama, and getting lost in an undersea forest. Imaginations are kindled as families search together for clues to the House's "inter-dimensional" mysteries.

MEET

Photo by Kate Russell, courtesy of Meow Wolf

ENTREPRENEURS:
 Corvas Brinkerhoff
 Sean Dilanni
 Vince Kadlubek
 Caity Kennedy
 Matt King

COMPANY: Meow Wolf
INDUSTRY: Entertainment
BASE OF OPERATIONS: U.S.
EMPLOYEES: Over 300
MARKETS: U.S.

NOTEWORTHY: An artist collective generating over $10 million in revenues annually.

Is it more fun than bowling? Well, 400,000 people paid for admission in the first year.[5] That's more than twice the number of annual visitors to the Georgia O'Keeffe Museum, Santa Fe's second most popular arts attraction.[6] After just 12 months of being operational, Meow Wolf has earned $8 million in revenues.

In 2015, co-founder and CEO Vince Kadlubek told the *Albuquerque Journal* that much of Meow Wolf's success followed directly from participation in the Creative Startups Accelerator:

> Everything that has fallen into place for us since then is a result of the Creative Startups program... We needed to develop a network of people, a better understanding of ourselves and real clarity about all layers of business development... By going through that process, we were able to boil Meow Wolf down to a precise product that investors would recognize as valuable.[7]

The Meow Wolf collective epitomizes a disruptive new breed of entrepreneur, combining a spark for art with a keen grasp of profit margins and a social conscience. They turn the fruits of intellectual property and imaginative experience-building into sustainable business models. The House of Eternal Return didn't reinvent the wheel: their secret to making money is they charge you to come in. Once people get inside, they have a blast. They post on Instagram. Their friends comment with exclamation marks. "Let's go back together," says the poster. "There's so much I missed!" say their friends.

What's disruptive in all this though is not Meow Wolf's approach but their context, as they are neither a traditional "cultur-

al" outpost—like a grant-funded museum or a commission-driven gallery—nor a refried corporate amusement park. Like the multi-million dollar creative economy juggernaut Cirque du Soleil, the Meow Wolf founders identified key shifts in the entertainment industry—before others in the industry saw the changes coming. They are an artist cooperative combining creativity and high tech with a behind-the-scenes apparatus of customized hardware and software. They're darlings of the regional business community, but they're not like the techies or smokestack solutions that city developers tend to chase with tax incentives and a desperate promise to the community to bring jobs—jobs that will likely evaporate when labor costs become cheaper elsewhere. The collective's ranks are much broader than these other industries' and include RISD graduates, materials scientists, filmmakers, and animators. Some of the members are locals whose parents are public school teachers, and others met as students at the local community college. These are young people from Santa Fe or who are in love with Santa Fe, who have envisioned how their success in this creative economy will translate into a boom for the region in which they've put down roots.

Like all entrepreneurs, the founders of Meow Wolf took a risk. They worked diligently, putting in time after their "real jobs," hammering to life the ideas in their heads. Then, with good timing and the right help, from Creative Startups and others, their risk paid off. And because they combined their entrepreneurial spirit with creative vision, theirs is a novel spin on the revitalization success story. In a TEDx talk, CEO Vince Kadlubek called it "radically inclusive art." Whatever one calls it, it's an economic development homerun, generating over 300 diverse, high-wage jobs and over

$2 million in profit in less than three years, with the New Mexico Economic Development Department projecting a total of 440 jobs and $358 million in economic impact over the next decade.[8] Meow Wolf has raised at least $20 million in public and private investment and announced in January a multi-million dollar expansion into the Denver market.[9]

Creativity Meets Entrepreneurship

What do we call these new leaders, those like the Meow Wolfers? After accepting them into the Creative Startups Accelerator, we realized that while their combination of artistry and entrepreneurship had the potential to lead market disruption—or creative destruction—they were also part of an enormous worldwide movement. We call them **creative entrepreneurs**, and they're not just found in Santa Fe.

All over the world, entrepreneurs in the creative industries are helping communities stage their next act. While the dizzying forces of technological innovation disrupt labor markets and collapse or reconfigure older sectors of the economy like manufacturing and agriculture, the creative economy represents a bright avenue for equitable, economically stable economic ecosystems.

Creative Startups was born because we realized that entrepreneurs like the Meow Wolf collective lacked access to a robust startup support ecosystem. This startup ecosystem, like natural ecosystems, should be rich in resources, allowing for a flow of creativity and connections, social capital and value exchange, across industries and among various players in a given economic area. These relationships encourage productivity and support myriad economic entities, from large existing creative companies to small

upstarts. The ecosystem, owing to these varied and fruitful relationships, adapts to inevitable disruptions stemming from changes in the environment and the introduction of new players, providing a resilient and adaptive environment for newcomers and old standard bearers alike.

When Meow Wolf first came across Creative Startups Accelerator, they were at the tail end of a frustrating and empty-handed search for startup support for creatives. The creative economy contributes over $700 billion annually to the U.S. economy, and produces exciting forms of innovation both continentally and abroad[10]. Despite this, the entrepreneurs at the heart of this burgeoning creative economy struggle to find support that meets their unique needs as founders of high-growth ventures, though they fulfill Schumpeter's classic ideas of "creative destruction" with as much elegance, vitality, and profitability as the tech sector.

In the ambition displayed by creative entrepreneurs, we see parallels to the innovative energy of tech startups. But while some forward-thinking economic development professionals and investors have begun to extend the ideas of Brad Feld's "startup communities"[11] to entrepreneurs outside the realm of the tech community, we have yet to see a widespread embrace of creative entrepreneurs as drivers of economic development and community revitalization.

"WE SUSPECT THAT PEOPLE OFTEN OVERLOOK CREATIVE ENTREPRENEURS AS ECONOMIC FORCES BECAUSE THEY ARE NOT YET FAMILIAR WITH THE NUMBERS THE CREATIVE ECONOMY PRODUCES. "

We suspect that people often overlook creative entrepreneurs as economic forces because they are not yet familiar with the numbers the creative economy produces. Take a look at some of these impressive figures:

- In 2013, global creative and cultural industries churned out revenues over $2.2 trillion, according to UNESCO. That's more than the entire telecom industry.[12]

- The creative economy (conservatively) provides 27 million jobs in the U.S.[13]

- U.S. creative exports reached $142 billion in 2012, more than aerospace or agriculture. Plenty of soybeans, but even more songs.[14]

- 10% of the Los Angeles economy is in creative industries.[15]

- Globally, demand for creative products and services will rise along with incomes and standards of living. The creative economy enjoys 8.8% average annual growth.[16]

- Globally, according to UNESCO, the creative industries grew throughout the 2007-2009 recession despite downturns in manufacturing, construction, and high tech.[17]

- Though popular wisdom claims otherwise, creativity isn't just for major players. Lower-GDP countries sport a better-than-average creative economy growth rate of 12.1%. For example, the value of exports of creative goods and services from Central America grew 70% from 2005

to 2014, reaching $269 million.[18]

- In Africa, the creative economy helped Nigeria overtake South Africa in 2014 as the largest economy on the continent. This was thanks to a film industry that is the country's second-largest employer and a music industry projected to grow to $8.1 billion in value by 2020.[19]

- In Southeast Asia, creative economy exports are booming in small countries like Indonesia, the creative economy grew 62% between 2010 and 2015, reaching almost $20 billion in exports to the U.S., Japan, and Taiwan.[20]

- In Europe, 10% of *all* exports stem from creative industries.[21]

- If the creative economy were its own nation, its GDP would be bigger than India's, bigger than Russia's, bigger than Canada's.[22]

It's no wonder that global exports of creative goods and services total $646 billion.[23]

To give context to the creative economy's magnitude, it's important to properly define its scope. According to John Howkins, the British author and analyst who popularized the term,[24] the creative economy comprises a wide range of sectors whose output and value creation is based on the intellectual property related to the creation of creative goods and services.

The creative economy runs the gamut from advertising to educational technology, video games to opera, fashion to film. Alongside mainstays like publishing and architecture, you'll find new

media and creative tech upstarts using 3D printing and augmented reality. Notable entrepreneurial successes in the creative economy include Etsy, Netflix, Entertainment Arts (EA), Pixar, Adobe, and Flickr. And three of 2014's top VC-backed companies in terms of ROI were in the creative industries: education (Lynda.com), culinary (Seamless), and photography (GoPro).[25] Wherever you have creative ideas becoming creative products and experiences, you have the creative economy.

As an emerging and evolving sector, the boundaries of the creative economy are dynamic. Various scholars, economists, and institutions have slightly different definitions. The differences in these definitions, combined with a deficit of standardized measurement tools suited to value this emerging economic juggernaut, means that the data surrounding the creative economy fluctuate. As an example, the U.S. Census has yet to assign creative economy sectors with codes that allow economists to single out the creative economy in the same way we can measure "manufacturing" or "transportation."

CREATIVE OCCUPATIONS

3-d Modelers
3-d Print Specialists
Animators
Architects
Art Directors
Branding Specialists
Creative Directors
Fashion Designers

Filmmakers
Game Developers
Graphic Designers
Industrial Designers
Lighting Designers
Media Technologists
Museum Technologists
Photographers

Projection Mapping Artists
Sculptors
Sound Designers
Theatre Technicians
VR Technologists
Visualization Experts
Web Designers
Writers & Publishers

However, the U.S. Department of Labor may recognize the seismic shift happening in creative industries. Their webpage, Careers for Creative People[26] opens with the bold statement, "If you think creativity is only for artists, think again." The page links to O*Net, the U.S.'s primary source for occupational information[27] where over 250 specific examples of creative occupations are listed - some of which may surprise you: mapping technicians, video game designers, mechatronic engineers, and microsystems engineers. We would add to the list 3D designers, projection mapping artists, sound designers, and robotics engineers.[28] Your list might include even more! Regardless, it is clear that today's creative industries encompass far more than arts and culture. Today's creative industries reside at the intersection of design, technology, engineering, and expression.

However, the undeniable story these lists and measurements and statistics tell is this: the creative economy is huge, it is growing, and creative entrepreneurs are now essential components of regional economic engines, not only in marketing and entertainment but in everything from urban farming to the creation of 3D-printed artificial hips.

Here are a few more examples of creative industries entrepreneurs:

Guy Laliberté and Gilles Ste-Croix, founders of Cirque du Soleil:

In Montreal, two former street buskers and fire breathers modernized the circus into a billion-dollar enterprise with 5,000 employees worldwide.

Sydney Alfonso, Founder of Etkie:

In rural New Mexico, a young college graduate returned home to launch a company aimed at combating the persistent unemployment rates found on American Indian reservations. Today, the Native artisans of Etkie create handcrafted luxury jewelry that is sold in nearly 100 boutiques globally via innovative branding strategies.

Hala Labaki, Founder of Shahiya:

In Beirut, a brand consultant built the largest online Arabic recipe exchange, translating Lebanon's culinary heritage into ultramodern career paths for domestic women. The creative company was acquired for $13 million by a Japanese firm in 2015.[29]

Mamou Daffe, Founder of Festival on the Niger:

In Mali, a video club owner turned a sleepy town on the Niger into the home of a global music festival, during which thousands of visiting attendees pay residents to stay in their houses.

Ivonette Albuquerque, Founder of Galpão Aplauso:

In Rio de Janeiro, an economist responded to a robbery at her home by opening a theatre-based skills workshop, a project that has employed over 7,000 young people in the creative economy and rejuvenated depressed residential zones.

Seeing these diverse entrepreneurs stacked together might

raise a few questions. How do these examples all fit into the "creative economy?" And what's that about an *economist* in Rio—aren't the practitioners of the creative economy all artsy types? And even if these stories are interesting, aren't creative entrepreneurs too mercurial to incorporate into practical economic development strategies? Don't these creatives only show up if you're lucky and leave when they get bored? Didn't your town add a co-working annex to the auditorium—isn't that enough? Shouldn't policymakers be chasing tech geeks, not art punks?

Given our combined 25 years of experience launching and supporting creative companies (including Meow Wolf, Etkie, and dozens of others), not to mention myriad marvelous hours we've spent with creative entrepreneurs all over the world, we have some surprising, exciting answers to these questions. And we have some data-grounded pushback to the skepticism. Let's begin with our own story.

From the Easel to the Entrepreneur

When we founded Creative Startups, it was the first creative entrepreneur accelerator in the world. Because our accelerator was the first of its kind, we weren't sure how it would be received. But when we put out a call for applications, we were inundated with responses from 14 countries. Not only did a chorus of creative entrepreneurs respond to our call, but inquiries flooded in from organizations, institutions, and investors across the globe who were interested in starting their own creative economy accelerators. Economic development leaders wanted information about our unique accelerator model—even before we really understood what our model would be.

As we grew and refined our ideas, our confidence was further buoyed by a $190,000 grant from the E.M. Kauffman Foundation, the global leader in researching, promoting, and fostering entrepreneurship.[30] We used the grant to build out our strategy for scaling into new regions and evaluating our impact on the economic ecosystem. We thank the Kauffman Foundation for becoming a vocal leader for the importance of startup ecosystems and for recognizing the gap in support for creative entrepreneurs and the creative economy.

Having run the Albuquerque accelerator for five years, we now operate accelerator programs around the world, bringing our educational and ecosystem resources to universities, cities, and NGO's located as close as North Carolina and as far away as Malaysia. Our global network of accelerators continues to expand, and to date we have graduated over 110 creative companies, generating over $25 million in new revenues, creating 450+ new jobs, and driving a noticeable shift in regional demand for creative entrepreneurs. The creative economy has continued to create more companies and more jobs, and people have taken notice of the disruptive innovation our accelerator brings and its positive implications for economies far beyond our region.

" THE CREATIVE ECONOMY IS TOMORROW'S ECONOMY. "

This global hunger for our model was a powerful demonstration that a sea change was happening, a disruption whose time had come. This hunger validated our hunch about the large scale of the emerging creative economy, a hunch born of working with creative entrepreneurs like Meow Wolf and realizing they

were not just local successes but also possibly indicators of a new global reality. To see creative entrepreneurs in action was to realize they had arrived: they had become pivotal actors in solving the economic challenges of the 21st century, not only in our own community, but all over the world.

Of course, eras of urgent questions never lack for answers. Plenty of smart voices are whipping up blueprints calling for the next big thing. But we haven't seen creative entrepreneurs get the spotlight their achievements merit. We want to see more people doing the critical work of introducing creative entrepreneurs to policymakers and civic stakeholders, connecting creative founders to investors, spelling out the importance of fostering local and global creative economies in terms that earnest, forward-thinking developers can understand. So, we wrote this book. Creative entrepreneurs have always been around, but *now* is their critical time. Investing in your creative economy ecosystem today will bring jobs tomorrow. The creative economy *is* tomorrow's economy.

Creativity Is Tomorrow's Fuel

Most of our hours and days fill up with routines, but when you think of those electrifying, precious stretches when you're plugged into your creative humanity with all your senses and imagination—playing a new tabletop game with your family, dancing at a show with friends, enjoying an inspired meal at a new restaurant, joshing your teammates across the world in an online game, or opening a space tunnel refrigerator at the House of Eternal Return—you've found yourself at the sweet spot of creativity.

In 2016, leading human resource and strategy officers from the globe's top employers told the World Economic Forum which skills

they thought would be the most important in the world by 2020.[31] First was complex problem-solving, second was critical thinking, and third—making a seven-spot climb from the 2015 list—was creativity. Creativity has many definitions, but perhaps Steve Jobs put it most succinctly: "Creativity is just connecting things."[32]

According to recent neuroscience examined in *Scientific American*, "creative people … have a richer, better connected, and more flexible associative network."[33] In other words, creativity means you can connect distant notions more easily, unleashing unexpected combinations that create new value. These are the connections that make stories more poignant and dramatic, that make melodies worm into your brain, that make a new combination of two foods you've had your whole life taste like nothing that's ever happened to your tongue before. They are also the connections that brought us iPhones with apps.

Who brings this new value to markets? Entrepreneurs. And established companies, too. However, markets tend to be more commonly disrupted by entrepreneurs than established ventures. In the creative industries, like all industries, entrepreneurs drive new value into markets. Creative entrepreneurs bring a range of benefits to their communities:

Creative entrepreneurs grow jobs and boost other local entrepreneurs:

Take the film industry for example, which provides high-quality jobs in locations as disparate as Vancouver and the Sahara Desert. In the U.S., the Motion Picture Association of America reports that the film industry accounts for two million jobs—with salaries 48% higher than the national

average. Like many other creative industries, most of these jobs (84%) are filled by small businesses founded by creative entrepreneurs. The industry also supports other local entrepreneurs, paying out "$43 billion per year to more than 300,000 businesses—85% of which are small businesses that employ fewer than 10 people."[34]

Creative entrepreneurs connect into global markets, expanding exports:

In a 2017 report, PricewaterhouseCoopers declared that "creative exports are soaring," crediting the spread of broadband with dismantling physical market borders and "fuel[ing] the export of creativity." As an example, they cite the gaming industry in South Korea, where a third of its $9.29 billion in revenues came from exports, "up from a quarter just four years earlier."[35] In a country where SMEs account for 86.9% of total employment,[36] growth in the creative sectors is no exception: it's driven by entrepreneurs.

Creative entrepreneurs aren't navel-gazing artists throwing warehouse parties and scrambling after arts grants: they're visionary entrepreneurs breathing life into various facets of their regional economies. Creative entrepreneurs are participants in a very old pursuit: finding new ways to express and share ideas, stories, and culture. And while production bases have come and gone, and industry has counted on various exploitative economic engines such as slavery, feudalism, and fossil fuel extraction, humanity continues to have weird ideas and make better things out of them. In

these uncertain times, the instinct to create and think differently is our best hope for navigating our increasingly complex economic ecosystem.

Creativity Is Building What's Next

To put a finger in the wind and announce the coming of global instability is uncontroversial, even understated. The world is caught up in the anxiety of a foundational transition—what the World Economic Forum calls the Fourth Industrial Revolution.[37] In the beginning chapters of this book, we'll take a broad look at today's economic challenges. Then we'll illustrate exactly how the creative economy plays a starring role in an economic revolution, and we'll show you how creative entrepreneurs—aided by the right infrastructure and support—are essential economic actors, poised to fashion this sector's promise into strong companies, economies, and communities.

Yet digesting all this info can feel a bit like eating an elephant. To break it down into bite sized pieces, we have identified seven of today's key economic challenges that, if solved, can help communities thrive. As you read through the book and meet many different creative entrepreneurs living and working across the globe—in cities and in companies big and small—you'll see how their ventures solve these seven challenges:

- **Creative entrepreneurs create high-quality, innovative, economic base jobs.**

- **Creative entrepreneurs strengthen and diversify local economies.**

- **Creative entrepreneurs attract and democratize private investment.**

- **Creative entrepreneurs unleash diverse talent.**

- **Creative entrepreneurs globalize local economies.**

- **Creative entrepreneurs empower and engage youth.**

- **Creative entrepreneurs bolster and develop unique regional identities.**

While it's true that the creative economy can only be one branch of a healthy economic ecosystem, what you'll soon discover is that this sector brings holistic benefits that can grow beyond its own success. The creative economy positions communities for healthier tomorrows, new ideas that see towns and regions overcome dependencies on old industries and outdated business models while drawing on deep cultural legacies.

To understand how this works, the first thing we need to do is zoom out. Before we dive into the details of the creative economy, we need to understand why the general economy is so shaky. What *is* this new global reality of breakneck innovation and wild uncertainty? What is driving all the uncertainty? Why can't we fall back on what's "always worked"? How do communities make the leap into what will work next?

It's time to take a sober look at the realities of our young century. From there, we'll be able to understand how a new crop of risk-takers—in Brazilian favelas, in repurposed American bowling alleys, in Lebanese comment threads—are the creative entrepreneurs with the vision, passion, networks, and knowledge to build the future.

2

The Fourth Industrial Revolution

Every day we interact with tomorrow. Cars drive themselves and wake us up when we've arrived. Toasters pronounce our names. Nanobot drugs know our medical history before we swallow them. We deposit checks with our smartphone cameras. In every corner of the economy, from small service businesses to large industries, the pattern is the same: automation and artificial intelligence are replacing humans. Truckers have diagnostic tools that network with big data, identify future mechanical trouble, and save them a trip to the service station. Farmers program drones to monitor their crops. Surgeons perform low-risk operations with VR gloves, letting robots perform their incisions while their hands are zip codes away. Not even professions based in the "humanities" evade the impact of this shift. Miss last night's game, and the recap you read could have been written by an algorithm, one that crunches all the clichés of sports-writing and translates them into every major language. File a dispute on eBay, and there's a nine out of ten chance your case will be mediated by automated legal software.[1]

Of course, with every innovation comes adaptation. Bank tellers get their hours cut. Service stations for truckers hang up GO-

ING OUT OF BUSINESS signs. Fast food employees hand their hairnets over to order-placing consoles and e-payment systems. And while the debate over immigration rages on, an understanding of the future of jobs, and who will fill them, remains elusive. People are not losing their jobs to other people—they're losing them to robots, to technological innovations, and to changing consumer demands. Innovations in automation account for 80% of lost manufacturing jobs,[2] and production and manufacturing is more efficient than ever. Mass manufacturing jobs may move back to high GDP economies, but factories will most likely be staffed by machines, not people.

We know the middle class has become hyper-specialized,[3] and the working class has shifted from the factory to the service counter, but even these jobs may be in jeopardy. The Bureau of Labor Statistics predicts that 75% of the next decade's fastest growing occupations will involve some form of outpatient healthcare[4] and a hospice worker might just show up at a client's house to discover a "home companion robot" refilling the client's pill box.

Klaus Schwab, founder of the World Economic Forum and a Ph.D in mechanical engineering, economics, and social science, has spent over 50 years surveying and striving to understand these seismic economic changes. At the beginning of 2016, he declared that our modern economic and social lives were on the "brink of a technological revolution," one that will forever change how we "live, work, and relate to one another." Here's how Schwab laid it out:

> In its scale, scope, and complexity, the transformation will be unlike anything humankind has experienced be-

fore. We do not yet know just how it will unfold, but one thing is clear: the response to it must be integrated and comprehensive, involving all stakeholders of the global polity, from the public and private sectors to academia and civil society.[5]

Schwab calls what we're experiencing a Fourth Industrial Revolution. Let's put that in context. The first two Industrial Revolutions enhanced efficiency through natural resource exploitation: first came the steam power of mechanization and then the electricity and fossil fuels of mass production. For the Third Industrial Revolution, the lynchpin was the transistor: the ability to encode vast flows of data and coax that information into processing itself.

4ᵀᴴ INDUSTRIAL REVOLUTION

Mechanical	Electrical	Digital	Cyber Physical

1784	1870	1969	TODAY

Now, in the Fourth Industrial Revolution, economies are evolving to handle and process our enormous mass of accessible information. With so much information available and so many methods of analysis, access to knowledge is no longer the challenge. Everything is connected, and these connections happen in-

stantly. The challenge of the Fourth Industrial Revolution becomes interpretation, reflection, and innovation. How do we create new value out of our hyperconnected knowledge?

As Schwab says, this has staggering implications for how we live, work, and relate to one another and the world around us, not to mention how we govern, teach, learn, and exchange ideas. These changes in our midst breed more questions than answers. How will leaders manage this explosion of progress and efficiency so it doesn't vacuum up the planet's resources or exacerbate global inequality, what Schwab calls "the gap between returns to capital and returns to labor?" What is the future of work, labor, and workforce training? What new ways of thinking, what new skills, and what new habits can we teach to ensure people find shelter in these storms of change? And how can we make sure that our answers to these questions form a cohesive story, one that rings true for both local communities and global connections? In short, how do we take all this change and make from it opportunity?

The Skill of Meaning

To throw logs on the campfire of this story, let's return to the prediction, mentioned in Chapter 1, of what creativity's importance will be in 2020. We'd like to examine more closely how an investment in creativity leads to a less uncertain economy. Then we'll make the case for the creative entrepreneur as a key figure to jumpstart a region's creative economy and propagate its benefits in local contexts. We'll outline some interconnected stories of how creative entrepreneurs solve the seven economic challenges we introduced in Chapter 1, laying the foundation for more detailed case studies throughout the book.

First, let us emphasize that a conversation about skills is a conversation about inequality. Globalized supply chains, advances in connectivity, and automation have grown the demand for "high skill/high pay" workers and shrunk demand for "low skill/low pay" workers. Less relevant "middle skills" result in a hollowed out "middle class." And all this leads to apprehension and community fractures.

Inequality is a tricky subject, because it's easy to tell different stories about the same facts and figures, albeit those from different regions. Certainly, for example, median wages for workers—compared to productivity—have stagnated in the U.S. since the 1970s.[6] And the gap between the wealthiest and the poorest citizens in the U.S. has widened. But the story changes when you pick a different protagonist. In Japan and some European

> " **...HUMAN BEINGS ARE UNIQUELY CAPABLE OF MAKING MEANINGFUL EXPERIENCES OUT OF THOSE PATTERNS.** "

countries, for example, that same gap has narrowed over that same timeframe. Many economists agree that global income levels have actually *risen* over the last several decades.[7] And Charles Kupchan, Georgetown University Professor of International Affairs, reports that the collective GDP of Brazil, Russia, India, and China is "likely to match that of today's leading Western nations by 2032," according to a prediction by Goldman Sachs.[8]

If we aim for a fair depiction of the entire scene, what appears true is that globalization has led to increased spending power across the globe, which in turn has led to new generations of con-

sumers picking up "middle class" habits like buying more entertainment, buying more leisure, buying more health—in short, buying more depth and meaning for their time.

Technology is the Spell; Creativity is the Wizard ⋮⋮⋮⋅⋅

And this is where creativity comes into play. Oceans of information generate currents and patterns, and machines are great at making sense of patterns. But while machines are great at patterns, human beings are uniquely capable of making meaningful experiences out of those patterns.

Meaningful is the key word. If something crazy happened in last night's game, a computer's recap can provide the facts and figures, but none of the clutch shot's excitement, or its relevance to the game. When computers attempt that kind of meaning making, they have a hard time knowing where to stop. In 2017, research scientist Janelle Shane created an artificial neural network to invent new paint colors and names. The result was a sludgy mix of browns, beiges, and grays with nonsensical monikers like "clardic fug" and "stargoon." If this is artificial intelligence's idea of creativity, it might be trying a little *too* hard.[9]

Nor can pattern-crunching solve problems outside of the pattern. Diagnostics can measure known associations to make sure a truck doesn't break down in the usual ways, but it has a harder time realizing that spotting an error in design can actually become a pathway to a better truck. Machines might beat us at pattern application and replication, but we still beat machines at pattern rearrangement and disruption. Frank Barrett, jazz pianist and professor of management at the Naval Postgraduate School, defines this as a person's ability to "dislodge their routines so that they pay attention."[10]

Creative thinking begins with an embrace of the world's chaos, inviting us to reconsider challenges, assets, and opportunities in a new light. When we're evocatively startled, we can make startling new connections and new solutions. We can root out lost memories. In a 2017 *New York Times* essay about humanity's unique habit of thinking about the future, psychologist Martin E.P. Seligman and science writer John Tierney sum up this concept rather beautifully: "We learn not by storing static records but by continually retouching memories and imagining future possibilities."[11] Those connections and memories allow us to understand and solve complex problems and deepen our relationships.

In an essay for 2013's *The Handbook on the Experience Economy*, Albert Boswijk cites the example of tomorrow's pacemaker supplier who needs to "focus not only on improving his device but also enlarging the user's world ... and make it possible for the patient to feel safe no matter where he goes."[12] This requires a deep understanding of humanity's daily routines and experiences, which requires creativity that data alone can't muster. As computers use big data to smooth out so many little mysteries, the big ones continue to perplex our day-to-day lives with even more ferocity. Our need for novel experiences and innovative solutions will only sharpen.

Creativity fuels innovation even outside the domain of the creative economy. In 2008, Beijing university students built atomic force microscopes out of LEGOs.[13] The inventors of Lotusan, a self-cleaning paint, got their idea from butterfly wing topography.[14] Jämtkraft, a Swedish utility company, built an energy storage model based on "cloud computing" principles.[15] At the Eastman Chemical Company's Innovation Lab, a graphic designer is

in charge of material science innovation, and he is the brain trust behind "serious" inventions like using synthetic rubber and acetate yarn to build guitars out of cellulose—which might just save an entire species of Brazilian rosewood.[16]

In all these cases, we see creativity: play, rambles, collaboration, new angles for old tricks, breakdowns of categories and hierarchies, weird questions, strange connections, odd bedfellows, and spiky dreams.

The technology to help develop and implement these sorts of creative solutions is cheaper and more widely available than ever. But technology—even at the frontiers of machine learning and quantum computing—is hard-pressed to look at a wet butterfly wing and think "Oh, paint!" Engineers can write the cleanest code in town, but that won't matter much if that code is executing tired, outdated ideas. Technology might be the spell, but creativity is the wizard. If today's story is about the awe and anxiety of seeing all this innovation upend our old ways of life, and

" ...WE NEED CREATIVE ENTREPRENEURS: NOT ONLY TO MEANINGFULLY FILL OUR OFF HOURS WITH ENTERTAINMENT BUT TO CIRCULATE CREATIVITY THROUGHOUT THE ECONOMIC ECOSYSTEM. "

if that story is full of contradictions about benefits and perils, then creativity is both the hero *and* the villain. To adapt to and harness the chaos of this Fourth Industrial Revolution, we need a vision that thrives on staring into chaos and daydreaming. We can't afford to wait for 2020: we need creativity today, and lots of it.

That's why we need creative entrepreneurs: not only to meaningfully fill our off hours with entertainment but to circulate creativity throughout the economic ecosystem. As esteemed social theorist Jeremy Rifkin has argued, we are moving from the "age of possession" to the "age of access."[17] Good stories challenge us to tell better stories, and wild solutions compel us to solve more fearlessly. And just as entrepreneurs forecast and lead change throughout the business world, creative entrepreneurs are the leaders who will ensure that this circulation of creativity happens, who will help it thrive and use it to solve specific economic challenges.

Something Next Made Out of Nothing Yet

In Mali, creative entrepreneur Mamou Daffe was a video club owner and hotel manager whose hometown of Segou—never much more than a quiet river city—was going through hard times. Daffe had a vision to shake it up, and it didn't involve anything that wasn't already there. He combined traditional Malian humanist values with modern management acumen and cutting edge communication technology to found a music festival. His festival mixes traditional events like canoe races with popular contemporary musicians. Today, Festival on the Niger is one of the biggest festivals in Africa.[18] Tourists flock to experience this unique hybrid of old and new, and to partake in small but innovative touches, like a lodging system where local residents make money opening their homes to guests.[19] Creativity breeds creativity, and creative entrepreneurship breeds creative entrepreneurship.

Creative entrepreneurs like Daffe are not from another planet. They talk, think, plan, congregate, and hustle like every other entrepreneur since, and before, French economist Jean-Baptiste

Say invented the term. In Say's calculations, an entrepreneur was a businessperson who could "shift economic resources out of an area of lower and into an area of higher productivity and greater yield."[20] Something next made out of nothing yet. Most academics tend to define the term entrepreneurship as "the pursuit of opportunity without regard to resources currently under control."[21] Early translations of Say's work didn't even think English readers would understand "entrepreneur," so they used "adventurer" instead. And creative entrepreneurs are visionary adventurers in this time-honored fashion, daring to pursue as yet unmade opportunities and betting their resources will catch up.

Often a creative entrepreneur will begin with more pursuit and less resources—less resources than most startups—and will need guidance to harness their entrepreneurial impulses, as in Chapter 1's example of Meow Wolf's experience in our accelerator. But do creatives merit this entrepreneurial education? Is there evidence that investing in creative entrepreneurs will reap the same kinds of benefits as investments in tech, finance, health, and energy startups? In other words, is there evidence that entrepreneurs in the creative economy build companies with better growth than non-entrepreneurs? Research shows they do. A joint study between the Centrum Catolica in Lima, Peru, and the School of Management at the University of Surrey, U.K. comes to an emphatic conclusion: "small firms" in the creative economy demonstrate higher growth (especially "under conditions of intense competition") when they employ an "entrepreneurial orientation."[22]

What does "entrepreneurial orientation" mean? The authors of the study highlighted several key characteristics, all of which we look for in Creative Startups applicants, and all of which we

emphasize in our programs. File away this list; you're going to see these qualities repeated over and over in our examinations of successful creative entrepreneurs around the world:

1. Creative entrepreneurs work in autonomously functioning sub-teams capable of coming together to collaborate.

2. Creative entrepreneurs promote cultures "tolerant of ambiguity" and "conducive to experimentation."

3. Creative entrepreneurs invest in and use new technology.

4. Creative entrepreneurs stay abreast of marketing trends and aim to be "first movers willing and able to shoulder the associated risks."

5. Creative entrepreneurs build organizations that never stop learning.

From our experience and research, we would add two more:

6. Creative entrepreneurs frequently have a background in a creative discipline but partner with people of different but complementary backgrounds: engineering, finance, mechanics, and so on.

7. Creative entrepreneurs draw inspiration from place: communities, cultures, and local heritage.

These are qualities to look for when considering the viability of creative entrepreneurs, but they're also qualities that can help you understand the general culture of creative entrepreneurship.

In our programs, we teach budding creative entrepreneurs to see the connection between their creative energy and entrepreneurial skills. Once they see this connection between what they're already good at and what can propel their economic success, the wheels really start to turn. As Meow Wolf's Vince Kadlubek explained at a 2017 Coronado Ventures Forum, "Before Creative Startups, I felt like a scam artist, someone trying to beat the system... Creative Startups made me realize that I was actually an entrepreneur."[23]

Creative entrepreneurs tend to be driven by both creative expression and capitalism. And they are determined to build companies and create jobs. Unlike individual artists, who are driven mostly by the need and ability to output an artistic vision, creative entrepreneurs are relentless in their pursuit of market opportunities:

- They leverage the power of markets to drive their vision into our headphones, gaming consoles, jewelry boxes, travel plans, and stomachs.

- They cluster, network, egg on, and compete with fellow creatives.

- They exploit the latest in technology to create, market, and distribute creative works.

- At the same time, they nurture cultural heritage, rekindle traditions, and translate heritage into contemporary and future contexts through market mechanisms.

- They mobilize public support and court private investment.

- They tailor their ideas to the unique features of their communities.

- They hire local people, creating both gigs and stable long-term employment, often giving tradespeople—carpenters, welders, mechanics—unusual and invigorating work that delivers more satisfaction than the usual construction site.

- And because their companies resist cyclical recession, these jobs stick around.

The Integrity of Authenticity

As more people all over the world make more and enjoy more leisure time, the creative economy will grow vertically—in size, in worth, in jobs—but also horizontally—more participants, more innovation, more storytellers. No longer will people be content to import their movies from Hollywood and their music from New York.

Such is the case with Jamaican creative entrepreneur Kenia Mattis, founder of ListenMi Caribbean, a digital media producer that specializes in "Edutainment for young children and youthful adults in the Caribbean and its diaspora"[24] and boasts a diverse array of content: Animation, illustration, sound design, graphic novels, and apps. In addition to commissioned work, their portfolio includes:

- **ListenMi News:** An innovative Web show that remixes current event reports over dancehall beats.

- **GreaterCakes:** A storytelling and digital illustration

workshop for kids that culminates in publication via the GreaterCakes app.

- **League of Maroons:** The Caribbean's "first interactive graphic novel," a collaboration with indigenous Jamaican group the Charlestown Maroons.

MEET

Photo courtesy of Kenia Mattis

ENTREPRENEUR: Kenia Mattis

COMPANY: ListenMi Caribbean

INDUSTRY: Digital Media and Storytelling

BASE OF OPERATIONS: Jamaica

MARKETS: Global

EMPLOYEES: 10

NOTEWORTHY: In 2015 Kenia was selected from over 5,000 applicants to win the Spark the Fire Award at the Global Entrepreneurship Summit.

As a marketing manager producing TV and radio advertisements for a Jamaican snack company, Mattis grew tired of spending all her creativity on the stories of others. A descendent herself of the indigenous Maroons, Mattis is the daughter of a minister father and a radio DJ mother, and she's also a reggae lyricist with credits on Grammy-nominated albums. So, her business acumen comes with a heavy dose of creative credibility. She was inspired to start ListenMi with music producer Donald Medder because they shared a vision for "more diversity in cool, educational and culturally relevant storytelling."[25] As she told CNN, "there was a great market for black heroes, for people that look like us."[26] In an interview for The Sylbourne Show, Mattis also explained that the Jamaican diaspora needed a "digital platform that's globally accessible" to help kids abroad stay connected to their culture.[27]

Thanks to ListenMi's high production values, the company is flourishing. Mattis beat out 5,000 applicants to win the best startup award at the 2016 Global Entrepreneurship Summit.[28] Though still modest job creators, ListenMi videos get thousands of YouTube views, and their apps rack up thousands of downloads. They produce content for both domestic and international clients and are establishing branding collaborations with U.K. producers. Their workshops spark hundreds of Jamaican schoolchildren to learn cutting edge, marketable digital skills while encouraging these kids' creativity.

Like so many creative entrepreneurs, Mattis sees herself not only as a businessperson but an ambassador for the authentic distribution of her culture. In 2016, she was appointed the Vice President and Director of Funding for the Jamaica Film and TV Association, and she aims for the Association to train and develop

Jamaican creative entrepreneurs to take control of Jamaican stories on the international stage.[29] "What we've often had happen is that the stories are here, but the persons telling them are not from here," she said on The Sylbourne Show. "There's a level of authenticity that you can't get unless we're an integral part of the storytelling."[30] To address this, Mattis is determined to tell stories that have "local significance and global appeal."[31]

In a conversation with Creative Startups, Mattis pointed out: "We have so many untapped, untold stories in Jamaica and throughout the Caribbean, and it's very interesting because although they are uniquely ours, they're also a part of a wider African narrative." Mattis went on to describe the stories' relevance to power of connection across the African diaspora.[32]

In lower GDP nations like Jamaica, neither artists alone nor businesspeople alone will build the platforms that can launch this authenticity into the international market. Instead, creative entrepreneurs like Kenia Mattis are the ones building innovative companies that not only tell authentic stories but have the reach and ambition to become global leaders. Thanks to Kenia Mattis's creative entrepreneurship, ListenMi Caribbean is poised to turn the world's ears and eyes (and dollars) to Jamaica.

Home is Where the Growth Happens

Creative entrepreneurs understand local communities because they don't just work there, they live there. Often they grew up there. One of John Howkins's twelve rules for creative success is "Be nomadic" and "learn to feel at home anywhere,"[33] and this seemingly fundamental quality of creatives can make policymakers nervous. But creative entrepreneurs, in contrast to creatives in general, are

often surprisingly rooted.

Painter and creative entrepreneur George Marks was born in tiny Arnaudville, Louisiana, a town wedged between two bayous off the main freeways. Like many young artists, Marks left his town for bigger cities. But when he returned to care for his mother after his father's death, he decided not to repeat his hometown detachment. Instead, he consciously re-encountered the distinctive culture that had inspired him in his youth—a gumbo of Cajun, German, French, Spanish, and Native American influences. Marks decided to try to make Arnaudville "happen," for his mother's sake as much as his own.

He turned an empty car parts store into a hub for local creatives, a place he called Town Market. He hosted conversations and potlucks where he dared friends old and new to swing for their dreams instead of just talking them up. This turned into an arts collective. And that turned into serious business.

A fiddle shop opened in a former drug house. A sculptor moved into an old water tower. A Trinidadian café called Little Big Cup opened on Main Street, owned and run by returned natives like Marks, drawn back by the buzz. Local businesses negotiated a profit sharing model with an accompanying skill workshop series. The community started its own French language school.

After six years of hard work, Arnaudville currently thrives on local involvement *and* tourism, with visitors from "Canada, Haiti, and Africa," according to an NEA study.[34] They visit to witness "bonfires floating down the bayou on flat-bottom boats." When a place knows itself that well, people will come to see the creative expression of that knowledge. And who better to encourage and enable this than a homegrown creative entrepreneur? Creative en-

trepreneurs share a belief that creativity and new ventures should "start from where you come from, first," as Jonathan Sims, a filmmaker from Acoma Pueblo, New Mexico, explains.[35] At Creative Startups we have come to think of "where you start from" as the creative substrate that underpins communities we work with. And we know that a deep self-knowledge and understanding of cultural and creative substrate underpins innovation and leaps in creativity. With a firm grasp of one's culture, traditions, place, and people, it is easier to embrace and integrate new ideas, wedding the deeply known with the unknown to create something inventive that delivers value in the market.

With a spirit of cooperative involvement and an "ask forgiveness, not permission" attitude toward local bureaucracy, Marks and his cohorts revitalized their town. Grants and cultural district designations developed later, but Marks' creative entrepreneurship came first. What never would've worked as a top-down effort of government cultural injection worked with Marks' deep connectedness to his home. Here was a prodigal son returning to build up the local identity, one that had always existed, but had yet to realize its economic potential. Marks told the *Times-Picayune*,[36] "We've created an authentic destination. It's not like we're trying to create storefronts or a theme park. It's just that we're frayed, and we're flawed and we like that."

Now, surrounding towns are getting in on the action, with new literary festivals and Cajun music jams. By bringing Arnaudville back to life, Marks brought his whole region to the global market. When *Country Roads* magazine asked the owners of Little Big Cup—creative entrepreneurs in their own right—why they came back to Arnaudville, they said, "There's an old Cajun saying, 'After

one time, comes another.' Well, that was the time."[37] Like all entrepreneurs, creative entrepreneurs see the "another time" coming. What's special about creatives is they see how to make that time connect to their community's past and future.

Meeting the Reasons

Creative entrepreneurs can help meet a diverse array of economic challenges, but they can't do it alone. They need support from power-brokers, decision makers, and gatekeepers who understand how much they bring to the table. In an interview with Creative Startups, Andy Stoll—a senior program officer in entrepreneurship ecosystem development at the Kauffman Foundation—gave us this remarkable insight: "Entrepreneurs don't die from a single blow of a hammer; they die of a thousand little cuts." What do these thousand little cuts consist of? Stoll lays them out:

> Inability to access the mentor, inability to find answers to a particular question, inability to find avenues to reach customers ... Entrepreneurs exist in systems that have structural barriers that get in their way. Whether that's a person in a rural community who can't connect with resources in a nearby town, whether that's a female entrepreneur who faces structural biases against women, whether that's somebody that lives in Seattle and the answer to their question lives in Texas and there is no easy route there ... The barriers are numerous and often times small and invisible.[38]

But good leaders can help entrepreneurs overcome these structural barriers. For example, consider the leap of faith the town al-

dermen in Arnaudville took when George Marks convinced them to sell the old water-processing center to an artist. An *out of state* artist, no less. Aldermen of lesser vision might've dismissed Marks and his crew as an insular clique whose schemes would only benefit themselves. For every Arnaudville, there are plenty of towns that miss out on the creative economy because they can't recognize creative entrepreneurs. But the civic stakeholders in Arnaudville believed in George Marks, and their town was rewarded.

Sometimes the nature of creativity means these entrepreneurs need some help before they approach those stakeholders. They can't recognize themselves, or they have trouble articulating the exact shape of their ideas.

In a few chapters, you'll meet Guy Laliberté and Gilles Ste-Croix, the creative entrepreneurs behind the multi-billion dollar sensation Cirque du Soleil. But you'll be meeting them 30-odd years into Cirque du Soleil's success, not in the 1970s when Guy Laliberté was a busker in the alleys of Europe. Even with stacks of pie-eyed data, the

> **" THE CREATIVE ECONOMY ISN'T A SILVER BULLET...** NO SINGLE SECTOR IS GOING TO 'SAVE' AN ENTIRE ECOSYSTEM. **"**

creative economy can sometimes feel like it banks on an unnerving fuzz. That's why it's important to build an ecosystem of resources, including accelerators and incubators for creative entrepreneurs that offers them the same boost as tech startups have enjoyed.

And, that's where Creative Startups comes in. In this book, we want to demystify the Arnaudvilles, ListenMi Caribbeans, and Festivals on the Niger of the world, those seemingly magical success

stories. Through our work and research at Creative Startups, we've learned a lot about how to discover and empower entrepreneurs—and we have success stories of our own with companies like Meow Wolf, Native Realities, Etkie, and Embodied Labs.

We've showed you why we believe that creative entrepreneurs—when they have private and public investment—can be major problem solvers of those seven key challenges for economic ecosystems, and we can back up that belief with numbers and detailed examples. By studying creative entrepreneurs who have built businesses big and small—all significant to their local communities—we hope you'll learn more about how to recognize and foster creative entrepreneurship in your own community, wherever you are in the world.

Before we start, though, a note of caution. The creative economy isn't a silver bullet. While it's true that—unlike manufacturing, construction, and high tech—creative industries grew around the world during the global economic downturn of 2007-2009 (referred to throughout the book as the Great Recession), no single sector is going to "save" an entire ecosystem. Rigorously diversified economies with strong central pillars are the economies that succeed.

But what we've seen during our work with the creative economy has unlocked our optimism like no other industry. Most of the other skills from that World Economic Forum 2020 list are social in nature, and there's a reason creative products engender social skill development. There's a reason storytellers are making more money when what we need is more emotional intelligence. There's a reason UNESCO's *2015 Cultural Times Report* shows how creative and cultural industries are strengthening local economies all over

the world faster and more thoroughly than any other industry.[39]

For every job lost to technological innovation, we believe creative entrepreneurs can use technology to develop new jobs. And we believe this innovation will curb inequality and help local communities achieve more diverse economies, with more resilience, more entrepreneurial diversity, more democratized private investment, more connection to global markets, more engaged and employed youth, and more development of cultural legacies. When we dig into the creative economy, we uncover some of today's most stirring market-based solutions to social and economic turbulence. Who is behind these solutions? Creative entrepreneurs. Let's meet them.

3

CHALLENGES, *Ecosystems,* AND THEMES

Stories and Structures

Bill Gartner—who teaches "entrepreneurship and the art of innovation at the Copenhagen Business School"—told Virgin.com that his students say they learn the most from the stories of guest entrepreneurs: "The personal stories show that entrepreneurship is possible."[1] There are many useful insights gained from tracking a company's history with charts and figures, but the histories come alive when they're framed with the familiar devices of narrative: protagonists overcoming struggles and taking surprising risks. We relate to stories. Through the exploits of others, we come to see greater potential in ourselves and our communities. Stories make data resonate. And they make convincing arguments. Barnaby Lashbrooke, founder of virtual assistant startup Time etc told Virgin.com: "No one wants to be preached to, especially not by a person they've never heard of before. They want to be entertained, and to learn—and storytelling delivers both."[2]

The purpose of this chapter is to provide a framework for understanding how supporting creative entrepreneurs can lead to practical solutions in your own entrepreneur ecosystem. We invite you to consider the stories we've gathered and imagine how

they inform and encourage efforts to build resources for entrepreneurs in your community, and your region. Chapters 4-10 each delve into a single challenge, putting faces to numbers and going far and wide for examples of creative entrepreneurship from regions of all sizes, cultures, and histories. In Chapter 11, we make a final pitch for why we're optimistic about an economic future in which creative entrepreneurs are empowered as agents of change and growth. Finally, in Chapter 12 we give you some concrete first steps to get you started in your local economy.

Throughout the book we use a variety of specific themes, motifs, and narrative tools that we hope weave these stories into a cohesive fabric. Because the creative economy is composed of many different sectors, it's important and useful to spot through-lines and connections among stories that might initially seem unrelated. These themes will give you a more comprehensive portrait of the creative entrepreneur and more nuanced insights into how creative entrepreneurs catalyze economic growth.

Before we dive into the stories, however, one critical point must be made: like all entrepreneurs, creative entrepreneurs exist within a larger organizing principle, the "**entrepreneurship ecosystem**."

LEGEND

THEMES

 Ecosystem
Concepts

 Activate your
creative ecosystem

MOTIFS

 Meet the
Entrepreneurs!

 Our work with
Creative Startups

Throughout the book we highlight and explore ecological concepts and ecosystem elements as they relate to efforts to build a vibrant creative economy. We identify opportunities for leaders to "activate" ecosystem elements and stakeholders. A wide range of stakeholders stand to benefit from the existence of a vibrant creative entrepreneurship ecosystem: from economic developers to policymakers, investors to university faculty, entrepreneurs to service providers. Indeed, we all stand to gain economically and culturally when creative entrepreneurs encounter a well-resourced creative entrepreneur ecosystem.

We aim to unpack and understand this ecosystem with you by sharing examples of creative entrepreneurs who build companies within the ecosystem and bring to life and apply its lessons. Not all creative entrepreneurial ecosystems are at the same stage of development. You'll meet some creative entrepreneurs well-supported by existing and vibrant ecosystems; you'll meet some who forged ahead in atmospheres of scarcity or adversity. But wherever you find successful creative entrepreneurs, you'll find creative entrepreneurial ecosystems, whether robust or nascent, interconnected or broken into islands. By learning to analyze the different varieties and stages of creative entrepreneurial ecosystems, you'll prime yourself to help build your local ecosystem.

Creative Entrepreneurial Ecosystems

What is an entrepreneurial ecosystem? Again, we asked Andy Stoll of the Kauffman Foundation, to give us a concise definition:

> An entrepreneurial ecosystem is the system of support that surrounds any entrepreneur. The primary function

of an ecosystem in the natural world is to move nutrients from the people who have them to the people who need them. In any case of an entrepreneurial ecosystem, you can think of entrepreneurs as the primary beneficiary. Entrepreneurial ecosystems circulate the knowledge and the resources to the entrepreneurs who need them.[3]

To dig deeper into the concept of a creative entrepreneurial ecosystem, we need to start with the more general concept of entrepreneurial or startup ecosystems. In 2010, Daniel Isenberg of Babson College established the Babson Entrepreneurship Ecosystem Project (BEEP) to help "public and private sector leaders" in a diverse array of locations—Latin America, the U.S., Scandinavia—understand how regions can support entrepreneurship.[4]

BEEP's work is based on a biological framework of ecosystems—defined as environments in which diverse abiotic and biotic actors interact, transforming and exchanging energy in complex and interdependent ways resulting in a self-organizing and resilient ecological system. The notion of "entrepreneurship ecosystem" draws on the field of ecology, which concerns itself with understanding the relationships among entities in a natural environment. By applying relational and systems thinking to understand entrepreneurial environments, scholars, practitioners, and investors aim to build more resilient and adaptive systems, providing support for more entrepreneurs to succeed. BEEP offers a framework for regional stakeholders to assess and observe their entrepreneurial ecosystems, and offers prescriptions to maximize ecosystem health.

The BEEP framework consists of individual elements that—

when combined—help entrepreneurship flourish. As Isenberg explains in an essay for the *Harvard Business Review,* "in isolation, each [element] is conducive to entrepreneurship but insufficient to sustain it..."[5] Together, however, these elements turbocharge venture creation and growth. And, increasing resources and connections among these elements, as well-crafted startup accelerators do, generates outsized impacts on developing entrepreneur ecosystems due to their cultivation activities.

Recently, Isenberg has become critical of the misuse or overly enthusiastic application of the ecosystem metaphor, pointing out that a true and undisturbed ecosystem, "lacks intervention" and that "central control" of entrepreneur ecosystems flies in the face of how ecosystems actually function.[6] Ecosystems are self-regulating, naturally evolving in response to disruptions and changes, without human intervention. Isenberg argues that efforts to cultivate or engineer entrepreneur ecosystems is more akin to farming than ecological processes. This criticism may be accurate. However, for those of us working to ensure brighter economic futures through increasing entrepreneurial activity, activating certain elements and stakeholders in ecosystems is one practical activity we can take on. At Creative Startups we have seen time and again the positive effects of cultivating a more connected, collaborative, and competent entrepreneurial environment. As with farming, amending and altering the entrepreneurial environment leads to increased output (jobs, incomes, creative output). At Creative Startups, we construct relationships, expand knowledge, and nurture nascent visionaries. We reap what we sow and our results speak for themselves.

Our work with regional ecosystem leaders and stakeholders is directed at cultivating relationships among ecosystem elements while

simultaneously delivering proven programs that educate and support entrepreneurs. Creative entrepreneurs are often on the sidelines of a startup ecosystem and sometimes the ecosystem is underdeveloped. To tackle both problems at once, Creative Startups weaves connections between creatives and ecosystem elements through our unique accelerator programs. Creative entrepreneurs can start businesses anywhere, but to ensure their ventures take off and grow, they need to be plugged into the right supporting apparatus.

As communities struggle to adapt to the shifting global economy, and as entrepreneurial activity increasingly huddles into urban "startup capitals" that already sport robust ecosystems,[7] accelerators provide vital catalysts to help other communities level the playing field. In addition to potentially increasing a region's tax base and available jobs, startup accelerators put nascent regional

THROUGH OUR ACCELERATOR PROGRAMS,

Creative Startups has directly led or significantly influenced the cultivation of creative entrepreneur ecosystems in the communities where we work. Our accelerator programs serve as conveners, catalysts, and capital aggregators. They infuse regions with new resources, bring forth overlooked assets, and draw new connections among existing stakeholders. The end results include new businesses, greater investment in startups, more jobs, and a widening tax base. Our LABS: Pre-accelerators give nascent entrepreneurs an open door through which they can pass to discover the startup ecosystem in their community, bringing new energy into the economy. Our workshops enable planners and funders, entrepreneurs and investors, to work toward a more resilient and growth oriented ecosystem.

entrepreneurial ecosystems on the map, attracting new entrepreneurs and catalyzing the success of existing entrepreneurs. They also attract investors seeking lower cost environments, tap into unique local resources, and support bolder innovation.

Ecosystems are, by definition, a set of relationships that allow for the flow of resources among actors in a given environment. For ecosystems to thrive, they need resources and energy to flow in and out of them. Ecosystems that enclose themselves and shut off outside inputs grow stagnant. Healthy ecosystems depend on the introduction of new resources: rivers deliver nutrient-rich sediment from hundreds of miles upstream, winds transport seeds from neighboring states, and animals digest and distribute seeds and nutrients across entire biomes. You can't get a diversified and resilient forest if it has no connection to resources beyond its boundaries. That's why community leaders need to think outside of their zip codes when it comes to growing their entrepreneurial ecosystems.

> "...ACCELERATORS PROVIDE VITAL CATALYSTS TO HELP OTHER COMMUNITIES LEVEL THE PLAYING FIELD. "

Increased flow and exchange of resources across boundaries can be facilitated through accelerators, conventions, and networking events. We call this the "fluidity of social capital"[8] and, when it exists among ecosystems elements, it speeds innovation and serves to inspire entrepreneurs to strive for newer and better solutions. We have seen time and again the usefulness of bringing together startups from around the world in one accelerator. A cross-pollination effect often leads to leaps in creativity and unlocks market

opportunities for startups whose market opportunities are global.

Among the cornerstone concepts of ecology, the notion of disturbance or disruption is especially instructive when considering entrepreneurs and their role in economic systems. As in all ecosystems, shifts in the environment allow for the introduction of new actors, and eventually necessitate adaptive responses from other actors in the system. Entrepreneurs capitalize on shifts in the environment, they often disrupt the system, bringing forth new economic behaviors and shifting the flow of resources, power, and influence. Entrepreneurs, being highly adaptive creatures, thrive on disruption, perpetuate disruption, and eventually come out as ecosystem leaders. But this process is challenging, and entrepreneurs cannot achieve success all on their own. They need mentoring, support, and programs like accelerators to nourish them along their journey.

Mutually beneficial—symbiotic—relationships emerge among actors in an ecosystem over time. Investors benefit from startups that grow and return their wealth, while startups benefit from investors who capitalize their growth. Higher education institutions graduate students who build companies, hiring more graduates and growing the need for more educated actors. And established companies benefit from startups moving into the ecosystem and responding to consumer demands in innovative ways, keeping markets fresh and expanding. Sometimes, these startups are acquired by larger companies, reaping financial rewards for the startups founders. The symbiotic relationships that develop within ecosystems reflect the interdependent nature of ecosystem actors.

The substrate, or foundation, on which organisms grow can determine and shape their products and services of startups. This

substrate can be nutrient rich, fostering growth and innovation, and sometimes can stymie flourishing upstarts and innovators. Cultural norms, heritage, and traditions can serve to inspire and inform innovation, but sometimes can exclude or reject innovation in an environment. Creative entrepreneurs often derive their passion from their local heritage, bridging this wealth of knowledge and perspective into new markets and opportunities. In this way, they are keeping alive the values of "the old ways" while generating jobs and meaningful engagement for youth today and tomorrow.

Ecosystems are home to varied species—in entrepreneur ecosystems these may include founders, investors, educators, policy makers, customers, and more. Within the biological domain, ecologists recognize "endemic species," those originating from that place and highly adapted to survive in that unique environment. Ecologists also study "introduced species," or species that have been brought more recently, usually through human activity, to a given ecological community. Many introduced species wreak havoc on an ecosystem as endemic species have difficulty competing for resources when these introduced species arrive. Much of our work stems from the belief that investing in and supporting "endemic" entrepreneurs invites innovation and adaptability that complements a given community instead of displacing existing cultures and stakeholders.

Finally, in many ecosystems "keystone species" are those species that exert an outsized effect on their ecological community, despite not being prolific in population. Wolves in the Southwestern U.S. can be considered a keystone species: Relatively few survive yet their presence can dramatically shift both ecological processes and human communities. Likewise, some startups or companies

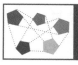

ECOLOGY CONCEPTS

- **Adaptation:** A change or the process of change by which an organism or species becomes better suited to its environment.

- **Disruption:** A disturbance or problem that interrupt a process.

- **Diversity:** The degree of variation of living things present in a particular ecosystem.

- **Endemic Species:** Species native or confined to a region.

- **Interdependence:** The dependence of two or more things on each other.

- **Keystone Species:** A species on which other species in an ecosystem largely depend, such that if it were removed the ecosystem would change drastically.

- **Resiliency:** The capacity of an ecosystem to respond to a disturbance by resisting damage and recovering quickly.

- **Resource Flows:** The circulation of the stock of assets that can be drawn on in order to function effectively.

- **Mutually Beneficial:** A symbiotic relationship between individuals of different species in which both benefit from the association.

- **Substrate:** The surface or medium on which an organism grows or is attached.

- **Symbiosis:** An interaction between two different organisms living in close physical association, typically to the advantage of both.

can have enormous effect on their entrepreneur ecosystem despite their small size, relative to other economic actors. Highly successful creative ventures tend to have both an outsized economic and cultural effect on communities.

The ecology concepts we denote throughout the book highlight the similarities between entrepreneur and natural ecological communities—and hopefully provide you a framework for con-

ceptualizing and building a more robust ecosystem for entrepreneurs. Our work has centered on launching successful accelerators as a lever for lifting up entrepreneurs and resources otherwise left on the sidelines. The result of accelerators and other entrepreneur education programs, when effective, is a more robust and competitive entrepreneurial ecosystem with linkages among entrepreneurs, investors, higher education, economic development, and outside markets. Arguably, creative entrepreneurs in resource rich ecosystems stand the best chance to succeed—and integrate this success into their local economies.

Tracking the Threads

As we said at the beginning of the chapter, Creative Startups has successfully developed resources and connectivity in creative entrepreneurial ecosystems across the globe. The stories in the following chapters explore and expound necessary elements of healthy entrepreneurial ecosystems. It is our hope that by organizing our themes and motifs within the framework of creative entrepreneurial ecosystems, you will more easily be able to apply these stories to your own efforts to develop creative economies. As you follow these threads, you will likely see how the stories relate, and you'll gain an understanding of how diverse entrepreneurs share common qualities—and very different creative economies share ecosystem characteristics—that empower regional economic success.

1. **Startup Culture**
 - **Vision:** The first step to successful creative entrepreneurship and successful creative entrepreneurial

ecosystems is a startup culture whose values are championed and supported by local stakeholders. Chief among these values is vision.

Vision is the substrate—or bedrock- of every creative economy startup. Vision drives the entrepreneur and evolves with feedback from product tests and consumer testimony.

Successful creative entrepreneurs envision new futures and lead others toward them, possessing the charisma to get others onboard and the conviction to persist through challenge. As Juan Jose de la Torre put it for *Entrepreneur*, "vision is what makes [entrepreneurs] dare: dare to explore, dare to challenge, dare to insist, dare to keep pushing, dare to have the determination to succeed."[9]

In this book, you'll find that vision is perhaps the single most important driving force shared by each creative entrepreneur we profile. You'll meet creative entrepreneurs walking 56 miles on stilts to convince bureaucrats of their commitment. If you track the qualities of persistent vision throughout these stories, you'll learn to recognize the visionaries in your own communities.

- **Dynamic Networking and Collaboration:** The other critical value of startup culture is a desire to create rich, meaningful, diverse networks that invite new actors in and generate robust flows of social and financial capital. Creative entrepreneurs share meals with strangers and team up with practitioners of wildly different disciplines.

Again and again in these stories, you'll meet creative entrepreneurs who never turn down a meeting, who serve as conduits between communities that would otherwise never interact, and who deeply value the stories of others and are intensely curious about connecting and collaborating.

Creative entrepreneurs compete in ways that challenge each other and reject the fear of scarcity or precarity. This leads to cultures like the Guildford, U.K. video game industry discussed in Chapter 5, where the swift and open movement of resources and knowledge helped create a sector of growth in a larger environment of recession.

2. Mentors and Support

- **Mentorship:** At Creative Startups, we consider our global network of mentors the "secret sauce" to our success, and that's because good mentorship is often the difference between a creative entrepreneur going boom or bust.

In these stories, you'll meet creative entrepreneurs who are mentors themselves, building companies to empower and educate youths and connect them with their heritage. You'll meet creative entrepreneurs inspired by the

INVITE SUCCESSFUL creative entrepreneurs in your region to mentor emerging creative founders.

encouragement of creative mentors. You'll meet college professors connecting students and urging them to turn

their classroom ideas into viable companies. You'll see mentorship take the form of skill sharing, signal boosting, and financial investment.

As you track the mentorship throughout these stories, consider the advisors and mentors in your community, their diversity of wisdom and talent, and how to create new opportunities for them to connect with creative entrepreneurs.

3. Markets

A Demand for Local, Authentic Experiences: Creative entrepreneurs are highly innovative and their success often lies in their ability to connect with others. Startups depend on markets, and consumers depend on startups. If you create a new market no one needs, you haven't actually created anything. Successful creative entrepreneurs can see the futures of consumer behavior: children's television migrating to YouTube; data-driven, personalized, subscription-powered fashion services in NYC; a booming youth population in Nigeria with an appetite for homegrown music.

These are three of many examples of a growing global consumer desire for local, authentic experiences. As you read how creative entrepreneurs respond to this growing desire, you'll learn how to identify both local entrepreneurs with a keen mind for markets, and you might learn new ways to see factors of regional identity as economic assets.

Global Networks: When it comes to creative entrepreneurial success, what goes hand in hand with this consumer desire for authentic local culture and experiences are creative entrepreneurs who know how to establish wide-reaching global networks. Creative entrepreneurs turn "think globally, act locally" into an economic mantra. You'll meet a Laotian fashion entrepreneur who went from a refugee childhood in Argentina to presenting at global leadership conferences, and you'll meet a Creative Startups alum who brought New Mexico Native American traditions to Paris Fashion Week.

As you read these stories, think about your local creative community, and see if you can identify creatives who are well-embedded locally but are also routinely active in large global networks. These networks are sometimes informal and not obvious, but these stories will teach you how creative entrepreneurs leverage their networks into economic success.

I D E N T I F Y and recognize creative industry clusters in your region; work with creative entrepreneurs to generate proactive policies to support their growth.

4. Policy

- **Recognition of the Creative Economy:** Implementing public policies that help actors differentiate the creative

 SUBSTRATE

The geologic substrate and soils of an ecosystem provide the foundation from which growth and success are possible. Likewise, cultural heritage can nurture new forms of entrepreneurship when infused with innovation and technology.

economy from other industries can serve as an early step to generating more supportive ecosystems. In Chapter 5, you'll read the story of the U.K. video game industry winning their own census classification codes in 2007 (part of a larger story of the U.K.'s leadership in establishing creative "hubs"), and in Chapter 8, you'll read how Taiwanese government initiatives made wedding photography a key plank in their creative economy efforts.

These policies are often reactive instead of proactive, but take note in these stories of how governmental recognition of pioneering creative entrepreneurs helped integrate those individual successes into robust regional economic clusters. Whether recognition takes the form of tax incentives, tourism funds, zoning, or other region-specific solutions, you'll see how important it is to highlight and celebrate what makes the creative economy unique.

- **Intellectual Property Support:** Likewise, you'll read how policies that help creative entrepreneurs proliferate their brands is key to a healthy creative entrepreneurial ecosystem. In Chapter 6, you'll read about how one

creative entrepreneur "neutralized" the intellectual property of his innovative television show to help it circulate through global markets and manifest in different associated products.

5. **Entrepreneurial Capacity**

- **Technology Meets Heritage:** As we said above, creative entrepreneurs share innovative visions. Their startups share business plans that build meaningful connections between new technology and respected legacies. You'll meet entrepreneur after entrepreneur whose success is based on a technological innovation that also breathes new life into stories important to their communities, their cultures, and themselves. From indigenous comic book publishers to pitch-shifted hip-hop, online Lebanese recipe communities to wildlife tracker apps, creative entrepreneurs translate heritage into fresh opportunity.

As you meet these innovators, consider the availability of resources in your community that allow creatives to both learn technological skills and interface with cutting-edge technology.

- **Platforms, Not Silos:** Another defining theme of the startups we profile is their ability to build creative teams that coalesce around overarching visions and grow their initial idea into platforms that cross genres, markets, and sectors. You'll meet the daughter of a minister and radio DJ who pivoted from a career as a reggae lyricist into creative

moguldom, running a Caribbean production company that seamlessly combines animation, illustration, sound design, graphic novels, and apps.

Understanding the stories of creative entrepreneurs who set out to create platforms for collaboration instead of single products will let you identify the ambition that distinguishes creative entrepreneurs from creatives, helping you find the roots of your creative entrepreneurial ecosystem.

6. Entrepreneurship Education

- **Business Foundation and Disruptive Drive:** One important thing you'll realize as you read these stories is that vision is not always immediately clear and eye-popping. Not every creative entrepreneur is transforming old bowling alleys into dimension-hopping interactive experiences, but they're all figuring out a way to turn creativity into profit. And most understand they need to learn the foundations of good business practice.

We profile a few Creative Startups alumni who gained their business skills in our accelerator, but we also consider alternative routes to knowledge. You'll meet several creative entrepreneurs who began in different careers that lent them the vocabulary and knowhow to return to their creative roots and successfully build a creative company. Some of them, like Chapter 11's Bethlehem Tilahun Alemu of Ethiopia, became serial entrepreneurs, exciting forces for disruptive design that grows regional economies.

As you read these stories, consider the opportunities in your community for creatives to learn business skills or for existing professionals to pursue creative entrepreneurship.

7. Investment Capital

- **Deep Connections:** The relationship between a successful creative entrepreneur and their investors is often more personal and nuanced than it is with other entrepreneurs, as you'll see in these stories. In Chapter 6, we discuss how creative entrepreneurs want investors who function more like mentors, and we explore how that relationship is mutually beneficial.

 As you read, consider how you can foster these deep relationships between investors and creative entrepreneurs in your community, and take cues from some of the surprising relationships you'll discover. The fit between an investor and a creative entrepreneur is not always obvious, and these stories will inspire you to broaden your view of which investor (or what kind of investment) might achieve synergy with a creative entrepreneur.

- **Public Leadership Investment:** Money is not the only kind of investment that helps creative entrepreneurs and creative entrepreneurial ecosystems. In these stories, you'll meet leaders who invest their political capital to support entrepreneurs and help creative economies flourish. From mayors in a small town in Portugal helping jumpstart bookstores, to governors in West

Java attending punk shows, you'll meet inspiring public figures who co-star in creative entrepreneurial success.

As you meet them, consider their strategies and how they balance the classic "push and pull" of government initiative. When does hands-on leadership become interference, and when does hands-off leadership become a void of leadership? These stories will raise provocative new answers to these questions and expand your idea of leadership as investment.

Inspiring Futures

These are a few of the most important threads and themes to follow as you read these stories of creative entrepreneurship. As we begin our journey with a couple of street performers who built a multi-billion dollar business out of a creative industry that common wisdom had thought dead, we also encourage you to simply enjoy the audacity of these narratives.

We asked a Creative Startups mentor, Lisa Alderson,[10] what makes creative entrepreneurs distinct from other entrepreneurs. As an entrepreneur who has been pushing the boundaries of creativity in technology, media, and biotech, Alderson has seen plenty of creative entrepreneur journeys. Since founding her first company at the age 19, Alderson has accumulated 15+ years of experience as a serial entrepreneur. For her, it's all about the passion and the story:

> Building the vision is what will attract investors, talent, customers, and partners. It's about crisping up that story, that vision, and bringing it to life, so others can be in-

spired and help to share the vision for what the entrepreneur wants to accomplish.

In this book, you'll meet plenty of creative visions turned enterprises. You'll meet colorful personalities and unlikely successes, and you'll encounter a humanizing number of rock bottom rebounds amidst all the eclectic innovation. The ability to pivot and learn from failure is a quality all entrepreneurs share, and when you see how creative entrepreneurs pivot to building new visions for the future, we think you'll become as excited about their work as we are.

4

Firebreathers and Apple Pickers

When a circus tent is raised, the central pole can't hold the weight of the entire tent. It needs help. Likewise, a single Canadian circus company can't turn into the largest theatrical producer in the world without a lot of people raising a tent together. For Montreal-based Cirque du Soleil, the story of that tent begins with two charismatic creative entrepreneurs: co-founders Guy Laliberté and Gilles Ste-Croix.

Like many creative entrepreneurial endeavors, theirs was not an overnight success. Laliberté spent his 20s busking in Europe before returning to his Canadian homeland to look for work fire-breathing and accordion playing. Ste-Croix took a similarly circuitous path. He quit stable jobs at an architect's office and as a theatre manager to pick apples on a commune, where he concocted his first set of stilts by attaching a ladder to his legs. When a power plant strike foiled Laliberté's burgeoning career as a nuclear engineer,[1] he and Ste-Croix threw themselves into do-or-die festival organizing. Slowly, enduring hardship alongside all the employees who stuck with them through early lean years, they built what became Cirque du Soleil.

MEET

Image courtesy of Cirque du Soleil

ENTREPRENEURS: Guy Laliberté and co-founder Gilles Ste-Croix

INDUSTRY: Entertainment

MARKETS: Global

COMPANY: Cirque du Soleil

BASE OF OPERATIONS: Canada

EMPLOYEES: Over 4,000

NOTEWORTHY: Sold a majority stake of the company to private equity firm TPG in 2015 for $1.5 billion.

In the Cirque du Soleil authorized history, *20 Years Under the Sun,* the company's first tour manager, Serge Roy, identifies complementary entrepreneurial qualities in Laliberté and Ste-Croix: "Guy was always the go-getter, the person who knocked on doors… Gilles Ste-Croix was the ringleader, the catalyst."[2] Both made bold entrepreneurial moves. When early tours earned audience raves but weak bottom lines, Ste-Croix shrewdly set up a

nonprofit holding company to mitigate losses. After the minister of cultural affairs rejected Cirque du Soleil's funding application, Laliberté dialed up the charm and sidestepped the middle man, making a personal trip to Québec City to convince Premier René Lévesque that his circus deserved a grant. When an early prototype of Cirque du Soleil slammed up against its host city's festival ban, Ste-Croix retooled it as a "fête" and emphasized its connection to medieval traditions, flattering the Canadian community's sense of lineage. For another project, Ste-Croix walked 56 miles on stilts to convince bureaucrats of his commitment.

Though the origin stories of Laliberté and Ste-Croix are colorful, they are not unique. Self-reliance and adaptation are hallmarks of the creative lifestyle. Creative entrepreneurs tend to have nonlinear employment histories, supporting their passions by supplying their labor where the market will compensate, stringing together freelance and short term gigs or using their skills in various vocations that happen to share the same toolkit of their creative specialty. They emerge with a knowledge of many fields and a realistic sense of what signifies job "quality." To this knowledge, creative entrepreneurs add ambition, maximizing size and impact, and the drive to do whatever it takes to make their own lives viable and—if all goes well—for a healthy community of employees.

Even Accountants Can Join the Circus

In 2010, Katherine O'Dwyer typed up a resume of her nine years behind desks in the Australian entertainment industry and applied online for an accountant position with Cirque du Soleil. As she told Girl.com.au, she wanted to "explore the world." Two years later, the Melbourne native moved into a Purchasing Coordina-

tor role and was doing exactly that, traveling with Cirque's Kooza show in 48 countries, from Germany to Japan to Argentina and beyond.[3]

Kooza is a nod to the Sanskrit word for "treasure chest," and O'Dwyer is one of 4,000 employees in 50 countries who keeps that chest brimming at Cirque du Soleil. As a Production Purchasing Coordinator, O'Dwyer interacts with many of these employees. Gaffers call when they need tape, cooks call when they break eggs, and plumbers send her into Russian hardware stores to attempt the phrase "trubnyy klyuch" (pipe wrench). For the record, O'Dwyer can say "forklift" in seven different languages. When she sees a props person coming her way, she braces. Since they might be a sculptor, a painter, a welder, a tailor, and an electrician—all in one—there's no telling what they might need.

For example, Holger Förterer, an Interactive Projection Designer, might need a special photodiode. He programs scenery that responds to performer movement, video-projected rocks tumbling from artificial cliffs.[4] Meanwhile, those performers get their heads 3D printed for mask fittings. They wear dresses adorned in 98 robotic flowers, all individually programmed to change colors from white to red. No wonder Cirque hosts "red carpet" events at STEM recruiting fairs. This is a company where stagehands know Auto-CAD and engineers speak carnival lingo. "I am midway between art and technology," Förterer says. "All of my efforts seek to use technology to the point where it becomes art."

A Ring of Creative Employment

At Cirque du Soleil, each of those 4,000 employees seeks to make such an integral contribution to these dazzling shows that

their efforts become creative, visionary instead of vocational, and they see themselves as essential assets in the company's creative ecosystem. Cirque nurtures this pursuit in many ways, not the least of which is a highly collaborative environment. At the headquarters in Montreal, which is so big that it fills the site of a former landfill, "the clowns and the suits eat lunch in the same cafeteria," as Sarah Barmak put it for *Canadian Business*.[5] Let's examine a few of the diverse skills mingling inside that cafe:

- A milliner chats with the engineers who 3D print the model heads they use for their hat designs.

- A dozen lawyers in the immigration department process work visas—4,000 to 5,000 each year.

- An on-staff physiotherapist designs a program that helps an aging acrobat repair their body so they can transition to coaching or clowning.

- A performance psychologist shares a laugh with an audio engineer who carries a broken synthesizer, comparing notes on their respective repair techniques.

- A technical documentarian with a Masters in Library Science quizzes a costume designer to make sure every detail gets archived.[6]

From milliner to documentarian, Cirque employees work in over 100 unique occupations. Together, they plan and produce 18 annual shows for an average of 10 million people—180 million since 1982—including permanent Las Vegas shows that attract five percent of that city's visitors *every night*.[7] All told, the shows

generate nearly 1 billion in annual revenue and have visited over 60 countries.[8] It takes a big crew to run the Cirque, and it takes every person to keep the lights on and changing colors.

Of those 4,000 employees, only 1,300 are performers.[9] The rest work behind the scenes, in front and back of house, building things, maintaining them, maintaining each other, keeping audiences happy, keeping the books in check. Aggregated data from hundreds of testimonials show that between 80 and 90% of Cirque employees are satisfied and would recommend working there.[10] Thanks to Cirque's horizontal career transition programs, many employees at Cirque can, and have, worked there for 15 years or longer.[11] Though the usual performer contract is only one to two years, the majority of Cirque's employees work at least four years on average.[12] These employees stay and thrive not only because they're traveling and having fun, they're also making living wages and receiving good benefits. The average wage at Cirque is $56,000, and Cirque offers a full suite of benefits, including generous 401(k) plans, tuition reimbursement, and perks on par with the sleekest of Silicon Valley companies.[13]

DIVERSITY

Ecosystems thrive when myriad species interact and exchange nutrients, building more adaptive and resilient communities.

Many workplaces aim to build communities, but Cirque feels truly communal because its employees unite around their attempts to create unforgettable experiences. These are the experiences—and stakes—that make the creative economy a distinctly satisfying sector for employees: there's nothing that brings teams together

like the make-or-break of assembling a stunning experience for other people.

Creative Risks for Employment Success :::::::::::::::::

From the beginning, Laliberté and Ste-Croix conceived of Cirque as not only a creative project but also an economic and employment powerhouse. The creative economy is no different than the overall economy in the fact that new job growth is overwhelmingly driven by entrepreneurs like Laliberté and Ste-Croix. E.M. Kauffman Foundation research shows that "new businesses account for nearly *all* net new job creation," as well as "almost 20 % of gross job creation."[14] In fact, the first government funding Laliberté and Ste-Croix received was not for Cirque as a subsidized "arts organization" but as a job-creation program.[15] And the numbers justify this framing.

As we mentioned in Chapter 2, the creative economy employs nearly 30 million people—one out of every 100 people you meet—and these numbers continue to grow.[16] According to the U.S. Bureau of Labor Statistics, the entertainment industry alone is poised to grow six percent over the next decade, creating 46,000 new jobs.[17] And the entertainment industry is only one slice of the creative economy. According to the National Endowment for the Arts, for every American "arts job" created, you get 1.62 jobs "outside the arts."[18] Scratch a filmmaker, for example, and you'll uncover electricians, pilots, software engineers, hairdressers, and more. The Occupational Outlook Handbook from the U.S. Department of Labor predicts job growth to range between six percent and 11% for creative occupations over the coming decade.[19]

Unlike other sectors that show growth, these are not "race to

the bottom" jobs. These are quality jobs that people enjoy, and they're innovating the meaning of work. Though average contract lengths are lower in the creative economy than in other sectors, overall time spent employed in the creative sector is higher.[20] This leads to what Gijsbert van Liemt of the International Labour Office (ILO) has called "portfolio careers," where workers develop an array of skills that carry them through a lifetime of diverse opportunities, as opposed to siloing in one place. Van Liemt argues that these "portfolio careers"—which "mix self-employment with part-time or fixed employment, unpaid work, self-financed training, networking, self-promotion and, in general, a blurring of the demarcation between working and non-working time"[21]—were born in the creative industries but represent the future for most workers, making creatives uniquely suited for adaptation.

Adapting and Embedding

In *Creative Work Beyond the Creative Industries*, researchers take another angle when they make the case for the development of the creative economy and for strong creative industry education: the high percentage of creative workers "embedded" in non-creative companies. Though we focus primarily on creative entrepreneurs, the scholars writing in this anthology make a compelling case for the holistic employment benefits of highly supported creative skill development. Editors Hearn and Bridgstock (et. al) point out that "a number of studies in different countries have shown that more creative workers are employed outside than within the core Creative Industries" and that "employment of creative workers 'embedded' in other industries, or providing creative services to other sectors, is growing at a faster rate than employment within the Creative Industries."[22]

Because of this ability to flexibly embed, scholars such as Stuart Cunningham argue creative workers do not face as much precarity as is commonly believed, especially compared to "their counterparts in other sectors, such as agriculture, mining or low-wage service sectors."[23] Much of the rest of *Creative Work Beyond the Creative Industries* is devoted to case studies of embedded creatives in many diverse industries, from healthcare to banking to manufacturing. What these case studies illustrate is that creatives add value and innovation to all of these industries, and that creatives in leadership at traditionally "non-creative" companies dramatically improve such companies' fortunes, especially within the thick competition of the Fourth Industrial Revolution.

One interesting example of intentional creative embedding is TILLT, based out of Gothenburg, Sweden. An organization that began selling discounted art event tickets to public employees, TILLT now embeds artists, creatives, and "cultural ambassadors" in "non-creative" workspaces to provide "catalysts for change," according to European regional policy magazine *Panorama*.[24] This shift in direction was the result of a creative entrepreneurial pivot by new CEO Pia Areblad, and the results have been impressive: where TILLT embeds artists, productivity rises, sick leave declines, and employees are more engaged in workplace communities. These embedded creatives are not entrepreneurs, per se, but they do tend to seed creative entrepreneurial thinking, and organizations benefit from this fresh injection of innovative problem-solving.

The success of such embedding underscores the importance—for the future of labor markets and general economic health—of robust education in creative skills, a subject we will delve into further in Chapter 8.

A New Door on the Same Floor : . .

Whether they lie within the brackets of the creative industry or not, cyclicality and flexible growth are both features for companies that embrace "portfolio careers" and embedded creatives. Cirque du Soleil, for example, routinely cycles in new artists for existing projects to generate more diversity in their creative product. That's cyclicality. But they also train longstanding employees to transition to new roles. That's sometimes called "horizontal growth." As William Craig put it in an essay for *Forbes*: "Vertical growth is like taking the elevator straight to your destination. Horizontal growth is like opening a bunch of new doors on the floor you're already on."[25] Workers in the creative economy might have less stability at any one individual "job," but they are better able to open new doors in a world where the meaning of the word "job" has changed.

Creatives stay hungry and curious their whole lives and are not content to follow the traditional model of sitting at the same desk or punching the same widget until retirement. Van Liemt found that recently graduated creative workers "welcomed the opportunity to work with different companies without making a long term commitment, and to meet and build relationships with new people."[26] As creatives themselves, the entrepreneurs who drive the creative economy understand this itch, and they build flexible companies and platforms that celebrate the freedom to meet new people and learn new skills.

As creative experience-makers and content creators continue to extend their reach into new markets via cheaper and flatter digital networks, these new flexible jobs have the potential to increase with the growing audiences for creative products. In Eu-

rope—where the creative economy employs 2.5 times more people than the automotive industry and more young people than any other sector—the creative economy showed 0.7% job creation growth during the Great Recession, while the number of jobs in other sectors fell 0.7%.[27] In Canada, a report suggests that the projected growth of the Canada Broadcasting Company's audience to 18 million by 2020 will gener-

% GROWTH IN JOB CREATION DURING THE GREAT RECESSION

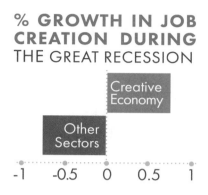

ate 7,200 new jobs.[28] These won't be centralized at the CBC; they will include contract work, broadcast technology innovations, and many more opportunities for creative entrepreneurs.

We have seen such job growth firsthand. Since 2015, graduates of the Creative Startups accelerators have created 73 new part time and 353 new full time jobs.[29] As is typical with accelerators, most of this growth often stems from one highly successful company, an example being Meow Wolf, which in 2014 had 2 employees. With plans to hire technologists, financial and human resources directors, and accountants, Meow Wolf is hiring a range of executives, artists, makers, marketing and media managers with the experience essential to fuel their rapid expansion.[30]

The creative economy is filled with dedicated employees, and that dedication ripples back into the communities where they live. In Montreal, for example, Cirque du Soleil runs schools and funds the rehabilitation of urban waste disposal sites.[31]

In this chapter, we will explore both numbers and lives. We'll share stories and stats that highlight four of our key arguments about jobs in the creative economy:

1. Like entrepreneurs throughout the economy, creative entrepreneurs drive job growth in the creative sector.

2. The creative economy creates a variety of jobs and keeps creating jobs. The jobs are growing, and they aren't racing to the bottom.

3. Jobs in the creative economy are economic base jobs, but are even better for their communities than traditional economic base jobs because they generate new traditions and community connectedness.

4. Creative economy jobs are "high quality," and workers employed by creative entrepreneurs enjoy what they do and experience unique opportunities for growth and lifelong learning.

In the story of Cirque du Soleil, we provided plenty of narrative supporting the first two points. So let's continue with the third: are creative economy jobs really economic base jobs?

Making a Place From an Economic Base

Creative economy jobs are unique in that they retain the most valuable characteristics of the economic base job category while offering new forms of local economy contribution as well. In *Creative Communities: Art Works in Economic Development*,[32] cel-

ebrated urban planners and policy advisors Ann Markusen and Anne Gadwa Nicodemus identify several ways in which creative economy jobs contribute to local economies:

- The presence of creative economy experiences for audiences increases local discretionary spending and changes local spending habits.

- Creative economy projects grounded in local strengths have a higher likelihood of evolving export-worthy products and services.

- Creative economy ventures attract skilled "workers, managers, entrepreneurs and retirees" in non-creative sectors to live and work in their region.

Markusen and Nicodemus argue that "given local access to new types of arts and cultural programming, people will change the composition of their spending toward the arts and away from other goods and services."[33] In other words, when locals are given a chance to hear live music at a club in their community, there's a strong chance that they will spend their discretionary income there instead of spending it at the local mall. Given the death of shopping malls, this prediction seems to be true. (Of course online shopping also has affected this shift. We believe that online shopping for mass consumer goods increases demand for unique and creative goods.) Creative and "local" ventures and events are thriving while monoculture shopping malls are dying out.

We can take this proposition even further: if a successful traveling theatre troupe has roots in a region, locals of that region will

be more likely to develop the habit of spending money on such experiences as part of the identity-building that accompanies civic life. Baseball caps are not the only ways for people to show their pride in where they live. And the more demand that local audiences have for creative economy experiences and products, the more jobs are needed to supply these demands.

In addition to generating local jobs, creative companies built from regional cultures, creative histories, and traditions, are both deeply rooted in their communities and also have wide reaching appeal. Contrasted with ventures not anchored in regional histories, local creative ventures are well suited to locally-oriented branding. Creative projects that stem from a deep understanding of a community build authentic brands and products that resonate with other communities as well, allowing for export and growth. Consider the success of New York's Metropolitan Opera whose shows are now broadcast in movie theatres across the U.S., or the dramatic rise of various microbreweries located in cities from Portland to Pittsburgh, whose products are enjoyed nationally. Today, these creative ventures and the economic resources surrounding them generate many economic base jobs, not only via tourism but also through export activities. And all of that export activity needs a diverse range of employees working to make it succeed.

ENDEMIC SPECIES

Entrepreneurs connected to their communities often generate businesses well-suited to their regional environment, capable of adapting and evolving as regional markets change.

Creative entrepreneurs build "creative places" rich in cultural activities and amenities. Richard Florida's "creative class" hypothesis[34] argues that creative people are drawn to live in communities where technology, talent, and tolerance abide. Furthermore, he posits that this "creative class" of workers, which includes artists, scientists, engineers, and designers among others, are the bedrock of a vibrant economy. Likewise, Markusen and Nicodemus reference the testimonials of employers outside the creative sector who are looking for quality employees as those who "often credit the arts with increasing their appeal to both managers and skilled workers," with some finding that "arts-rich locations help them attract customers too."[35] Since creativity is on track to be one of the most valuable skills in all professions by 2020, and more and more people will thus develop creative habits, it stands to reason that more and more of these creative people will want to live where they—in the tradition of artists and musicians and writers and designers and other creatives—can get a daily creativity fix.

High Quality Jobs

Creative economy jobs help their regional economic ecosystems, but do they help the people who hold them? What makes a creative economy job a "high quality" job? For that matter, how do we define a quality job?

Though many economists agree that measuring job quality standards leads to more accurate estimations of economic productivity as compared to binary calculations of employment status, agreement tends to end there. What makes for a quality job itself is a subject of complex, ongoing debate. Measuring job satisfaction can be misleading without measuring worker aspiration, for ex-

ample, and depends on which definition of "workers' needs" that is used, which itself depends on subjective theories of "need" in general.

For our look at high quality jobs in the creative economy, we studied various ideas and predictions about the global future of work—as we discussed in Chapters 1 and 2—and found that our values aligned best with the 2013 European Union Employment Committee Indicator Group.[36] Though these four factors are drawn predominantly from European surveys and analysis, we believe they represent universal concerns relevant to contemporary job quality.

5. **Socioeconomic security, including adequate earnings and job and career security:** We'll start with a relatively easy factor to parse: a high quality job pays more than just a living wage. It pays a comfortable wage, and it does so with reasonable surety that the wage will continue to grow over time.

- **Creative economy analysis:** While wage data for creative economy jobs vary based on geography, healthy creative economies in general boast higher wages than other sectors. For example, the *2017 Otis Report* on California's creative economy found that 8 of the 12 creative industries analyzed had a higher annual wage than the statewide average[37]. This report mirror's Adobe's *2016 State of Create Report* findings.[38] 2009 U.S. census data—from the middle of the Great Recession—showed that "artists" had a higher median wage than the rest of the labor force,

and the gap widens even further if factoring in creative economy jobs that don't fit under the strict definition of "artist" in the census.[39]

6. **Education and training, including skills development through lifelong learning and employability:** A high quality job includes upward or lateral mobility, and it features built-in opportunities for advancement and continued learning through education and training.

- **Creative economy analysis:** Data here are consistent across geographic regions: creative economy workers are generally more educated than most workers. This education only continues when you're employed in the creative economy, another reason for the high satisfaction of employees in these jobs and the high "confidence in the future" these jobs inspire.

> " **FOR EVERY DOLLAR CONSUMERS SPEND ON ARTS EDUCATION, AN ADDITIONAL 56 CENTS IS GENERATED ELSEWHERE IN THE U.S. ECONOMY. **"

Creative education also attracts and inspires those employees in other highly educated sectors. Consider Cirque du Soleil's job training program, Spark, which, through the lens of the circus, teaches collaboration and the value of continued accumulation of learning skills. Spark is now sold

as a corporate retreat for executives, using Cirque-based methodology to inspire high-level employees at Google, Adobe, and Kmart Australia.[40]

A 2013 U.S. Bureau of Economic Analysis study of how arts education affects the economy found that "for every dollar consumers spend on arts education, an additional 56 cents is generated elsewhere in the U.S. economy."[41] The robust benefits of such education explain why we have observed a growing number of universities around the world offering programs devoted to creative entrepreneurship.

Learning lives throughout the creative economy, elevating job quality and connecting the creative sector with the rest of the economic ecosystem.

7. **Working conditions, including health and safety at work, work intensity, autonomy, and working practices, as well as collective interest representation:** High quality jobs necessitate high quality working conditions that help workers enjoy the time they spend at their job. This includes benefits such as comprehensive health insurance.

- **Creative economy analysis:** What gets grouped together here under "conditions" is somewhat eclectic, and this is reflected in an analysis of how creative economy jobs fare. While creative economy jobs boast significantly higher than average rates of autonomy, and high satisfaction relative to stress levels, they do tend to lag in the areas of comprehensive

benefits and collective interest representation.

Thinking about the culture of creativity helps us understand this fact. Creatives push themselves and their peers to work longer and harder, gravitating toward "high risk/ high reward" scenarios that correspond with narratives of "genius" or "glory" in creative production.

At Creative Startups, we bring in mentors, usually successful creative entrepreneurs and business leaders, to teach creative entrepreneurs how to build more structure into their working conditions, supplementing the excitement of creative employment with the benefits of health and productivity.

8. **Equity in labor participation demographics:** The EU includes considerations of labor parity under their heading of "work/life" balance, and in this area of measurement

DIVERSITY IS ONE OF OUR KEY CONCERNS

at Creative Startups. Creative entrepreneurs are often undervalued in their importance as social change catalysts who bring diversity and economic inclusion to their communities. We believe an ecosystem of diverse creative entrepreneurs—telling a variety of stories and building a variety of experiences that draw from rich heritages— improves both economic and social health. That's why 70% of our accepted accelerator participants self-identify as being a "woman" or a "minority." In Chapter 7, we'll highlight stories that show how creative entrepreneurs bring diversity to economic ecosystems.

they focus primarily on gender. We consider work/life balance part of the working conditions category, and we believe equity is an important enough component of a high quality job to give this consideration its own category and to include other factors of parity such as race, age, varied physical abilities, and sexual orientation.

- **Creative economy analysis:** When measuring diversity, here, again, data vary by geography, but there's no sugarcoating the fact that the creative economy continues to lag when it comes to diversity in race and age. However, regions that have invested in the creative economy over the long term show positive signs. In the U.S., for example, 47% of creative economy workers are women, the same percentage as the overall workforce.[42]

Hollywood in the Moroccan Desert

If you've seen 1960's *Lawrence of Arabia,* you've seen the town of Ouarzazate. If you haven't seen *Lawrence,* maybe you've seen *Gladiator* (2000), *The Last Temptation of Christ* (1998)—the list goes on. Ouarzazate is a small city in Morocco known as the "gateway" to the Sahara Desert. Under the clear desert skies, some of Africa's tallest mountains tower over waves of sand. In 1983, hotelier Mohamed Belghmi saw that Hollywood kept coming back to the area, and he decided to build a way for them to stay permanently.[43]

Today, the lots of his movie studio, Atlas Studios, stretch over 300,000 miles, making Atlas the world's largest movie studio by square footage. Though the city of Ouarzazate is far more rural than Casablanca or Marrakech, it's one of Morocco's main eco-

nomic drivers. Atlas and the other studios that sprang up in its wake shoot nearly 50% of the country's 140 annual productions. They generate an estimated revenue intake of $75 million annually, which is direct and indirect income for 90,000 people.[44]

In addition to providing technical facilities and services for all the visiting moviemakers, the region also attracts tourists who want to tour the old lots, and a film industry training center opened—in partnership with Italian cinema company Cinecittà Luce—to entice studios to consolidate costs by hiring locals for specialty set jobs.[45]

Ouarzazate has had a remarkable effect on the region and serves as a great example of how the creative economy can generate jobs, proving the notions of Markusen and Nicodemus. The presence of a highly established local film studio has helped the film industry grow in Morocco and increased local consumer spending on cinematic experiences.

KEYSTONE SPECIES

Ecosystems sometimes host a species with a disproportionate effect on the environment. These species can shape communities and influence cultures and economies.

If your region makes a lot of movies, people in your region will go to the movies. Training local employees to work on set means that the money generated by these films will re-circulate through the local economy, and the talent and equipment will stay put for local movie-making efforts as well. Finally, population growth in Ouarzazate reflects Moroccans' desire to move to where the movies get made.

Mohamed Belghmi began as a hotel owner, but he saw a cre-

ative opportunity for people to stay longer than a few nights in his rooms. Today, his entrepreneurial efforts showcase the creative economy's ability to generate economic base jobs. If it can happen in the Sahara Desert, it can happen anywhere.

The Creative Future of Work and Workers

As we discussed in Chapter 1, creativity is essentially "lateral thinking," as famously coined by Edward de Bono.[46] Creativity moves laterally, making associative leaps to connect ideas. So, embracing lateral career growth—and the portfolio of skills that creatives bring to their work—is a natural act for organizations built by creative entrepreneurs. These lateral moves allow for innovative and associative thinking to transpire more readily. As non-creative organizations strive for ever-greater innovation, we predict they will evolve to mirror the long standing tradition of "lateral moves" in the creative sectors for career development.

Such movement is the future of work. In a global economy where one third of workers told global professional services firm Ernst & Young (EY) that work-life balance is getting more difficult,[47] it's no wonder that a Cornerstone survey found that over half of all employees would willingly make a lateral career move for "greater personal satisfaction and growth opportunities."[48] These workers can see the writing on the wall. Job tenure is shorter than ever, job security is fraught with the uncertainty of automation, and workers need more assurance of development opportunities if they're going to stick around. Citing a 2013 CareerBuilder survey, *Entrepreneur* reported that "35% of workers agree that increasing on-the-job training and development opportunities entices them to stay with a company."[49]

In a related trend, people are less afraid these days to shift fields entirely if they aren't satisfied at work: the *Harvard Business Review* reports that "29% of [career] moves take people across industries."[50] As jobs no longer promise a source of comfortable stability, workers are instead prioritizing their personal growth and happiness. To buck this trend major global firms like Motorola, Xerox, GE, and others have begun transitioning to horizontal organizational structures that allow for employee mobility. Yet the non-creative economy still lags in this respect with 32% of workers telling Cornerstone that their companies lack opportunities for the lateral movement and development they desire.[51]

For new generations filling the workforce—generations coming of age in a Fourth Industrial Revolution that demands innovation—this free-flowing career movement is even more important. By 2020, millennials will make up half of all the world's workers. They are already more highly educated than any generation before them.[52] They're also more easily bored. Gallup's groundbreaking 2016 study, *How Millennials Want to Work and Live*, shows that millennials change jobs at a rate three times higher than non-millennials.[53] Millennials do not feel engaged at work, yet they seek engagement, hunting for workplaces with missions that align with their values. They want "a purposeful life" and "active community and social ties." As a generation, they're hyper-connected, innovative, and idealistic.

But such values are not confined to millennials. Generations both younger and older are pursuing more entrepreneurial opportunities and creative lifestyles. Boomers, for example, are retiring differently than older generations. Living longer than their parents and swapping out Great Depression era frugality for investment

in personal enrichment, boomers "prefer to reinvent themselves," reports *The Atlantic*.[54] Often this means an "encore" career with an entrepreneurial bent.

That's why the general job market can learn from creative entrepreneurs who understand how to build companies that appeal to more creatively oriented workers, whether those are portfolio career millennials, encore career boomers, or younger "digital natives" who will shape the workforce of tomorrow.

Hollywood North

The success of the creative industries in Vancouver, B.C.—known as "Hollywood North"—presents a compelling portrait of an economic ecosystem where creative workers use their portfolio of skills to circulate between opportunities. As with so many thriving clusters in the creative economy, this success can be traced back to innovative creative entrepreneurs and visionary community leaders.

One such leader is Prem Gill, president and CEO of Creative BC, a "creative industry catalyst." The story of Gill's supernova rise—from broadcaster to industry powerhouse—gives a wonderful insight into her region's bright future.

> " ...IF I WANTED TO SEE CHANGE, I HAD TO HELP DRIVE THAT CHANGE. "

The child of immigrants, Gill was born and raised in the Vancouver suburb of Burnaby. Creativity has been a cornerstone of Gill's professional life since her first job out of college, co-hosting a radio show called "Youth Raap," which aimed to get Cana-

dian youth of South Asian descent stimulated in their communities. "It was a call-in show, and it was the only show in English," Gill told *BCBusiness*. "Everything else was in Hindi or Punjabi or other Indian languages."[55] Gill continued to engage in this passion for reaching audiences, moving from voice-on-the-dial to face-on-the-screen, then moving behind the scenes to work as Director of Content at Canadian national telecommunications company Telus. In 2015, she was appointed president and CEO of Creative BC. Here was a creative with "fire in the belly" passion for supporting other creatives. "My thing has always been about storytelling," Gill explained to *BCBusiness*. "Helping, enabling and supporting people in telling their stories."

We were lucky enough to talk with Gill in January 2018,[56] as she explained her journey to Creative BC and her mission at the organization. One thing that has driven her since the beginning is a commitment to representation: "As a woman of color that grew up in the late 70's and 80's in Canada, there weren't a lot of people like me in the Canadian media. That was maybe the impetus: if I wanted to see change, I had to help drive that change."

As President of Creative BC, Gill is able to translate that drive into cracking open new opportunities for British Columbia's economy. She explained that B.C.'s tax credits for creative sector employment help spread the opportunities from the central creatives working on a TV show like *The Flash* (which is filmed in Vancouver) to all the supporting roles. Not only everyone on set but catering, hospitality, and even the "dry cleaner responsible for all of *The Flash's* costumes every week."

Thanks to the efforts of pioneering creative entrepreneurs like Prem Gill, British Columbia sports one of the busiest and most

successful creative sectors in the world. And it continues to grow. The *Globe and Mail* reported that Vancouver alone saw a 40 percent increase in "film and TV production activity" between 2014 and 2015. All that activity means jobs. A single production alone, such as the action blockbuster *Deadpool*, employs more than "2,000 local cast, crew and extras."[57] Altogether, the Vancouver Sun reports that "film and TV production is worth more than $2 billion a year in B.C. and employs about 35,000 people."[58]

Many factors contribute to Vancouver and British Columbia's success—Canadian tax credits and B.C.'s geographic proximity to Hollywood both help—and innovative evolutions in entertainment contribute to the stability of that success. The *Globe and Mail* points to the emergence of Netflix and Amazon's new strategy of producing whole seasons to accommodate "binge watching" habits, noting how this strategy provides guaranteed employment with no risk of sudden stoppages due to cancellations.[59]

But the biggest factor in B.C.'s success is the talent available and the entrepreneurship generating more talent. Carpenters, lighting designers, costumers—the list goes on, and people hear about it. Peter Mitchell, president of Vancouver Film Studios, explained to *The Globe and Mail* how collaboration among producers spreads the reputation of Vancouver's talent: "There's a very small club of production heads. They talk to each other and exchange stories about how things went in one or another jurisdiction."[60] All this talking is good news for newcomers like millennial Kendall Green, who returned to her native B.C. from photography and design school in Montreal. Within a week, according to *The Globe and Mail*, Green got "an art-department assistant's job on a major U.S. TV series."[61] She's paid well in Vancouver and is "100% confident"

that she can keep progressing.

Between outposts of major Hollywood studios and "pop-up" studios started by local creative entrepreneurs, Vancouver has two million square feet of studio space. That's a lot of opportunity doors. One industry veteran summed things up with excitement: "It's unbelievable. It's unprecedented. You just show up and you have a job, a full-time job. And you might have a little bit of skill— or no skill—and you can get in by doing."[62]

Nor are the jobs limited to the film industry. In an article on female entrepreneurship in the Vancouver animation industry for *Vancouver*, Stacey McLachlan points out that Vancouver is "actually a huge heavyweight in the animation field" with "over 60 studios specializing in VFX or animation … the largest (and fastest-growing) cluster of domestic and foreign-owned studios in the world."[63]

Vancouver's ecosystem of highly skilled, flexible creative economy employees is good news for everybody. The production companies get talented experts who are eager and passionate. The city gets 35,000 economic base jobs and all the related benefits. And the employees get a goldmine of opportunities that offer high quality jobs with plenty of room for growth and circulation.

We Won't All Sit by the Pool When Machines Start Delivering the Mail

In a 2015 article for *Forbes*, bestselling *The Future of Work* author Jacob Morgan argued that tomorrow's jobs will be all about "flexibility, autonomy, and customization."[64] Morgan cited Valve, a video game company, as an example of an organization that understands how to incorporate all three. Valve was built by Gabe Newell, a creative entrepreneur who left Microsoft to innovate both new

genres of games and new methods of software delivery with Steam, a completely online distribution platform for PC games—one of the first such platforms and now the world's largest. At Valve, Morgan explained, employees are not cogs:

> Employees are able to pick the projects they work on and once those are completed they move onto something else they want to work on. In other words, they have the choice to work on the things they care about and value.[65]

It's no surprise that a creative entrepreneur would be behind Morgan's example of a successful, healthy, forward-thinking vision of work. For a 2017 *Polygon* article, Colin Campbell described Newell's approach as: "give clever people room to do what they want, and see what happens next."[66] This could serve as a decent summary of what all creative entrepreneurs—from Prem Gill to Guy Laliberté—aim to do. And this approach just so happens to dovetail with the future of high quality jobs that benefit communities.

> " ...ENTERPRISES OF CREATIVE ENTREPRENEURS **ARE ENGINES OF QUALITY JOB CREATION.** "

Between high quality jobs generated in creative fields and high quality jobs generated in the support apparatus, the enterprises of creative entrepreneurs are the engines of quality job creation. They diversify opportunities for existing citizens and entice talented newcomers, expanding tax bases and boosting overall economic health.

In 2017, the Pew Research Center published an extensive look at the future of jobs, synthesizing research and canvassing over a thousand leading global "technologists, scholars, practitioners, strategic thinkers and education leaders."[67] As one might expect with such high-powered experts, there wasn't a lot of unanimous agreement. However, two trends emerged in these authors' thoughts: the inevitable disruption of artificial intelligence (AI) across all sectors of the economy, and the need for workers to learn "tough-to-teach intangibles" that include "emotional intelligence, curiosity, creativity, adaptability, resilience and critical thinking."

We won't all sit by the pool when machines start delivering the mail. Innovative companies will invent new ways for people to work. As we automate so much of what we do, we need to re-purpose and advance human talent. For creative entrepreneurs, the future is already here. They are already building companies and platforms where employees are putting "tough-to-teach intangibles" to work and learning new skills. Accountants are joining the circus, and they're not the only ones. With creative entrepreneurs building central poles out of innovative, flexible companies, there is plenty of room under the tent.

5

CREATIVITY
for Resilience

The Planet Above the Bathroom Shop

In the video game series *LittleBigPlanet*, you make the game as you play. You control Sackboy, an anthropomorphic burlap sack, running and jumping and nabbing objects to both manipulate and expand your environment. You can build rope-and-pulley devices to swing over objects, motorized sponges to zip over water. Prize "bubbles" allow you to redecorate levels, leaving your creative mark on completed puzzles.

After you learn the basic gist of gameplay in a story mode, you can dive into "Create" and "Share" modes. In "Create," you paint your own levels out of basic shapes and mechanical features, gluing objects together, hiding prize bubbles, and triggering realistic physics with simple, intuitive controls. Then you can share these levels online with the *LittleBigPlanet* community, who can promote and appreciate your creations with social-media-style tags and hearts. Play alone or with friends, build levels together and see who can race through fastest.[1]

The PlayStation 3 game hums with wry British charm and a warmly realized arts-and-crafts aesthetic, where graph paper clouds hang from string and sardine-tin go-karts sport bottlecap

MEET

Image courtesy of Media Molecule

ENTREPRENEUR:
Alex Evans

Mark Healey,

Kareem Ettouney

Dave Smith

Siobhan Reddy

COMPANY: Media Molecule

INDUSTRY: Gaming

BASE OF OPERATIONS: U.K.

MARKETS: Global

EMPLOYEES: Over 30

NOTEWORTHY: Purchased by Sony in 2010.

wheels. Early playtesters remarked that the game brought them a childlike joy. "I'm happy with the joyous tag," Media Molecule co-founder Alex Evans told Iain Simons for the book *Inside Game Design.*[2] "One of the biggest things we got from playtesting is it's really funny because people laugh." Another co-founder, Mark Healey, agreed: "I'm a big fan of people laughing with games."

But it wasn't all laughs along the way. Before the game was released in late 2008, the developers worried that people wouldn't get it. When they pitched the game to Sony, they tried to downplay the "weird bits" and present it as more of a traditional run-and-jumper. But Sony loved the "mad stuff." They gave *LittleBigPlanet* top billing during their 2007 Game Developers Conference keynote and promoted the game as one of the then-new PS3's marquee titles. A huge marketing push aimed for a Christmas 2008 release. Sony even opened a *LittleBigPlanet* pop-up shop in Manchester, U.K. where people could demo the game and make their own t-shirts.[3]

This was a big gamble for a tiny U.K. studio. Media Molecule formed in 2006 on the underground success of a goofy fighting game called *Rag Doll Kung Fu,* built as an after-hours project while Media Molecule's founders worked at Lionhead, a bigger studio.[4] *LittleBigPlanet* was their first real project. If it flopped, so would Media Molecule.

Of course, Media Molecule weren't the only

LOOK FOR & LIFT UP creatives building weird and wonderful startups. Their unique products and services may be harbingers of markets to be.

ones biting their knuckles in Guildford, U.K. at the end of 2008. Thanks to the Great Recession, 20 retail shops had closed downtown.[5] The University of Surrey, one of the area's largest and most historically stable employers, was looking to cut 65 jobs.[6] Despite Guildford's status as a well-educated, affluent town in a scenic part of Surrey county, it hadn't escaped the global economic downturn. Construction and housing sectors had weakened; credit had dried up; unemployment had risen.[7] And in a cramped office above a

bathroom showroom near the train station, the 10 creative entrepreneurs who started Media Molecule were hoping their unique game would capture the imagination of a rocky market.

Sharing the Joy in the Room

"We always jammed, played music together." That's how Kareem Ettouney, one of Media Molecule's co-founders, described the original team's collaborative spirit to Alex Witshire for the official *Playstation* blog. "We had a creative chemistry. Mark is a bit of an all-rounder game maker, back from the Commodore days. Alex and Dave are legends in very different and technically complementary ways. Siobhan could make stuff into a story, into a culture."[8]

The Media Molecule team combined diverse talents with energetic vision, two of the key creative entrepreneurship tenets we espouse at Creative Startups. Alex Evans wrote Mark Healey's resignation letter for him while he was on vacation, daring Healey to follow through on the chemistry that arose from making *Rag Doll Kung Fu* together.[9] Healey and Evans were both visual artists and coders, and co-founder Dave Smith enthusiastically told the *Globe and Mail* he loves both "art and maths!"[10] Ettouney, for his part, got a degree in interior design.[11] On YouTube, you can watch Evans playing British folk songs on the piano and Ettouney giving a talk at a learning conference.[12] You might also notice different faces than those normally seen in the gaming world. Ettouney's family immigrated to the U.K. from Egypt, while female co-founder and studio director Siobhan Reddy regularly advocates for diversity in the gaming world.[13]

Together, these co-founders had an entrepreneurial vision of how video games could evolve. "One of my personal ambitions is

that I want to make this game easy enough for my mum to play," Healey told Japanese gaming website *Kikizo*.[14] Beyond attracting new audiences, Media Molecule wanted to unleash their players' creativity. As veterans of the modding and demo scenes of the 1990s, they foresaw the potential of online collaboration that went beyond online competition. "It shouldn't just be person versus person, it should be sofa vs sofa," said Healey in *Inside Game Design*. "You get these little local and distributed social clubs emerging. You get the joy in the room but also get to share it."[15]

Their vision was so entrepreneurial they had a hard time explaining it. In 2008, despite the growing popularity of casual social network and mobile games, the mainstream video game industry was still stuck in rehashed franchises and bloated expansion packs. In fact, the monocultures of big studios looked a little like the monocultural economic ecosystems that were headed for big crashes in the Great Recession. Would Media Molecule's vision of an entirely new gaming style, one that relied on gamers' collaboration and creativity, fit the market?

The Creatives Don't Crash

LittleBigPlanet didn't rocket into orbit. Early sales were slow, overshadowed by third and fourth iterations of competing mega franchises. In a recession, the common wisdom says, consumers tend to fall back on reliable comforts. Video games offer a great price for your entertainment hours, and within any entertainment sector it's easier to go for the kicks you've already met. But Media Molecule insisted *LittleBigPlanet* would have a "long tail," as players created content for online communities and attracted their friends. Despite early doubts, Sony stuck by their bet.

It paid off. While closing 2008 with a modest 611,000 units sold, *LittleBigPlanet*'s gravity grew. By the end of January 2009, sales had spiked to 1.3 million. Over the year, that number nearly quadrupled to over 4.5 million.[16] Over in the U.K., while those 20 shops were closing in downtown Guildford, the tiny game studio above the bathroom shop grew from 10 founders to a team of over 45.[17]

Numerous sequels and spinoffs later, with Game of the Year awards and more than seven million user-created levels released, Media Molecule has outgrown the bathroom shop. These days, their new open-floor studio has the ping-pong table and in-house chefs that mark a successful creative tech startup. But Media Molecule hasn't left the U.K., where it's part of an impressive interactive media ecosystem.

In Guildford alone, which *The Guardian* has called the "Hollywood of video games," you'll find the towering headquarters of EA Criterion—the company's European flagship—and a dozen micro-studios churning out games for console and mobile.[18] All of this arguably due to creative entrepreneur Peter Molyneux of Lionhead, who started the first video game studio in Guildford in the early 1980s.[19] Economic reports commissioned

INTERDEPENDENCE

Entrepreneurial teams are more likely to succeed than solo entrepreneurs. Connect creatives keen to build new ventures through networking events.

for the Guildford Borough Council acknowledge the importance of the games industry, ranking its significance for the local economy on par with finance and advanced manufacturing. Both of

which, for the record, suffered during Media Molecule's recessionary success.[20]

Media Molecule's surge during the Great Recession might've been an anomaly in Guildford, but it was no surprise in the larger story of the U.K.'s creative economy. According to Bain and Company, the U.K. creative economy "has grown by 19% since 2010, much faster than the U.K. economy as a whole."[21] British innovation foundation Nesta reported in 2013 that the creative industries added more jobs in the U.K. during the Great Recession than construction, manufacturing, or finance.[22] Today, the creative economy in the U.K. accounts for 3 million jobs.[23]

As an important sector of the creative economy, the U.K. game development industry—which until 2007 wasn't even classified by the U.K.'s Standard Industrial Classification codes—is the third biggest in the world.[24] In 2009, U.K. sales of video games exceeded consumer spending on films.[25] While the video game industry didn't completely escape layoffs or slowdown during the Great Recession, it fared better than nearly all other industries. In an extensive 2012 study, the Computer and Communications Industry Association (CCIA) found that the global video game industry grew over $20 billion in value between 2008 and 2010.[26]

Fast forward to 2014, when the British game industry finally won the tax incentives for which they'd lobbied nearly a decade.[27] The game industry's success during the Great Recession convinced the British government the proof was in the pudding. No doubt similar tax initiatives established in Canada also had an effect, with the accompanying threat that the U.K.'s lucrative games industry might pull up stakes. As a further sign of possible trouble, today, even though gaming trade association TIGA's 2017 Business

Opinion Survey found that 88% of game studios plan to grow their workforce (a 16% bump from 2016), Brexit has renewed some of the games industry's anxiety about the U.K., as many of its employees are hired from Europe and beyond.[28]

But the U.K. has long been out front on the creative economy. Back in 1998, the Labour government published the *Creative Industries Mapping Document*, becoming one of the first governments in the world to recognize the creative industries.[29] After the Great Recession, both investors and policymakers are betting hard on the creative economy. Enterprise partnerships in cities like Hertfordshire—home of the studios that filmed *Harry Potter*—secure and circulate public and private funding.[30] Local governments in cities like Nottingham have established creative "hubs," and they're paying off: in Nottingham alone, creative industries account for 44,000 jobs.[31] In 2016, the U.K. Creative Council published a comprehensive plan to center the creative industries in

MAP YOUR REGION'S creative economy and identify gaps in connectivity among start-ups, investors, and markets.

the U.K.'s economy, targeting education spending, infrastructure support, intellectual property policies, and access to financing.[32] Attitudes in the U.K. have come a long way since the Department of Culture, Media, and Sport was mocked as the "Ministry of Fun." As if fun doesn't pay—and pay big!

For now, Media Molecule has no plans to leave Guildford. They enjoy the camaraderie of all the game studios in town, and they like the supporting firms as well. There's Fireproof Studios, for example, another successful small studio (known for their franchise

The Room) that Media Molecule contracted to provide the bulk of *LittleBigPlanet 2*'s 3D background art. All of this creative clustering is lucky news for Guildford and the regional economy. If Brexit heralds another economic dip, the Borough Council might need to send someone to play British folk piano with the Media Molecule team. Because these creative entrepreneurs clearly know how to diversify and strengthen local economies—even to the point of resisting recession.

Recession Puzzles

Of course, recessions are complex and contextual. What you can learn from one recession might not apply to the next one. So while we don't posit the creative economy as a surefire antidote, we do want to highlight how creative entrepreneurs have a knack for anticipating patterns in consumer desires during recessions—including the recognition of a prime opportunity for market innovation—and how a thriving creative economy (like Guilford's cluster of video game studios) helps regions resist economic monocultures and more sturdily resist the ebbs and flows of recessionary cycles.

The Value of Experience

As you've seen in several of the stories we've featured so far, creative entrepreneurs do more than provide consumers tweaked variations on commonly accepted desires. Instead, like all gifted entrepreneurs, creative entrepreneurs give consumers what they *don't yet know* they want.[33] Creative entrepreneurs survey marketscapes and see their future, innovating new markets and providing new meaning during (and after) times when the public is most urgently seeking new stories to resolve their anxieties.

To provide resolution to these anxieties in the clutter of contemporary life, those new stories must increasingly focus on tangible and meaningful experiences, as we discussed in Chapter 2. In 1998, academics Joseph Pine II and James H. Gilmore coined the phrase "experience economy" to describe this global shift in the paradigm of consumption.[34] Fading is the model of mass produced commodities, the numb comfort of strip mall consistency. Instead, Pine and Gilmore argue that consumers are hungry for novel, multi-sensory engagement, interactions made meaningful by their one-of-a-kind ephemerality. In the experience economy, consumers aren't content to be passive targets in an economic life cycle; they want to be part of a story.

> "LIKE ALL GIFTED ENTREPRENEURS, CREATIVE ENTREPRENEURS GIVE CONSUMERS **WHAT THEY DON'T YET KNOW THEY WANT.** "

And they'll hunt vigorously for the most memorable stories in which to participate. Pine and Gilmore predicted in 1998 that "the next competitive battleground lies in staging experiences"[35]—borrowing the concept of "staging" from theatre to analogize how production needed to shift to meet increased consumer demand for authentic engagement.

Changes in consumer habits after the Great Recession have proven Pine and Gilmore right. In 2015, MasterCard's Sarah Quinlan—head of Market Insights—told *NBC News* how the 2008 Great Recession challenged consumers to clarify their underlying values: "We value a sense of what's permanent, what we can take with us: memories."[36] What this means is a decline in many retail sectors

EXPERIENCES NOT OBJECTS

and an uptick in leisure travel, restaurants, and entertainment of all stripes. In 2010, *The Guardian* reported that theatre revenues rose and music festivals sold out in the U.K. during the Great Recession.[37] According to the U.K. Film Council, admissions rose £12 million from 2007 to 2009, and the industry topped £1 billion in receipts for the first time ever—thanks in no small part to the renewed popularity and increased quality of 3D movies, another example of consumers seeking creative innovation during hard times.[38]

Of course, these numbers don't tell the whole story. A 2015 U.S. Bureau of Labor Statistics report showed that entertainment spending in the U.S. dipped in 2009 from pre-Recession highs. But the exception came in the category of "fees and admissions," with spending on events and gatherings actually peaking during the Great Recession.[39] Taken with post-Recession shifts in consumer habits, these data are consistent with the idea that economic crises cause people to re-think what's most important and realign their lives to prioritize meaningful experiences. For example, *NBC News* reported that "government spending data" covering the transition out of the Great Recession show an "uptick in recreation services, which includes membership clubs, sports centers, theaters and museums."[40]

What do these habits and patterns mean for creative entrepreneurs and local economies? Whether it's live culture or digital entertainment content (consumption of which rose during and after the Great Recession), creative entrepreneurs understand how to tap into consumer hunger for new experiences because they understand our need for stories and community. Consider the example of Media Molecule's innovative user generated content com-

munities for *LittleBigPlanet*. When people have less time and less money to spend, they want more out of both.

As is seen in the story of Media Molecule and Guildford, local economies that empower creative entrepreneurs to develop innovations that embrace this consumer desire for experiential novelty will reap the rewards of the creative economy's agility and durability. Economies that hunker down with old markets will wither as those markets disappear, often during the sudden collapses of recessions.

In their introduction to 2013's *The Handbook on the Experience Economy,* Joseph Pine II and James Gilmore argue that "the economic doldrums in which much of the advanced world found itself after the 2008 economic crisis resulted from a failure to experientially innovate."[41] What they mean is that there was a failure to create "wholly new categories" of experience instead of mere "differentiation of goods." Perhaps the creative entrepreneurs themselves can explain this concept the most clearly. At the World Economic Forum in 2009, Etsy founder Rob Kalin explained to Loic Le Meur why Etsy saw "record week after record week" during the Great Recession: "When money is scarcer, this idea of value is a lot more than the dollar cost of something. Value is something where these items have stories in them, the meaning behind who gave the item to you or who made it."[42]

In other words, consumer desire for meaning and innovation is consistent through tough times, and this desire flourishes during the period when consumers clarify their values following tough times. Empowering these creative entrepreneurs who respond to this consumer desire provides a powerful fortification to local economies.

One Company is Bad Company

Another fortification creative entrepreneurs provide regions is economic diversity. This diversity is important because economies dominated by a single industry have trouble evolving. We've seen it in New Mexican communities with mining and oil. We've seen it in the Pacific Northwest with logging, in Detroit with the automotive industry, in the Rust Belt with steel. Economic monocultures are slow to adapt and usually fail to adequately shift resources: their financial capital, human capital, and even social capital all end up bound in one vulnerable system.

When you have one thing to export, and the market does not want that thing, can't pay for that thing, or can get that thing cheaper somewhere else, your economy will suffer. And the future will not be any easier for monocultural economies, as technological advances allow more companies to trade their goods, as more efficient manufacturing produces more goods, and as global competition increases. We're two decades into the 21st century, and the company towns aren't coming back. What will take their place?

DIVERSITY

Communities thrive when a diversity of resources and actors are engaged, enabling resilient responses to tough times.

The creative economy provides economic diversity with a proven track record of resisting boom-and-bust recessions. Specifically, the creative economy does a great job providing diversity that incorporates two other key factors proven to enhance a region's ability to anticipate, absorb, and recover from recessions: interconnectedness and innovation.

Flowing Between Clusters

In 2016, three well-credentialed economists—David A. Fleming, Stephan J. Goetz, and Yicheol Han—published a comprehensive study of economic resilience in *The Conversation*. Their research found that when an economy's diversity was interconnected, that economy did a better job resisting recession.[43] In other words, a diverse set of industries that have nothing to do with each other aren't as recession resistant as a diverse set of industries that engage with each other, exchange resources, and generate flows of capital—human, social, and financial. This is exactly what happens in the creative economy.

Let's return to U.K. video games for one example. A Nesta study found that video game companies don't just hang out with other video game companies. Rather the gaming industry is "strongly co-located" with a variety of interconnected creative industries, including "design, advertising, software, film, video and TV."[44] Reams of evidence point to the economic benefits of such creative clustering. This is not only true in easily recognized cities like Nashville, Paris, and Seoul, but also in places like Bogotá, Colombia, which sports a *telenovela* production powerhouse.

Creative entrepreneurs drive a greater flow of resources and are more likely to increase engagement across sectors and companies, which is why they lead innovation while old companies tend to become silos. This innovation attracts other creative entrepreneurs, not so much for "something in the water" as for the social electricity: the desire to learn best practices, swap knowhow, share resources, and fan the flames of competition and dedication. Then creative entrepreneurs in related fields see an opportunity to

help companies deal with the burden of all that new business, as in the relationship between Fireproof Studios and Media Molecule. Labor and knowledge flow between firms. Creatives enjoy living among like-minded creatives. Clusters boost the community's profile and buoy it against economic downturns.

Even if one pod in the cluster experiences a slump—as the video game industry did in the early 1980s, for example—the interconnected creative industries that arose in support roles and grew independently viable mitigated the overall effects. Social networks and funding alliances that developed within and among clusters buoyed individual actors and maintained the cluster's structural integrity.

RESOURCE FLOWS

Ecosystems are defined by the relationships among elements and actors in a region. The attraction, conversion, use, and exchange of resources among actors determines the viability of the ecoystem.

This kind of cooperative clustering isn't only found with creatives though. As we discussed in Chapters 1 and 2, creative entrepreneurs tell new stories with new technology and so do entrepreneurs in other industries. That's why the patterns we see in creative clusters mirror those we see in other innovation-based sectors such as biotech, aerospace, 3D printing, and other cutting-edge industries. What was true for creative entrepreneurs like Gutenberg—when printing presses and paper manufacturers clustered with the new industry of "book publishing"—is true today.

A Nesta study of how creative industries cluster—both with each other and with innovative, non-creative industries—makes

several recommendations for encouraging such groupings:

1. Avoid one-size-fits-all clustering models and involve the stakeholders (i.e., creative entrepreneurs!) in strategic planning.

2. Identify and catalyze latent clusters instead of trying to build them from scratch.

3. Support universities that seek out, interact with, and foster success in local entrepreneurial communities.

4. Promote organic networking and collaboration that respects intellectual property protection.

High quality broadband access—a literal symbol of interconnectedness—also tracks with creative clustering, high self-employment, and—by extension—regional resilience. Take the robust broadband access on the tiny Isle of Man, for example, a long-standing innovation hub. The Isle of Man was the first European "country"[45] to offer 3G, and its minister for economic development has credited both technology and diversity for helping the island escape the Great Recession.[46] With high growth IT and filmmaking sectors, along with an embrace of disruptive creative technologies like bitcoin, the Isle of Man understands how to keep the creative economy connected. And its keep-the-data-flowing philosophy doesn't stop with broadband: in 2011, the Isle consolidated all its sectoral business support programs, making it easier for diverse varieties of businesses to apply to such programs.[47] Clearly, the Isle of Man understands how to stay open for business. Just as fiber optic cables connected to the outside world encourage cre-

ative connections, labyrinthine bureaucracy discourages the kind of freeform clustering that helps spark innovation.

Evolutionary Leaders

A 2010 study by Oxford academics in the *Cambridge Journal of Regions, Economy and Society* suggests that innovation tends to works in economies the same way it does in ecosystems.[48] Entities that can innovate in the face of challenges survive better and adapt better to future challenges. Just as diverse economies need interconnectedness, they also need innovation. You don't want a hodgepodge of companies all behind the times. You want a cluster based on breaking new ground. In short, you want creative entrepreneurs.

Creative industries have always produced widely-adapted innovations, and today is no exception. As non-creative companies in all sectors attempt to learn from their mistakes and adapt to the challenges and opportunities of the Fourth Industrial Revolution, the creative economy is already there. From video game companies, businesses have learned the "agile development cycle," which skips inefficient, speculative planning phases in favor of getting things out, getting widespread feedback, and making constant tweaks. This leads to lean, flexible products that resist failure the way a bendy skyscraper (also a creative economy innovation) survives earthquakes.

Other examples? The music industry reacted to piracy by revolutionizing digital distribution. The design industry drove innovations in business-client interaction. Advertisers, by and large, built the mainstream experience of the Web. Creative economy providers like Netflix expanded the notion of "subscription" to the point

where consumers can now subscribe to everything from gourmet meals to razor blades.

In each of these examples, creative industries faced crises and reacted. While many of these innovations began in R&D think-tanks, entrepreneurs moved them out of the labs and into markets. As Nesta said in December 2008, in the heart of the Great Recession, "we will be led out of recession by entrepreneurs creating new low-cost business models and finding new markets."[49] We know that creative entrepreneurs are already out there developing those models and markets. Will regional economies find them or get left behind?

Nigerian Notes

You might know the story of how Hollywood thrived during the Great Depression of the 1930s. Audiences escaped dusty realities in dark theaters. A similar thing is happening today—only this time, it's in Nigerian nightclubs.

Social media and innovative marketing moves—such as spreading songs to listeners as mobile ringtones—have skyrocketed the music industry in Nigeria, a country that in 2014 overtook South Africa as the largest economy on the continent.[50] The Nigerian music industry made $4.8 billion in 2015, a number projected to grow to $8.1 billion by 2020.[51] Auditing firm Pricewaterhouse-Coopers described Nigerian music as "one of the fastest-growing markets in the [global] entertainment and media industry."[52]

Nigerian artists export the Afrobeat sounds that dancers sweat to in Lagos nightclubs, performing concerts all over the world and commanding the highest fees among African artists. They incorporate Nigerian folklore and history into their raps and songs, and

one popular Nigerian artist—Wizkid—hit #1 on the U.S. singles chart with a Drake collaboration.[53] Nigerian-born producer Harmony Samuels wrote a gospel hit for Destiny's Child alum Michelle Williams that caused *The Fader* to call Nigeria's sound the future of pop music.[54] Back home, the success of these artists powers a large infrastructure: radio stations, TV channels, venues, and more.

All of this is taking place against the backdrop of recession and turmoil in Nigeria. While the overall economy contracted 0.4% in the first quarter of 2016, the entertainment industry grew 8.41%.[55] PricewaterhouseCoopers estimates that Nigerian consumers spent $51 million on music in 2016, despite shoddy infrastructure suppressing growth.[56] Even accounting for the wealth of the music industry, 80% of the country works in the informal economy.[57]

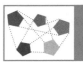

SUBSTRATE

The Nigerian music industry has, in large part, been successful due to its deep connection to local sounds and rhythms.

The Nigerian music scene is packed with creative entrepreneurs who want to turn their success into their country's success. Take Audu Maikori, the founder of record label Chocolate City and pan-African music industry conference Music Week Africa. In 2016, Maikori told the Nigerian Stock Exchange: "The new oil is in the creative industries."[58] In other words, as the middle class grows in Nigeria, the economy will follow the pattern seen in developing countries all over the world: a shift away from oil and extraction to the creative industries. Artist Bukola Elemide, known as Asa, told *Reuters* that "artists can pay taxes." Like Maikori, she has an entre-

preneurial vision for how creative industries can help the homeland: "We need to establish a collecting society so that when radio [stations] play the songs, they pay. And then something goes to you, as the government, to help build a good country."[59]

In a study of entrepreneurs in the Scandinavian music industry for Colette Henry's *Entrepreneurship and the Creative Economy*, Maria Aggestam finds that "in the unpredictable and uncertain creative industry world … entrepreneurs serve as creative magnets around which supportive ventures consolidate."[60] The Nigerian music industry—and its array of successful creative entrepreneurs—shows this proposition holding true across borders. Nigerian music is also excellent example of how an innovative, interconnected creative economy can buck recession.

And the Nigerian music industry is doing all of this on an African stage that represents one of the world's fastest growing audiences for creative media. According to research by Sarah Personette, head of global business marketing at Facebook, rates of broadband and mobile connection in Africa will grow the "mobile ecosystem" to over $100 billion in economic value by 2020 and "create or influence over 6 million jobs."[61] Who will be connecting? The world's youngest major population—200 million 15 to 24 year-olds, a number that will grow to 400 million by 2040—with a huge appetite for creative goods and experiences.[62]

AS JOBS IN THE extraction industries become mechanized, consider leading conversations about regional cultural assets that can be infused with innovation to generate jobs and opportunities for youth.

By maintaining a powerfully tight network of artists and pro-

ducers, and exploiting technological advances to distribute local cultural heritage to the ears of listeners in Africa and beyond, Nigerian music is thriving. What remains to be seen is whether policymakers in Nigeria will have the good sense to recognize that a thriving music industry is not only a source of pride: it can also be a resilient economic engine.

Creative Entrepreneurs in Orbit

Globally, the picture is clear: the creative economy thrived during the Great Recession. An excellent and dense 2010 UN tome, *Creative Economy: A Feasible Development Option*, found that while overall international trade decreased 12%, global exports of creative goods and services increased 14%.[63] This held true in economies big and small: the design industry in Romania grew right along with the design industry in the U.S. Sustained growth of Italian fashion didn't stop nascent growth of Jamaican fashion.[64] If you wanted to ride out the recession with less pain, the creative economy was a good ticket.

So if you want to bring the creative economy to your region to help you weather the next recession, where do you find it? We hope this chapter has showed you one big answer: in the innovative, interconnected clusters built by creative entrepreneurs. The entrepreneurs we work with at Creative Startups understand that good storytelling—in the form of experiences, products, and services— is not a "luxury" people will abandon during hard times. People will keep buying *LittleBigPlanet* and Wizkid singles. In response, creative entrepreneurs will keep taking creativity to the market.

In a 2013 paper entitled "Creatives After the Crash," Canadian and British academics set out to determine how creative work-

ers fared after the Great Recession.[65] Despite acknowledging their skepticism of what they call "boosterism" about the creative economy, the perhaps over-inflated optimism of its proponents, these researchers nonetheless find that "in aggregate … the creative workforce has been less vulnerable to the downturn." They identify two intriguing trends:

1. Creatives are particularly good at coming together to create shared physical spaces during recessions "that support and nurture experimentation and collaboration." These spaces "buffer" creatives by providing "collective, collaborative production models that operate at some distance from the vagaries of the market."

SYMBIOSIS

Creative entrepreneurs, long faced with a dearth of resources, readily share and exchange resources, leading to cross-pollination and shared success.

2. Regions with more coordinated market economies "provide a stronger context for increased entrepreneurship, innovation, risk-taking and experimentation among creative workers."

These trends point to the importance of supporting creative entrepreneurs during recessions. (Before and after recessions, as well!) As we've discussed, creative entrepreneurs are leaders among creative workers. They take the risks and pour the energy into creating companies and clusters. Inside these clusters, creative workers help each other and spur each other to new innovations. At Creative Startups, we consistently tell policymakers and investors that if they understand how to embrace this creative clustering,

there's no reason such clusters have to operate "at some distance" from the rest of the economy. The creative sector can be interwoven with tech, finance, and health. Regional economies can integrate these clusters for the benefit of all.

This is where the second trend comes in. To ignite this benefit-for-all, it's important for regional policymakers to meet creative entrepreneurs and understand what specific kinds of support and coordination they need. Creative entrepreneurs are going to resist recessions no matter what, with or without institutional support. If regional stakeholders want that resistance to flow back into the general economy, they need to reach out and bring creative entrepreneurs into their economic plans. Where policymakers and

HOST A MEETING for creative youth and entrepreneurs and ask them what they need, what market trends they are seeing, and how relevant and effective policies can be generated from creative entrepreneurs' expertise.

investors have done this, the creative economy has repaid the favor, bringing diverse and durable economies to the places it calls home, a little big satellite that helps keep economic planets in orbit.

6

INNOVATIVE
Investment

From $20,000 Down the Drain to $1.7 Million in the Bank

For Lynda Weinman, success began with failure. Co-founder with her husband of multibillion-dollar online learning company Lynda.com, 62-year-old Weinman is a creative tech entrepreneur who's been called "the goddess of Web graphics."[1] But when she was 27, Weinman nearly swore off entrepreneurship for good.

That was the year she closed her store Vertigo, a Los Angeles boutique that sold punk clothing and accessories. Her grandfather had loaned her $20,000 to open the store, and she'd lost every penny. She told Forbes this was her biggest failure.[2] "I learned a lot of painful lessons on his dime," Weinman said in an article for Lynda. com. "And spent the rest of my career as a consultant or independent contractor shying away from financial risk or entrepreneurship."[3] But though Weinman thought she was done with entrepreneurship, entrepreneurship wasn't done with her.

Nor was she done with the twists and turns of the relationship between private investment and creative entrepreneurship, though her next journey to outside capital would follow a much more self-aware path, one that exemplifies both how attractive high-growth

creative entrepreneurship can be to investors, and the unique conditions necessary to maximize such a relationship's co-benefits.

After the failure of Vertigo, Weinman began helping her animator boyfriend with his new toy, an Apple IICi. She quickly overtook him in expertise, which led to work as an animator in film special effects, including major productions like *RoboCop 2* and *Star Trek V*.[4] Her peers began to seek her tutelage on computer

MEET

Image courtesy of Accel.com

ENTREPRENEUR:
Lynda Weinman

COMPANY: Lynda.com

INDUSTRY: Online Education

BASE OF OPERATIONS: U.S.

MARKETS: Global

EMPLOYEES: Over 500

NOTEWORTHY: An overnight success 18 years in the making, bought in 2015 by LinkedIn.com for $1.5 billion.

graphics software. Such software was in its infancy, with little pro-fessionally-focused training material. As an autodidact who could demystify complex workflows simply and clearly, Weinman was in high demand. Soon she was teaching at the Art Center College of Design in Pasadena, California, and when she couldn't find a good text for showing her students how to create websites for their artist portfolios, she published her own: 1996's *Designing Web Graphics*,[5] a pioneer in its field.

"When [the book] became way more successful than I ever imagined, it was sort of addictive," Weinman says in a Lynda.com video. "I realized being able to touch all of those hundreds of thou-sands of people who were buying this book was a little bit more gratifying than reaching maybe 80 students a year at Art Center."[6] So Weinman quit and became an independent consultant, deliver-ing workshops all over the world. This was also the birth of Lynda.com, a domain Weinman bought for $35, using it first as a sandbox to teach herself Web design and then as a promotional site ("Lyn-da's Homegurrrl Page") for her seminars and articles.[7]

But it was another creative in Weinman's life—one with an emotional investment in her success—who encouraged her to take the next leap: her husband Bruce Heavin, an illustrator who de-signed the logo (a distinctly '90s likeness of Weinman) that Lynda.com still uses. Heavin encouraged Weinman to alleviate the stress of her travel schedule by teaching workshops out of a high school computer lab in Ojai, the small, artsy Southern California hill town where they lived. Weinman thought Heavin's idea was "cra-zy," but she gave it a shot. It worked—and then some. Students ar-rived from places as far as the Vatican and from companies as hefty as L.L. Bean and Martha Stewart. Heavin and Weinman invested

$20,000 their first year—the same amount Weinman's grandfather had loaned her—and made $1.7 million in revenue.[8]

Creativity Doesn't Want to be Free

Weinman often jokes that Lynda.com was an overnight success 18 years in the making. It's true the company's growth was by no means a steady upslope. Their initial burst met the dot-com crash of the early '00s, and a sudden dip in their tech startup customer base sent Weinman and Heavin to the ropes. They fired 75% of their employees.[9] Post-9/11 travel jitters slowed the influx of students to Ojai. Out of necessity as much as inventiveness, Weinman and Heavin began recording courses on VHS, then CD-ROM and DVD. They even put videos online, years before YouTube or widespread broadband access made streaming viable.

DISRUPTION

Entrepreneurs disrupt markets; investors are challenged to perceive the potential of these disruptions, especially in emerging sectors, such as the creative industries.

But as internet speeds caught up with their offerings, Weinman and Heavin realized their library of online instructional videos was their ace in the hole. "We could not hire enough people to help us with this growing online training library," Weinman told the Brooks Institute.[10] They instituted a contributor model whereby content authors received an initial advance, then royalties based on views. By 2011, their revenue had grown to $70 million,[11] and Inc. had ranked Lynda.com as the number one job creator in the education industry.[12]

One big key to this financial health was Lynda.com's disruptive pricing model. Against the common tech wisdom of the time ("information wants to be free") as well as the advice of tech investors (who regurgitated the common tech wisdom), Weinman decided early to put a pay gate on Lynda.com's content. At first, her compatriots in this model were mostly porn websites, but Weinman was undeterred. She felt confident that people would pay for high quality, reasonably priced, trustworthy learning, as she told Andrew Warner for mixergy.com.[13] Two big factors in her favor were her existing reputation and the fact Lynda.com didn't see itself competing with other Web resources. Instead, Weinman believed they could pluck customers who wanted the rigor and credibility of in-person training without the high fees they'd pay, for example, at local community college classes. And Weinman's creative entrepreneur wisdom—garnered from years teaching and interacting with the fellow creatives who fit her target subscriber demographic—turned out a lot wiser than common techies.

Though Lynda.com's prices—ranging from $25 a month to $250 a year—have barely risen since the site began, they now serve over 4 million subscribers—including seven of eight Ivy League schools and over half of the Fortune 100 companies[14]—and pull in $100 million a year in revenue.[15] They have over 500 in-house employees and fly in hundreds more contributors to record thousands of hours of content—available in multiple languages—at state-of-the-art California studios. Almost 20% of these contributors earn their entire annual income from Lynda.com,[16] making the site a platform, a production company, and a content repository all in one.

For someone who didn't buy her first computer until she was 27, and who told *Fast Company* that she's never been "techy or

geeky,"[17] Lynda Weinman's success is a testament to the potential of creative bootstrapping. As Weinman explained to Sean D'Souza of *Psychotactics*: "We didn't come from the business world. We came from the creative arts world."[18] And that made all the difference.

Fitting the Right Funding

Like many such creative entrepreneurs, Weinman and Heavin long resisted outside funding. In 2012, they told TechCrunch that they'd rejected "sizable investment offers" and stuck to a policy of "if you don't need money, don't take it."[19] They believed that you stayed in business by turning a profit—shopworn wisdom Weinman no doubt learned after losing her grandfather's loan—and preferred self-reinvestment to exterior influence.

What finally convinced Weinman and Heavin to seek funding was competition and expansion. By 2013, Lynda.com needed to produce more videos more quickly to keep up in the increasingly crowded online video space, and they needed to shift their reliance on quickly-outdated tech instruction to more evergreen content.

> " THEY WANTED TO DO IT IN A WAY THAT REMAINED TRUE TO THEIR VISION AND THEIR ROOTS AS CREATIVE ENTREPRENEURS. "

Increased overhead and a desire to tap into international markets also drove the decision to sit down with investors. But as they'd done for 17 years, Weinman and Heavin did it their way.

First, they sought investors connected with the management team they'd hired in 2007, preferring like many creatives to keep business within an extended network of personal connections.

Next, they wanted investors who would embrace and allow their continued engagement in the business, and—as Weinman put it in a blog post—"share a passion for what we have built [and] respect our vision."[20] If they were going to trade absolute ownership for access to new capital, which Weinman called an "agonizing decision,"[21] they wanted to do it in a way that remained true to their vision and their roots as creative entrepreneurs.

In January 2013, they raised $103 million in Series A growth equity. According to *Forbes*, $103 million was "the largest investment round for an online education company on the books."[22] In 2015, they beat their own record when TPG Capital invested $186 million.[23] (Don't forget the name TPG—you'll meet them again later in this chapter.) These infusions allowed Lynda.com to buy Austrian online learning company Video2brain, which boasted a large collection of multilingual content, and Compilr, a "cloud-based platform for people to learn, write and test code from within a browser."[24] Interestingly, Compilr had been rejected by 35 VCs and implemented its own monthly subscription model—perhaps Weinman recognized a kindred spirit.

Today, after a blockbuster $1.5 billion dollar sale to LinkedIn in 2015—by some accounts the fourth biggest deal in "social media history"[25]—and then an even bigger $26.2 billion dollar sale of LinkedIn to Microsoft,[26] Lynda.com is under the umbrella of tech behemoths. Analysts such as Audrey Watters speculated that LinkedIn's purchase of Lynda.com positioned the social network as a "certification platform,"[27] offering educational paths that match the demands of Fourth Industrial Revolution jobs, a hot topic in the tech world. MasterClass, a service where $90 scores you hours of exclusive video lectures by A-list celebrities—Serena

Williams teaches tennis, Werner Herzog teaches filmmaking—recently snagged $35 million in Series C funding.[28] Silicon Valley, it seems, has finally caught up to creative and disruptive learning technology.

But Lynda Weinman has been innovating education for many years, and when she wrote a blog post about the sale to LinkedIn, she gave some clues as to how creative entrepreneurs and private funders might do a better job of finding each other. She mentioned the "cultural fit" of LinkedIn as paramount to the deal, and she noted that she and LinkedIn CEO Jeff Weiner both believed "the skills gap is one of the leading social issues of our time."[29] Here we see familiar qualities and concerns of creative entrepreneurs—collaboration, culture, social heritage—meeting those of an investor who could understand why and how these values contribute to that creative entrepreneur's success.

Closing the Gap Between Venture Investors and Creative Entrepreneurs

In this chapter, you'll read stories of investment success in creative entrepreneurship, and through these stories, we'll share some of the best strategies for alignment between entrepreneurs and investors, strategies that Creative Startups

> " IF INVESTORS CAN LEARN HOW TO INTERFACE WITH AMBITIOUS CREATIVE ENTREPRENEURS THEY STAND TO GAIN **A TICKET ABOARD THE SHIP BEST EQUIPPED FOR A GLOBAL ECONOMIC SEA CHANGE.** "

has seen provide big payoffs for all parties, including the communities these entrepreneurs call home.

While creative industries have historically faced challenges in attracting private investment, the tide is shifting. Today, bold investors don't want to wait 20 years and spend $1.5 billion to align themselves with the "overnight" success of creative entrepreneurs like Lynda Weinman. Increasingly, investors recognize the creative economy as a growth sector that offers significant returns in an unpredictable, fast-changing market. If investors can learn how to interface with ambitious creative entrepreneurs they stand to gain a ticket aboard the ship best equipped for a global economic sea change.

The Changing Face of Private Investment in Creativity

Across the centuries, creativity, culture, and the arts have been primarily financed by two related investment mechanisms: patronage and commissions. Europe was pulled from the Dark Ages in large part by the patronage of a wealthy family—the Medicis—perhaps the earliest creative economy investors on record.[30] The Medici family's support of creatives such as Leonardo Da Vinci and Galileo eventually gave way to the invention of the printing press, and myriad other inventions that hallmarked the Renaissance. Unfortunately, innovations in the financing of creativity have not kept pace with the innovations themselves.

Until just a few years ago, gamers, filmmakers, musicians, designers, and other creatives remained stymied by the limited array of financing options. (Leaving us to wonder how this lack of resources has constrained creativity and limited the development

of solutions to pressing problems!) But in the last five years crowd-funding has brought a welcome and insurgent form of financing to the table. Today capital for creatives is far more likely to come via Kickstarter, Wefunder, or Indiegogo than from either a government program, or a philanthropist. This democratization of finance is spurring dramatic expansions in inventions and making possible new startups in the creative industries birthed from customer pre-orders and crowd-sourced "patronage." The democratization of finance contributes to the democratization of creative expression in markets. Crowdfunding is unleashing forms of expression that highbrow art buyers would likely never give a second glance.

Recently, Yancey Strickler, co-founder and former CEO of Kickstarter, shared with us statistics on Kickstarter outcomes.[31] Yancey described the mission of Kickstarter as stemming from the three co-founders' own experiences as creatives struggling to find support for their creative projects: "We launched Kickstarter to give creatives like us a platform to find and support other creatives. Our mission is to bring creative projects to life."[32] To date, Kickstarter has supported over 140,000 creative projects, helped launch over 10,000 creative companies, and generated over $3.3 billion in pledges for creative ventures.

In part this financing revolution is brought on by consumer demand for more direct interaction with producers and creators. Segmentation of communication channels fuels the success of crowdfunding, too. Gamers passionate about an esoteric storyline can find and connect to one another, then refer each other to additional creative projects they share a passion for. An esoteric game development project on Kickstarter can easily find a global tribe of like-minded supporters.

The pent-up demand for a wider array of creative expression also drives the success of crowdfunding platforms. Market outlets from radio stations to movie theatres to museums have so narrowed their product offering that consumers are bored by the same hit songs being played over and over, the same storylines and characters dominating the big screens, and the same art forms being presented. Consumers are hungry for novelty and authenticity; dominant market outlets offer skimpy servings along these lines-thus their appeal is shrinking. Consumers are only too eager to make an investment in innovation when presented with the opportunity on a crowdfunding platform, and they recognize the importance of their $100 contribution to such creatives.

" CONSUMERS ARE HUNGRY FOR NOVELTY AND AUTHENTICITY. "

The crowdfunding movement is moving beyond the business models of Kickstarter and Indiegogo with the passage of the JOBS Act,[33] that now allows for shares of stock (ownership) in fledgling companies to be sold via online crowdfunding platforms. Previously, in the U.S.A, startups were limited to pitching their new venture to either accredited investors (high net worth individuals) or to professional investors. This limitation has been lifted and startups can now offer equity in their startups directly to supporters via online platforms. One such platform, Wefunder.com, claims to have facilitated over $62 million in investment for 197 startups.[34]

While these numbers are dwarfed by the traditional venture capital industry, which funneled well over $80 billion into startups in 2017 alone,[35] crowdfunding is still in its infancy. We expect it to grow

and continue to force change on the finance sector. As the entrepreneurs who raised financing through crowdfunding reach success and return the favor to the next generation of creative companies seeking financing, crowdfunding will only expand. And, as people realize financial and feel-good returns through crowdfunding, this success will breed more success.

A majority of established venture capital firms seem oblivious to the rise of creative entrepreneurs despite recent data indicating robust return on investment in creative companies. We reviewed recent data on exits available through Pitchbook and Business Insider reports[36] and find that several of the most profitable investments by venture capital firms in recent years are in the creative industries. While the "tech sector" takes credit for these companies, they fall squarely into the creative economy.

Additionally, venture capital and banks alike have been slow—or totally stalled out—when it comes to financing women and people of color.[37] It is well known that women receive less than three percent of venture capital dollars, while people of color receive less than one percent. Arlan Hamilton, founder of Backstage Capital, a venture firm dedicated to investing in women, people of color and LGBT founders, shared with us her critique of the exclusive

RESOURCE FLOWS

Ecosystem health depends on the fluidity and ease of resource flows. Established venture capital firms have been slow to respond to the needs of diverse entrepreneurs, constricting the flow of resources and innovation. Slowly, this is changing, as new forms of financing open doors to diverse startups.

nature of the venture industry saying, "When investors say they don't understand 'the market' when it relates to women/LGBTQ/ founders of color, what they're really saying is they're not interested in doing their homework."[38]

But Arlan did her homework. As a professional in live music production, Arlan saw a steady stream of talent that never received venture backing. So, she set out to change this trend, launching Backstage Capital in 2015 with a $5 million fund.

In a recent interview with *Fortune*, Arlan described her early backers worrying about the viability of a fund focused on women and minorities: "They wondered if there would be enough deal flow."[39] However, Backstage sees over a 1,000 deals a year and to date they have invested $3 million in over 50 start-ups.[40] Like other founders coming out of the creative industries, Arlan was able to draw connecting lines between trends and gaps and build a visionary solution. She began with a niche and is now at the center of a national conversation about inclusion and equity.

GO BEYOND YOUR familiar networks to proactively build linkages between angel groups and emerging startup organizations led by women and people of color. Break down barriers and invite in people who have been shut out of startup financing networks.

The increasing segmentation of channels and platforms, and the boredom with creative expression delivered by mass market channels, means that "niche" products and services are both in higher demand and more readily accessible. Lee Francis (who you will meet in greater detail in Chapter 7), founder of Indigenous

Comic Con, was able to raise funding, attract vendors and sponsors, and host over 5,000 people from around the world for his first crack at hosting Comic Con. Startups founded by people who have long been overlooked or ignored can now get their footing in new markets that traditional investors may not know exist (like Comic Con for Native Americans!). Women, people of color, and others who are regularly excluded from the financing world are slowly finding new ways to secure initial funding and scale up.

Impact Funders

Shifts in the environment call for adaptations among ecosystem actors. As the financing and startup landscape shifts, investors and entrepreneurs will need to adapt to the new reality. Sometimes, however, these shifts transpire slowly, as is the case with impact investors and the creative economy. In 2017, Upstart Co-Lab and the Calvert Foundation published a MacArthur Foundation funded report that surveyed the global relationship between the creative economy and impact investors, who focus on "social and environmental impact" alongside financial return. Owing to the community-enhancing benefits of the creative economy, one would think impact investors and creative companies would fit hand in glove. But the Global Impact Investor Network (GIIN)'s 2015 survey reported "Arts and Culture" receive less than $300 million of the $60 billion in impact assets that its global members manage. By their accounting, that rounds down to zero percent.[41]

Of course, "arts and culture" is not the same thing as the creative economy, and this common misconflation is part of the problem. Investors who have put money into a startup like Etkie, a fashion company sourcing luxury items from artisans on the Navajo

DISPARITY AMONG RESOURCES AVAILABLE TO STARTUPS

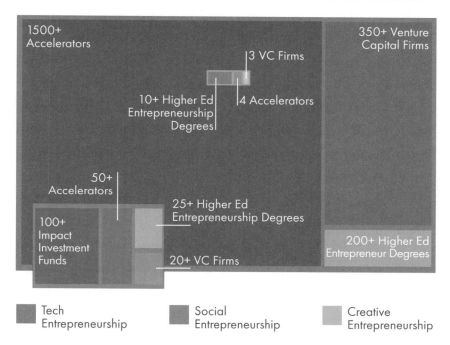

1500+ Accelerators

350+ Venture Capital Firms

3 VC Firms

10+ Higher Ed Entrepreneurship Degrees

4 Accelerators

50+ Accelerators

25+ Higher Ed Entrepreneurship Degrees

100+ Impact Investment Funds

20+ VC Firms

200+ Higher Ed Entrepreneur Degrees

Tech Entrepreneurship

Social Entrepreneurship

Creative Entrepreneurship

Nation, would likely categorize the investment as "social" in nature given the startup's mission to create jobs for Native women. However, the startup is categorized as a creative company—fashion is a creative sector—by economists. A recent conversation with Anne Misak of the Colorado Enterprise Fund about their regional investments showed that 35% of their investments are in creative industry startups. Anne tells us that before she reviewed the portfolio with a creativity lens she would have answered: "We don't really invest in creatives."[42]

As impact investing continues to grow and its practitioners seek out more impact opportunities, we predict more of these investors will engage in the creative economy. The potential to drive social change through creative entrepreneurs' success is enormous.

Coming back to Lee Francis and Indigenous Comic Con, we see a founder driven by a vision of eradicating negative stereotypes of Native people while inspiring indigenous youth to believe in their own "super powers." His venture brings to life indigenous super-heroes through comics, animated movies, and events. As indigenous communities struggle with centuries of oppression, poverty, and violence, empowering Native youth with relevant and hopeful stories has the power to shift self-perception and open pathways to self-empowerment.

Embodied Labs tackles a very different set of challenges: this film and virtual reality company works to improve health outcomes while reducing medical costs. Embodied Labs creates films for VR headsets, allowing caregivers to experience the same symptoms their patients experience from a variety of illnesses. The result is both increased empathy and new treatments that stem from deeper understanding of the illness. Co-founder and CEO, Carrie Shaw, launched the company after her mother was diagnosed with macular degeneration and she wanted to understand her mother's experience. (We'll talk more about Embodied Labs later in the book, but for now, we want to highlight this company as an example of a great opportunity for impact investors.) For

SYMBIOSIS

Technology companies like Cisco, Intel, and Microsoft depend on creative companies that use their routers, chips, and software to create and distribute creative content. And, creative companies depend on tech companies, too. As in all ecosystems, various organisms interact in mutually beneficial or symbiotic ways.

impact investors seeking both social and financial returns, a film company in the VR sector solving the pressing problem of soaring health costs while creating empathy and improved patient outcomes strikes us as an ideal investment opportunity!

This same conversation is mirrored in countless talks we have had with "tech investors" who have invested in "tech" startups that are actually creative companies, founded by creatives. Kickstarter is such an example. Flickr, Patreon, Laura & Wolf, and many more startups are better classified as creative companies than "tech" or "social," but the old definitions have yet to catch up with the new reality of the creative economy.

Despite the many examples of creative companies generating returns for investors, community leaders and economic developers might still come across investors who remain unconvinced by the potential of creative economy. The problem according to Allan Rasmussen of Danish venture capital firm CAPNOVA, "is that most investors simply don't know the creative industry very well and have a lot of prejudices against the sector."[43] In contrast to this idea, in 2010, British thinktank Demos debunked the old thinking that creative industries are more "inherently risky" than other industries. Instead, the study found that the five year survival rate of creative companies was better than in manufacturing.[44] As Rasmussen went on to explain to the European Creative Industries Alliance: "it is not that [investors] do not see the potential in the [creative] sector. It's more that they feel out of [their] depth."[45]

A 2004 Nesta survey of U.K. venture capitalists found that only 22% were interested in creative industry investment, yet of those who had invested, more than 80% identified the creative economy as the sector with "the most growth potential." And while 40% of

investors with no experience in the sector declared it "too risky" to get involved with, only 14% of investors with creative sector experience said the same thing.[46] When investors actually delve into the creativity economy, their prejudices fall away. And well they should. Our experience suggests these startups may even prove a less risky opportunity for seed and angel investors. Meow Wolf generated enough revenue in years one and two to pay back interest-based loans in half the time they originally promised their investors. So, while the venture capital model for startups remains stuck on betting big, waiting eight years, and hoping that one out of 10 investments returns the whole fund and more, new forms of financing for new types of entrepreneurs helps develop not only new companies, but new avenues for investment gains as well.

Even within the entertainment sector, we shouldn't think of creative entrepreneurs as "hitmakers" with short shelf lives. As we've demonstrated throughout this book, the ecosystem of the entire creative economy is bigger and more complex than the entertainment sector. But even within that sector, "the great bands of the world, the great films, tend to be evergreen," explained venture capitalist Patrick Bradley, one of the early investors in Simon Fuller's revolutionary "Pop Idol" brand, in an interview with creativeentreprenuers.com.

"MORE THAN 80% IDENTIFIED THE CREATIVE ECONOMY AS THE SECTOR WITH 'THE MOST GROWTH POTENTIAL'. "

"Content has a long economic life cycle," Bradley said, "and can be continually licensed, remade, cross international borders and exported in terms of format."[47] So we shouldn't advocate for

investors to deal in inauthentic opportunities for quick turnaround revenue at the cost of extended value. Intellectual property is only the *beginning* for creative entrepreneurs.

What the best creative economy investors understand is that true creative entrepreneurs are visionaries who can foresee the long, lucrative journeys of their companies. Unlike individual artists, who tend to focus on expressing their own perspective through pieces they make, creative entrepreneurs envision building a platform for myriad creatives to express themselves with products that speak to market demand and fulfill consumers' desires and tastes.

The Pitfalls of Creative Pride

Our analysis of the gap between creatives and investors would be wholly incomplete without recognizing the role creatives play in generating this gap. Despite the efforts of sympathetic figures like Bradley and Rasmussen, creative entrepreneurs tend to avoid equity financing altogether, preferring bootstrapping, peer-to-peer lending, or crowdsourcing platforms. And, they seem averse to traditional loans. As Ilyssa Meyer, a Public Policy Analyst at Etsy, told Upstart Co-Lab: "Less than one percent of all U.S. Etsy sellers ever sought a loan, and it can be a point of pride that they don't seek out that financing option."[48] Even if creative entrepreneurs have a solid business plan, know how to protect their intellectual property, and can balance their books, they might have prejudices or knowledge gaps of their own preventing them from pursuing funding opportunities.

An independent review of policy options for creative industries commissioned in 2015 for the U.K.'s Labour Party found similar hurdles to investment among creative entrepreneurs. In our

experience, creative entrepreneurs are often unaware of how equity and debt financing work. Only a handful entrepreneurs coming into our accelerator report having experience in working with investors and most often report they have "poor investor networks." (We collect pre and post surveys for all cohorts.)

For some who have encountered investors, they may have been intimidated, overwhelmed, or underwhelmed by the investor. The culture of the investment sector is palatably different from that of creatives. Some startups have confessed deep concerns that investors will dilute their creative vision and they are unwilling to brook the "interference" that investors may bring. Creative entrepreneurs worried about diluting the purity of their ideas can be just as risk averse as investors.

Another impediment to funding comes when creative entrepreneurs are so focused on product development and creative collaboration they overlook bringing in more business-minded partners. Lynda Weinman told *Psychotactics*: "I wished I had that business background before we started the business."[49] Stefan Kosciuszko, chairman of entertainment

> " THE CULTURE OF THE INVESTMENT SECTOR IS **PALATABLY DIFFERENT FROM THAT OF CREATIVES.** "

and tech start-up TwoFoldTwenty, concurred: "There is also a need … to find people who have all the creative knowledge but can also read a balance sheet and read a model."[50]

Finally, investors can be understandably skeptical of whether creative entrepreneurs are building their business for success or merely as a "lifestyle option." Indeed, venture investors in all in-

dustries struggle to identify entrepreneurs who will build a company beyond a successful lifestyle company into a global phenom. As in all industries, many creative entrepreneurs plateau at a comfortable level of success. For creatives this is sometimes motivated by their desire to return more fully to their initial creative impulses. They might be in it for the *creative* capital, not the financial returns. Before venture investors can believe in a creative entrepreneur's ambition, they need to make sure it's a greater ambition than that of an artisan or small business owner.

Sport Candy and Serious Money

Despite these challenges, investors and creative entrepreneurs continue to find each other and figure out how to develop mutually beneficial relationships. Take Magnús Scheving's Icelandic children's show, *LazyTown*, which he created, directed, and starred in.

Even before he became the backflipping, blue tracksuited Sportacus, defender of "sport candy" (fruits and vegetables) and all things active and healthy in *LazyTown*, Magnús was no stranger to creative risks. When he was working as a carpenter in the 1980s, he bet a friend that he could master aerobics in three years, a sport he'd never tried. By 1994, he was the European gymnastics champ and a sought after motivational speaker. When he met unhealthy children, he realized he could become a role model for healthy lifestyles.[51]

Within a few years, he'd published a children's book that outsold *Harry Potter* in Iceland and adapted it into a touring stage play, a 24-hour radio station, and a cultural brand popular throughout the country.[52] No doubt Magnús's extraordinary dedication to his goals stood out to investors when he sought funding for what he

declared would be "the most expensive children's [TV] show in the world."[53]

Magnús did several things that helped investors take him seriously. In return, investors overcame their preconceptions and adapted to Magnús's unique propositions as a creative entrepreneur. Here's what Magnús did right:[54]

- **He built his network to reach investors:** Smart creative entrepreneurs know how to plug up their shortcomings through the relationships they build. Entrepreneurs are challenged to traverse the network linkages that shape the venture investing worlds. And creatives are more challenged than most. As most creatives move in circles of creatives instead of the typical "tech" and "VC" networks, they have to push their networks into entirely new domains.

- **He came to understand investors' needs and priorities:** Right from the start, Magnús launched a *company* that sought to grow returns on the investment he received from the outside. And the strategy was based on more than a product and its attributes; the business model was attractive to investors.

- **He set himself up for success from the beginning:** Magnús invested in the expense of a lawyer with considerable background in the music industry, who impressed investors by establishing a limited liability company with credible structures in place that would allow for the protection, expansion, and repackaging of Magnús's IP rights.

- **He focused on building a brand that would outgrow the TV show:** Magnús didn't only hitch his idea to the children's TV show format, believing that format would carry his idea furthest. He respected the nuances of the business and traveled to numerous children's television tradeshows, where he learned something interesting: the TV show probably wouldn't make a ton of money, but the brand would. He created a detailed matrix of additional income sources before the first episode was even scripted, and today the *LazyTown* brand has spread with wild success to "bottled water, coloring books, shoes, fruit, beach toys, T-shirts, cod liver oil, toothpaste" and more, according to Robert Lloyd from the *L.A. Times*.[55]

- **He "neutralized" his idea so it would scale globally:** In addition to the significant market research Magnús conducted by touring with the stage show of his creation and meeting hundreds of kids, Magnús intrigued investors with his understanding of how to boil down the show's essential elements and "neutralize" everything else so the show could easily translate to cultures around the globe. As Anna Hedberg and Hedvig Stenius-Bratt explain in their case study of *LazyTown*, a yellow schoolbus might play well in some nations but baffle the people of others.[56] Magnús wisely avoided a common pitfall among creative entrepreneurs: attachment to an idea so strict it stifles that idea's circulation through diverse markets.

In the end, the biggest thing Magnús did right was communicate. Some investors make confused squints at the value of "intan-

gible assets" like intellectual property. And creatives aren't always great explainers. As Magnús told Hedberg and Stenius-Bratt, "an idea can be as hard to explain as the words freedom or humor."[57] But because Magnús was able to communicate his idea's value—and demonstrate further business savvy via the moves detailed above—he gained a few unusual concessions from his investors:

- *LazyTown* **began with no detailed shareholder's agreement:** Magnús and his spouse retained a majority of the shares, and Magnús retained final control over all decisions. This early control was a big win for Magnús and something often even more important to creative entrepreneurs than general entrepreneurs.

- **Magnús kept** *LazyTown's* **brand authentic:** Though Magnús wisely neutralized his brand for global scaling, he still maintained the creative entrepreneur's usual concern for authenticity, rejecting sponsorship with Pepsi despite investor anxiety about "leaving money on the table." For Magnús, his passion about healthy kids was more important. This authenticity won the devotion of the Icelandic public, where sales of fruits and vegetables shot up 22% and sales of "fizzy drinks" sank 16%, numbers that Iceland's health ministry attributed directly to *LazyTown*.[58]

How, in the end, did *LazyTown* fare? Did it pay back on the investment of its $1 million-an-episode budget? The numbers do their own amazing backflips. Broadcast in over 100 countries,[59] *LazyTown's* 107 episodes won a BAFTA,[60] were nominated for Em-

mys,[61] employed over 1,000 people (including 160 Icelanders),[62] and catalyzed Iceland's creative economy ecosystem. And though *LazyTown* was not immune to Iceland's financial crisis—2010 refinancing forced Magnús to sell his intellectual property in return for a 40% stake[63]—*LazyTown* still fared better than the Icelandic economy as a whole, losing few employees and keeping production in Iceland for two final seasons after Turner Broadcasting bought the show for $25 million.[64]

Magnús Scheving's charisma and dedication made *LazyTown* shine, but his ability to build relationships with investors amped the voltage and spread the light. In 2017, Francine Sommer—former President of the Venture Investors Association of New York and Creative Startups Mentor—told the Coronado Ventures Forum, "When looking at opportunities within the creative environment, you're always betting on the people."[65] Magnús Scheving serves as a great example of the right kind of person to bet on in two ways: to investors he was a model creative entrepreneur, and to creative entrepreneurs he was a model that would attract investors. Now that's a healthy superhero.

Alternative Models

Once creative entrepreneurs and investors have learned how to connect with one another and adapt to each other's respective realms, they might need to employ a little innovation to unlock the maximum potential of their relationship. To demonstrate, let's revisit our friends Meow Wolf and Cirque du Soleil.

As we told you in Chapter 1, Meow Wolf raised over $3 million in private funding in their first year after graduating our accelerator. However, their model wasn't industry standard. Meow

Wolf initially sought a community development financial institution (CDFI) loan for startup costs, but the team didn't like the constraints the CDFI terms would impose—it might possibly impede their growth down the line. CDFIs had that familiar squinty reaction of many investors, unable to understand the revenue possibilities of a unique creative experience.

Starting off the fundraising process with misgivings about relinquishing equity to investors, Meow Wolf found themselves $1.75 million in debt in just 14 months, including $800,000 from individual investors in five-year, $25,000 notes with 12% interest rates. However, they mitigated this debt with over $100,000 in Kickstarter fundraising and other alternative sources, including a $25,000 award from us at Creative Startups. Even though they still needed a bridge loan of $15,000 right before they opened, their success enabled them to pay down 35% of their debt in the first year and make $1 million in profit.[66]

> " WHEN LOOKING AT OPPORTUNITIES WITHIN THE CREATIVE ENVIRONMENT, YOU'RE ALWAYS BETTING ON THE PEOPLE. "

Needless to say, those CDFIs missed out. Angel investors likewise missed out. As one active angel investor explained to us, "I just didn't get it. But they did. And I wish I had!"[67] We saw Meow Wolf's funding model and encouraged them to take a chance because we understood that some creative entrepreneurs don't need the trappings of traditional lending or investment models. What they need is a deeper connection with their audience, which is why that network of individual investors made so much sense for Meow Wolf.

In our experience, early on in their venture, creative entrepreneurs seek mentoring and advice more readily than they seek investment. Connecting them with "smart money"–money invested by knowledgeable and networked advisors–can bridge their need for investment with their desire for mentoring. Azin Mehrnoosh, a creative entrepreneur from a different Creative Startups company (BrightBot), described his interest in raising "smart money" this way: "We want a partner to mentor us, make introductions, and promote the business, not just be a lender."[68] If investors are prepared to put in this extra work, they can reap the rewards of building exciting creative companies.

Keeping the Circus in Town

Some big investors already get it. Take TPG, for example. When we mentioned their $186 million investment in Lynda.com in an earlier chapter, we suggested you remember them, and here's why: in 2015, TPG bought a 60% stake of Cirque du Soleil.[69] Cirque joined a strong creative economy portfolio at TPG, including not only Lynda.com but also guitar manufacturer Fender, talent agency CAA, and various movie studios.

How did TPG's experience with creative entrepreneurs of all sizes help them make the right moves with Cirque? "This was a very sensitive transition," TPG co-CEO Jim Coulter told *Fortune*. "We had to make sure we didn't impact the creative genius that is Cirque."[70] At the same time, TPG needed an aggressive plan to position their exit strategy—they're still a private equity firm, after all—and prop up Cirque for a big public offering or a major acquisition. This is a wonderful example of balancing investor and creative needs, and here's what TPG did:

- **They respected creative leadership:** Though TPG did sack most of the management at Cirque, they were careful to retain the creative talent. They didn't fire Bernard Petiot, vice president of casting and performance. Nor did they fire Benoît Mathieu, head of costumes and creative spaces. In short, they respected what they didn't know and let the creative leaders retain their autonomy.

- **They upgraded by listening:** Cirque offers a one-of-a-kind experience, and TPG was careful to honor that experience. Instead of forcing Cirque to deviate or normalize, they closed unprofitable side ventures, refocused Cirque on its roots, and invested in resources that helped Cirque do what it already did—except bigger and better. When they saw the library of plaster heads—replicas of performer heads that costumers used to nail proportions—they didn't question the process. Instead, they modernized it with automated chiselers and synthetic plaster replacements.

- **They brought the old fans even closer:** A creative business is only as valuable as its audience, and good investors recognize that they will never understand audiences as well as the creative entrepreneurs who first discovered them. Remember: creative entrepreneurs innovate new markets, and new markets are made of people. That's why when TPG brought in analytics and dynamic ticket pricing, they didn't use all the new tech to reconfigure Cirque's customer base. Instead, they

helped Cirque expand their social media presence to communicate more directly and more often with their existing fans.

Instead of asking all his Silicon Valley friends how they should change Cirque to make it better in their opinion, Coulter invited these friends to a Cirque show. They left buzzing with ideas for virtual reality and beyond, and Cirque's creative leaders were excited by these prospects of collaboration. By embracing this untraditional collaborative role, TPG was able to fully plug into one of the world's most successful creative entrepreneur firms, intertwining creative strengths with investor know-how.

The Architect Who Would Be Mayor

Sometimes private investment can spot creative entrepreneurs—and get help interfacing with them—by paying attention to the right public programs. Sometimes it's easy to pay attention because these public programs directly support investors as well, as in Seoul, where a state-sponsored creative economy fund put up $4 billion to match venture capital injections "up to seven times over," according to the *Financial Times*,[71] Though recent political upheavals in South Korea have dampened enthusiasm for the ideas of the "creative economy," we strongly believe such programs correctly employ a light touch approach that best helps investors help creative entrepreneurs, whose ventures will in turn help their communities—a full rotation of wins.

The British Council's Young Creative Entrepreneur of the Year (YCEY) program is another interesting example of innovative mingling of public and private sectors. This program rewards "emerg-

ing" creative leaders with a two-week U.K. program of "meetings with U.K. industry experts, international peer networking, practical business skills workshops and attendance at key U.K. industry events."[72] When two creative entrepreneurs from Bandung, Indonesia—an architect and a youth space director—won the Indonesian YCEY contest two years in a row, the British Council decided in 2008 to make Bandung their "creative city pilot project in Asia," according to an article by Dan Cohen.[73] This investment sprouted further investment like a colony of mushrooms after a rainstorm, including new startups, festivals, expos, and Indonesian government initiatives—all of which piqued the interest of local and international financiers and jolted Bandung's economy.

This example provides a textbook example of a flourishing creative entrepreneurial ecosystem. Bandung's per capita income doubled between 2008 and 2013, and its economy grew four percent faster than the rest of the nation.[74] The governor of West Java even attended a punk show and proclaimed, "I will encourage the people in Bandung to be creative by building a place for the young creative people to gather and create something."[75]

In 2013, the architect who won the 2006 Indonesian YCEY contest[76]—Ridwan Kamil—was elected mayor of Bandung, and he's since been stridently pursuing private investment to fund ambitious creative infrastructure projects.[77] With a creative entrepreneur as mayor, Bandung is a city that knows how the creative economy can drive growth. The fact that Kamil first won recognition through the British Council's Young Creative Entrepreneur program shows how the right public programs can wave huge flags at attentive investors.

A final example of smart public/private cooperation takes us

to upstate New York. In the town of Kingston, actress, director, and creative entrepreneur Mary Stuart Masterson is renovating a former furniture factory—say that five times fast—into a TV and film studio with additional maker spaces.[78] By sprinkling a dash of Hollywood hustle into the rural Hudson Valley, Masterson funded her $12 million project with a mix of tax credits, grant money, and $2.5 million of debt capital.[79] Masterson shrewdly tapped into sentiment shared by both private investors and policymakers in the Hudson Valley: heritage preservation. Her other aims—a new film union zone around Kingston and a boot camp for high schoolers to train for film industry jobs—likewise demonstrate a creative entrepreneur leveraging her lifetime of creative experience to build a venture that has something for everyone, spreading the windfall of the creative economy among an ecosystem of community stakeholders.

A Sense of Community

Unfortunately, the examples in this chapter shine as exceptions rather than norms. By and large, investors and creative entrepreneurs still aren't at the same parties. When they are, they don't know how to talk to each other. For the sake of our overall economic ecosystem, these passing ships need to connect and collaborate.

We talked to Aner Ben-Ami, a successful venture investor with a focus on natural resource conservation, and he emphatically agreed. In his experience, some of the best entrepreneurs he's worked with have not come from backgrounds investors traditionally look for: "Our experience is that entrepreneurs who are extremely mission driven and come from more of an activism background might look suspect to a traditional investor. But they end

up being some of the best entrepreneurs we have worked with."[80]

Our alumni are showing early return on investment that surpasses most tech accelerators' alumni ROI.[81] Thus, we don't believe that tech startups should have a monopoly on major investor funding. Our accelerator shows that with access to capital, mentorship, networking, and support services, creative businesses thrive just like startups in other innovation industries. As Francine Sommer says, "With Creative Startups, there's a sense of community that's different than what you find in a straight venture startup [accelerator]."[82] We know how to invest in creative entrepreneurs, and we know creative entrepreneurs want to invest their success back into their own communities.

Investors who don't yet understand the creative economy or harbor outdated interpretations of "creative entrepreneurs" should look to the success of TPG, the stories of Magnús Scheving and Mary Stuart Masterson, the ingenuity of Meow Wolf, the leadership of Ridwan Kamil. While it's true that Lynda Weinman's first financier lost his $20,000, you don't have to be a creative entrepreneur's grandfather to see the potential of authentic innovation—and invest accordingly.

7

From Wrapping Chocolates to Curating Identity

Who has the face of an entrepreneur? In a global economy of instant competition and constant innovation, communities cannot afford to overlook any entrepreneurial talent. While we've discussed the value to be seen in a diverse mosaic of stories—both culturally and economically—it's also important to know that many diverse creative entrepreneurs go beyond only telling their own stories. They empower others to tell their stories as well—and to grow their economic impact.

For NYC fashion entrepreneur Monica Phromsavanh, that empowerment goes out in the mail. Phromsavanh is the founder of ModaBox, an innovative membership-based fashion subscription club that Phromsavanh calls a "a data-driven, personalized online styling service catering to professional women."[1] New members fill out a "style profile," and a proprietary algorithm crunches their answers and matches them with one of ModaBox's personal stylists, who use the data to assemble custom outfits that feature pieces from both emerging and established designers. "It's a scalable, personalized shopping solution that has historically only been available to a very affluent clientele," Phromsavanh told *Entrepreneur.*[2]

MEET

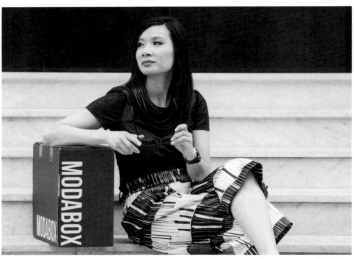

Image courtesy of ModaBox

ENTREPRENEUR: Monica Phromsavanh

INDUSTRY: Fashion

MARKETS: U.S.

COMPANY: ModaBox

BASE OF OPERATIONS: U.S.

EMPLOYEES: Over 40

NOTEWORTHY: Arriving NYC with $200 at age 17, Monica has built a fashion forerunner that is disrupting how professional women buy apparel.

Her customer niche of professional women face conflicting demands: a culture where their advancement is heavily based on judgments of their appearance, and a lifestyle where their careers and families leave them with no time to shop. "Instead of searching hours online for the right look," Phromsavanh says, "Our customers are provided with simple, targeted choices that are on-trend and affordable."[3]

Moda means "fashion" in Spanish, one of Phromsavanh's first languages. She grew up in a refugee camp in Argentina after her parents fled Laos during the Secret War. During the years her family lived in a warehouse without running water, her parents struggled to keep their children fed. Phromsavanh's mother participated in the informal economy by "smuggling clothes from Paraguay and selling them to local stores," Phromsavanh wrote for the Australian site *Femail*.[4] Fighting her way out of this early poverty, Phromsavanh learned the creative resourcefulness and sales skills that would serve her entrepreneurial goals. At 17, her mother bought her a one-way plane ticket to America. In 2006, she arrived on a Greyhound in NYC with $200, $73 of which went immediately to a Metrocard. Eating off the dollar menu and selling suitcases of clothes at street fairs, Phromsavanh worked her way through retail jobs into entrepreneurship with a philosophy of curiosity, persistence, grit, and gratitude, she told *Inc.*[5] Of course, all entrepreneurs have persistence and grit, but let's highlight the two especially creative qualities she mentions: curiosity and gratitude.[6]

- **Curiosity:** As a creative, Phromsavanh didn't stop at learning just enough to get by in a new society and culture. She soaked in everything she could about her new home and the business of fashion. Curiosity is a classic hunger of creatives, and this curiosity bleeds into their entrepreneurial ideas and strategies. ModaBox, after all, encourages their customers' curiosity about new trends and the possibilities of their self-image.

- **Gratitude:** Monica described to us how ModaBox

supports immigrants just arriving to the U.S. who have potential to adapt their skill set to her startup's needs: "We created a community where we can help them see their highest potential…maybe they don't have a skill set for that application but we help them apply other skills. I think that obviously, on a larger scale, if you could do that more for the community it's something that is really making a difference."[7]

Creatives live to connect with people, and they appreciate others as much as they're curious about them. Phromsavanh's advice to aspiring entrepreneurs echoes this theme: "I would tell them to surround themselves with a community of inspirational and intelligent friends and mentors," Phromsavanh told Little Laos on the Prairie. "You'll attract a support system that will become one of your greatest assets."[8] Her gratitude extends from that support system to her employees as well: "I don't point fingers at anyone on my staff," she told Maker's Lane. "I always believe that when the fish stinks, it starts from the head. And if I'm the head, I'm stinky."[9]

But not much is stinky these days for Phromsavanh, who in 2016 was invited to speak at a White House Summit hosted by the Obamas and Oprah Winfrey.[10] Phromsavanh's identity informs her entire journey. She is a creative entrepreneur and founder of a multi-million dollar company with 42 employees[11] and thousands of clients. And she is a Laotian refugee who dropped out of school when she was 14 and whose first jobs were scrapped together in under-the-table economies: boxing sweaters, cleaning apartments,

and wrapping chocolates. She gathered the courage to found Mod-aBox in 2013 after traveling to Laos to connect with her roots, an explicit illustration of a creative entrepreneur powered by heritage. In every ModaBox, a card invites members to donate "gently worn business attire for women," in collaboration with the Bottomless Closet organization. This is part of Phromsavanh's mission to stay true to her journey. "I am where I am today both because of all the circumstances of my life, but more importantly because of the re-silience they created in me," she told *Entrepreneur*.[12]

Today, Phromsavanh supplements her earnings from Moda-box with professional speaking gigs on e-commerce and entrepre-neurship, and she told *Her Campus* that the best part of her job "is meeting amazing and inspiring entrepreneurs."[13] All over the world, creative innovators like Phromsavanh are disrupting indus-tries like fashion—not known as a bastions of diversity—and turn-ing the lessons of their life journeys into inclusive entrepreneurship.

Diversity for Success

Academic research on diversity is emphatic: all communities need diversity to grow. Nicholas Brooke's landmark 2003 study of what makes a successful city puts diversity at the top of the list: "Cities that embrace diversity in all its forms, including cultural and ethnic diversity, seem better equipped to generate the cre-ativity that cities need."[14] Advocating for ecosystems that support a more inclusive field of entrepreneurs is not just a social justice cause—it's imperative for a healthy economy.

Most savvy communities around the globe already understand the well-documented benefits of entrepreneurship. If you were interested enough to read this far into a book about creative en-

trepreneurs, you probably already know that small and medium businesses account for half of all formal jobs in the world.[15] You probably don't need the Center of American Progress to tell you that entrepreneurs are "a critical component of a strong local economy" whose businesses "generate sales tax revenue, contribute to the quality of life in neighborhoods, and attract potential new residents to help bolster a community."[16] You probably don't need to hear about a Chicago study reported in *Entrepreneur,* which showed that "for every $100 spent at a local business, $68 remained in the city,"[17] compared to $43 of every $100 spent at a non-local businesses.

Those numbers probably don't surprise you. These, however, might:

- A 2013 American Express funded study found that of all privately-held firms, only the firms owned by women showed a net job growth in the U.S. between 2007 and 2013.[18]

- In 2015, *Fortune* reported that African-American women are the fastest growing group of entrepreneurs in the U.S.[19]

- A 2015 Stanford Graduate School of Business report showed that 86% of all small business growth between 2007 and 2012 "can be attributed to Latino-owned businesses." (And 75% of those business are not in construction or manufacturing, deflating the common stereotype.)[20]

- Since 1995, 35 to 40% of new firms in the U.S. have "at least one immigrant entrepreneur connected to the firm's creation," according to a study in the *Harvard Business Review.*[21]

- The 2017 Kauffman Foundation State of Entrepreneurship report emphatically concluded: "If minorities started and owned businesses at the same rate as non-minorities do, the U.S. would have as much as an extra 9.5 million jobs in the economy."[22]

- McKinsey research into recruiting practices found that LGBTQ recruits were "more highly skilled and more likely to have advanced degrees."[23]

- Looking out across the globe, entrepreneurs (with the right ecosystem support) have the potential to create 10 million jobs for young people across the G20 countries, according to a 2014 Accenture study.[24] This comes during a time when young people (ages 15-24) are more than three times more likely to be unemployed, according to the International Labour Office, a figure that UN analysts have suggested is a major factor behind social unrest around the world.[25]

ADAPTATION

Adapt - or go the way of the dinosaurs! Today's entrepreneurs include people of color, people with disabilities, LGBTQ and others who are not yet fully included in the startup ecosystem. Tomorrow's thriving ecosystem leaders are adapting to this exciting reality today.

- Where is the world's highest average rate of entrepreneurship? According to a 2017 Global Entrepreneurship Monitor (GEM) report, Africa shares

the world lead in what the GEM calls "Total Early-stage Entrepreneurial Activity" (TEA) with Latin America and the Caribbean.[26]

These numbers tell varied stories, but they combine to form one firm truth: entrepreneurship needs diversity just as much as communities need entrepreneurship. The entrepreneurial qualities we mentioned earlier—adaptability, resiliency, self-sufficiency, and innovation—parallel the survival strategies of those who face institutional underrepresentation and inequality. To put this another way, many people without privileges already employ entrepreneurial thinking simply to get by.

Barriers to Creative Entrepreneurship

Across the globe, under-represented groups are stymied by a lack of formal and subtle discriminatory practices. For example, despite the impressive growth of entrepreneurship among African-American women in the U.S., *Fortune* reports that their firms "tend to be smaller than average and have lower employment growth."[27] Why the contradiction?

Well, consider the fact that 87% of venture capital funding goes to white entrepreneurs,[28] yet a McKinsey analysis of firms across the Western hemisphere found that "companies in the top quartile for racial and ethnic diversity are 35% more likely to have financial returns above their respective national industry medians."[29] Perhaps we're not dealing with contradictions so much as unsupportive ecosystems.

Such ecosystem gaps—or outright barriers—often drive entrepreneurs across the globe to informal economies, which "repre-

sent a third or more of employment in developing and transitional economies," according to the Center for International Private Enterprise (CIPE).[30] By necessity, entrepreneurial activity—especially creative entrepreneurship—flourishes in these informal economies. Yet these informal economy participants also face oppressive laws, predatory funding and lending sources, and other debilitating challenges. When the CIPE analyzed scholarship centered around informal economies, they found that "expanding access to opportunity for informal entrepreneurs can create jobs and improve the business environment."[31] Not only would the unleashed growth of these entrepreneurs help their firms and their workers—it would also "increase public revenue and increase confidence in public institutions."[32]

Whether communities are struggling with the integration of informal economies or an institutional lack of parity, creative entrepreneurship represents an innovative avenue to unleash entrepreneurship and adapt to an increasingly competitive and diverse economy. Other hotbeds of entrepreneurial activity, such as the tech sector, have struggled to attract a diverse range of founders, but the creative economy has had more success. In the U.K., for example, the percentage of minority workers in the design sector increased 126% between 2011 and 2014.[33] Dennis Layton, co-author of Diversity Matters, researched the relationship between success and diversity in the creative sector and found "a correlation be-

SEEK OUT & SUPPORT
Seek out and support entrepreneurs building unlikely ventures for markets and customer segments you may be unfamiliar with.

tween increased diversity and better financial performance."[34] Creative entrepreneurs, specifically, have a deep relationship with diversity. As creatives, they innovate and build on the cultural wealth they inherit and encounter. As entrepreneurs, they market those innovations to a global economy yearning for novel experiences, with an ever-growing middle class across the globe eager to see themselves and their stories represented.

A parking app is egalitarian in an anonymous way: anyone can build it, and everyone uses it more or less the same way. If the hot stories you hear about entrepreneurs are all about parking apps, there is little incentive for those who want to solve more diverse, and in many cases more significant, problems to explore entrepreneurship. And if the only ecosystems built to support entrepreneurs are aimed at those who build parking apps, they are not going to attract and include diverse participants. Creative entrepreneurs are innovators curious about their legacies, curious about the stories of others, curious about big ways to unleash these stories. Without a foundational diversity, there would be no creativity, let alone creative entrepreneurship.

INVITE ENTREPRENEURS who fall outside the "tech startup" scene to speak on a panel, teach a workshop, or mentor a startup you support. Include founders, investors, and educators who have been overlooked and underestimated and watch your ecosystem flourish!

In this chapter, we're going to show how fostering creative entrepreneurship unleashes entrepreneurial potential for the historically marginalized. By analyzing the success stories of diverse

creative entrepreneurs and creative entrepreneurs who foster diversity—and discussing our experiences with diversity at Creative Startups—we'll illuminate strategies for spreading entrepreneurial potential that spurs egalitarian economic and social growth.

Dreaming in Indiginerd

At Creative Startups, we're committed to inclusive entrepreneurship: 88% of the startups we work with have at least one female or one minority founder. Our accelerator participants span the globe, coming from not only the U.S. and the U.K. but also Mexico, Singapore, Peru, Portugal, and more. And 75% of those participants have no previous business education.[35]

Sometimes the entrepreneurs who come to us not only see the world in a unique way, they see a market opportunity we don't understand. Regardless, we get revved up when people come to us with ideas we might not understand but a determination we definitely get. Because those who see opportunities before the rest of us are often the most innovative entrepreneurs, matching their creativity with insight into markets that others—including us—have yet to discover.

One such entrepreneur is Lee Francis, the founder of indigenous comic book company Native Realities and organizer of the world's first Indigenous Comic Con. A tribal member of Laguna Pueblo, New Mexico, Francis's father read so much science fiction that when he saw a new cover in the bookstore, he'd have to check the original publication date to make sure the book wasn't a reissue. If the original copyright was between 1984 and 1996 or so, chances are he'd already read it. Hence the younger Francis's growth into what he calls an "indiginerd" (indigenous nerd) and

later a creative entrepreneur.[36]

We met Francis in 2016 at an event hosted by a 2014 Creative Startups alum, Rezonate Art.[37] Lee shared his vision for the company and we encouraged him to apply to our upcoming accelerator, sensing we were a great fit for him. Lee applied and was accepted into the program. He wrought great benefit from the learning experience, winning the pitch competition and a $25,000 investment

MEET

Image courtesy of Native Realities

ENTREPRENEUR: Lee Francis IV

INDUSTRY: Publishing and Gaming

MARKETS: Global

COMPANY: Native Realities

BASE OF OPERATIONS: U.S.

EMPLOYEES: 5

NOTEWORTHY: Launched world's first Indigenous Comic Con.

at the end of the program. "Creative Startups is a vision realizer," Francis says of his experience. "We realize we actually can make a business out of this, we can make a change with what we're doing, and we can live this out."[38]

Francis's mission with both his publishing company and the Indigenous Comic Con is to use "fantasy as a way of changing reality." Wresting back the mythology of indigenousness from pop culture—where indigenous people are limited to roles of mystical relics, noble savages, and "Pochahotties"—the comics that Francis publishes and promotes allow Native people to tell their own stories. They tackle overlooked histories—like Arigon Starr's Tales of the *Mighty Code Talkers*—and topics of serious importance in the Native community, like suicide and sexual abuse. Unifying all of Native Realities' titles is a belief in the power of fantasy to challenge—and change—reality.

Francis explained to Arizona Public Media that indigenous people have been "enamored with superheroes since ... time immemorial. These are our Tricksters. These are our Hero Twins."[39] No wonder there is a market for indigenous representation in this genre, both in the Native community and among fans of all backgrounds tired of the same stories being rehashed over and over. As a creative entrepreneur, Francis understands that innovation on long-standing traditions is how culture sustains. New episodes honor the backstory. Or as Francis put it to the *Albuquerque Journal*: "That story becomes a future."[40]

The success of Native Realities and the Indigenous Comic Con speaks to the vitality of that future. The first Comic Con attracted over 5,000 visitors and provided a platform for 52 vendors who made over $78,000.[41] The Con was so popular that many vendors

ran out of products. Comics were the centerpiece, but the event also featured "illustrators, writers, designers, actors, and producers" from a rich indiginerd culture of "games, sci-fi, fantasy, film, TV and graphic novels," as reported in the *Albuquerque Journal*.[42] Both Native Realities and the Comic Con have drawn coverage from major outlets like NPR and *VICE*. He is networking with other new conventions like blerDCon (Black Nerd Con) and Chicano Con, and he just opened a retail/event space, Red Planet Books and Comics, in Albuquerque. Again we see creative entrepreneurs facilitating the success of additional creative entrepreneurs. "I've seen a lack of outlets for tribal entrepreneurs to actually distribute and get their business out," says Southern California Tribal Chairmen's Association Director of Technology, Matt Rantanen. "This is finally a venue with their brand and their name on it."[43]

In addition to being a science fiction fan, Francis's father was a respected poet, professor, and "'central force' in the encouragement of young Native American writers," according to the *Albuquerque Journal*.[44] He had his own entrepreneurial spirit, founding and directing the Wordcraft Circle of Native Writers and Storytellers. Francis III passed away in 2003, but the creative entrepreneurship of the Francis family lives on. Before Francis IV founded Native Realities, he taught indigenous students for 15 years, where he saw that his students lacked pop culture iconography that "speaks to their heart and who they are," he told CreativeMornings in Albuquerque.[45] Just as he inherited the directorship of Wordcraft Circle from his father, he inherited the ambition to unleash creative entrepreneurship.

This inheritance echoes larger trends of interfamilial creative entrepreneurship, especially in U.S. Native culture. In a ground-

breaking study Creative Startups conducted with University of New Mexico economics professor Dr. Melissa Binder,[46] we found a provocative association when we examined census data of Native American families: we discovered higher positive socioeconomic outcomes (economic stability, advanced education, and linguistic preservation) among families where a head of household is engaged in creative and cultural entrepreneurship (compared to families not engaged in creative entrepreneurship). More importantly, we also discovered that "*cultural* [entrepreneurship] activity appears to be more closely associated with positive socioeconomic outcomes than entrepreneurship alone."[47] In other words, creative entrepreneurship is a stronger predictor of family wellness than non-cultural entrepreneurship or working for others.

No entrepreneur truly goes it alone, but creative entrepreneurs are especially in tune with their legacies and their communities. Entrepreneurs like Francis are growing previously ignored markets and helping storytellers translate heritage into future-facing businesses. You can bet on Creative Startups' alums like Native Realities because they're market makers. With his sincerity and excitement, Francis isn't waiting for the old guard of DC and Marvel to bestow representation—he's making it happen, and he's doing it with other creative entrepreneurs. Sounds like a team of superheroes to us.

RESOURCE FLOWS

Innovation comes when different ideas, perspectives, and traditions mix with established structures and systems, causing new forms of thinking to emerge.

A Struggle to Integrate

For diverse creative entrepreneurs, figuring out where they fit in their communities is sometimes tricky. One solution, as with the Indigenous Comic Con, is to carve out new spaces. Other creative entrepreneurs pursue integration from the beginning—often with a struggle, but sometimes with inspiring success. The stories of two Rotterdam creative entrepreneurs—both women of Moroccan descent—cover both ends of this spectrum.

When Mahasin Tanyaui started her blog *Girls of Morocco*, she was frustrated at the lack of representation for women of Moroccan descent in the Netherlands. Her blog combined daily life chronicles of ambitious Moroccan women with inspiring memes, and soon she found herself with 12,000 followers.[48] Buoyed by the blog's success, in 2011 Tanyaui entered a local entrepreneurship competition for funding to create a Muslim women community center. She found herself the only competitor of Moroccan descent, and she didn't win. But she did digest the advice and establish connections among Rotterdam's business elite—a community with an unfortunate record of ignoring the non-Dutch residents that makes up 47% of the city's population.[49] Tanyaui was determined not to be ignored, and she pivoted her idea into a 2013 festival called Djemaa el Fna based on a famous outdoor food court in Marrakech.[50] Her vision for a slice of Morocco prominently exhibited in downtown Rotterdam was a smash hit, with over 70 stands and events attracting over 12,000 visitors.[51] Tanyaui rode the festival's success into founding an event agency that has managed productions for international music and film festivals.

Unlike Tanyaui, creative restaurateur Alia Azzouzi hadn't yet

made inroads with the Rotterdam business elite when she, her brother, and her husband opened Espresso Dates, a cafe specializing in healthy food and hearty conversations, with an emphasis on providing space for local artists to exhibit their work. But Azzouzi was no stranger to ambition. As a child in Dutch schools, her teachers often predicted she would one day be the first female mayor of Rotterdam. She hasn't

SOME OF THE MOST valuable resources in entrepreneur ecosystems are found in communities that have been marginalized or overlooked. Reach out to these communities, host startup events and programs in their neighborhoods, include their leaders in the development of a robust ecosystem.

ruled it out, but the arts sector veteran and former social science teacher currently has her hands full with the popularity of Espresso Dates.

The cafe appeals to all audiences—featuring artwork by Dutch schoolchildren on its windows—while also remaining an authentic gathering place for diverse communities, hosting Ramadan-themed fashion pop-ups and documentaries about the dangers of plastic.

Azzouzi has achieved all of this despite exclusively funding her business through family savings. She took out no bank loans, and in an interview with Humanity in Action, she said "many Muslim women who wear the hijab are often discriminated against when seeking loans or business advice."[52] Yet with hard-won neighborhood support, Azzouzi has persevered in her creative cafe vision,

campaigning on social media to help the cafe find a new location when she was evicted by her landlord. Today she employs 10 people and spreads entrepreneurship: selling pastries baked by other Moroccan women and sweetening teas with honey from a local Dutch-Moroccan beekeeper. Even the mayor is known to drop by, perhaps to scope out his future competition.

Both Tanyaui and Azzouzi told Humanity in Action they still face adversity in Rotterdam, despite the city's rhetorical championing of entrepreneurship. Azzouzi, for example, struggled to find "external financial and logistical support" for a second cafe. The authors of the Humanity in Action study cite "a common narrative of gaps between groups, such as funders, the government, and business incubators, and urban entrepreneurs of ethnic minority backgrounds." This gap, they note, goes beyond finances: "There seems to also be a gap in communication, outreach, and understanding."[53]

Despite these gaps, the stories of Tanyaui and Azzouzi show us how individual creative entrepreneurship can swell into community entrepreneurship. As creatives, Tanyaui and Azzouzi embraced collaboration, innovative problem-solving, and cultural legacies. Creative entrepreneurs set themselves apart from other entrepreneurs because their hunger is not just for success: they understand how important it is to become indispensable to their community. And that means both the community they come from and the community in which they might be a minority. Between festivals and cafes, Rotterdam can't ignore Tanyaui and Azzouzi. They are creative entrepreneurs who have turned minority status into major success.

Recipes for Innovation

Let's travel now from Rotterdam to Beirut, where we find another empowering female creative entrepreneur—and another empowered online community. Instead of comic books or handmade crafts, this community unites around a deceptively modest genre of creativity: the culinary recipe.

Creative entrepreneur Hala Labaki left her home country of Lebanon for career success in Europe, managing development of major brands like United Pharmaceuticals and Unilever. But her heart—and her stomach—longed for home. "We thought it was difficult to get good recipes online in Arabic, which is surprising considering that food is so important in Lebanese culture," Labaki told *El Confidencial*.[54] Sensing an untapped market, Labaki and her two co-founders returned to Lebanon and, in 2010, launched Shahiya (Arabic for *appetite*), an online recipe-sharing portal. Users contributed recipes and reviews, while Shahiya's in-house food experts tested and moderated content to maintain quality (rejecting about a third of submissions, according to Labaki) and designed an algorithm to measure nutritional info for all recipes.

Shahiya's initial revenue stream was classic for online start-ups—it came from advertising—but its audience was revolutionary, and its rapid growth led to one-of-a-kind numbers for a Lebanese startup. In the Middle East, women maintain traditional roles and do most of the cooking, but the spread of broadband access in the region has helped them join women all over the world, who make up the bulk of active internet users. Shahiya offered community with its content, advertising on regional cooking shows, curating special menus for Muslim holidays like Eid-al-Adha, and

deeply integrating social media, becoming "one of the first Arabic websites to integrate Facebook Connect," according to Daniel Neuwirth, the company's other co-founder.[55]

By 2012, Shahiya boasted 1.3 million unique monthly users, attracting international brands like Kraft as advertisers.[56] Three years later, the unique user count had grown to 3.5 million a month.[57] These users—90% women, most over the age of 35—contributed 15,000 recipes in Arabic and English.[58] Despite their Lebanese roots, most of Shahiya's users were expats or residents of other Gulf countries, especially Saudi Arabia. By 2013, Shahiya owned half of the Saudi recipe website market share, a culinary example of creative heritage's export power. According to a talk Labaki gave at the 2013 Banque du Liban Startup Workshop, Shahiya had become "the market leader in every single market in the MENA region."[59]

What Labaki discovered was that Shahiya offered more than a space to upload and review recipes. It empowered Arab women to connect with each other and their roots, just as Labaki had yearned to do in Europe. On Shahiya's private, registration-only forums (unindexed by search engines), wives discussed relationships with in-laws; mothers discussed weight loss; emigrants discussed homesickness and the impossibility of finding good baklawa. Labaki told *Wamda* that this sense of community solidarity "eases the isolation experienced by many homemakers or expats."[60] She described how the average Arab woman spends much of her time in the kitchen because of "a culture that often limits their interaction outside the home."[61] One of her favorite stories involved a mother and daughter separated by the Mediterranean:

She was originally Syrian, but had been living in Saudi

Arabia for 15 years, and was posting excellent recipes in Arabic. One day, we noticed a review on one of her recipes in English, from Germany. The review said 'Mom, I'm so happy I found Shahiya because now I don't have to bug you on the phone to get your recipes.' It was actually her daughter, who was living abroad in Germany. That's when we felt like we had hit on something.[62]

To empower this audience in a male-dominated business culture—and to achieve this success in a young startup culture like Lebanon's—wasn't easy for Labaki and her team. Two forms of skepticism greeted them:

- **First, there was the skepticism that a creative tech startup could work in Lebanon.** But Labaki rejected what she called "cliche problems" in an interview with Startup Megaphone: "no internet, no infrastructure, some instability in the country." Labaki cited the "right team and the right determination" as Shahiya's solutions.[63]

 To tackle infrastructure challenges in a country where, in 2012, *TechCrunch* reported "six hours of electricity per day and a 2 gigabyte monthly download cap on the office internet connection,"[64] Labaki courted the best among the country's small pool of tech experts and reached out to the Lebanese diaspora as well, convincing Shahiya's CTO to move back from the U.S.

 Labaki's remark about the "right team and the right determination" reflect the collaboration and innovation

common to all successful creative entrepreneurs. Ask yourself: would a CTO of a non-creative tech startup move back to a challenging country to apply their expertise if they didn't feel some deeper identification with the startup's mission? Tapping cultural pride is one of the more subtle but significant skills that set creative entrepreneurs apart.

- **Second, there was the skepticism and confusion of male investors**. Although Labaki told *Wamda* that Lebanon's more progressive attitudes about gender allowed her more latitude than her peers in other MENA countries, she also told the BBC that a heavily male investor community didn't know what to make of Shahiya. "The decision-makers didn't cook, even the few women [investors] didn't, so they couldn't relate."[65] She credits the presence of male co-founders with helping Shahiya capture its initial round of VC funding, and the site took pains to avoid branding that would pigeonhole it as "feminine." In Labaki's approach to investor sexism, we see another example of the strategic collaborative thinking of creative entrepreneurs.

But women, of course, constituted the undeniable majority of active users. Equally undeniable was the fact that advertisers poured major dollars into the site to address this large audience. Here, we see the power of creative entrepreneurs to cultivate enthusiastic audiences. Plenty of tech startups offer convenient, practical products, but creative tech startups offer spaces we care about and identify with, spaces to explore and allow us to take pride in who we are.

In 2015, Japanese recipe site Cookpad acquired Shahiya for $13.5 million, one of the largest-ever acquisitions for a Lebanese startup.[66] All of Shahiya's team stayed on in Beirut, managing the transition to the new portal, as well as managing their standalone pay-to-download app Cook Lebanese, which has had over a million downloads since its launch in 2011.[67] Today, Hala Labaki remains CEO of what's now called Cookpad MENA, and she's done some investing of her own: putting $350,000 into DMD Panorama, an innovative photography app built by a fellow Lebanese creative entrepreneur—a former video game programmer and math teacher—that the *Wall Street Journal* called "the easiest-to-use panoramic picture app on the iPhone."[68]

Clearly, Hala Labaki's creative entrepreneurship follows the pattern of creative ventures unleashing more entrepreneurial talent. Just as importantly, her creative entrepreneurship has also significantly contributed to the social well-being of her region by offering a space for a marginalized community to gather and support each other. Like creative entrepreneurs around the world, Hala Labaki's innovations helped people honor their histories and cook up their futures—in a world where more and more people are claiming the right to tell their own stories.

Bringing Their Own Seats

Creative entrepreneurs excel at growing and diversifying the entrepreneurial ecosystem, and this collaborative spirit enables them to build global brands. Take Caterina Fake, for example, the co-founder of Flickr.

Fake trained as an oil painter and began her career as a Web designer and Art Director, but she was never satisfied with per-

sonal artistic output. Her heart was in collaboration. In an interview with *Fast Company*, Fake explains that her love of the internet comes from a love of people:

> Connecting to other people, and people that you wouldn't otherwise be able to find… That sense of "wow," that manna-from-heaven feeling when you find something or someone or some person you lost touch with, like your old classmate. Or you discover somebody else who feels the same way you do, say, if you're the lonely gay teenager in Indiana. All those people looking for connection, that perennial human desire. It's just insatiable.[69]

By retooling a failed multiplayer computer game, Fake and her husband created Flickr, a hugely successful online photo-sharing and photo-tagging platform they sold to Yahoo for $40 million.[70] Fourteen years old and still going strong with over 30 million users all over the world, Flickr may have lost its market leader status to Instagram, but Fake's early success—and the creative way she integrated photo sharing into social networking—proves the potential of entrepreneurial leaders.

For Fake, as for most creative entrepreneurs, art wasn't so much about self-expression as communication. This is key to understanding why creative entrepreneurs are so interested in unleashing further entrepreneurship. Fake's shared sense of "wow," Monica Phromsavanh's inspiring journey, Azzouzi's cafe counter space for fellow entrepreneurs, Hala Labaki's empowered Saudi women—all of these generate the energy that diversifies and fuels economic ecosystems, locally and globally. You want creative entrepreneurs

like these building companies in *your* community because they already think in terms of community. The faces of creative entrepreneurs might be new to the table, but they've brought their own seats, and they know how to make more room for others too.

8

Jostling Photographers and a Visionary Beautician

If you're the best in the world, the world will find you. For over 30 years, that's how things have worked in the Taiwanese bridal photography industry. In the early 1980s, creative entrepreneurs in Taiwan revolutionized the modern bridal package. Photographers and stylists innovated the ritual of the pre-wedding glamour shot and created a democratized experience of elegance that defined a new style for the region—and, eventually, for the world.

In *Framing the Bride: Globalizing Beauty and Romance in Taiwan's Bridal Industry*, Bonnie Adrian attempts to uncover the "creative heroes and heroines" behind the rise of Taiwan's bridal photography success.[1] What she finds is a story common among clusters of creative entrepreneurs: competitive innovation. One photographer takes credit for the pre-wedding photoshoot, claiming he invented the idea of establishing a more intimate photographer/client relationship in order to compete with general studios. Another salon owner claims she was the first to combine dress rental with photography. Throughout the whole process, creativity is paramount. "In essence, producing such a photo album is just like making a film depicting a relationship," industry pioneer and

MEET

BRIDAL
Chris Photography

Photo credit: chris20140508.weebly.com

ENTREPRENEURS: Thousands of founders of locally owned Taiwanese photo studios

INDUSTRY: Digital Photography

BASE OF OPERATIONS: Taiwan

MARKETS: Asia

EMPLOYEES: Over 20,000

NOTEWORTHY: Generates $3 billion annually in Taiwan!

wedding album maker Tsai Ching-hua told *Taiwan Today*.[2]

Adrian notes that insiders in the industry see its history "as a matter of which entrepreneur was the first to coin a new idea or begin a certain practice that later became standard." This is a story we recognize. As we've seen time and time again in creative entrepreneurial clusters around the world, a global phenomenon was born from a local hotbed of creative entrepreneurs dueling like jazz guitarists, not for the sake of undercutting rivalry but out of a genuine

inspiration to solve market problems with ever fresher disruptions.

But one of those creative entrepreneurs, according to Adrian, was not trying to one up anybody. She went into the business to bring some beauty. Although "Mrs. Suzuka" chose to remain anonymous for Adrian's book, her contributions seeded the ground for well-known industry figures like Lin Li and Mai Canwen. Her story is also a great example of how creative entrepreneurs synthesize global influences and, in turn, infuse global markets with local ingenuity.

A beautician by trade, Suzuka landed in Taipei in the late 1970s when her husband returned to his homeland from Tokyo. She noticed that young brides weren't up to date with global fashion trends. So she began renting out gowns imported from Europe at her salon and hiring seamstresses to update these styles with a local spin. Adrian's research suggests that Suzuka worked with the unique "sense of beauty she developed growing up in Tokyo." First she spread this aesthetic throughout Taiwan—training the first generation of stylists that would join enterprising photographers in their one-stop shops—and later exported it throughout the world, just as Taiwan's wedding studio industry was going big.

These two qualities—competition and innovative creative sensibility—often complement each other when local creative entrepreneurship goes global. Taiwan needed both its jostling photographers and its visionary beautician to reach the world stage. Today, the Taiwanese wedding photography industry has gone global in a big way. According to *Taiwan Today*, it's worth over $3 billion (counting related services).[3] Over 1,000 studios employ about 20,000 people.[4] Marriage rates in Taiwan have declined, so the main business traffic comes from visitors. Some 5,000 foreign cou-

ples a year flock to the island for its aesthetics and great value.[5] The rise of the Taiwanese *hunsha sheying gongsi,* or bridal gown photography company, has also spawned a diverse cluster of supporting businesses—from caterers to consultants to makers of electric flower carts. Taiwanese government initiatives have made wedding photography a key plank in their creative economy efforts, and cities like Tainan host official mass wedding ceremonies as tourism boosters. Taiwanese bridal art salons are routinely commissioned for portraiture photography by international politicians and celebrities, including former U.S. President Bill Clinton.

Despite competition in recent years from South Korea, Japan, and mainland China—with many of these countries' photographers visiting trade fairs, festivals, and schools in Taiwan to learn the trade—the Taiwanese wedding studio industry has remained strong for over 30 years. "Creativity is…the primary reason the wedding industry has been able to make a name for itself," Tourism Bureau Deputy Director Liu Hsi-lin told the *Taipei Times* in 2014.[6]

According to interviews with hospitality sector leaders, the industry did not suffer as big a hit during the Great Recession as did other industries in Taiwan.[7] And Taiwan recently became the first Asian country to legalize same-sex marriage, another sign that the nation values its place as a destination for (and exporter of) creative wedding experiences.[8] Expats also benefit from Taiwan's global reputation, as with Alex Kuo, an award-winning Taiwanese photographer who opened a Tai-

RESILIENCY

Creativity drives adaptation in human systems and leads to more resilient economies.

wanese-style wedding studio in Melbourne in 2014.[9] Other shops founded in Taiwan have expanded into international markets, such as BlueBay Wedding in Singapore.

In *Framing the Bride,* Bonnie Adrian sweeps through Taiwan's cultural entanglement with the wedding, both in its own matrimonial traditions and its stake in the Western variety. Beyond photography, a single company in Taiwan, PFI International, comprises 18% of the global wedding dress market.[10] But the history of innovative bridal studios in Taiwan is not limited to its national knack for weddings. It's a story about how the clustered talent and risk-taking of creative entrepreneurs can boost a small country into the position of global leader. "Taiwan's wedding photography is second to none in the world," Tsai Ching-hua told *Taiwan Today.* "It is a perfect example of the country's soft power."[11] And it's also a perfect example of how creative entrepreneurs can stay local and go global at the same time, propelling their regional economies into international success.

At Home with Creative Entrepreneurship

In the Fourth Industrial Revolution, no local economy can afford to isolate itself from the global marketplace. This holds true on every scale, from national to regional to municipal.

In *Towns in a Rural World,* a comprehensive 2013 study of socio-economic opportunities for "small and medium-sized rural towns," Waldemar Ratajczak and other academics explore the role of such towns in regional economies. Combining his European research with scholarship that covers Africa, Asia, and Latin America, Ratajczak considers both the history and future of these towns and the economic role they play.

Historically, such towns have generally produced commodities—especially agricultural products—that find their way to large urban centers and from there spread to national and international markets. This is a familiar portrait of how things were. How things *will be*, however, is far more dynamic.

Knowledge and innovation-centric economies have upended this traditional picture. As we discussed in Chapter 2, hyper-connectivity has flattened the world, and a growing global middle class has shifted patterns of consumption and production. Among other consequences, rural and small-to-medium towns face the challenge of what Waldemar Ratajczak summarizes as "obsolete infrastructure, dependence on traditional industry, transformation of human capital base … declining competitiveness, feeble civic infrastructure and capacity, [and] more limited access to resources." These challenges drove the large-scale migration to cities, with the 2000s famously seeing "the percentage of the world's population living in cities … exceeding those living in rural areas for the first time in human history," according to Australian creative industries professor Terry Flew.[12]

Ratajczak then quotes Atkinson & Court's description of a future that's already here:

> A knowledge and idea-based economy where the keys to job creation and higher standards of living are innovative ideas and technology embedded in services and manufactured products. It is an economy where risk, uncertainty, and constant change are the rule, rather than the exception.

Ratajczak has several prescriptions for how communities outside of major urban cities can stay competitive in this new economy. Among the qualities that will be needed, several lie emphatically in the wheelhouse of creative entrepreneurial ventures: diversity, a culture of innovation, and distinctive branding. The others are the environmental factors that are vital for creative entrepreneurial success: connectivity, a business-friendly culture, and a high quality of life.

As we've discussed, creative entrepreneurs—with their diverse, innovative storytelling that helps communities capitalize on the "branding" of their heritage—present a golden ticket to the future. One of Ratajczak's major conclusions is that a new cooperation between local stakeholders—including governmental authorities, businesses, universities, and the general population—and the "creative class" (a term coined by Richard Florida) is the key to turning the pitfalls of globalization into opportunity for communities outside major global epicenters.

The numbers track with this idea. In 2011, INTELI—a Portuguese thinktank—published a deep dive into "creative-based strategies" for "small cities." Scholarship on the specific relationship between creatives and non-metropolitan areas has mostly focused on the United States and Europe, but the story so far is undeniable. According to INTELI's summary of the research, "small counties [in the United States] with a high proportion of creative class residents...generally had job growth rates that were twice as high as counties with less creative class."[13] In rural areas of the U.K., creative sector job growth between 2001 and 2005 grew by 20%, compared to eight percent overall job growth.[14]

Yet the idea lingers in the minds of many civic stakeholders that the "creative economy" only belongs to sleek, large, and Western

(or Westernized) cities. This is despite the fact that in-depth studies—such as Elizabeth Currid-Halkett and Kevin Stolarick's 2013 article "Baptism by fire: did the creative class generate economic growth during the crisis?"[15]—have found that the creative economy has impacted urban and rural areas equally. Other studies, such as Andrey Petrov's 2007 study of rural Canada, suggest that the creative economy "can be even more critical for reviving economies in middle-sized and small towns (and perhaps rural areas) than it is in the metropolis."[16]

" THE CREATIVE ECONOMY 'CAN BE EVEN MORE CRITICAL FOR REVIVING ECONOMIES IN MIDDLE-SIZED AND SMALL TOWNS (AND PERHAPS RURAL AREAS) THAN IT IS IN THE METROPOLIS.' "

Part of the problem is the idea of the "creative class" itself, and the misleading geographic indices that proponents have developed to trace the movement and settlement of this overly ambiguous "creative class" population. Measuring where the "creative class" lives is not the same as enabling the entrepreneurship that can help an economy flourish, and creative entrepreneurs are more than members of the creative class: they are *instigators* of the creative class.

Rural and low GDP economies boast assets that can—if developed, staged, and promoted properly—attract creative entrepreneurs (or uncover, retain, and invest in those who already live there) and the benefits that accompany them. So far, we've discussed jobs, diversification, recession resiliency, and strategies to attract investment. In this chapter we want to focus specifically on how regions that might not

see themselves in the running for creative economy growth are often, in fact, exactly what creative entrepreneurs are looking for.

There is no one size fits all explanation for which regions attract creative entrepreneurs and how they do so. In *Growth of the Creative Economy in Small Regional Cities: A Case Study of Bendigo*,[17] Andrew Bishop and Sun Sheng Han survey the scholarship and find a bouquet of answers. Where in smaller Danish cities, creatives seek "affordability, specialized employment offers, work/life balance, authenticity and a sense of community," the attraction in Norway is more about the business climate. Meanwhile, in Australia, creatives are after "small-town/rural characteristics of outdoor amenity, a more relaxed and slower-paced lifestyle, increased family time, proximity to nature, and a strong sense of community." Even in economically similar regions, creative entrepreneurs are diverse in their desires. Nonetheless, as you can probably spot in these lists, trends emerge.

Before we consider the "soft stuff," let's reiterate the hard necessities of a creative entrepreneurial ecosystem. Fast and affordable broadband access is essential. In Chapter 3, we mentioned PricewaterhouseCoopers' (PwC) 2017 study of the connection between the democratization of high-speed internet access and the growth potential of the creative economy.[18] With 51% of the world's population connected to the internet, and with time spent consuming digital creative products increasing everywhere, creative entrepreneurs need to be online to compete. Among PwC's findings, some of the most compelling relate directly to creative entrepreneurs in local economies:

- **More creative exports:** PwC found that widespread high-speed internet "enabled easier access to international

markets" in countries with traditionally strong creative sectors, which "yielded significant export revenues for the industry's products."[19]

- **Stronger local content industries:** PwC also found that more internet equated with more creative entrepreneurship and "reduce[d] barriers to entry for independent creators," and internet access increased the availability of locally supplied content. And local populations want local content: in countries as diverse as Australia, Thailand, and India, PwC found that increased broadband tracked with increased traffic to and consumption of local creative content.[20]

We got a chance to talk with Nathan Eagle, who has explored local content quite a bit as the founder and CEO of Jana, a mobile advertising company that is also "the largest provider of free internet in emerging markets." Eagle agrees with PwC's findings about the strength of content produced for local audiences by local creatives:

> Local content is becoming a major deal. In all of this market the price per megabyte is plummeting. Ultimately what that means is people are spending more and more time online. One of the things we are starting to see is that entrepreneurs are getting more savvy about creating content that is very targeted to their demographic in a particular region.[21]

In fact, Eagle believes that local content itself is actually driving

broadband adoption, further explaining:

> Before today, you get ... content that's much more target-
> ed to U.S. or Western European users, and you can un-
> derstand why people don't want to pay per megabyte ...
> there is not a lot of appeal. But now [people in Nigeria]
> are getting Nigerian soap operas, and even video blogs
> from Nigeria are getting a lot of traction, ultimately being
> able to monetize via YouTube. We have this kind of West-
> ern platforms out there that enable the modernization
> but the content is coming locally from the entrepreneurs.

For these reasons, creative entrepreneurs often become local leaders in rallying for high-speed internet penetration. In *The Contribution of the Creative Economy to the Resilience of Rural Communities*,[22] Elisabeth Roberts and Leanne Townsend tell the story of one rural Scottish community where local government was slow to lobby for increased broadband access until a local creative entrepreneur did her own survey of local businesses and called the First Minister

RESOURCE FLOWS

High speed internet in far-flung regions opens a channel of resources to creative entrepreneurs who can engage with, sell into, and learn from markets around the world.

of Scotland herself. For creative entrepreneurs, life without connection is unthinkable, and they carry that connection to their neighbors.

After broadband, research suggests that creative entrepreneurs

desire other forms of connection as well: to local heritage and civic participation, to public and eco-friendly transportation, and to the inspiration of the land itself. Finally, as Roberts and Townsend mention, it certainly doesn't hurt that in these regions creatives can escape the "high rents and homogeneity of urban areas."[23]

Once creative entrepreneurs emerge from or integrate with local economies, they are excellent at innovating successful methods to sell local, authentic goods and experiences on a global stage. With platforms like Etsy, a handwoven shawl made on a rural sheep farm in the Scottish Highlands can be ordered, loaded on a cargo plane, and delivered to a doorstep in Tokyo 48 hours later. And the profits of the creative entrepreneur behind that woven shawl go back into the local community.

> "CREATIVE ENTREPRENEURS INNOVATE COMPANIES AND INDUSTRIES THAT ARE UNIQUELY SUITED FOR CLUSTERING IN RURAL AND SMALL-TO-MEDIUM COMMUNITIES."

In addition to being skilled liaisons between local authenticity and global markets, creative entrepreneurs innovate companies and industries that are uniquely suited for clustering in rural and small-to-medium communities. In fact, INTELI found that most creative people attracted to "small urban areas or rural context" started more companies and had a stronger entrepreneurial "spirit," proportionally, than their metropolitan counterparts. As INTELI put it, this spirit "induces the emergence of new cultural and creative businesses, promoting job creation and economic growth." INTELI describes rural creative entrepreneurs as "ambassadors"

who can "motivate the attraction of more creative people, associations and businesses." And this ambassadorship goes beyond even the creative sector, with INTELI suggesting that creative entrepreneurs produce "knowledge spillover" that incites "innovative inputs for other areas of activity in local economies, such as agriculture, crafts, textiles, tourism or gastronomy."[24]

Towns in a Rural World proposes that many small-and-medium communities are "striking back" against the prospect of decreasing global relevance. And INTELI confirms that this "striking back" is creativity-based. Forward-thinking communities are diversifying their economies, capitalizing on "counter-urbanization" trends, and taking advantage of "territorial capital," their region's unique cultural and geographic features.

We would also note that larger cities in what are traditionally called "developing economies" have also begun to diversify and emphasize their territorial capital. Economies might still be developing in the sense of GDP, but it doesn't mean those regions or countries are "underdeveloped" if they're rich in cultural and human resources.

There's no denying that major global cities are more important than ever: economically, politically, socially. But they don't have a monopoly on cultural or creative importance. Nor are they the only places creative entrepreneurs build companies. In this chapter, we'll explore stories of creative entrepreneurs outside the NYCs, Londons, Tokyos, and San Franciscos of the world. Through these stories, we'll highlight strategies that civic stakeholders and policymakers can use to attract, retain, and unleash the creative economy in their region.

The Turkish Word for Impact on the Navajo Nation ⋮⋮⋮

For Sydney Alfonso, entrepreneurial inspiration found abroad spurred her to bring her creativity back home. Alfonso, who grew up on a ranch in rural New Mexico, was studying in Turkey when she met local artisan women weaving silk wire in the *kazalik* tradition.[25] Wowed by their craftsmanship and convinced they could sell their pieces in the international market, she began a co-op to help the women market their work. This was the beginning of Etkie ("impact" in Turkish). But Alfonso's future was not in Turkey.

Even as Alfonso returned to the United States to take a PR job in Silicon Valley, Etkie remained her most passionate ambition. So she returned to a place she knew had a rich legacy of artisans: her home state of New Mexico.

Ninety minutes from where Alfonso grew up is a Navajo reservation community named To'hajiilee with a history of textile and bead artistry. This is not an anomaly in the larger Native American community, where over 60% of families have at least one member who works in the "arts and crafts sector," according to Alfonso. Yet these artisans struggle to reach global audiences, lacking capital, marketing, branding, and distribution expertise. These gaps prevent their craftsmanship from making a significant dent in the endemic levels of Native underemployment. On the Navajo Nation, for example, 38% of people face "extreme poverty," according to the 2010 U.S. Census.[26]

Alfonso realized that what she learned in Turkey could make a meaningful difference close to home. "The allure is there, the richness in culture and heritage is there," Alfonso told *Elle*. "I just want to position our brand to be able to make the most amount of dif-

ference in their community."[27]

So Alfonso rekindled Etkie as a "social enterprise committed to the financial and social empowerment of Native American women in New Mexico."[28] Today, Etkie provides a platform for Native artisans who hand-make upscale beaded bracelets. Most of Etkie's artisans are mothers who work from home, on their own schedules, mixing indigenous culture with global materials, such as glass from Japan and 24-karat gold from the Czech Republic. They sew beads onto "genuine deerskin linings sourced from a New Mexico leather company," according to *Indian Country Today*, and have introduced solar cell phone recharging to the Navajo reservation.[29]

IN 2014, WE SELECTED ALFONSO to participate in the Creative Startups Accelerator. As Alfonso told the *Albuquerque Journal*, her experience in the Accelerator was invaluable in helping take Etkie to the next level. Network connections she built through Creative Startups led to Etkie being invited to join 2015 Paris Fashion Week, a prestigious showcase that helped her sell into European boutiques. Alfonso explained to the Journal how important Creative Startups was for her business:

> Creative Startups helped me learn how to pitch, tell my narrative and figure out the strategic steps I need to get in front of ideal customers... With the expanded connections and enhanced business insight I received from my mentors, I've been able to increase the platform from which I conduct my business and reach a wider audience, improving my ability to not only be successful—but also to increase social empowerment and make a difference in the world around me.[30]

In exchange for access to these goods, Etkie offers "collective design support, branding, partnerships and the market to help our artisans reach larger audiences," Alfonso told *Cool Hunting*.[31] Alfonso is involved as both a creative and an entrepreneur, fundraising for high-end equipment and designing patterns that blend tradition with styles that will appeal to contemporary audiences.

Social empowerment is a key part of Alfonso's focus. She gave a TEDx talk in Hamburg to spread awareness of unethical labor practices and promote "conscientious consumerism to improve the economic status of female artisans."[32] Before Etkie, lead designer Dru Chackee was homeless. Today she has a full time job participating in a creative tradition passed down from her mother. As Alfonso told *Elle*, her ultimate goal with Etkie is "creating dignified jobs in local communities by honoring their inhabitants' customs and traditions."[33]

Alfonso understands the big numbers in the global jewelry industry—estimated to hit $250 billion by 2020, with online fashion jewelry accounting for 15% of that market[34]—and she understands the small numbers too. Such as the fact that less than half of one percent of that amount is spent on "ethical or sustainable fashion."[35] But creative entrepreneurs like Alfonso can see that the landscape is changing as local creativity becomes more available. Etkie's target demographic, like consumers across the world, seeks more than anonymous glitter. From the $35 billion a year spent by 45- to 65-year-old women in the top third income bracket of U.S. households on apparel and accessories,[36] more and more of that sum is being spent by women who increasingly want to wear authenticity that resonates. As one Etkie customer gushed: "The beading and designs are absolutely lovely. I am honored to be able

to wear them, and I feel good when I do."[37]

But it isn't only U.S. women who want to feel good about the stories on their wrists. Etkie stocks its products in 90 luxury boutiques in 7 countries—from Paris to Berlin, NYC to Los Angeles—where they sometimes sell out in as little as a week. Overall, 85% of Etkie's wholesale customers re-order, an impressive rate in a crowded market.[38] No wonder Etkie achieved $600,000 in sales in their first two years, which Alfonso projects to climb to $3.5 mil-

MEET

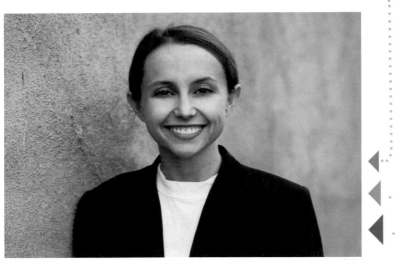

Image courtesy of Etkie

ENTREPRENEUR: Sydney Alfonso

INDUSTRY: Design, fashion

MARKETS: Global

COMPANY: Etkie

BASE OF OPERATIONS: U.S.

EMPLOYEES: 14

NOTEWORTHY: Etkie is available in 90 high-end boutiques globally, bringing the designs of the *Diné* to the world.

SHIFT → from cities to towns
from local to global
Going Global Staying Local ⋮ 189

lion by 2020.[39] Along with glowing profiles in the *New York Times* and *Elle,* Etkie has burst out of the gate with financial proof of its successful locally-oriented mission. Alfonso crowdfunded over $20,000 and received $34,000 from the Los Alamos National Laboratory's Venture Acceleration Fund—one of the only "non-tech" recipients in the history of the fund.[40]

As Etkie grows, Alfonso is committed to keeping her global success local. She wants to create "great jobs for the people of New Mexico." She plans to open two new workshops in New Mexico by 2019 to employ a waitlist of artisans and meet increasing demand from wholesalers, direct consumers, and a new experiential retail store.[41] Alfonso points to similar projects across the globe as indicators of potential. In Kenya, for example, Chan Luu created 782 artisan jobs.[42] Omba in Namibia has been around since 1981 and is still going strong: 2014 saw a 38% increase in income for their 450 women producers in rural villages.[43] Meanwhile, in rural Egypt, Nagada has persisted and evolved, starting as an employment opportunity for local weavers and now running pottery workshops and helping former employees start their own ventures. Nagada is an excellent example of how an entrepreneurial investment in local talent can set an entire community on the path to self-sufficiency through creativity.[44]

What determines success in all of these ventures are two complementary qualities: global networks and embeddedness.

- **Global networks:** Creative entrepreneurs weave local production with global ambition, often by leveraging the access potential of the digital economy. According to *Elle,* Etkie is the "first jewelry brand" to introduce the

"specialized skills" of Southwestern Native American artisan women "to the mass market."[45] This is an example of how a creative entrepreneur's navigation of non-local networks feed local success.

- **Embeddedness:** Entrepreneurship scholars define embeddedness as the level to which an entrepreneur has integrated intimately and genuinely into a network, developing meaningful connections and sharing a sense of ownership or investment with the local community.[46] In other words, an embedded entrepreneur may or may not be a local; regardless, they are not "outsiders" as they instinctively enmesh themselves in local networks. Even locals who start out with deep community ties need to undergo a process of embedding to garner trust for their new startups.

Despite not being explicitly members of the communities where they've started companies creative entrepreneurs like Alfonso are able to achieve crucial community buy-in because they understand the value of culture and legacy. As storytellers themselves, they know why and how people construct their identities and treasure practices that maintain and evolve these identities. In turn, communities are loyal to the embedded creative entrepreneur and believe their win is a win for all.

Alfonso's regional connection with her Navajo employees got her off on the right foot, but her ability to forge respect through mutual creativity helped her embed. As Alfonso says, "Our business simply can't exist without the people we serve. We're codepen-

dent on each other to succeed."[47] It takes the sensitivity of creativity to avoid exploitation and unlock support for a vision of collective success. And with Etkie, success is exactly what Sydney Alfonso and the craftswomen of To'hajiilee have achieved—together.

Big Flight for Bug Wings

Sydney Alfonso returned to New Mexico to build Etkie, but creative entrepreneurs aren't always local heroes. Some heroes begin as strangers.

As we discussed earlier in the chapter, many creative entrepreneurs leave cities for attractive rural opportunities. Though they may not be homegrown talent, they can still make a positive mark. Like a new star on an old team, the right creative entrepreneur can help their new hometown enter global markets in a way that avoids the alienation of gentrification and honors the character of the place they've joined.

In a converted primary school on the coast of Portugal, illustrator, children's author, publisher, and creative entrepreneur Mafalda Milhões makes the case for rural opportunity—with a little help from the goats who tend her lawn. The town Milhões and the goats share, with around 12,000 others, is Óbidos. From the hill that holds O Bichinho do Conto, a bookstore and reading library Milhões founded with her husband, you can see the historic medieval castle walls that give Óbidos (Latin for "fortified city") its name. In town, terracotta

CONSIDER CONNECTING the diaspora of creative talent that has left your community to entrepreneurs embedded in the local culture. These connections might spark creative output that reaches new markets while staying rooted in regional values.

roofs hug together above sloping cobblestones, and the smell of cherry liqueur drifts from corner stalls.

Yet the city is not just a postcard. Beyond the castle walls, on what used to be the agricultural outskirts, sits a 44,000 square foot technology park designed by award-winning Lisbon architect Jorge Mealha.[48] The building, a white steel square with a hollow central plaza, looks from above like a picture frame balanced gracefully between two hills, with the plaza inhabitants filling in the picture.

Like many of the creatives who work in this technology park, Mafalda Milhões was not born in Óbidos. But this village has become the perfect place for O Bichinho do Conto—Portugal's first children-dedicated bookstore and "creative workshop" as Milhões calls it[49]— to flourish. Milhões,

" THE RIGHT CREATIVE ENTREPRENEUR CAN HELP THEIR NEW HOMETOWN ENTER GLOBAL MARKETS IN A WAY THAT AVOIDS THE ALIENATION OF GENTRIFICATION AND HONORS THE CHARACTER OF THE PLACE THEY'VE JOINED. "

in turn, has helped the fairytale town begin its next chapter.

Milhões was born in the mountains of Portugal and grew up with a passion for illustration that swept all her senses. In an interview with *Noticias Magazine*, she recalls the smell of the Swiss crayon cans her cousin would bring to town.[50] She knew early on that she would write and draw, but she had no idea that these pastimes would lead her to become a local leader.

Milhões graduated from the Polytechnic Institute of Tomar

with a degree in Graphic Arts, and she published her first children's book with her husband Pedro Maia. O Bichinho do Conto (Portuguese for "the bug's tale") was born as a publishing company and bookstore in Lisbon, but in 2007 Milhões and Maia began scouting for a rural town where the project could evolve. For Milhões and her husband, entrepreneurial growth meant leaving the city. "We were looking for an abandoned place on the top of a hill with a big tree and a sea-view," Milhões told INTELI.[51] A defunct primary school in Óbidos turned out to be the perfect spot. Taking her sensory journey from the smell of crayons to the smell of ocean and cherry liqueur, Milhões found a new home that resonated with her childhood dreams.

To land her "bug's tale" on its new hilltop, Milhões dedicated herself as much to the town's success as her own. "We have to respect the people who live here," she told *Público*. "We do not want change, but integration."[52] She conceived of the bookstore as "a place of meeting and sharing ... designed to welcome readers in the daily life of creation."[53] At O Bichinho do Conto, Milhões does more than sell and publish books: the space also hosts exhibitions, workshops for local educators and animators, and consultant services for distribution and graphic design. As Milhões told INTELI, O Bichinho do Conto merges the global and local, with both community development initiatives and "partners and clients all over the world."[54] And Milhões was determined to bring the world back to Óbidos. She spearheaded Óbidos as a host for Fólio, one of the largest book festivals in Europe, and in 2010 *Público* reported that Milhões was instrumental in convincing influential Lisbon booksellers Ler Devagar to convert Óbidos' 13th century Church of Santiago into a beautiful new literary center.[55]

The success of the Church of Santiago conversion prompted Ler Devagar to develop a citywide project with Óbidos, whose mayor, Telmo Faria, entered office in 2001 with a specific focus on the creative economy. Today, Óbidos houses a dozen bookstores, libraries, and creative workshops in unique locales: old vegetable markets, wine cellars, and even the main bus stop. Everywhere in Óbidos, visitors can experience the fusion of rural history and the creative present. In 2015, Óbidos became a UNESCO City of Literature, 1 of only 20 cities in the world to earn the honor and one of the smallest cities on the list.[56] Although Óbidos had long been a Portuguese treasure, now international tastemaskers—from *Condé Nast Traveler* to the *New York Times*—write glowing profiles. Thanks to the partnership Milhões and other creative entrepreneurs developed with local officials, Óbidos has grown from a local summer attraction to a year-round global tourism hot spot.

The success is more than aesthetic; the numbers verify the influence of the creative sector in the town. In the *Handbook of Research on Entrepreneurial Development and Innovation,*[57] an entire chapter is dedicated to Óbidos as a model of rural creative economy success:

- Between 2001 and 2011, Óbidos had the "third highest relative [population] growth among the 12 municipalities" of rural western Portugal.

- Inhabitants are also getting younger, and the employment base has shifted from agriculture and manufacturing to "tertiary industries," most of which are based in the creative sector and tourism infrastructure.

- More proof? Gross value added to Óbidos' economy grew an astounding 30% between 2013 and 2014, a number *five times higher* than the six percent average growth of the western region.

Clearly, creative entrepreneurship has paid off for Óbidos. But why Óbidos? Certainly Milhões found a receptive audience in Mayor Telmo Faria and a municipal government unafraid to risk reinvention. INTELI cites numerous supportive local and regional policies, from tax reductions to "real estate facilities" and "effective linkages to business angel networks."[58] Needless to say, the success of the first risky leap makes each proceeding leap easier and bolder. And Óbidos has implemented numerous cutting edge plans to develop everything from education to scientific prototype labs, all enacted with careful inclusion of local stakeholders.

> " ÓBIDOS IS HONORING ITS HERITAGE BY INNOVATING ITS FUTURE. "

For all of this, forward-thinking leaders like Telmo Faria deserve credit; according to INTELI, Faria long argued for taking "promotion of the creative industries out of the Culture Ministries."[59] But Faria would likely be the first to point out that entrepreneurs like Mafalda Milhões started to move to town in 2007, five years before 2011's publication of the Óbidos Creative Strategy and Local Action Plan.

When INTELI asked Milhões what attracted her to Óbidos she cited "proximity to Lisbon, good access, quality of life, historical heritage, and a mix of coastline, beaches and countryside."[60] Interestingly, this answer echoed INTELI's substantive findings about

worldwide rural creative entrepreneurs. They found that four categories of amenities "can potentially attract creative people to small communities." Óbidos sported all four:

1. **Natural amenities:** Milhões herself listed "beaches and countryside." The ocean isn't the only smell creatives like. As INTELI reports, "econometric analysis showed that the creative class is growing most rapidly in areas that are mountainous, with a mix of forest and open area, where winters are sunny, and with a relatively large number of bicycle and sports store jobs per capita."

 Of course, civic leaders can't control the climate or geography of where they live. But policymakers in places of natural beauty struggling to emerge from agricultural and manufacturing legacies, where an attractive landscape has always been considered a nice feature but not a viable economic development strategy, might do well to heed INTELI's econometric analysis.

2. **Cultural amenities:** These include "architectonic and archaeological heritage" such as, in the case of Óbidos, a giant castle. But also included are "intangible heritage, like memories, testimonies and legends, and traditions." A growing global middle class wants authentic storytelling, and well-supported creative entrepreneurs can turn "intangible heritage" into tangible economic development.

3. **Symbolic amenities:** When it comes to creative entrepreneurs, community is vital. Interestingly, despite

Richard Florida's thesis that "weak ties" and individualism are hallmarks of the "creative class,"[61] INTELI's research suggests that creatives who start businesses want "strong ties and a culture of collaboration and participation." Many coastal Portuguese towns are beautiful and historic, but in tightknit Óbidos, Milhões found a lively community proud of their history and excited to work together on their future.

4. **Built amenities:** The final category is the "quality of life" Milhões mentions, and includes such things as "health and social services, quality schools, hotels, restaurants, bars, meeting places, small studios, live-work houses, etc." But we want to stress that cool bars alone do not attract creative entrepreneurs. More subtle infrastructural amenities are vital. INTELI quotes the work of Nathaniel M. Lewis and Betsy Donald, which says that smaller cities are especially adept at offering attractive infrastructure: "multiple land uses ... and pedestrian connectivity within a compact environment."[62]

In 2002's *Journey to Portugal: In Pursuit of Portugal's History and Culture,* Nobel Prize winner José Saramago describes Óbidos as he saw it back then: a tourist town overflowing with beauty, with "good paintings and sculptures," with so many flowers that "the traveller would have liked Óbidos to be rather less floral."[63] Saramago suggests that Óbidos was somewhat trapped in its self-image:

Since it is an obligatory place for tourists to visit and stay, it's all been arranged so that it will come out well in not just

one but every photograph. Óbidos is a bit like a young girl in former times who goes to a ball and is waiting to be asked to dance. We can see her sitting pertly in her chair, not moving an eyelid, worried because she's not sure whether the curl on her forehead has come loose in the heat.

But the Óbidos of 2017 is not resting on its past nor waiting for anybody to dance. No longer the "museum town," and no longer relying on agriculture and industry for employment, Óbidos has become a lively year-round destination and a percolator of creative enterprise. The "bug's tale" of Mafalda Milhões has deceptively large wings. And on these wings of creative entrepreneurship, Óbidos is honoring its heritage by innovating its future.

Rhymes on the Coast of India

Chennai, India is even closer to the water than Óbidos, but no one would mistake this bustling city for a bucolic village. Yet Chennai is home to our final profile of a creative entrepreneur going global and staying local, and the story of Vinoth Chandar and ChuChu TV provides a powerful example of how creative entrepreneurship can scale to its environment. In the success of ChuChu TV, we also find a model for how mid-size cities—too big for rural strategies yet lacking the name recognition of a Berlin, Sydney, or Shanghai—can avoid a crisis of identity and embrace a future of creativity.

A serial creative entrepreneur, Vinoth Chandar cycled through several modest successes before his big break. His inspiration came in 2013 from the most local community in his life: his family. Seeing how much his two-year-old daughter Chu Chu loved bubbly

YouTube videos, Chandar enlisted the help of his creative technology company—Buddies Infotech, founded by Chandar with childhood friends—and they made Chu Chu a video of her very own. A few weeks later, they made a second video based on the nursery rhyme "Twinkle Twinkle Little Star." Within a month, these two videos had garnered Buddies Infotech 5,000 subscribers, and Chandar and his team quickly realized they'd struck creative gold.[64]

Today, ChuChu TV is one of YouTube's most watched channels. The subscription numbers have climbed to over 12 million, with views at 10 *billion*.[65] That's enough for every child in the world to have watched a ChuChu TV nursery rhyme several times, and the toddlers who make up ChuChu TV's primary audience often watch over and over. On YouTube advertising alone, ChuChu TV makes around $5.8 million a year.[66] They've also carefully managed their intellectual property and diversified their revenue stream with international licensing deals for toys and other merchandise, as well as partnerships with premium streaming services like Amazon Prime. For their licensing, they've translated their audience retention into an eight to 10% royalty rate, which is high for the industry and an especially impressive coup for a small company in southeastern India.[67]

In Chennai, ChuChu TV employs 200 people, from animators and 3D model riggers to dancers and singers.[68] Chandar's crew of childhood friends has seen ChuChu TV grow into a robust creative star in the fast-growing Chennai tech sector. Most importantly, ChuChu TV is an example of the Indian tech sector expanding and diversifying its opportunities. The fourth most populous city in India[69] (with the third-largest expatriate population),[70] Chennai is making an intelligent investment in creative entrepreneurship.

Home to the world's largest music festival and the second largest movie industry in India, Chennai has a rich creative history, and they're aiming for an even richer future—driven by creative entrepreneurs. The city is no stranger to creative entrepreneurs; for example, native son Seetharaman Narayanan was the engineer who spiked Adobe Photoshop's popularity by porting it to the Windows platform in 1993.[71] Back then, Narayanan had to move to San Jose to find a lucrative career in creative innovation. A quarter century later, Vinoth Chandar doesn't need to leave his family behind to be an intercontinental media mogul.

A Coller Venture Review report, *The Role of Ventures in Strengthening the Fabric of the City*, argues that Chennai is a perfect example of a city where innovative entrepreneurship has exploded economic growth and lit up Chennai's "leadership position" in cutting-edge sectors. The report discusses startups across the creative sector—from post-production studio Real Image to music education startup Rhapsody—and specifically credits digital ventures (like ChuChu TV) for priming the turf for established digital companies to set up outposts in Chennai.[72]

Chandar told *Mint* that ChuChu TV was far from the first successful YouTube nursery rhyme channel.[73] A Google article about ChuChu TV's success concurs, citing that a YouTube search for "Humpty Dumpty" spits up 263,000 results, of which only 43 crack the million view mark.[74] How did Chandar distinguish his channel from the others? He credits innovation and authenticity in ChuChu TV's meteoric rise to the top. Many of ChuChu TV's characters are voiced by children in Chandar's family, and Chandar—whose creative DNA includes a popular Tamil composer for a father—pushes his Chennai-based team to improvise, improve, and call on their

own heritage. For example, Buddies Infotech team member B.M. Krishnan was a chartered accountant before ChuChu TV, yet he grew up wanting to be a filmmaker.[75] When Krishnan kept pestering his childhood friend Chandar with suggestions, Chandar suggested they collaborate, and today Krishnan is ChuChu TV's lead lyricist.

ChuChu TV's strategies feature the product differentiation and audience engagement that mark successful creative entrepreneurship. In addition to inviting fans to submit their own clips, they innovated classic nursery rhymes with new positive messages and unique local characters. Despite the fact his audience was immediately international, Chandar never lost sight of the fact that his core fan base was Indian, and that a hyperconnected world means local buzz can scale to global adoption.

In today's India, an increasingly connected population is hungry to feel that buzz and see themselves represented. Mobile broadband penetration has shot to 73%, and online video consumption doubled between 2011 and 2013.[76] Yesterday's media platforms—cable TV and even newspapers—struggled to proliferate in rural India. Yet today, "more than 73% of rural connected users in India use the internet for entertainment," according to PricewaterhouseCoopers.[77] Technology has democratized content consumption and production alike, and if Vinoth Chandar can launch one of the world's most popular YouTube channels from Chennai in 2013, perhaps the next Indian creative economy

> " **TECHNOLOGY HAS DEMOCRATIZED CONTENT CONSUMPTION AND PRODUCTION ALIKE...** "

triumph will come from further inland and in a more rural area. Or perhaps a creative entrepreneur will realign the distinction between rural and urban, as India undergoes what UNESCO calls "the second largest urbanization in human history"[78] as it also increases its rural connectivity.

As UNESCO's 2013 *Creative Economy Report* points out "'rural' and 'urban' in India are not just locations; they also embody complex histories and traditions." Such complexities are the breeding ground for successful creative entrepreneurship. As UNESCO argues:

> Spaces within and between rural and urban locations, the emerging and ever-changing margins and the multiple fault lines between these systems are all fecund locations for disruptive innovation for an early 21st century creative economy.[79]

In 2015, the BBC ranked Chennai as one of the "hottest" cities in the world, thanks to both its compelling Tamil heritage and its embrace of a future based on creativity. No longer "sleepy" or a "jumping off point for the rest of India," the beaches of Chennai have welcomed the creative entrepreneurs like Vinoth Chandar with an exciting future. "[Chennai] has moved from being a very conservative city to one that now has a great mix of tradition and modern chic," lifelong resident and creative foodie Dr. Wasim Mohideen told the BBC. "People ... now accept change with open arms."[80]

For Vinoth Chandar, the coastal city where he stayed to raise his family has also been the perfect place to launch an international children's media sensation. Once a major travel port, Chennai is now home to a different kind of ship: a YouTube channel that trav-

els the world and docks downtown, bringing the world's economy back home with it.

What Will Your Talking Bear Say?

We close with a cautionary tale—and a talking fiberglass bear. In the foothills of the Sierra Nevadas in California, a town called Oakhurst was founded during the Gold Rush of the late 1840s. Today, it doesn't look much different. In a sleepy downtown, a brown fiberglass bear sits outside a real estate office. Put your hand in the bear—as journalist Steven Levy did for his 1982 classic *Hackers: Heroes of the Computer Revolution*—and he'll read a poem, sing a song, advocate for local ecology, or list land prices—depending on which year you're visiting.

If you visited Oakhurst between, say, 1983 and 2000, the bear might be abuzz with a story about the video game studio Sierra On-Line. Started by the husband-and-wife creative entrepreneur team of Ken and Roberta Williams, Sierra's first headquarters were in tiny Oakhurst. The booming popularity of the studio—whom IBM personally asked in 1982 to develop games for its new home computer—could've been a major source of employment and development for the small California town. Local newspapers even ventured nicknames for the area like "Silicon Mountain."

Yet "Silicon Mountain" never came to pass. In 1993, Sierra re-headquartered to Bellevue, Washington, and by the late 1990s it had closed for good. Sierra's rise and fall is more complex than you could fit into a talking bear, as NYU professor Laine Nooney explores in her fascinating academic work (forthcoming) *Before We Were Gamers*. But in our interpretation of Nooney's work, the city of Oakhurst and the surrounding region made some clear

mistakes. Sierra couldn't convince municipal leaders to invest in high speed broadband, couldn't get favorable corporate taxes, and couldn't get buy-in from local landlords.

Did Oakhurst refuse to take the risks of, for example, Óbidos? Was Sierra's departure to Bellevue a severing of a vital connection to the company's cultural heritage? The talking bear has no answers. But in the story of Oakhurst and Sierra, we see a missed opportunity for creative entrepreneurship to help a local region break into a global wave. Today, Oakhurst is just another town in the mountains.

" WILL YOUR CIVIC LEADERS HIDE AWAY IN ITS SHADOWS? WILL THEY MINE INDUSTRIAL LEGACIES FOR DIMINISHING RETURNS, IGNORING THE ECONOMIC POTENTIAL OF CULTURAL LEGACIES? WILL YOUR REGIONAL HISTORIES INCLUDE A CHAPTER ON INNOVATIVE COMPANIES THAT DEPARTED BECAUSE THE REGION COULDN'T INNOVATE THEIR INFRASTRUCTURE OR POLICIES? "

Yet Oakhurst—and so many towns like it across the world—can still become far more, and they can do so without sacrificing their identity. No matter how big or small your city or region's name might be on yesterday's maps, creative entrepreneurs can help grow that name into a star, written about in tomorrow's guidebooks and case studies. The Fourth Industrial Revolution has made the world smaller than ever. Will your civic leaders hide away in its shadows? Will they mine industrial legacies for diminishing returns,

ignoring the economic potential of cultural legacies? Will your regional histories include a chapter on innovative companies that departed because the region couldn't innovate their infrastructure or policies?

Or will your storytellers bring your city onstage? Creative entrepreneurs are photographing brides from across the ocean and selling handmade traditions at Paris Fashion Week. They don't need to live in the biggest cities to animate their nursery rhymes for international online audiences. And they don't need to live in a big city at all to toast thousands of literary visitors with cherry liqueur. Creative entrepreneurs are ready to localize global opportunity. They are ready to turn their hometowns into the world's hits.

9

EMPOWERING
Youth Engagement

Applauding Opportunity

In 2002, Ivonette Albuquerque huddled with her son in the bathroom of her home in Leblon, the richest neighborhood in Rio de Janeiro, while young men ransacked her apartment. They stole jewelry and electronics, all the valuables they could sell in the favelas that overlook Rio's affluent beach neighborhoods.[1]

The trauma of the event spurred Albuquerque to investigate the lack of educational and vocational opportunities for youth in Rio. As a successful economist and financial director of a pension fund with $400 million in assets, Albuquerque was familiar with entrepreneurial problem-solving. As a creative—the founder and editor of Rio's most popular theatre magazine, *Aplauso*—she was troubled by these minors' estrangement from society.

Instead of following her friend's suggestion to buy an armored car, thereby further isolating herself from the community, Albuquerque innovated a plan to produce structural change in the lives of Rio's struggling youth. Devised over five sleepless hours, Albuquerque's plan was the bold work of someone with no preconceptions about social work, and it hinged on creative entrepreneurship.

The youth of Rio de Janeiro sorely needed an out-of-the-box

MEET

Image courtesy of Galpão Aplauso

ENTREPRENEUR: Ivonette Albuquerque

MARKETS: Latin America

EMPLOYEES: Over 25

COMPANY: Galpão Aplauso

INDUSTRY: Entertainment, Theater

BASE OF OPERATIONS: Brazil

NOTEWORTHY: 2,000 youth from Rio's favelas have participated.

approach to opportunity. "We have millions of young people who are known as the 'neither-nor,'" Albuquerque told *Público*. "They do not study, work, or look for jobs."[2] Unemployment rates among youth (15-29) in Brazil have been rising for decades, reaching nearly 16% in 2014.[3] Neither education nor family provide much refuge: 20% of youth do not work, study, or contribute to household chores, and only 23% are likely to graduate from college (a

significant dip from the 36% of the previous generation).[4]

This is the reality Ivonette Albuquerque sought to disrupt. She envisioned a program that mixed arts with industry, where young people would mount theatre productions and take entrepreneurial responsibility for its success. Along with acting and singing, they'd train for manufacturing skills—rigging lights, tailoring costumes, woodworking and locksmithing for sets[5]—that could transition into steady employment once they graduated from the program. "Welders during the day and musicians at night," Albuquerque told *O Globo*.[6] To overcome low literacy rates, the teaching would take place via oral workshops in creative contexts. Math, and Portuguese language classes, for example, would blend into planning the show's logistics and memorizing character scripts.

Many of the dramatic scenes would simulate everyday life, putting students in touch with practical equipment, a clever way to use the rhythms of theatre to introduce a working world that might be otherwise alienating. "We create a bridge between the socio-affective and the rational world," Albuquerque told *O Globo*.[7] This "socio-affective" aspect of Albuquerque's vision was vital. She understood that learning all of the "soft skills" inherent in creative endeavors—collaboration, self-discipline, flexibility, and so on—was, ultimately, just as important as learning mechanical skills. Perhaps even more so.

Albuquerque's idea was radical. As a Fomin study of her program acknowledges, "Although expressive arts have long been used as a vehicle for teaching—including for at-risk youth—their use in a labor training program is uncommon."[8] Such an unusual and ambitious premise struggled to find early backers. In Rio's "port zone," Albuquerque discovered an abandoned warehouse—once

the origin for 90% of Brazil's metallurgical exports[9]—that she felt would be the perfect setting, but the property owner (the federal port authority) wouldn't even listen to her proposal.

Yet Albuquerque was stubborn. "I stayed a week, from 9AM to 5PM, waiting," Albuquerque says. "I knew that by going in and showing off the project they would bump into it."[10] Her persistence paid off in the form of a significant investment. The Inter-American Development Bank (IDB) agreed to fund the project, but they challenged her to balloon her initial vision of 20 students to 700.[11] No stranger to creative entrepreneurial ambition, Albuquerque agreed, and in 2004, Galpão Aplauso (the Applause Shed) was born.

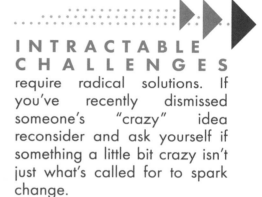

INTRACTABLE CHALLENGES require radical solutions. If you've recently dismissed someone's "crazy" idea reconsider and ask yourself if something a little bit crazy isn't just what's called for to spark change.

From Creative Education to Opportunity

In nearly 15 years of operation, Galpão Aplauso has worked with over 11,000 young people.[12] Youths from low-income families stay for six months of intensive creativity, personal growth, and practical training. They leave, resoundingly, with jobs. A 2011 to 2013 study showed "a general employability index of 64% in the first five months after the students entered the labor market," a result four times higher than any other IDB-financed project. Within two years, almost 90% of Galpão Aplauso graduates find work.[13]

By numerous metrics, Galpão Aplauso has been an unequiv-

ocal—and unusual—success. Students increase their incomes by 46% within five months of leaving the program, and for every $5.3 million *reais* invested in Galpão Aplauso, $10.9 million reais are created in the local economies where these graduates circulate.[14] No wonder the program won an international award from the U.S. Department of Treasury for its impact.[15] What's more, the prestigious Getúlio Vargas Foundation has implemented methods from Galpão Aplauso in its International Master's Program in Practicing Management, spreading Albuquerque's techniques to managers around the world. "The method promotes the rebirth of these people and increases their self-esteem," IDB specialist Luciano Schweizer told *O Globo*. "It

" **STUDENTS INCREASE THEIR INCOMES BY 46% WITHIN FIVE MONTHS OF LEAVING THE PROGRAM.** "

is possible to apply it perfectly in several places of the world, like Mexico and China."[16]

Even more telling are the testimonials and stories of the youths themselves. In interviews with Fomin and the IDB, students discuss how the creativity of the Galpão Aplauso curriculum—*O Globo* cites the examples of learning "proportion while preparing a cake" and "teaching grammar through mime"[17]—resonates more than formal schooling. They discuss the value of learning initiative, dedication, and improved interpersonal skills. And the entrepreneurial abilities needed to hustle a show from first rehearsal to the opening curtain—bold problem-solving, seizing opportunity, and rebounding from failure—have served many Galpão Aplau-

so graduates later in life. They continue to act, play music, and do acrobatics. These young people, who enter Galpão Aplauso estranged from society, become storytellers, teachers, and leaders in their communities.

What distinguishes Galpão Aplauso from similar ventures is the entrepreneur at the helm. Albuquerque's background inspired her to build an NGO aligned with the private sector and dedicated to market principles. She did not view "culture" as an escape from everyday business. At Galpão Aplauso, creativity is *everyday* business: it's a framework for education, a path to gainful employment, and the foundation of entrepreneurial empowerment. "My main intention," Albuquerque told *Revista Epoca,* "is that this is the last social project of the young people who come here."[18] In other words, success at Galpão Aplauso does not lead to continued dependence on social programs. Rather, students leave with the creativity to adapt and the entrepreneurial drive to excel. Former student Flávia Falcão da Silva told *O Globo* that "More than teaching me a profession, the Shed changed my way of seeing life, of communicating and even of feeling."[19]

After her house was robbed, Ivonette Albuquerque took a stand against fear of her young neighbors. But more importantly, she took a stand in favor of innovative connection. She blended the creative values of her passion for theatre with the entrepreneurial wisdom of her career in finance. To give the youth of Rio a new opportunity, she understood they needed a new model. In the booming echoes of an old metallurgical warehouse, Galpão Aplauso students sing and weld, dance and hammer. Together, they create their own future.

Youth in Crisis

What Ivonette Albuquerque accomplished in Rio de Janeiro comes at a moment when the rapidly growing youth population faces a growing crisis of social disengagement. According to the UN, there are 1.8 billion people between the ages of 10 and 24, an historical high. Of these 1.8 billion, 90% live in the economically developing world.[20] But everywhere they live, youths face a clouded future. Rising unemployment, lagging education, and epidemics of poverty all disproportionately threaten tomorrow's citizens, and by extension, today's communities.

In 2014, Duke University's Sanford School of Public Policy released *The Global Youth Unemployment Crisis*, an extensive study that laid bare many distressing statistics. Youths worldwide are three times more likely to be unemployed than adults, and "over 350 million young people are not engaged in education, employment, or training," a status commonly described in the literature as NEET.[21]

The International Labor Office (ILO) concurs. Their 2015 report pointed to a slight decline in unemployed youth between 2009 and 2014—yet still concluded that youth are "strongly overrepresented among the unemployed."[22] How overrepresented? According to the ILO, 40% of all "economically active youth" are either unemployed or "working in poverty." Other troubling conclusions from the ILO's 2013 and 2015 reports include:

- Youth were 1.5 times more likely to be found in the extreme poverty class than adults.

- Young workers are disproportionately represented in low-paid work.

- Most young workers in developing countries are in the informal economy.

- Temporary employment and lack of permanent employment for youth is rising.

- The transition among youth from school to work continues to slow.[23]

Perhaps the most worrisome statistic from the ILO reports points to the persistence of the problem: global youth participation in the labor force has declined for over two decades, from 59% in 1991 to 47.3% in 2014.[24] In other words, the problem of endemic youth underemployment itself is almost old enough to no longer even be in the 15 to 24 category.

A 2015 UN white paper suggests that many countries are failing to provide educational opportunities and modernized economies that could help a majority of their youth populations to keep up with the Fourth Industrial Revolution. The problem is at its worst where the youth population is growing fastest. "In 32 countries, fewer than 80% of 15-24 year olds are literate," according to the UN. "Of these 32 countries, 18 are projected to see a more than 40% increase in the number of youth between 2015 and 2030."[25] Meanwhile, some countries with deceptively adequate youth employment rates show an overrepresentation of youth engaged in unsustainable fields, like subsistence agriculture, and those industries won't be able to absorb new workers that will result from the population boom. Other exacerbating factors include minority and gender inequality; young women, worldwide, lack access to sufficient education and training opportunities.

Economically developed countries are not immune to this crisis either. Despite a slight leveling off in NEET youth among OECD countries in the aggregate, the ILO reports that pockets of NEET instability remain high. Six southern Mediterranean countries, for example, still have youth unemployment rates above 30%.[26] In fact, two-thirds of European countries had youth unemployment rates of 20% or higher in 2014.[27] Sometimes, not even a traditional college degree helps. According to the ILO, the share of highly-educated NEET youth has risen since the Great Recession. In the U.S., the Rockefeller Foundation reported in 2016 that "the unemployment rate for younger workers remains more than double the national average."[28]

With this high proportion of NEET youth comes destabilized communities, with higher homelessness, poverty, political unrest, and violence. In 2011, the Institute for Security Studies—a South African think-tank—blamed Nigerian post-election violence on "young impoverished people, many of whom probably did not vote."[29] Wherever young people face a dearth of opportunities, they displace their angst onto the society they feel has failed them.

The ILO and UN both prescribe similar solutions: empowering young people with the education that can connect today's youth with the skills of tomorrow. The Duke University Sanford School of Public Policy report further broke the solution down into specific challenges: decrease the gap between the skills employers desire and the skills youth learn or possess, which includes a general lack of skills and opportunity awareness, especially among lower-income NEETs, and a lack of "investment in youth-led entrepreneurship."[30]

Creativity to Close the Gaps

If communities want to close these gaps, address these lacks, and embrace entrepreneurship, we believe the best investment is in the creative economy, specifically the ventures of creative entrepreneurs. We're not alone in this belief. In the opening statement of a 2013 UN Youth Forum, Néstor Osorio—then President of the United Nations Economic and Social Council—specifically cited the technology and innovation of the creative economy being able to open up "amazing new opportunities."[31]

The UN's 2013 Fact Sheet *Culture as a Vector for Youth Development*[32] goes even deeper, making several persuasive arguments about the creative economy's potential to reverse the fortunes of struggling youth. The report makes the point that creative ventures offer both gainful employment and meaningful opportunities for youth to participate in their communities. Creative companies often bring to life heritage by marrying traditions with technology. Innovative entrepreneurial ventures offer new approaches to reverse trends in both employment and education among youth:

- **New ways to educate, old ways to connect:** The UN explains that creative economy ventures "help strengthen identity and social cohesion," while at the same time serve "as a springboard for new ideas and innovation, which can open up new opportunities for employment and learning." Not only do creative entrepreneurs innovate new methods for knowledge transfer, they understand that education steeped in relatable heritage has a better chance of connecting with youth who are searching for their story.

As we've already seen in the example of Galpão Aplauso, youth who can participate in their own education and connect it to self-expression have higher self-esteem and more inclination to pursue further opportunity. Creative entrepreneurs are invested in market solutions that place a premium on self-expression, community participation, and culture, making their educational ventures an excellent fit for youth traditional approaches can't seem to reach.

- **From skill gap to skill innovation:** Many NEET youth have plenty of skills; they just don't know how to translate them into what employers are seeking. Likewise, employers might not have the creativity to recognize how well a youth's non-traditional skillset might translate to the professional world.

But the recognition of these associations is the specialty of creative entrepreneurs. Creative entrepreneurs offer dynamic environments that reward adaptive learning and embrace qualities that other employers might consider a "gap" in knowledge or training. Likewise, highly collaborative creative entrepreneurs are at the forefront of innovative network technologies, and they understand how to harness youth acumen with social media and digital technology that non-creative employers might find no room for.

When youth work for creative entrepreneurs—or are empowered to become creative entrepreneurs themselves!—they can use their existing skills to overcome environmental

challenges. Many Galpão Aplauso youth come into the program having developed the "street smarts" to survive. The collaborative problem-solving and disciplined flexibility that accompany the opportunity to mount a theatrical production—and the contacts in the many professional worlds that overlap with such a production—help them move beyond surviving to thriving.

Across the globe, entrepreneurs and other innovators in the creative economy are unveiling solutions that connect, educate, employ, and empower youth to become active agents in their own futures and leaders in the stories of their communities. This is happening in epicenters of the creative economy, such as Portland, Oregon, where apparel design firm Dfrntpigeon is staffed by formerly homeless youth who sell custom t-shirts and design on commission for local businesses.[33]

MUTUALLY BENEFICIAL

Entrepreneurs who recognize the mutually beneficial relationships among youth, digital technologies, and cultural innovation are leveraging young talent to generate new value in markets.

According to the YouthfulCities Index—a Toronto-based social enterprise well-regarded by major media outlets such as the *Financial Times, CNBC,* and *Fast Company*—the top 10 most youthful cities in the world are also epicenters of creative entrepreneurship.[34] And the IDB reports that "the [creative] sector has a higher percentage of youth employment than the rest of the economy."[35]

Even when training opportunities in the creative sector don't

translate into jobs within that sector, studies still show considerable benefits. In a study of Melbourne-based Youthworx Media, Aneta Podkalicka and her co-authors suggest that "creative education" can function as a "multidirectional pathway for disengaged young people towards inclusion in societal structures."[36] Podkalicka found that Youthworx Media offered nearly all participants viable nonlinear paths toward quantifiable situational improvement, as well as improved "intangible" communication skills and motivation "applicable in professional and social contexts."[37]

While Podkalicka's report is "cautious about idealizing media-based interventions," the conclusions nonetheless powerfully suggest the scalability and portability of the Youthworx Media training model:

> The program is successful in supporting youth transitions into a range of formalized education, training and employment settings. This is a powerful finding, given the background of the Youthworx young demographic.
>
> ...
>
> Our research demonstrated that the Youthworx integrated model—with a full time social worker on site—is fully functional and effective. In many cases it helps alleviate practical barriers to engagement in the program and often beyond, such as the lack of available housing or transport.

Nor is this sort of youth empowerment happening only in the Melbournes and Portlands of the world:

- In La Plata, Argentina, a theatre school similar to Galpão Aplauso created job opportunities for 600 NEET youth.[38] Meanwhile, in Guatemala, TV Maya offers practical media training to help inspire a new generation of young filmmakers from historically marginalized communities who can bring both the economic and cultural benefits of film, TV, and animation back home.[39]

- In Buea, Cameroon, 31-year-old creative tech entrepreneur Churchill Nanje has devised a job aggregation site geared toward unemployed African youth, which is monetized through employer subscriptions and features an innovative job-seeker/job-poster matching algorithm.[40]

- In Kingston, Jamaica, 29-year-old creative tech entrepreneur Alex Morrissey has created a website that allows for virtual turntable mixing of reggae music, unlocking the entrepreneurial potential of a DJ platform for young people who can't afford the physical equipment.[41]

- In 2012, *Southern Innovator* highlighted the animation industry in India and the Berber rap music industry in Morocco as creative economy bounties of youth employment opportunities and identity empowerment.[42] Cheaper and more widely available production technology has democratized access to content creation, and creative entrepreneurs are teaching and hiring young people to bring diverse stories to more screens and headphones. Often, these entrepreneurs are young people themselves, ready to take the initiative.

- Speaking of music, scholars are increasingly taking note of youth-driven music entrepreneurship around the globe. In 2011's *Youth, Music and Creative Cultures: Playing for Life*, Geraldine Bloustien and Margaret Peters study how young creative entrepreneurs from disenfranchised backgrounds all over the world merge cultures of graffiti, hip-hop, skateboarding, and breakdancing to build economically successful retail and performance spaces.[43] In 2010's *Dancehall: From Slave Ship to Ghetto*, Sonjah Nadine Stanley-Niaah studied the youth-driven success of Jamaica's dancehall industry, which employs 6,000, indirectly supports 43,000 more, and is estimated to account for 10% of Jamaica's GDP.[44]

In this chapter, we will highlight a few creative entrepreneurs whose endeavors innovate new solutions for educating and employing youth. Some of these entrepreneurs are youths themselves (or were when they started their ventures) and are embedded in the communities from which they originate. All of them move beyond the idea of "serving youth" and achieve the integration and enabling of youth agency and self-determination.

A model of "social services" will not win the future. For tomorrow's citizens to succeed, they need the confidence and flexibility that creative entrepreneurs excel at unleashing. The Fourth Industrial Revolution is already dawning, and its greatest impacts will be felt among today's youth. In this chapter, you will meet creative entrepreneurs with powerful models for empowering young people to turn uncertainty into opportunity.

From Aid in Africa to Made in Africa : : : : : : : : : : : : : : : : : .

From prize-winning electronic waste to locally produced rechargeable cordless hair dryers, the story of 3D printing in Africa is one of accelerated futures and micro-manufacturing revolutions. And at the heart of this tale, we find multi-talented creative entrepreneurs dedicated to youth empowerment.

When young Togolese creative entrepreneur Kodjo Afate Gnikou made a crowdfunding campaign for his 3D printer project, he made the "personalized video message reward" very expensive because he was so shy.[45] Instead of speaking, he spends his time observing. One thing he observed were all the e-waste scrapyards in his home city of Lomé, the refuse of secondhand computers shipped from Europe. "These machines are dumped in large landfill sites that are very poorly regulated," Gnikou told *France 24.* "More and more waste is building up as the years goes by."[46] Gnikou decided to recycle the imported trash with local imagination: he challenged himself to build a 3D printer out of nothing but e-waste.

His design featured what 3ders.org described as "rails and belts from old scanners, the case of a discarded desktop computer, and even bits of a diskette drive."[47] And it worked. Built for $100, Gnikou's 3D printer won him worldwide attention and acclaim, including first place at the 2014 Fab10 accessible technology showcase in Barcelona and a slot in NASA's prestigious International Space Apps Challenge in Paris.[48]

His ambitions began modestly, 3D printing household utensils and other staples difficult to find in adequate quantities in Togo. But his vision goes much further. He has printed custom prosthet-

ic knees—an urgent need for a country where all prostheses are expensive standardized imports—and is planning a space to "train young people to build machines themselves" so they can "create objects that respond to concrete needs…in their daily lives."[49] He told Euronews that his dream is "to give young people hope and to show that Africa, too, has its place on the global market when it comes to technology."[50]

This kind of hope is important for a booming African youth population that's searching for a foothold in the competitive global economy. According to the McKinsey Global Institute, "Africa will be home to one in five of the planet's young people and will have the world's largest working-age population" by 2040.[51]

Yet this large youth population is struggling. They account for 60% of all African unemployment, and "more than 72% of young Africans live on less than $2 a day," according to the UN.[52] ILO reports that most of Africa's youth are "working long hours under poor conditions in the informal economy."[53] As with the Rio youth discussed earlier, their prospects are challenged by high levels of illiteracy and a lack of skills that match with current labor market needs. From the MESA region—where *Southern Innovator* reports that "100 million jobs need to be created in the Middle East and North Africa by 2020 to meet the demand for work"[54]—to Sub-Saharan Africa—where the ILO reports that the "majority of young people" work "long hours under poor conditions in the informal economy"[55]—the story is the same: African youth need innovative opportunity.

Njideka Harry believes that 3D printing offers just such an innovation. Harry is the founder of the Nigeria-based Youth for Technology Foundation (YTF), which runs several programs ded-

icated to teaching African youth creative 3D printing skills and entrepreneurship. "We fundamentally believe that young people are creative," she told *Ventures Africa*. "They want to create, they want to make, and they want to innovate. And by so doing they can actually transform our continent from 'aid to Africa' to more of a 'made in Africa' continent."[56]

Harry is confident that a "made in Africa" future will heavily involve the micro-manufacturing opportunities of 3D printing. Citing the fact that by 2025, emerging markets will account for two-thirds of global demand—right around the same time the global 3D printing market is projected to be

" HARRY IS CONFIDENT THAT A "MADE IN AFRICA" FUTURE WILL HEAVILY INVOLVE THE MICRO-MANUFACTURING OPPORTUNITIES OF 3D PRINTING. "

generating $550 billion a year—Harry's 3D Africa website argues that "3D printing has the capacity to transform the supply chain through next-shoring, transcending geography, participating in global marketplaces, and focusing on physical proximity to emerging markets, talent, and customers."[57]

In a report for GE, Harry expanded on these ideas. "With the right tools and training," Harry argued, "young innovators in Africa have the opportunity to skip the second industrial revolution—traditional mass production—and leapfrog straight to digital manufacturing."[58] She explained that Africa's lack of "an established manufacturing sector" leaves it relying too heavily on imported goods—and leaves young people without the bank of familiar "sta-

ble" jobs that manufacturing sector has provided.

But as we've discussed, automation is eradicating that stability, and Harry believes that creative 3D printing will spawn a "micro-manufacturing" ecosystem that will reward entrepreneurship, especially for young people who lack the resources traditionally necessary to enter the manufacturing field. "[3D printing] will create an environmentally friendly ecosystem that doesn't require factories, machinery, labor or capital," Harry explained. "The savings, both direct and indirect, will afford many people the opportunity to lift themselves out of poverty."[59]

YTF's programs have shown how young people—and especially young women, one of Harry's focuses—can benefit from 3D printing-based entrepreneurial opportunities. "We know that online markets allow markups ... for as much as 25 to 50%," Harry told *Ventures Africa*. That's why YTF's programs train young African entrepreneurs how to model and print marketable products infused with creativity, "like small household consumables and jewelry."[60]

Next in our story is Afrocentric Afrique, which highlights the "mentorship ecosystem" YTF enables between creative entrepreneurs and young tech workers. Afrocentric Afrique is a "made-in-Africa" boutique, the brainchild of Nigerian creative entrepreneur Maureen, whose global ambition is to "make every home have something that is made in Africa." To help her scale and streamline her business, YTF paired her with young workers who could 3D print Maureen's designs. Now, instead of having to import materials from outside Africa, Maureen is exporting African creativity.

Exporting and economizing African creativity is the hallmark

of YTF youth success. Students helped Nigerian cosmologist Afoma design "a 3D printed rechargeable, detachable, cordless hair dryer."[61] Now Afoma markets this product to regional cosmologists and no longer wastes money on a yearly trip to China for bulk supplies. Other students have 3D printed drones and started hubs for entrepreneurs in Lagos. In a country where only 1 of every 35 engineering graduates can find a job in the traditional economy, YTF offers a path to creative entrepreneurship, where these engineering students can develop their own ideas and "actually express themselves," says YTF graduate Emmanuel.[62]

In only a few years, YTF's 3D Africa program has trained over 650 students and indirectly impacted more than 2,000.[63] YTF's 2015 Impact Report shows further tangible success across all their programs:

- Over 315,000 YTF Academy graduates, 75% of whom "have chosen to pursue STEM careers or education" and 90% of whom "have been engaged in some form of entrepreneurship."

- These graduates boast "a high job placement rate" with salaries "three times more ... than non-YTF Academy graduates."

- Of these YTF-graduated employees, 40% earn promotions "within 3-6 months of graduation."[64]

Africa is full of young people hungry to embrace their own destiny. A 2011 Gallup poll showed found that 1 in 5 Africans between the ages of 15 and 24 wanted to start their own business.[65] And entrepreneurs like Kodjo Afate Gnikou and Njideka Harry

are ready to help them, proving that African youth can be empowered by creative 3D printing to leapfrog traditional economies and forge disruptive, self-reliant paths to economic leadership.

Feeling Tomorrow's Intelligence

In Winston-Salem, North Carolina, Creative Startups alum Karen Cuthrell doesn't use 3D printers (yet!) to make the plush Feeling Friends toys that adorn the stage when she performs at schools, churches, and children's hospitals. But like Njideka Harry, Cuthrell is passionately committed to educating youth with the skills of tomorrow. For Cuthrell, however, one of the most important skills is emotional intelligence, and her journey into creative entrepreneurship began with the feelings, or a seeming lack thereof, of a very important person in her life: her daughter.

In 1994, Cuthrell's daughter six-year-old daughter, Lana, was diagnosed with depression. "Her first year she didn't smile," Cuthrell told the *Winston-Salem Journal*.[66] As Lana herself explained to the *Journal*, she simply didn't know what to say when her mother asked her how she felt. So Cuthrell drew on her background in singing and art and decided to create characters that could help her daughter recognize and express her feelings. She made 12 animal characters for 12 potent feelings: a loving kangaroo, a confident bee, and so on. Characters for "bad" feelings were perhaps the most important part of the project, as the panicky ant, angry tiger, and lonely whale all gave Lana a vocabulary and image to help her see how even "bad" feelings can be explored and productively expressed.

The Feeling Friends immediately helped Lana, and Cuthrell realized she could help other kids as well. She found success per-

forming with the Feeling Friends at prestigious venues: The National Theatre in Washington, DC, the National Council of Negro Women, and even the White House Easter Egg Hunt. In 2004, Cuthrell was profoundly affected when one of Lana's friends passed away from bone cancer. At the end of his life, the 13-year-old expressed his feelings by identifying with Cuthrell's Feeling Friend, Griswold the Grumpy Grizzly.

After this experience, Cuthrell decided to make the Feeling Friends her life's mission. In 2008, she collaborated with illustrator Steven "Sash" Scott on a coloring book, and in 2012 she piloted a program that used the Feeling Friends to teach "emotional health" to over 300 elementary school children. At the request of other teachers, Cuthrell began producing instructional CDs, and the Winston-Salem State University's Center of Excellence for the Elimination of Health Disparities hired Cuthrell to incorporate the Feeling Friends into a program for mentally ill adults. The Feeling Friends even found their way into a North Carolina Department of Public Health program for "cultural competency and customer service."

"For students living with adversities, it is challenging to benefit fully from educational experiences," Winston-Salem based school psychologist Corliss Thompson-Drew told the *Winston-Salem Journal*.[67] Educators, parents, and healthcare professionals across Winston-Salem who have worked with Cuthrell all agree that the Feeling Friends represents a bold, innovative approach to improving student engagement. One teacher told Cuthrell: "Not only did you transform the children in the classroom, you transformed me, which transformed my family."[68]

Cuthrell has built on this celebration to further success. The

Feeling Friends has expanded into eBooks, with plans for an animated TV show, a curriculum package for classrooms, and more interactive digital products in the works.

As we've discussed, one consequence of the automation revolution is the renewed value of emotional intelligence. In a world where human hands are disappearing from not only from predictable physical labor but common service spaces as well, we will look for increased meaning in the human interactions that remain. And as consumers mature beyond marveling at the novelty of AI, they will increasingly demand more human-like experiences. Robots that can make real faces, if you will. This demand is already playing out in the tech sector, where it's no longer enough to simply have a chatbot or a virtual assistant device like Apple's Siri or Amazon's Alexa. Rather, the market is rewarding personality, humor, warmth—and the engineering jobs of the future will demand workers who understand the deep complexities of these human qualities well enough to endow AI with them.

Throughout the economy, managers are recognizing the value of emotional intelligence. In 2011, Career Builder surveyed nearly 3,000 HR managers and found that 71% "valued emotional intelligence in an employee over IQ," according to *Fast Company*.[69] And you might remember from Chapter 1 that emotional intelligence will be one of 2020's top 10 job market skills, according to the World Economic Forum.

That's why creative ventures like Karen Cuthrell's Feeling Friends are so important for today's youth. To be truly competitive in the Fourth Industrial Revolution, today's youth will need to develop skills that might have been dismissed or taken for granted in yesterday's markets. But creative entrepreneurs like

Karen Cuthrell understand the power of such skills, and they are innovating market solutions to help today's children stay in touch with the most poignant aspects of their humanity. Today, Cuthrell's daughter Lana is her co-author and editor. The Feeling Friends are helping both mother and daughter succeed in their mission to teach the next generation—through exciting, innovative storytelling—the importance of self-knowledge.

THANKS TO THE TRANSFORMATIVE POWER of the Feeling Friends, Cuthrell won second place at the 2016 Creative Startups Winston-Salem Accelerator program. She told the University of North Carolina Kenan Institute for the Arts that her experience was "life-changing." Cuthrell used her $15,000 prize money to expand to new platforms and audiences. "I have spent thousands and thousands of dollars on training, and I've never walked away with something as valuable as Creative Startups," Cuthrell told the Kenan Institute. "The mentors, the one-on-one conversations, the personal interest that people gave you, understanding that you were a creative company. For the first time, we were smiled upon instead of being frowned upon. Our creativity was celebrated."[70]

A Collage of Bold Approaches to Education

Around the world, creative entrepreneurs like Cuthrell are innovating bold new approaches to youth education, whether by providing training for overlooked skills, reaching marginalized audiences, or motivating students by contextualizing their learning with local heritage. In fact, we could spend the entire book on innovative creative educational technology! Here is a brief collage

MEET

Photo by Taneka Bennett, courtesy of Feeling Friends

ENTREPRENEUR:
Karen Cuthrell, pictured with her daughter Lana

COMPANY: Feeling Friends

INDUSTRY: Publishing

BASE OF OPERATIONS: U.S.

NOTEWORTHY: At the forefront of growing markets for social emotional skill development and interactive educational tools.

of stories that illustrate how diverse and widespread this field has become, and how successfully creative education entrepreneurship is reaching young people.

- **Ormschool**: In Thailand, creative entrepreneur Nuttaya Thaitham founded an online education channel with the goal of making one million free videos that would reach Thai kids who lacked traditional access to educational materials, especially in rural areas. The channel has been

a rousing success, with over 120,000 subscribers, 10,000 videos, and expansion into neighboring Laos.[71]

- **Yoruba101:** In Nigeria, creative tech entrepreneur Adebayo Adegbembo created a tablet app for kids to learn the indigenous Yoruba language, connecting them to their cultural heritage and laying the foundation for future careers in translation, education, media, and services abroad among Yoruba diaspora.[72]

- **Women Techmakers Buea:** In Cameroon, 25-year-old Mpara Faith is the leader of a Google-affiliated STEM group for young women, the only one of its kind in the country. Faith creates educational software tailored to Cameroonian culture. As she told *The Guardian*, imported software fails to fit Cameroonian culture. "So we want to develop African [software] so we have a feel of the culture and make sure it fits African needs."[73]

- **Kahoot!:** In Norway, a team of behavior design creative entrepreneurs created a new platform for gamified social engagement in classrooms. A global smash hit with 50 million users worldwide, Kahoot! allows teachers to design their own quizzes, which students play on mobile devices, competing against each other or the "ghosts" of their previous efforts. The platform encourages teachers to express their own creative connections with their material, and it brings innovative play elements to knowledge retention for students.[74]

- **Mihi Maker:** In New Zealand, the creative entrepreneurs

behind innovative Web-based game design platform Gamefroot designed a new way for indigenous Māori youth to connect with their heritage. One important rite of passage for Māori people is developing a "pepeha," a speech to introduce themselves at formal gatherings that describes their specific lineage and the journeys of their ancestors. Gamefroot's Mihi Maker guides kids to make their pepehas as colorful, interactive games, portable on mobile devices. Gamefroot's success demonstrates how creative entrepreneurs are bucking the idea that contemporary technology washes out cultural heritage.[75]

- **Upper One Games:** In Alaska, creative entrepreneur and Iñupiat native Gloria O'Neill was tired of how Alaskan natives were portrayed in media, so she decided to harness a new media form that would reach the youth who would define the future of Iñupiat identity: video games. Partnering with E-Line Media, O'Neill founded a new video game company, Upper One Games, the first indigenous-owned American video game studio. O'Neill created *Kisima Inηitchuηa*, which in English translates to Never Alone, a "cinematic adventure platform game" that served as "game-based cultural storytelling," according to *Polygon*.[76]

With contributions from 40 community members, the game is steeped in respect for Iñupiat heritage, with an aesthetic that references traditional ivory scrimshaw carving. You play as a young Iñupiat girl and her companion fox,

attempting to survive in the Arctic wilderness by applying an understanding of nature that is passed down from Iñupiat elders.

The game was released in 2014 to rave reviews, especially among Natives who praised the game's potential to connect young Iñupiats with their history. Native American gamer Daniel Starkey wrote for *Eurogamer* that the game moved him beyond a self-piteous relationship with his Native identity, "not only telling me to be better, but showing me how."[77]

The game sold well, with all proceeds benefiting the Cook Inlet Tribal Council educational efforts. And Upper One plans to expand as a publisher. *Kotaku* reports that Upper One Games has been "contacted by communities from Siberia, Hawaii and Amazonian indigenous peoples, all wanting to implant their stories and customs into a video game."[78] As Iñupiat Elder Ron Brower enthused in a video interview, "[Making a video game] is a great way of transferring some of our historic knowledge to the younger generation."[79]

Flying to Control of Your Story

The idea of connecting with heritage to empower youth success is not simple. For many young people around the world, heritage itself is a major barrier, with inherited trauma stifling their development and making their connections to ancestors too painful to probe. But in Cambodia, a team of eight young creative entre-

preneurs—who met in a refugee camp—developed an initiative to help young people process their trauma and emerge as community leaders.

In 1986, French artist and educator Véronique Decrop arrived at a refugee camp on the border between Thailand and Cambodia, where thousands of children were stranded in the aftermath of the genocidal reign of the Khmer Rouge. At the camp, Decrop taught students how to use art as therapy, an approach controversial with camp directors. For *Contemporary Southeast Asian Performance: Transnational Perspectives,* Eric Prenowitz and Ashley Thompson wrote how Decrop eschewed "rote copying exercises" and "never altered a student's work."[80] She was teaching them how to work through their trauma by taking charge of their creative destiny.

Years later when eight of these children returned to their home city of Battambang and saw how many children still suffered from the same trauma they'd endured, they were inspired to build on what they learned from Decrop. Together Srey Bandaul, Tor Vutha, Khuon Det, Lon Lor, Chea Yoa, Svay Sareth, Chan Vuttouk, Dy Mala, and Rin Nak started their own art school. In a modest wooden structure in a damp rice field, they founded Phare Ponleu Selpak (PPSA), Khmer for "the brightness of the arts."

Since its inception in 1994, PPSA has grown into a multifaceted organization that combines education—housing both a visual/applied arts school and a performing school—with entrepreneurship—running a popular circus and a design studio that offers employment to school graduates. The program boasts thousands of graduates, and its circus has toured all over the globe. PPSA alumni teach, start art galleries, continue on to major international art schools, and one has even joined Cirque du Soleil.

Beyond their economic success, the young people who have passed through Phare Ponleu Selpak have been instrumental in revitalizing a Cambodian culture stifled during the Khmer Rouge, healing not only themselves but their country. As co-founder Tor Vutha explained in an interview, the goal is for graduates to get a job that keeps art in their lives. That is what's going to keep the culture alive. "Solidarity, collaboration and spreading the artistic culture," Vutha says.[81] In 2017, *Cambodia Daily* reported that PPSA was one of the inspirations behind an Education Ministry initiative to transform STEM curriculum into STEAM, adding art to science, technology, engineering, and math.[82]

The methodology of Phare Ponleu Selpak is similar to Galpão Aplauso, but we close this chapter with Phare Ponleu Selpak to inspire leaders not to get trapped in a mindset of patronage and overlook the entrepreneurial potential

" THE POWER OF CREATIVE ENTREPRENEURSHIP IS NOT LIMITED TO OUTSIDE ACTORS... WISE STAKEHOLDERS...MIGHT DO WELL TO EMPOWER THE YOUTH THEMSELVES. "

within challenged youth communities. Galpão Aplauso works so well because Ivonette Albuquerque understands that she and her team of educators learn as much from their students as the students learn from the program. The success of Phare Ponleu Selpak teaches us that the power of creative entrepreneurship is not limited to outside actors, and wise stakeholders aiming to initiate the benefits of the creative economy within their youth communities might do well to empower the youth themselves.

After all, Veronique Decrop did not draw her students' futures for them. As co-founder and successful artist Srey Bandaul puts it, Decrop encouraged them to make a "step-by-step observation of our world," and they were the ones who took the initiative to change that world.

At Phare Ponleu Selpak, this tradition continues. As student Makara Vin told *TakePart*, "It's amazing because I can fly. I can jump. I like when people watch."[83] One circus school cannot melt the pains of intergenerational trauma, but when students with bleak income prospects are earning money to have people watch them fly, they have taken control of their story, and they are writing their own future.

Growing Up with Innovation

Today's youth have grown up in the thick of a technological revolution that has changed everything from consumption to communication, and every day they face rapid-fire advances that sway their futures in unpredictable directions. Much of this future they're already navigating, participating in online expression and engagement across demographics. A 2008 University of Minnesota study of U.S. youth found that "low-income students are just as technologically proficient as their wealthier counterparts,"[84] and broadband access continues to rise exponentially across the globe, even in the most impoverished communities.

In a 2006 study of participatory youth culture, Henry Jenkins found that youth today are engaged in an extraordinary amount of everyday creativity, where there are "low barriers to artistic expression and civic engagement" and "strong support for creating and sharing one's creations."[85] Today's youth intuitively understand that

creativity does not stop at the original idea but extends to remixing, recontextualizing, scaling, and translation across platforms—all important concepts for creative economy success.

Yet traditional economies often don't know how to incorporate these skills, and education designed for these traditional economies threatens to turn away an entire generation. To reverse a global NEET youth crisis, policymakers and stakeholders need to embrace the models of Galpão Aplauso and Phare Ponleu Selpak, the ambition of Njideka Harry, Gloria O'Neill, and Nuttaya Thaitham, the innovativeness of Karen Cuthrell, Kahoot!, and Kodjo Afate Gnikou. In short, they need to discover and empower creative entrepreneurs who, in turn, understand how to educate, employ, and empower the creative entrepreneurs of the next generation. There can be no huddling in the solutions of yesterday's economy. Tomorrow's citizens deserve to innovate their futures today.

10

DEVELOPING
Unique Regional
IDENTITIES

Stories in the Streets

Inside the Dewan Sri Pinang auditorium in George Town—the capital city of the Malaysian island state Penang—26-year-old Alena Murang is breaking new ground for regional cultural identity. She is playing a sape, a lute shaped like a flat-bottom boat, indigenous to Murang's homeland of Borneo. What makes this performance special is that Murang is one of the first women to ever perform with the sape, and she is also one of the first performers to sing with an instrument traditionally reserved for trance rituals.

While a packed house listens to Murang embody her belief in progressive cultural heritage—"the past made present," she told *Time Out*[1]—the wind picks up on the beach a few blocks away. There, onlookers are bewitched by a sandwalking robo-sculpture, built out of wood and recycled PVC, powered entirely by shoreline gusts. This is the Strandbeest, an invention of Dutch technology artist Theo Jansen that is making its Southeast Asian debut—not in Bangkok or Kuala Lumpur, but in George Town.

All around the city, the streets hum with activity. Thousands of people have taken the ferry to Penang's capital, where they watch aria singers on the street and martial artists in formerly abandoned

fortresses. A lack of "proper" venues in George Town is no match for the collective innovation on display: interactive plays take place in colonial hotels, and a rice paddy in an empty lot is the site for a "contemporary reinvention of ancient rituals and celebrations associated with the rice harvest," according to the *South China Morning Post.*[2] While award-winning films are projected on the walls of old shophouses, visitors slurp *char kway teow* on banana leaves in the refurbished Hin Bus Depot, where the crumbling art deco walls have become canvasses for muralists near and far.

MEET

Image courtesy of Joe Sidek Productions

ENTREPRENEUR: Joe Sidek

COMPANY: George Town Festival

INDUSTRY: Festivals and Entertainment

BASE OF OPERATIONS: Malaysia

NOTEWORTHY: 250,000 visitors join this event annually.

It's the summer of 2016, and this is the George Town Festival, a yearly event that attracts over 250,000 visitors and has "played no small role in the remaking of George Town into a chic destination," according to *The Strait Times*.[3] Today, *Smart Investor* reports that tourism is Malaysia's "second highest private investment contributor" and "third largest [gross national income] contributor."[4] In 2016, *The Malay Mail* reported that the festival generated $1.25 million for supporting businesses like restaurants and hotels, with a total "public relations value" of around $5 million.[5]

Until recently, this identity as a booming tourist destination did not seem to be George Town's destiny. Despite a rich architectural and cultural history, George Town (and Penang in general) suffered an economic decline in the late 20th century, losing the identity of its free port status and falling into the shadows of the Malaysian government's efforts to develop Kuala Lumpur.

While UNESCO's 2008 designation of George Town as a World Heritage site inspired the creation of the George Town Festival, its six years of growing international success is largely due to the enthusiastic innovation of one creative entrepreneur: Joe Sidek.

Sidek answered the call from the Penang government when all others were daunted by a "tight deadline…a small budget, and no team!" as Sidek told *Smart Investor*.[6] But Sidek prevailed, embracing the creative economy, capitalizing on cultural heritage, and tapping cutting-edge social media technology to re-introduce his region to the world.

How did the manager of a textile chemical factory become a re-inventor of an entire state's regional brand? For Sidek, creativity and business have long mixed. He inherited the factory from his father, who sent him off to London to study urban planning, ignor-

ing the younger Sidek's desire to enroll in art school. Yet Sidek's father also instilled in him a love of theatre, taking him to see shows when he was five years old. Over the years, Sidek found ways to integrate creativity into his life, designing costumes for operas, running modeling agencies and nightclubs, and co-founding the Little Penang Street Market "to encourage creative entrepreneurs," according to *The Star*.[7]

This mix of entrepreneurial acumen and creative passion served Sidek well when he accepted leadership of the George Town Festival. Thanks to his social media outreach, he was able to woo international contributors, from renowned Cambodian film director Rithy Panh to Burning Man founder Larry Harvey. Meanwhile, due to his business savvy, Sidek was able to court corporate partnerships to cover a third of the operating costs—a high percentage

" HE WANTS THE FESTIVAL TO INSPIRE PENANG LOCALS TO TAKE OWNERSHIP OF THEIR IDENTITY AND KEEP PACE WITH CUTTING EDGE INNOVATIONS FROM AROUND THE GLOBE. "

compared to similar Asian festivals.[8] He also understood how to stave off insularity by establishing partnerships with other regional festivals and the Association of Southeast Asian Nations investment collective.

Though the festival swells Penang with visitors, Sidek's ultimate goal is "not about tourism or even the arts," he told *The Straits Times*.[9] He wants the festival to inspire Penang locals to take ownership of their identity and keep pace with cutting edge innovations from around the globe.

Of course, the festival makes plenty of more prosaic contributions, as well. "At the end of the day, the goal is to marry culture and tourism to the dollar sign," Sidek told *The Star*.[10] He explained to *Penang Monthly* that the festival keeps all its labor and equipment local: "It's all from Penang. There are carpenters, designers, electricians, florists, tailors..."[11] And the effects ripple beyond employment. The George Town Festival was the only Malaysian project to earn a spot in the Asia Europe Foundation's 2014 publication *Enabling Crossovers: Good Practices in Creative Industries*, which cited the festival's contribution "to the promotion of a sustainable and vibrant urban environment, including a planned creative design centre."[12] In fact, *Biz Events Asia* reported in 2017 that the uptick of "corporate events" for August in Penang is directly attributable to the festival.[13] "People choose a place to live and work… because there's life," Sidek told *Penang Monthly*. "If people want to buy property, why would they be interested if there's nothing going on there?"[14]

Creative entrepreneurs like Joe Sidek understand that authenticity doesn't preclude innovation, and honoring legacy doesn't have to trap regional identity in the amber of nostalgia. The George Town Festival might not be the only place in the world someone can experience the Strandbeest, but thanks to Sidek, the 2016 George Town Festival was the only place (and time) where you could watch the Strandbeest while listening to indigenous Malaysian music, where

> " JOE SIDEK HAS LAUNCHED A FESTIVAL THAT TELLS THE STORY OF PENANG'S **REGIONAL IDENTITY ON THE GLOBAL STAGE.** "

locals could participate in a Berlin theatre troupe's interactive theatre survey, where fashion shows took place in dilapidated mansions—a kaleidoscope of unique experiences rooted in George Town and branching out to meet the rest of the world.

"How do you sell George Town?" Sidek rhetorically asked *Penang Monthly*. "We have histories … smells, food … [the festival] promotes the endangered, intangible heritage and gives it a commercial appeal."[15] Every year, the George Town Festival provides an innovative, authentic, one-of-a-kind experience locals take pride in and benefit from economically. "We can't compare with Hong Kong or Singapore on money and structure," Sidek told the *South China Morning Post*. "But what we have are stories."[16] With the zest of his days designing opera costumes and the shrewdness of his experience managing a textile factory manager, Joe Sidek has launched a festival that tells the story of Penang's regional identity on the global stage.

Regional Identity in an Era of Identity Crisis ⋮⋮⋮⋮⋮⋮⋮⋮

While the George Town Festival has kept Penang's identity fresh and competitive, many regions are not so lucky. The forces of globalization threaten the strength of local identities everywhere, sapping civic participation and hitting economies with the bottom line consequences of anonymity.

The threat to regional identity begins at the level of the individual citizen's everyday lifestyle. In *Place Branding: Glocal, Virtual and Physical Identities, Constructed, Imagined and Experienced*, renowned place branding scholar Robert Govers lists the hallmarks of the contemporary lifestyle as "mobility, fast-pacedness, polyscriptedness, and parallelization of experiences."[17] He discuss-

es how we cycle between material, mental, informational, and social spaces so fluidly we lose track of where exactly we are. If we're thumbing through Instagram on the subway or bus to a job where we sit and communicate through a screen to remote people, where exactly do we "live?"

This philosophical question has concrete implications for civic structures—cities, counties, states—whose economic viability depends on their citizens' active association with the identity of the place they most often sleep, eat, patronize businesses, pay taxes, and raise kids in. Without a strong identity for people to pitch into, a region loses its market value to the people who live there. When people can experience any place they choose via the internet, the place where they physically exist has to compete for relevance.

Yet where place-based identity itself is flattening, creative identities can help stage a resurgence. As we've discussed throughout the book, globalization has kindled a renewed appreciation for unique creative experiences rooted in local meaning. Where regions and localities have been successful at establishing, developing, innovating, and exporting a "unique identity," they have found their niche in an era of global identity competition.

As a concept, "unique regional identity" has a stirring ring. But how do we measure such an identity? And how does this identity become a competitive brand with quantifiable economic potential, capable of attracting visitors, property buyers, and business investment—without losing authenticity along the way?

What is Regional Identity?

First, let's tackle the concept of regional identity itself, which is "ambiguous and dynamic," according to Lies Messely and Joost

DIGITAL NOMADS .v- LOCAL

Dessein, two Belgian researchers who have studied regional branding extensively.[18] We use the term "region" rather loosely in order to respect the variety of civic organizational structures across the globe in which stakeholders band together with shared interests.

Whatever the size of the "region," the important feature is symbolic distinction. Messely and Dessein explain that identity is what makes a place "more than just a random collection of physical and material elements." To have a regional identity means the people who live there look out and see themselves in their surroundings and among their neighbors. This means identifying "not only with the landscape, but with a whole set that encompass culture, sociality, morality, tradition and the social system specific to that region."[19]

DIVERSITY

Diverse regional identities attract tourists, build civic pride, and give youth a sense of place and belonging. The era of mass strip malls and monoculture entertainment experiences is waning as consumers and communities demand unique, localized products and services.

While many metrics might measure unique identity in an economic context—healthy tourism, formal and informal community networks, well-known symbolic, natural, and cultural amenities—we believe the right question to start with is this: are there authentic experiences in a place? Because today's consumers want to access the most authentic experiences, through visitation of physical spaces and through distant interaction with exports that retain authenticity rooted in place-based heritage. Such desires are not limited to outsiders: the most engaged and productive citizens

FROM MASS CITIES TO SMART EVERYWHERE

FROM DIGITAL NOMAD TO LOCAL GLOBAL → GLOBAL ONLY

increasingly want to live and work in the thick of authenticity. All of the strongest identity-defining metrics—tourism, community networks, amenities—begin with authentic experiences.

Multi-sensory Authenticity

Let's return to Chapter 5's discussion of the "experience economy," as coined by Joseph Pine II and James H. Gilmore in 1998.[20] The last two decades have shown Pine and Gilmore's prediction of the shift of consumption to experience to be cannily prophetic. An Eventbrite survey of millennials found that 78% "would rather spend money on an experience than a material thing," according to *CNBC*.[21] Among the entire U.S. population, consumer spending "devoted to experiential travel and events" has risen dramatically as well: 70% since 1987.[22] Consumers want to be a part of the story, not just a casual observer.

Social media has made consumers young and old more conscious of the staging of their own lives; our histories of consumption and engagement has become increasingly curated for networks of onlookers. We pick and choose our experiences knowing they'll live a second life in social media feeds. We seek interesting backdrops and associations, images and narratives that will elicit reactions from the people we share stories with online. The privacy of the souvenir has given way to the publicity of the Snapchat.

This new desire for experiences matters for local economies: the key to sustaining the success and growth that comes with a strong identity begins with establishing a brand that is known for providing authentic experiences that can't be found (or associated with) anywhere else. In a global economy where place itself is an ephemeral concept, we expect a lot from the boundaries of space

and time. Surrounded by the outsourced and anonymous blend-
ing-in of globalization, we yearn for creativity that stands out, be-
cause that means we will stand out as well—and we'll have the In-
stagram to prove it.

In *Driving Tourism Through Creative Destinations and Activi-
ties,*[23] Alžbeta Kiráľová details the benefits of a tourism that moves
beyond antiquated sun and sand leisure to incorporate a bouquet
of experiences—whether based
in culture, ecology, agriculture,
education, or other authentic
interactions with local identi-
ties—all under the umbrella of
"creative tourism." According
to Kiráľová, creative tourism
not only does a better job than
"classical" tourism at creating
jobs and stimulating local busi-

> " SURROUNDED BY
> THE OUTSOURCED
> AND ANONYMOUS
> BLENDING-IN OF
> GLOBALIZATION,
> WE YEARN FOR
> CREATIVITY THAT
> STANDS OUT. "

ness, but it also diversifies economies, protects cultural heritage
and the environment, "boosts the consumption of local products,"
and decreases "seasonality."

It's not only tourists who are on the lookout for authentic cre-
ative experiences derived from local identity. A 2012 report in the
International Journal of Consumer Studies found that food prod-
uct consumers value geographic labels even above organic labels,[24]
while a 2016 Cohn & Wolfe survey found that 90% of consum-
ers would reward brands for "authenticity" with loyalty and rec-
ommendations to friends.[25] Clearly, authentic experiences are not
confined to tourism: with the right strategies, they can be exported
to distant consumers as well.

Who will innovate creative branding that attracts authenticity seekers and ensures economic relevance? The answer is well-supported creative entrepreneurs. Like Joe Sidek did for Penang, creative entrepreneurs innovate branding strategies that succeed beyond the ability (or imagination) of top down policies. Such entrepreneurs introduce new interfaces for authentic relationships with places and experiences.

No one person can invent a regional identity, and successful creative entrepreneurs who respect authentic heritage understand this. But as we've shown in the previous six challenges we've discussed, creative entrepreneurs are experts at innovating market solutions that draw on creative expression, pulled from the fabric of shared heritages and experiences. In many ways, the ability to translate identity to authentic, marketable experiences is a summary of how creative entrepreneurs solve all the challenges we've discussed, and that is why we've saved this challenge for last.

> **"THE ABILITY TO TRANSLATE IDENTITY TO AUTHENTIC, MARKETABLE EXPERIENCES IS A SUMMARY OF HOW CREATIVE ENTREPRENEURS SOLVE ALL THE CHALLENGES WE'VE DISCUSSED, AND THAT IS WHY WE'VE SAVED THIS CHALLENGE FOR LAST."**

In this chapter, we will look at several stories of how creative entrepreneurs have innovated, developed, and exported regional identities to the benefit of local economies. Strongly developed identities focused on authentic creative experiences are the key to maintaining a clear regional brand in the blur of globalization, and

these creative entrepreneurs demonstrate how local pride can become a market solution.

Cheetahs on Your Phone

In the midst of the fast-growing popularity of new kinds of tourism, creative entrepreneurs like Nadav Ossendryver are using social technology to innovate new ways to authentically participate in the stories of local ecologies without degrading habitats.

The World Conservation Union defines "ecotourism" as "environmentally responsible travel to natural areas in order to enjoy and appreciate nature." Where traditional tourism often "appreciated" nature to the point of exploitation, ecotourists aim to "promote conservation, have a low visitor impact, and provide for beneficially active socio-economic involvement of local peoples."[26]

Ossendryver grew up in Johannesburg, South Africa, and from an early age he loved visiting the Kruger National Park, the nation's largest wildlife preserve. For Ossendryver, love of wildlife was not a solitary joy. "Whenever we came here I used to beg my parents to stop every car passing and ask them what they'd seen," Ossendryver told CNN.[27] In 2011, he was only 16 when he innovated the social experience of Kruger. He developed a smartphone app called *Latest Sightings* that crowdsourced wildlife "events" in real time, allowing Kruger visitors to log sightings with photos, streaming video, and GPS coordination.

The app quickly exploded, racking up users, catching the interest of Google and Microsoft, and earning the teenaged Ossendryver a leopard's coat of accolades, including a speaking engagement at the Tech4Africa conference, the title of "eco ambassador" from the Endangered Wildlife Trust,[28] and a spot on *Forbes Africa's*

2016 "30 Under 30" list.[29] In 2014, *Latest Sightings* became South Africa's most viewed YouTube channel.[30]

Today, *Latest Sightings* has over 500,000 subscribers on You-Tube, where their videos earn 20 million views per month, generating enough ad revenue for the company to start an affiliate earner's program, through which uploaders earn money for videos they share on the *Latest Sightings* platform.[31] The company has expanded to include other South African national parks, and it's diversified its revenue stream with electronic guidebooks and partnerships with conservation-oriented lodging and safari packages.

For Ossendryver, the major accomplishment of *Latest Sightings* is a thriving community that shares his passion for conserving South Africa's ecological identity. "I just love knowing about all the sightings, seeing and helping animals especially, creating awareness, trying to end poaching and learning more about Kruger," he told CNN.[32] That's why *Latest Sightings* teamed up with South African eLearning innovators Tendopro to provide rural and impoverished students with online courses on wildlife education, helping South African youth connect with their region's ecological heritage.

One of the app's main accomplishments has been to reduce poaching. The platform rejects rhino sightings (in fact, Ossendryver claims the app has been directly responsible for saving numerous rhinos) and shares all its information with rangers and vets, who are able to attend to injured animals "that would have otherwise gone unnoticed...before the *Latest Sightings* community," according to the *Latest Sightings* website.[33]

Nevertheless, the popularity of Ossendryver's app has also garnered some controversy, with *TakePart* reporting in 2016 on

complaints from South African National Park officials that *Latest Sightings* and related apps "induce an unhealthy sense of eagerness for visitors to break the rules."[34] Officials attributed an increase in "incidents of speeding, wildlife roadkill, and road rage" to wildlife apps. *Latest Sightings* responded by pledging to work with South African National Parks officials but also pointed out "the tremendous benefits of sightings apps and social media to wildlife and tourism should not be discounted."[35] These benefits not only include the animals *Latest Sightings* has helped save and the research projects to which those using the app routinely contribute, but, as their statement explained, "the good that social media communities can do with the education about wildlife ... and the bringing of more tourists to our shores to see wildlife."[36]

As a creative entrepreneur, Nadav Ossendryver is passionate about building a community around the unique, authentic South African wildlife experience, and his success suggests vast potential for creative entrepreneurs in the fields of ecotourism and sustainable tourism in general. Perhaps the most conservation-oriented aspect of Ossendryver's innovation is how it enables people to connect *without* visiting, and potentially damaging, parks like Kruger. With *Latest Sightings*, fans of South African wildlife can watch baby cheetahs from screens thousands of miles away. They can stay connected, share and re-post, and spread the gospel of Kruger. And South Africa can benefit from its unique identity.

Riding Inside a Story

Mumbai native and creative entrepreneur Sanket Avlani felt that his birthplace—despite being the most populated city in India and the richest—had an identity problem.

Who gets to tell Mumbai's story? For citizens and visitors alike, the authenticity of experiences in a megalopolis like Mumbai suffers when access to creative expression lacks egalitarianism. Mumbai is also a city with significant chasms in equality, and these chasms lead to an atmosphere where the power to determine identity is consolidated among too few.

This is not merely a "soft" problem. With less opportunity to invest in Mumbai's creative identity, fewer people are incentivized to innovate Mumbai's economic destiny. "There's a huge gap in good design, everyone [in India] is very heritage oriented and not innovating," Avlani told *Forbes*.[37] For these reasons, Avlani left Mumbai to work at global design firm Wieden + Kennedy in London.

But Avlani didn't want to simply become another young creative who had abandoned Mumbai to design for global brands like Honda and Nike. "I was quite satisfied with the application of my skill, but I wanted to be relevant for India," Avlani told *Forbes*.[38] He decided to come back home and try to foster an ecosystem for young designers to have more of a stake in Mumbai's identity, and this sentiment flashed into an entrepreneurial vision in a space common to Mumbai life: the back of a taxi.

According to *Fast Co Design*, "over 50,000 taxis pick up at least 25 to 30 people every day"[39] in Mumbai. One of those people was Avlani, who in his daily taxi ride to work began to become fascinated by the redundant interior fabrics. All the taxis had the same floral and blocky prints because all the drivers bought from the same markets.

In this anonymity, Avlani saw a perfect example of Mumbai's dismissal of design as "pure function," but he also saw an opportunity. "This space can be more relevant, more contemporary and can

speak to people," he told *YourStory*.[40] What if these fabrics could tell stories? Even better, what if talented young designers could collaborate with taxi drivers to tell stories together? Young creatives could stay and contribute to Mumbai identity alongside taxi drivers, who routinely competed to stage authentic experiences.

So in 2015 he launched Taxi Fabric, a platform to showcase the work of young designers on the upholstery of Mumbai's classic "kaali peelis" (yellow black taxis). After a successful Kickstarter campaign and investment from his old bosses at Wieden + Kennedy, Avlani's company quickly caught fire, as social media fell in love with the colorful interiors and the stories behind them. *Forbes India* named Avlani one of its 2017 "30 Under 30",[41] and international outlets from *Slate* to *Fast Company* picked up the story.

Global followers, interestingly, powered much of this early buzz. Pushes from social media giants like Instagram and American design companies like Refinery29 "changed the game for us," Avlani told *The Hindu*.[42] Here was a case where the forces of globalization were in fact supporting a resurgence of local identity.

By 2016, Taxi Fabric had reupholstered over 200 taxis and rickshaws and collaborated with over 70 designers. They'd worked with Google and *Architectural Digest* and picked up sponsorships from global brands like Crest. Avlani was familiar with working with such brands from his time at W+K. But now, instead of Avlani designing *their* stories, they were sponsoring *his* support of authentic Mumbai stories. "The designers are local, the styles are inspired from all around the world, but the topic is still Mumbai," Avlani told *Mashable*.[43] Success allowed Taxi Fabric to branch out into a home decor line and a participatory design studio called Design Fabric to host workshops and events.

All the printing and fitting for Taxi Fabric is done regionally, and each design comes with an "identity label" that fills in riders on the story of the design and the designer's contact info. The designs themselves are inspired by ordinary Mumbai citizens, "from businessmen to children to vegetable vendors; and the personal stories of the cab drivers themselves," according to CityLab.[44] Passengers call designers to thank them, and drivers feel a renewed sense of ownership. Drivers also report that "riders often give them larger tips or stay in the taxi longer than usual,"[45] according to *VICE*. "Often, passengers make our drivers wait, so they can call their friends, take pictures, do repeat rides," Avlani told *The Hindu*.[46] This is participatory identity development—and the accompanying economic benefits—in action.

Taxi Fabric even showed up in a Coldplay video, with lead singer Chris Martin riding in a taxi that featured the work of Pakistani Samya Arif, a design that told a story of reunion between Pakistan and India. While the band received flak for cultural appropriation, Indians did celebrate the showcase of Taxi Fabric.

> " WITH A WIDER RANGE OF EMPOWERED STAKEHOLDERS, LOCAL IDENTITIES ARE STRONGER, MORE COHESIVE, AND—LIKE THE BACK OF A MUMBAI CAB— MORE CONNECTED TO THE AUTHENTIC, COLORFUL STORIES OF A PLACE AND ITS PEOPLE. "

ric. "Many were happy that the Taxi Fabric project was a part of representing the contemporary Indian culture," Avlani told *The Drum*.[47]

One of Avlani's biggest points of pride is how Taxi Fabric has tackled social issues through design, collaborating with TEDx on a design that features Indian sign language primers, an important social contribution in a country with a larger hearing impaired population than all of Europe. Meanwhile, Samya Arif's Coldplay-featured work led to an email from a UN representative "greatly appreciative of our efforts towards trying to bring about peace between two countries notorious for rivalry," Avlani told *YourStory*.[48]

The success of Taxi Fabric provides a blueprint for how creative entrepreneurs are introducing participatory design principles into regional branding. With a wider range of empowered stakeholders, local identities are stronger, more cohesive, and—like the back of a Mumbai cab—more connected to the authentic, colorful stories of a place and its people.

Flipping Winter

From steamy Mumbai, we now travel to frosty Winnipeg, where two creative entrepreneurs, chef Mandel Hitzer and architect Joe Kalturnyk, are disrupting the traditional constraints of seasonality to construct an innovative gastronomical and architectural experience authentic to the region, boosting tourism and helping Winnipeg embrace its sub-zero identity.

The story of Winnipeg's RAW:almond—an annual restaurant pop-up event constructed on the frozen ice of "The Forks," Winnipeg's famous intersection of the Red and Assiniboine Rivers—begins in what Joe Kalturnyk calls "the other Winnipeg." That's the impoverished urban center of the city where Kalturnyk was born in 1979. As a kid, he dreamt of escaping the frozen gloom because

"every band I listened to was from some other city, and everybody I'd heard about that made it from Winnipeg made it out," he said in a TEDx talk.[49]

But after stints in construction all over the world—from Arctic tundra to Pacific rainforests—Kalturnyk returned to Winnipeg for an MA in architecture. When he saw all the empty shop windows of his hometown, he realized that too many dreams of escape had hobbled the city. So in 2010 he started RAW:Gallery of Architecture and Design, as a "forum … where designers, artists, and architects could experiment with ideas … and the public could engage with them."[50] The gallery built community buzz, but too many artists Kalturnyk met still talked of jumping ship for New York and L.A. He realized Winnipeg needed something more innovative—and more true to its spirit—than a gallery.

That's when he met Mandel Hitzer, the owner-chef of an innovative restaurant called Deer + Almond. In Hitzer, Kalturnyk found a companion in Winnipeg passion. According to the CBC, Hitzer's business approach was all about "building community within the restaurant industry … to celebrate food and celebrate Winnipeg and Manitoba."[51] Hitzer's devotion to community and celebration of identity marked him as more than a restaurateur: he was a creative entrepreneur. So when Kalturnyk pitched the idea of a pop up restaurant "in the middle of winter in the middle of nowhere," Hitzer didn't reject the vision as crazy. He embraced the innovative celebration of "Winterpeg."

Historically, Winnipeg—and the entire province of Manitoba—is slow in the winter, to put it mildly. Locals split, and tourists avoid what they imagine as nothing but cold misery. But Kalturnyk believed Winnipeg's epic winters were part of what makes it unique.

"The myth of your city becomes your city," Kalturnyk said during his TEDx talk.[52] So he and Hitzer started RAW:almond in 2013, a "twenty-one day fine dining experience" in a temporary structure built on The Forks. Not on the banks but *on the river* itself.

Kalturnyk designed the structure, and Hitzer designed the menu. Before they opened, they weren't sure people would under-stand RAW:almond, so they scheduled days off on Monday and Tuesday and designated Wednes-day as a "soup only" day where people could "skate up for soup." They also faced resistance from local bureaucrats con-vinced their idea was too wild to meet various code requirements.

CONSIDER INVERTING regional "deficiencies" to discover regional assets. Turn everything on its head and ask, "Could there be a market for this?" You might sur-prise yourself!

But they met all the re-quirements, and word spread. When ticket sales opened, they sold out in a week.

Five years later, RAW:almond is a local powerhouse. Attract-ing over 2,500 people a year,[53] RAW:almond has been profiled in *The New York Times* and "franchised" to the small Manitoba town of Churchill.[54] In 2015, RAW:almond won the Tourism Industry Association of Canada's Innovator of the Year award.[55] Hitzer has used RAW:almond as a platform to raise money for charitable causes, and the restaurant has premiered the work of globally ac-claimed Winnipeg filmmaker Guy Maddin. The restaurant invites different chefs every year, showcasing gastronomical innovation both local and international, using the allure of their unique plat-

form to show how Winnipeg's food scene can stand fork to fork with the rest of the world.

While RAW:almond's success has led to Kalturnyk and Hitzer scouting other locations for expansion, they plan to take the "Winterpeg" brand—and the Winnipeg identity—wherever they go. "I'm most proud about adding an element to the city," Kalturnyk told Travel Manitoba. "That thing that Winnipeggers can be proud of and brag to their friends about when they're traveling—or their friends are traveling here."[56]

How has their success helped Winnipeg? A *Q4 2016 Economic Development Winnipeg Progress Report* noted that "Winnipeg's winter identity has experienced a welcome transformation of late, thanks in part to high-profile attractions validating Winnipeg's wintry allure." Singling out RAW:almond, the report noted that "over the last five years [The Forks'] winter weekend numbers have rivaled peak counts in July and August."[57]

The branding of Winnipeg as a "winter city" has also attracted industries looking to test equipment, including GE's icing-certifications for jet engines and New Flyer's zero-emission buses,[58] both of which require cold temperatures for proper testing. Plenty of cities around the world are cold enough to run these tests, but the efforts of Winnipeg's creative entrepreneurs to brand its cultural identity as *the* winter city helps lend authority to industrial branding. "Tested in Winnipeg" might soon be the same powerful shorthand as "California raisin" or "Perrier sparkling water."

Thanks to the efforts of creative entrepreneurs like Kalturnyk and Hitzer, "Winterpeg" is no longer synonymous with gloom. Instead, it now means innovative and authentic experiences that embrace the sensory onslaught of the deep cold. In his TEDx talk,

Kalturnyk tells the story of the restaurant's first night, when the heavy 30-foot table where all the guests would sit to eat was barely assembled and had yet to be flipped from sitting on its face a mere 20 minutes before service was slated to begin. Kalturnyk looked around and decided to put his creative entrepreneurial faith in community to the test. He gathered everyone in the makeshift igloo-like dome—staff, photographers from the media, and even patrons—and together they flipped the table.

If RAW:almond can attract thousands of visitors to the intersection of two frozen rivers, what *can't* creative entrepreneurs do to flip regional brands all over the world? As Kalturnyk says, "the myth of your city becomes your city." In Winnipeg, that myth is still cold, but now it's delicious too.

Unt(r)apped Opportunity :::::::::::::::::::::::::::::::::

As we said earlier in the chapter, unique regional identity is not just about tourism. Creative entrepreneurs understand how to export identity and brand regions as leading industry hotbeds. Such branding—if well-supported by local policymakers and stakeholders—can be the genesis of flourishing creative economy ecosystems. For a well known example, consider what *Lord of the Rings* director Peter Jackson did for the film industry in New Zealand.

But what if the rest of the world loves the identity you're exporting, yet the policymakers in your region don't appreciate or see themselves in that identity, and therefore aren't willing to invest in making such an ecosystem flourish? That's the dilemma of trap music, an innovative genre of rap born in Atlanta, Georgia. And it's the battle of Kevin Lee, a creative entrepreneur whose label Quality Control has made Atlanta ground zero of the next big wave in

rap—and arguably in the entire landscape of pop music.

Lee, who goes by "Coach K," was born in Indianapolis and grew up with a single mother who worked on the factory floor for RCA, pressing records. She filled the house with the newest music, including Sugarhill Gang's seminal "Rapper's Delight." Lee told *XXL* the record "hooked him" on rap and launched a life of creative entrepreneurship.[59] But it wasn't until he moved to Atlanta in 1997 that his talents synced up with a community of young creatives on the verge of a groundbreaking movement.

1997 was the year OutKast released the bestselling and critically acclaimed *ATLiens*, and Atlanta was already gaining a global reputation as a hotbed of rap. Reporter Phil W. Hudson told NPR's Rodney Carmichael that when he was in China, "it wasn't Coca-Cola that the Chinese knew us by. It was the Olympics and OutKast."[60]

Into this scene's burgeoning global reputation stepped Lee, who had studied economics at Saint Augustine University in Raleigh, North Carolina. Lee began managing a new crop of Atlanta rappers, and, as *XXL* put it, "developing his identity as a tastemaker who could take regional artists and repackage them for a larger audience."[61] These artists included the likes of Jeezy and Gucci Mane, both of whom shot to the top of the *Billboard* charts and sparked a frenzy for a new sound coming out of a city that's come to be known as rap's "third coast." That sound was "trap."

Lyrically, trap—named after the Atlanta term for both the places where drug deals take place and the feeling of being trapped in those cycles of drug violence—is even harsher than the bicoastal gangsta rap that preceded it. (And, trap is often criticized for its violent and misogynistic lyrics, a criticsm we share.[62]) Musically,

producers like Lex Luger, Southside, Shawty Red, and DJ Toomp innovated a sound that distorted the vintage kick drums of Roland TR-808 synthesizers, triple-timed the high hats, pitch-shifted the snare fills, and topped everything off with dark swooping strings. Don't fret if the music jargon is obscure. What's important to know is that the sound layered rule-breaking beat technology with authentic storytelling based on urban black life in a city that still struggles with a history of segregation and the largest income gap of any metro area in the U.S.

Needless to say, the practitioners of trap didn't exactly earn the keys to the city. But Kevin Lee recognized a pitch-shifted snare fill of enormous opportunity. In 2013, he and Pierre "Pee" Thomas co-founded Quality Control Music, a label that quickly developed a reputation for gathering all the stars of trap under one roof and innovating the scope and methodology of the "indie record label" as an entity.

These innovations include an industry-unique deal for distribution and marketing with an NYC entertainment company run by former Warner Bros. executives, as well as an in-house staff of producers, engineers, publishing agents, and managers. Quality Control Music is more than a record label; it's a "digital-age hybrid company," according to *Billboard*.[63]

Today, trap has become a mainstay of pop charts with pop idols like Cardi B proclaiming trap stardom and bridging the once niche music style into the mainstream.[64] Quality Control's roster of young superstars now commands global acclaim. The group Migos debuted at No. 1 on the *Billboard* charts, and they can make up to $45,000 a day at shows.[65] Grammy-nominated Lil Yachty— who spun the genre with a positivity sometimes referred to as

"bubblegum trap"—has signed endorsement deals with brands as wholesome as Target and Sprite. The sonic trappings of trap dominate nearly all the top pop and dance tunes. The genre has even spawned a popular TV show, *Atlanta*, which won the 2017 Golden Globe for Best TV Musical or Comedy Series.[66]

But creative entrepreneurial pioneers like Kevin Lee haven't felt the generosity bestowed by civic leaders to spinoffs like *Atlanta*, which earned hefty Georgia film tax incentives that powered its success. In a 2017 article for NPR, Rodney Carmichael explored the opportunity Atlanta (and Georgia at large) is missing to develop its trap music identity into a bonafide economic ecosystem. As Carmichael explains:

> The twice-as-old, homegrown music industry, on which [*Atlanta's*] plot is centered, still runs off an ecosystem largely unsupported by state funding or investment from the city's civic and corporate communities ... While local politicos and power brokers look outside the city for world-class inspiration, they often overlook the one thing the rest of the world looks to Atlanta for.[67]

In Carmichael's article, reporter Phil W. Hudson makes the point even more directly: "Why do we have this homegrown industry that we're not helping?" In his work for the *Atlanta Business Chronicle*, Hudson covered both music and industry and often wondered why the two didn't overlap. "If we catered to our music industry better and incentivized it more we might be able to get more record labels to come here and stay here and leave their offices here. It creates jobs and brings revenue to the state," Hudson told Carmichael.

A few politicians are beginning to recognize the power of Atlanta's homegrown creative identities, embracing the prospect of what Carmichael calls "hip-hop as an economic growth engine." City Councilman Kwanza Hall, for example, wants to formalize Atlanta's music industry and "considers the city's wealth of home recording studios greater innovation zones than Georgia Tech," according to Carmichael. That's the kind of creative entrepreneur embracing leadership all regions would be lucky to have.

Carmichael imagines "hundreds of hip-hop related businesses" for Atlanta, not only labels and studios but "consumer tech startups and media outlets." He points to Nashville as a model for a city that didn't invent country music but did develop a creative entrepreneurial ecosystem to brand the music and propel it to worldwide success.

While Carmichael is ultimately pessimistic about the prospects of a hip-hop Grand Ole Opry in a city where "racial baggage and class exclusion…criminalizes [hip-hop] in the eyes and ears of many in power," creative entrepreneurs like Kevin Lee continue to innovate. Whether policymakers catch up with trap or not, Lee and his fellow creative entrepreneurs have done more than certify their own

> **" LEE AND HIS FELLOW CREATIVE ENTREPRENEURS HAVE DONE MORE THAN CERTIFY THEIR OWN SUCCESS. THEY'VE TAKEN THE REINS OF ATLANTA'S CULTURAL IDENTITY, AND NOW IT'S UP TO THE CITY TO UNDERSTAND THIS LEADERSHIP FOR THE ECONOMIC OPPORTUNITY IT REPRESENTS. "**

success. They've taken the reins of Atlanta's cultural identity, and now it's up to the city to understand this leadership for the economic opportunity it represents.

Unforgettable Distinction

When policymakers try to take regional identity and creativity into their own hands, the results are often less than impressive. Consider the case of "West Mass," where the Economic Development Council (EDC) of Western Massachusetts hired a branding agency to freshen up the region's identity.[68] This agency made a widely panned commercial featuring a nonsensical collage of activities with dubious connections to the region, which they tried to epitomize as "West Mass" culture. After an outcry from area citizens about the inauthenticity of both the commercial and the name, the EDC quietly reverted to "Western Mass"—a name everyone already used.[69]

But you can't blame West Mass for trying. As Robert Govers discusses in *Place Branding*,[70] the hyper-competitive experience economy has made regional stakeholders desperate to contend in an era where places need brands as strongly as products need them, if not more. Govers sympathizes with place branders struggling to juggle disparate "cool factors" and manufacture identities that impossibly combine adventure, exoticism, entertainment, wellness, natural beauty—the list goes on but falls apart for lack of authenticity. As Govers says, "Is not there more to this? In this post-modern era, should one not be looking for differences, subjectivity, social contact and otherness?"

Because when we look for authentic regional identity in the Fourth Industrial Revolution, we look for difference. We look for

multisensory "hereness" that tells a story. Experiences are staged, but that doesn't mean they are fake: it means they are arranged to invite participation. From the street spectacles of the George Town Festival to *Latest Sightings'* streaming videos of baby cheetahs at Kruger National Park, contemporary "being there" is all about doing and interacting—even when you're interacting with an essence from afar.

Creative entrepreneurs intuitively understand this, whether they're inspiring storytelling collaboration through Mumbai taxi upholstery, inviting visitors to chow down on the icy winters of Winnipeg, or innovating beats that export Atlanta's authentic culture. What makes creative entrepreneurs so vital for developing and exporting unique regional identities is that they respect heritage, but they don't stop there. They know how to keep regional stories evolving without losing authenticity. They know how to develop regional brands that attract thousands of people and remind them what exactly a "place" should be: an experience you can't find anywhere else.

11

NO FEAR OF
the Future

Daring to Ask 'What If?'

We began this book with a sober look at the future. Exciting and dizzying in equal measures, the future is a landscape of potent, even paralyzing, uncertainty. In Chapter 2, we discussed some of the technological and social upheavals—automation, resource scarcity, instantaneous global interconnection—that mark the dawn of the Fourth Industrial Revolution.

However, we don't believe we need to fear the future. We believe the best version of the future will be invented, and creative entrepreneurs will play a key role. With their unique combination of market savvy and visionary imagination, creative entrepreneurs reject the idea of the future as a wave that will sweep us powerlessly along. Instead, they understand disruption and sea change as opportunity. They envision the leaps that will manifest innovation as economic solutions. And they take those leaps. Especially when playing an integral part of healthy entrepreneurial ecosystems, the success of creative entrepreneurs translates to the growth and modernization of local economies.

Over the last seven chapters, you've met creative entrepreneurs all over the world who are tackling seven of tomorrow's economic

challenges today. Creative entrepreneurs are:

1. Creating meaningful, well-paying jobs and re-defining the nature of work toward more personal fulfillment.

2. Diversifying economies and boosting their resilience.

3. Influencing and attracting new patterns of private investment.

4. Attracting a diversity of new faces to entrepreneurship.

5. Bringing rural economies into global relevance.

6. Empowering underserved youth.

 Developing regional identities for local attraction and global export.

We're not alone in our call for investment in creative entrepreneurs and the creative economy. The World Economic Forum calls the creative economy "a vital and growing engine of growth and employment in many countries" whose sectors are "becoming a key force in entrepreneurship and innovation, helping to boost social development and employment."[1] UNESCO touts the creative economy as "highly transformative … in terms of income generation, job creation and export earnings,"[2] while influential global consulting firms like PricewaterhouseCoopers have concluded that innovations in digital content distribution have been responsible for the "emergence of a cultural renaissance."[3]

Nor are we alone in highlighting the significance of creative entrepreneurs who drive innovation and growth within this

economy. The World Economic Forum singles out "inspiring entrepreneurs" as one of the five key factors for "enabling the creative economy," declaring these entrepreneurs the "catalysts" who "demonstrate what is possible while inspiring and training other creative entrepreneurs."[4]

Our investment in creative entrepreneurship did not arrive in a single Eureka moment. Like the projects of the creative entrepreneurs we accelerate and support, our process was an evolution, replete with fits and starts and dramatic pivots. Even our name—Creative Startups—wasn't there at the beginning. Before we were Creative Startups, we were the Global Center for Cultural Entrepreneurship (GCCE). And back then, we were focused almost exclusively on the cultural sphere of creativity. We were stuck in an old way of thinking about arts and culture. The Great Recession changed all of that.

How GCCE Became Creative Startups

In 2010, New Mexico was still in the throes of the Great Recession. Its traditional economic engines—oil and mining, for example—were facing the pressures of globalization, and our state was not immune to 2008's U.S. housing crisis. As the *Albuquerque Journal* reported, "Government employment dropped and the loans that supported construction employment almost disappeared."[5] Artists were coming to us to borrow $25 or $50 to be able to buy gas and travel to an art show in hopes of making enough at the art show to support their family for a month.

This environment highlighted how broken the arts and culture funding model had become. The bigger picture included entire communities shifting away from cultural and creative assets. If art-

ists can't support their families via artmaking and sales, they will take jobs at a local mining company or call center, or move into urban centers where they can find work. If youth are not encouraged to become creative entrepreneurs, leveraging their passion for self-expression and a natural sense of innovation, they may divert their energy and frustration into destructive social behaviors. The model for funding creativity was broken - and our communities were losing out.

> " **THE GREAT RECESSION MADE IT CLEAR:** GRANTS AND PATRONAGE ALONE CANNOT FUEL THE GROWTH OF AN INCLUSIVE AND WEALTH-GENERATING GLOBAL CREATIVE ECONOMY. "

The Great Recession made it clear: grants and patronage alone cannot fuel the growth of an inclusive and wealth-generating global creative economy.

At GCCE, we understood that New Mexico's creative economy was a source of untapped economic potential. As we told the *Green Fire Times* in 2012, "12% of New Mexicans already work in the creative/cultural economy … it is a cornerstone of our economic foundation." John Howkins's *The Creative Economy* had inspired us, as had Edna Dos Santos's 2008 report on the creative economy for UNCTAD.[6]

The data supporting the idea that creative entrepreneurship could catalyze the growth of the economy were there, but we still hadn't pinpointed what this catalyzing force was. During a discussion about our organization's strategic direction, a board member asked: "What have you noticed that your mind keeps coming back

to?" That question made us realize that our favorite stories and experiences all shared one thing in common: high potential creative entrepreneurs. Our work with Patricia Michaels, Lee Gruber, and Norma Naranjo ignited an epiphany: culture and heritage was only one sphere of the creative economy. The entrepreneurs who were forging scalable ventures were embracing technology and leveraging culture as intellectual property and inspiration, a resource for innovation. We realized that through focusing on entrepreneurs with the drive and talent to go global, we could spark scalable economic development emerging from local talent.

With their forays into technological innovation and their creation of new markets, these creative entrepreneurs had the potential to build high growth companies beyond the traditional domain of "culture and the arts." In fact, these creative entrepreneurs had the potential to be true economic powerhouses. They were rejecting incremental change and reactionism in favor of bold new thinking. It hadn't yet occurred to us that this might be a globally applicable concept—we just knew that New Mexico needed exactly this kind of shot in the arm.

An opportunity to experiment with embracing creative entrepreneurs came when one of GCCE's partners—New Mexico's Established Program to Stimulate Competitive Research (NM EP-SCoR)—invited us to request support for an entrepreneurship institute as part of their grant application to the U.S.'s National Science Foundation. The grant needed to implement economic and workforce development programs so they turned to us. With the idea in mind that we wanted to do something with creative entrepreneurs, we looked for models of entrepreneur development in other sectors, and we discovered an emerging model for entrepre-

neurial support in the tech sector: the startup accelerator.

However, when we surveyed the landscape for similar programs in the creative industries, we found they didn't exist. Nobody was doing a creative entrepreneur accelerator where the goal was to build growth companies, founded and led by creatives. Everything was still restricted to "how artists can do accounting" and "how poets can organize their files."

So we decided to build our own accelerator. We knew we had to get great mentors, so we asked people like Alan Webber, founder of *Fast Company*, and Steve Arnold, a leading venture capitalist. We knew it needed to be flexible enough to attract entrepreneurs who couldn't

> " OUR VISION INCLUDED AN OPENNESS TO ATTRACTING ENTREPRENEURS FROM ALL OVER THE WORLD; **WE UNDERSTOOD THE BEST COMPANIES DON'T DEPEND ON ZIP CODES.** "

easily travel, so we built an online curriculum. A year later, the funding came through, we had a clear vision, and our accelerator was ready.

We were still thinking this program would mainly attract entrepreneurs in New Mexico. We hoped a few people from outside the state would apply, but our main focus was developing our regional economy. That being said, our vision included an openness to attracting entrepreneurs from all over the world; we understood the best companies don't depend on zip codes. We knew a global program would be more attractive to the best entrepreneurs, and a global program would in turn empower local entrepreneurs to be

globally competitive. We also knew we didn't have all the pieces we needed locally for a true entrepreneurial ecosystem. We needed to bring in all the connecting pieces and build relationships among the creative economy elements.

With this organizational ethos in place, we put out the call for applications. Our goal was to get 30, but we had a slow start. Over six weeks, we fretted as only a few applications trickled in. Five days before applications were due, we only had nine completed applications. That's when a friend who runs an accelerator in Seattle asked us what turned out to be a crucial question: "How many have *started* an application?" We had no idea, so we emailed our application platform—Submittable.com—and asked. The number they gave us blew our minds: 119. We scrambled and proactively emailed all these applicants-in-progress, and we ended up exploding our original goal, getting 57 applications, in only our first year, from all over the world.

Our small team of three (at that time) pulled off that first accelerator. It was a good learning experience, and the startups loved it, giving us universally positive feedback. People began paying attention to us: we were getting an inquiry a week about applying, and an inquiry every other week about bringing the accelerator to different regions around the world.

Fortunately, we had the foresight to begin collecting data on participating startups from the outset. Our first impact report in 2015 analyzed our early results. Then, with a generous grant from E. M. Kauffman Foundation, we built a robust evaluation platform that scaled to all accelerator sites. Three years later, we have data from working with over 110 startups, across four years. Our pre and post data tell a story about the shared success that comes from

having diverse entrepreneurs come together to shape one another's success. More broadly, we have learned that fostering knowledge and skill development in creatives opens an entire realm of economic opportunity. Instead of only teaching creatives how to manage small businesses, we know now that we can empower them to start growth companies with global reach. Instead of assuming a young architect needs to get a job at a traditional architecture firm and have an "artistic hobby" in VR, we can empower her to build a VR architecture and design company that employs hundreds of creative people.

These were the kinds of entrepreneurs we met at that first accelerator, and they helped us realize our true passion, which became the new name of our organization: Creative Startups.

Creative Startups: Today and Tomorrow

Today, our accelerator is the only one in the world focused exclusively on founders with professional or academic backgrounds in creative disciplines. The success of Creative Startups alumni continues to renew our motivation. Every day brings new excitement as we check in with our 167 creative entrepreneurs and meet the people taking up the 410+ new jobs they've produced. Whether they're 3D printing pinball machine modifications in suburban New Mexico, revolutionizing culinary trends in Kuwait, or designing garments that help people with implanted medical devices live with less pain and more style, the entrepreneurs we work with are redefining possibilities across industries and geographies. They're shattering barriers for women and minorities, and they're changing the rules for local economies to capitalize on creative heritage and spread technological innovation. Communities all over the

world are inviting us to bring Creative Startups to their region, from leading sessions at the Global Entrepreneurship Conference in Malaysia to launching the first U.S.-based wing of the Creative Business Cup, a global competition described as the "United Nations of creative entrepreneurs."[7]

We began the journey to become what Creative Startups is today with the same question that began this book: where will the world go? Are we doomed to an uncertain future, or can we embrace the possibilities of the Fourth Industrial Revolution? These are big questions; we are now confident the answers are rooted in the essential qualities that distinguish humanity itself: originality, creativity, and the daring to ask "what if," to solve old problems with dreams of new connections.

As we close the book, we will introduce some practical first steps for stakeholders and creative economy leaders to grow and support creative entrepreneurship in their communities. But first we want you to meet one last round of creative entrepreneurs. We saved this particular group for last because we believe their stories showcase the edges of possibility. These stories are not anchored to specific economic challenges, though each of these creative entrepreneurs represent economic opportunity for the communities into which they've integrated.

But most importantly, they represent optimism about the future. They motivate and inspire. They show us how the combination of innovative technology and powerful, resonant stories keeps us connected to our heritages and fuels our economic futures.

After all, we need to make a choice about which future we invest in. Do we invest in a future that rides the models of the past until they corrode into obsolescence? Or do we invest in the cre-

ative visionaries forging a new path forward? How can we ride the wave of the future instead of drowning in the undertow of "how we've always done things"? These final three creative entrepreneurs do more than show us answers; they move us with their solutions.

A New Way to Know Each Other

When bestselling *Eat, Pray, Love* author Elizabeth Gilbert set out to write a book about creativity, she talked to many creatives about the nature of their imaginative impulses, and she discovered something surprising: creative people don't brim with passion and inspiration like we might imagine. Instead, they are filled with a quieter urge: curiosity. "Passion burns hot and fast, which means it can come and go," Gilbert told *New York Magazine*. "Curiosity is so accessible and available, every single day."[8] And one constant curiosity for creatives is curiosity about others.

Carrie Shaw was a student at the University of Illinois in Chicago when her mother was diagnosed with early-onset Alzheimer's. Shaw and her sister became their mother's primary caregivers. As empathetic creatives, they not only wanted to help their mother but wondered deeply about life through her eyes. What was she thinking? Feeling? How had Alzheimer's changed her perception of the world?

Shaw's career took her through medical illustration and a master's degree in biomedical visualization, and she never stopped being curious about these questions. That's why she founded Embodied Labs, which creates virtual reality experiences that simulate medical conditions. These experiences help healthcare professionals and families experience what it's like to be the people they're treating and loving.

Like many creative entrepreneurs, Carrie Shaw is a worldbuilder—it's just that for her, the brave new world is another person. "VR puts you in this world and that creates empathy," Shaw told *Forbes*. "Which has been shown to lead to better communication skills and professionalism for the healthcare workforce."[9]

Investors and stakeholders agree. Early demos impressed audiences considerably, with Embodied Labs winning hackathon and startup competitions from California to North Carolina. Dr. Leslie Sacson, founder of the University of Southern California's Center for Body Computing, gave *Forbes* some insight into why a recent Goldman-Sachs report predicted that the market for virtual reality in healthcare will reach $5.1 billion by 2025:

> The Embodied Labs team took us on the type of experiential ride that makes VR the ultimate medical empathy machine … It will change how we treat patients by providing an immersive experience that creates emotional intelligence and ultimately more compassionate care.[10]

Shaw and her team recognize that technology without narrative makes for less relevant experiences. That's why their powerful VR film "Alfred"—in which the viewer experiences life through the eyes (and hands) of an elderly man losing his hearing and vision—is such a vital tool for healthcare professionals. In "Alfred," the viewer is immersed in the character of Alfred and is able to experience—rather than simply witness—his struggles. When Alfred's hands shake during a test or knock over a wineglass, the viewer's hands do the same. As *ChicagoInno* reported, participants feel embarrassment and frustration, giving them empathetic

memories that will help them more richly understand what their patients go through.[11]

We met Shaw when Embodied Labs participated in the Creative Startups Winston-Salem Accelerator. On the strength of their VR demo and business model pitch, they took home the top prize of $25,000. What set Embodied Labs' VR experience apart was its emphasis on connecting with people within a story. "In the same way that being part of Creative Startups opened our eyes to our business possibilities, we are working to help healthcare open its eyes to better care for vulnerable patient populations," Shaw told *Lioness Magazine*.[12]

Since their win in Winston-Salem, Shaw and her team have been busy—and in demand. Along with numerous technology awards and speaking invitations, Embodied Labs has been featured on PBS and licensed use of The Alfred Lab to both health science education programs and long-term care facilities.

> **"HUMAN CONNECTION WILL ALWAYS BE THE HEART OF OUR BEST VISIONS, AND AT THE HEART OF OUR THRIVING.** THAT'S WHAT CREATIVE ENTREPRENEURS LIKE CARRIE SHAW UNDERSTAND."

They train diverse teams on how to use VR—nurses, art therapists, HR staff—to better connect with patients, students, and customers.

The future of health will involve plenty of big-data pattern sifting and new frontiers of artificial intelligence, everything from therapist chatbots to robot caretakers. But human connection will always be the heart of our best visions, and at the heart of our

thriving. That's what creative entrepreneurs like Carrie Shaw understand. And that's why they're building technological solutions that don't skip past our essential desires for empathy.

Shaw knows that the market will reward innovation that treasures humanity. When Embodied Labs won first place at the Creative Startups Accelerator, Shaw dedicated her win to her mother. In huge industries like healthcare, where existing infrastructure can sometimes stifle creative solutions with regulatory bureaucracy, the entrepreneurship of Embodied Labs is the disruptive force necessary to keep healthcare relevant: looking within to our deepest relationships, and looking ahead to the future of human connection.

From Recycled Rubber to Foot Fashion

Bethlehem Tilahun Alemu did not invent the idea of making shoes from recycled tires. For years, Ethiopians have been crafting "barabassos" from salvaged rubber. Long before sustainability became a buzzword, the barabasso existed as a symbol of Ethiopian ingenuity and environmental awareness.

The innovation Alemu brought to the barabasso was—you guessed it—creative entrepreneurship. Not only did Alemu enhance the utilitarian barabasso with cotton, leather, and heritage design, she also built a company that empowers artisan labor and leverages digital distribution channels to compete in the global fashion marketplace.

Alemu grew up in Zenabwork, a village on the outskirts of Addis Ababa. The daughter of an electrician and a cook, Alemu saw how traditional talents in her village struggled to translate themselves into viable jobs, leaving many overly dependent on foreign

aid. After a career in accounting and sales, she wanted to develop "well-paid meaningful work" for her community "while leveraging their immense creative skills," she told PRI.[13]

She found inspiration in the local heritage of artisanship and waste management. "For people to be innovative ... they don't have to really travel a long way or copy somebody's business idea," she told Reuters.[14] In 2005, she started soleRebels, a footwear company that uses traditional loom techniques and locally-sourced and recycled materials to produce fashion-forward apparel. From the beginning, Alemu aimed for a net zero carbon footprint and a meaningful work environment for her employees, paying them three times the "industry average wage for similar work in Ethiopia," according to PRI.[15]

Committing to an all-local approach, Alemu collected discarded tires, sourced homegrown cotton, and even incorporated camouflage "cut from old army uniforms," according to *The Guardian*.[16] Alemu also established direct negotiation and coordination with online retailers—eschewing outsourcing that would siphon off revenue—and took advantage of online tools to offer user customized designs.

In classic creative entrepreneurial fashion, her respect for heritage artisanal techniques did not slow her knack for innovation: soleRebels developed "new thread types" and "a new weave technique that gave birth to a new, more breathable and absorbent fabric," Alemu told *Knowledge@Wharton*. As Alemu explained, innovation is not just about brand new technology but "is in fact substantively improving the state of what was before."[17]

Alemu's vision captured the imagination of the global footwear market—and a hefty slice of the market share as well. Since 2005,

soleRebels has grown to annual revenues of $15 million, with projections to reach "over $200 million in revenues by 2019," according to Reuters.[18] The only company of its kind to earn World Fair Trade Organization certification, soleRebels shoes have been sold in both major retailers like Whole Foods and Urban Outfitters, as well as proprietary brick-and-mortar stores across 55 nations, from Spain to Taiwan to Silicon Valley.

Alemu is also succeeding in her goal to empower her community. With high production demands from retail partnerships and robust online sales, Alemu has created over 1,200 jobs, and *CNN* reports that 3,000 more full-timers will come onboard by 2018, upon the completion of a new solar-powered production facility.[19] soleRebels also provides health and education benefits to its employees, many of whom have gone from chronic underemployment to sustainable lifestyles based on lifelong skills. "We have embraced the idea that tradition and innovation go hand in hand," Alemu told *Ynaija*. "Yesterday's hand loomer of fabrics is tomorrow's textile innovator; yesterday's cobbler is tomorrow's added value shoe artisan."[20]

Despite her success, Alemu is not resting on her laurels. In 2016, she launched a new coffee brand, Garden of Coffee, that aims to disrupt the industry with source roasting and a "total realignment of the value chain"[21] that boosts the share Ethiopian bean suppliers receive by making the Ethiopian identity more visible (and therefore valuable) in the market. As a consultant, Alemu's major feather-in-the-cap has been the Made By Ethiopia initiative, which The EVE Project credits with creating "over 100,000 new job opportunities and over $1 billion in export revenue."[22] No wonder *CNN* ranked her alongside luminaries like Coco Chanel as one of

the 12 female entrepreneurs who have "changed the way the world does business."[23]

For Alemu, changing the way the world does business means investing in the future of the community she grew up in, whose fortunes she has radically boosted with the success of soleRebels. She believes that other creative entrepreneurs can learn from her model to propel their own communities. "If I put up a sustainable way of working, a sustainable lifestyle brand, then people will aspire to follow that lead," she told Reuters.[24]

soleRebels proves that so-called "developing nations" can build global brands and economic base jobs. And the future of this approach is creative entrepreneurship. "It is not footwear we are producing," Alemu told Reuters. "It is a kind of art." Alemu sees a future for Ethiopia beyond what the soleRebels website calls "low value commodity exports." Instead, creative entrepreneurs offer a future where all communities can "control [their] own destiny by rising up the value chain and exporting higher value branded finished goods."[25] Alemu sees the potential for soleRebels to become the Nike of Africa, with consumer loyalty rooted in their desire to participate in a story of Ethiopian success, and Alemu's track record has proven her ability to grow without compromising her values.

Bethlehem Tilahun Alemu represents the creative entrepreneurial spirit of embracing the future by innovating the past. "My driving passions," Alemu told the Young African Leaders Initiative, "are sharing Ethiopian cultures with the world and finding exciting ways to keep these cultures vibrant and fully relevant."[26] Alemu exports Ethiopian heritage with an eco-friendly product that empowers her community and— rolling along with recycled rubber

and beautiful designs—demonstrates the future of how to showcase local identity in a global market.

The Fungal Future of Manufacturing

If recycled tire shoes aren't audacious enough, how about mushroom plastic? That's the vision of Eben Bayer and Gavin McIntyre, the creative entrepreneurs behind Ecovative Design, a biomaterials company out to disrupt the basic assumptions of manufacturing and "rid the world of toxic, unsustainable materials."[27]

McIntyre and Bayer met as students at Rensselaer Polytechnic Institute (RPI) in Troy, New York. McIntyre is the son of two Brookhaven National Lab scientists; by the age of 20, he knew how to steer a particle beam. Bayer, meanwhile, grew up in Vermont with a writer mom and a maple sugar farmer dad. He spent his time boiling sap and building sugar shacks out of scrap metal. His dad's maple farm was also the first place he noticed the durability of mushrooms, according to *The New Yorker*.[28] Every spring, he would see how mycelium—the fabricy mushroom root networks whose texture resembles the top of a dandelion—would grow between wet wood chips fusing them into huge clumps. Little did Bayer realize the annoying chore of pitchforking these chips apart would later inspire a million dollar company.

In an RPI class called "Inventor's Studio," McIntyre and Bayer kept failing to impress their professor, Burt Swersey, himself an inventor of medical equipment for burn victims. Their task was to patent and launch a business-ready solution to a significant global problem. Yet none of their ideas were big enough for Swersey. Then one day Bayer remembered his childhood mycelium. What if he could mass "produce" the annoying phenomenon from the maple

farm, combining agricultural waste with mushroom roots to create tough, eco-friendly biomaterial? When Bayer showed Swersey the results of an experiment with a simple DIY mushroom kit, Swersey immediately saw the potential. As he explained to *The New Yorker*:

> It's … this amazing piece of insulation that had been grown, without hydrocarbons, with almost no energy used. The stuff could be made [from] almost any waste materials … and it wouldn't take away from anybody's food supply, and it could be made anywhere from local materials, so you could cut down on transportation costs. And it would be completely biodegradable! What more could you want?[29]

Swersey persuaded Bayer and McIntyre to abandon stable career paths in architecture and mechanical engineering to bootstrap a startup. However, investors couldn't understand the potential of their vision—not an uncommon problem, as we've discussed earlier in the book. So Bayer and McIntyre turned to an alternative path: competitions and accelerators in the same vein as Creative Startups. A $750,000 win at the Postcode Lottery Green Challenge funded a prototype,[30] and in 2008 Ecovative Design was off and running.

A decade later, Ecovative's success has proven those skeptical investors very wrong. According to The Lemelson Foundation, Ecovative is the first company to "commercialize renewable materials made from fungi."[31] In 3 large upstate New York factories, Ecovative employs 80 people and brings in several million dollars a year in revenue.[32] They sell their compostable, sustainable, ful-

ly grown packaging materials to global corporations like Dell and Crate and Barrel. Their grow-it-yourself (GIY) consumer kits have inspired mushroom lamps, mushroom slippers—you name it, you can grow it. From mycelium insulation to biodegradable drones, Ecovative is revolutionizing the future of nothing less than how things are made.

The major implications come into focus when one considers the impacts of current construction practices. As *Forbes* points out, "40% of global carbon dioxide emissions are linked to the construction industry" and "residential and commercial building contributes up to 40% of landfill wastes."[33] Biofabrication firms like Ecovative are poised to upend all the old conversations about renewability, waste, and emissions.

For Bayer and McIntyre, the big goal is about more than making things; it's about what happens to those things after they've been around a while. They believe Ecovative products will not only transform the sustainability of basic manufacturing practices but also dramatically alter any situation that calls for materials to last or

" FROM MYCELIUM INSULATION TO BIODEGRADABLE DRONES, ECOVATIVE IS REVOLUTIONIZING THE FUTURE OF NOTHING LESS THAN HOW THINGS ARE MADE. "

respond to environmental conditions. "For instance, if there were an issue, say, a leak in your roof. This material could react to that leak and self-repair,"[34] McIntyre told WAMC. They're also working on programming colors into the organisms. But a process based on an organism's natural metabolic growth is not only responsive; it's

also dye-free and energy-neutral.

Ecovative isn't content with the bare minimum of environmental "standards." They shoot for exemplary. "I think the biggest achievement we can strive for as a society is 'steady state,'" McIntyre told the Plasticity Forum. "A point where we're not taking out more than we're putting in."[35] The mycelium that Ecovative grows in a roughage of discarded stalks and husks might soon consign Styrofoam to the ash heap of history. And maybe Ecovative will be able to recycle those ashes as well. As Bayer told The Lemelson Foundation, "We're giving customers a nutrient, not a pollutant, for their neighborhoods."[36]

With technological innovation and entrepreneurial ambition, the heritage practices of Eben Bayer's maple farm roots have "spored" a creative future for manufacturing. "Let's make products that people can actually experience and buy that are beautiful,"[37] Bayer told *VICE*. Thanks to the familiar hallmarks of creative entrepreneurship—collaboration between complementary skillsets, early mentorship in the form of Burt Swersey, and a supportive ecosystem of accelerators and competitions designed to reward market-ready solutions that might slip past overly cautious investors—Ecovative Design is growing tomorrow's solutions. Imagine your grandchildren telling their grandchildren a bedtime story of cardboard landfills and petroleum wasted on plastic forks. It might sound so unbelievable, so spooky, the kids will ask to keep the mushroom lamp on all night.

Winning the Fourth Industrial Revolution

To envision a sustainable future that opens up our free time and eases our economic anxiety takes us full circle to one of the

core premises we introduced in Chapter 1: the most rewarding hours of our life are the result of—and result *in*—creativity. In a thought-provoking 2014 article for *Scientific American*, psychology scientist Scott Barry Kaufman explored the history and future of creativity. Citing the reverence for creativity from historic heavyweights like Kant (for whom "exemplary originality" was a key component of "genius"), Kaufman declares that creativity "drives progress in every human endeavor, from the arts to the sciences, business, and technology."[38]

Creative entrepreneurship, likewise, drives progress in every economic endeavor, keeping us connected to the best versions of ourselves, to the clearest histories of where humanity has been, and to the brightest stories of what humanity can become. At Creative Startups, we convene people from around the world to celebrate creative entrepreneurship. We relish in what we can learn from our differences to build a shared future. Through our accelerators, bootcamps, collaborations, and other projects, we aim to catalyze more entrepreneurship in the creative economy—and more creativity in the entrepreneurial community—to the benefit of all the gatherings people form, from the teeming diversity of regions and communities, to the nurturing legacies of families and partnerships.

Whether creative entrepreneurs pass through our programs or others, we are proud to be part of the brightest vision for our global economic future. The jobs of tomorrow will result from the chemistry of human creativity mixing with the indomitable entrepreneurial spirit. The companies of tomorrow will be creative companies. Creative entrepreneurship brings forth leaps in innovation, moments of inexplicable beauty, and meaningful connections to

people, places, ideas, and ourselves.

Making our way to the next economy will require grit and steadfast determination. We will have to persist despite unexpected challenges and setbacks. And while our current angst is understandable, it isn't solving any problems. We think it's time to focus on a future with places like Meow Wolf's House of Eternal Return instead of refried corporate amusement parks. As we said in Chapter 1, creative entrepreneurs all over the world are helping communities invent their next act. And they're not doing this alone. We're excited that emerging ecosystems of investors, policymakers, economic developers, and stakeholders of all kinds are ready to shake free from nostalgia and anxiety to rally toward a creative future.

Are you ready to join us? We hope so! In our final chapter, we will offer concrete "first steps" for enabling creative entrepreneurship in your community. It doesn't matter where you are, how big you are, or what shackles of economic legacies you might be struggling to cast off. All that matters is that you're ready to embrace creative entrepreneurship—its vision, passion, networks, and knowledge—to win the Fourth Industrial Revolution and invent a future of success.

12

PRACTICAL TIPS FOR
Developing Your Creative
E n t r e p r e n e u r i a l
E C O S Y S T E M

Ecosystems Aren't Easy

As promised, our final chapter is devoted to practical steps toward establishing, developing, and nourishing your local creative entrepreneurial ecosystem. We say steps *toward* because ecosystems are complex systems with dynamic interdependencies. As Andy Stoll told us, successful entrepreneurial ecosystems must essentially develop their own culture:

> A culture that says collaborate, trust each other, think, dream big, trust or crave the ideas, try, fail, get up, start over again—it's that type of system that allows entrepreneurs to find the knowledge and resources they need—and where we see the most success. It can't be built by one institution or one individual. It takes a collaborative effort across the community to make it work.[1]

Every ecosystem is different. No single prescription is going to energize every variety of regional economy. Though these steps follow a thematic arc and hew to the ecological concepts we introduced in Chapter 3, there is no correct "order" in which they

should be completed. And though these steps certainly interlock, a failure in one area will not topple efforts in another.

That being said, this list might seem intimidating at first. But we don't believe this intimidation is out of keeping with the optimism we expressed in Chapter 11 or the inspiration of the stories throughout the book. Instead what this list reflects is the basic reality that developing a creative entrepreneurial ecosystem is a complex undertaking. With 25 years of experience, we understand this firsthand.

The path has been steep to the results our programs and startups have achieved. In Chapter 11, we told the story of how we became Creative Startups. Many startup accelerators—no matter their sector—don't last this long. As former TechStars managing director David Tisch told *Fast Company*: "The majority of accelerators are not good for companies and will fail."[2] On LinkedIn, Andy Cars details nine reasons why most accelerators (like most startups) don't make it:[3]

1. They don't attract the best startup teams.

2. They lack a strict and streamlined selection process.

3. They don't specialize at all or they specialize in a way that is "out of touch with the local investor and mentor networks."

4. They don't attract top entrepreneurs as mentors.

5. They don't build large active investor networks.

6. They don't recruit an experienced team to run and market the accelerator.

7. They don't scout for a large enough pool of participants or they get bogged down in arbitrary rules.

 (Note that while Cars considers "a balanced gender and ethnic perspective" and "inclusion of underserved groups and individuals is prioritized" as examples of arbitrary rules, we argue that striving for greater inclusion strengthens programs, for reasons we explain at length throughout the book, particularly in Chapter 7) .

8. They don't nurture a "loyal and generous alumni network."

9. They lack a strategy to measure their results.

That's a long list, and the degree of comprehensive effort needed to overcome each of those pitfalls not only contributes to accelerator failure, it also goes a long way toward explaining why entrepreneurial ecosystem development efforts are so daunting for local stakeholders and policymakers to take on alone.

The solution is to leverage your expertise and capabilities and partner with other experts for the rest. **Interdependency** is a good thing! At Creative Startups, we are still standing - and growing - because we are well-aware of the challenges Cars outlines. We devote significant resources to solving those challenges through partnerships and meaningful community relationships that allow us to find and select the best creative companies. And, by homing in on what we know we're good at and staying focused.

The following 19 tips are borne of that focused effort. In each of these tips, we refer back to stories we discuss throughout the book that provide excellent examples, and we offer solutions large and small. These 19 tips are not a "cheat sheet" or a replacement for

establishing meaningful partnerships. In fact, many of them explicitly urge strategic, **mutually beneficial** partnerships and communication as the fastest avenues to ecosystem development. We encourage you to read these tips as launching pads, nuts-and-bolts demystifications of creative entrepreneurial ecosystems and how to develop them.

In the end, we believe that the future will (and should!) look a lot more like Meow Wolf's House of Eternal Return and a lot less like strip malls or abandoned bowling alleys or obsolete factories. Here are 19 tips to pave the way toward ecosystems where that future can grow.

19 Tips: From Finding Leaders to Celebrating Failure

1. **Find the entrepreneurial leaders:** The creative entrepreneurs you've met in this book have been more than artists with clever ideas, more than shrewd business thinkers. They are **disruptive** thinkers, do-ers, visionaries. They combine both of these qualities, and they add leadership. Consider hotelier Mohamed Belghmi from Chapter 4, who led his region and his own business in a new direction when he saw a creative opportunity to build Atlas Studios.

 So find the **endemic** leaders in your community - and attract or cultivate new ones. Find the catalysts, change makers, entrepreneurs, the ones who are different, who are "weird and wonderful," and ambitious. Turn to the people who are entrepreneurs in whatever sector you're in and convene them with other entrepreneurs. Be deliberate about making room and making time for conversations that make connections.

When someone wants to meet, say yes and wonder what you'll get out of it later. Re-meet and re-categorize people you might've filed away as "just" artists, "just" creatives. As TechStars co-founder Brad Feld suggests,[4] borrow a page from the playbook of university professors and hold open "office hours," blocks of time where you make yourself explicitly available to new people and new ideas.

Consider Ler Devagar's meeting with creative entrepreneur Mafalda Milhões from Chapter 8. As influential big city booksellers, Ler Devagar didn't need to open a new bookstore in an old coastal church. But they recognized the opportunity in Milhões' passionate vision.

How do you know a leader when you see one? The first word is trust. Leaders inspire instinctive trust with their transparency and work ethic. Leaders don't try to go it alone. They assemble teams, then they show up and work shoulder-to-shoulder with their teams. Consider the team of chef Mandel Hitzer and architect Joe Kalturnyk from Chapter 10, and the story of how they flipped the heavy table with staff, photographers from the media, and patrons at the opening of RAW:almond.

We've met a lot of leaders in our accelerators, LABS, boot camps, workshops, seminars, and community programs. Not only creative entrepreneur leaders but mayors, economic developers, investors, professors, and more. We've found these leaders share a desire for more connection and *resource flows* among all participants in their local creative entrepreneurial ecosystems. We work with leaders to facilitate those

connections, and that's one big reason our programs have proven such valuable assets for so many communities across the globe.

2. **Support education that builds the future:** To achieve the success seen in these stories of creative entrepreneurs—and to ensure a competitive future—you need a local and regional educational ecosystem that integrates with your creative entrepreneurial ecosystem. In other words, human talent is the *substrate* of your ecosystem, so work to amend and strengthen this substrate so it will, in turn, support innovative ventures.

 This translates into interdisciplinary college courses and departments for creatives that are tech and entrepreneurship oriented, reflecting the reality of not only the creative industries but all healthy and resilient economic sectors. You want film students learning about alternative avenues of film distribution *and* getting plugged into the local film scene, as in the Vancouver film industry from Chapter 4. You want universities with creative entrepreneurship tracks and relationships with *keystone* companies that have agile workforces and support portfolio careers.

 At the primary education level, we suggest supporting project-based, interdisciplinary programs like the ones we spotlight in Chapter 9. From Galpão Aplauso to Phare Ponleu Selpak, these organizations provide strong models applicable worldwide: they encourage entrepreneurial mindsets, make the case for STEAM curricula, and bring exciting technological

opportunities with a creative focus to communities where those opportunities are scarce, as in the case of Upper One Games in Alaska.

We built our educational curriculum with entrepreneurship educators who spent years at Stanford University. The result is a unique path designed for entrepreneurs in the creative industries. Our programs address a wide range of topics and present entrepreneurs with engaged learning activities. Our online interactive classes incorporate peer-to-peer discussion, case studies, guest faculty discussions, and cohort collaboration. We've seen how quality education can provide creative entrepreneurs a platform from which they can lead their startup to new heights.

3. **Broadband:** Whether it's rural India or the Isle of Man, the case is clear: to compete in the Fourth Industrial Revolution, communities require strong regional broadband to ensure access to resources and markets. There is not a one size fits all platform, but there is an unequivocal imperative.

 As we discuss in Chapter 5, high quality broadband access tracks with creative clustering, high self-employment, and—by extension—regional resilience. The 2017 PricewaterhouseCoopers study we reference in several chapters provides further evidence of the connection between the democratization of high-speed internet access "yielded significant export revenues for the [creative industry's] products" and increased traffic to and consumption of local creative content.

So, heed Chapter 8's cautionary tale of Sierra Games and the talking bear in Oakhurst, California; follow instead the lead of Chapter 8's story from Roberts' and Townsend's "*The Contribution of the Creative Economy to the Resilience of Rural Communities.*" Unite local businesses, partner with sweeping broadband programs like the Global Connect Initiative, and lobby local policymakers for increased broadband access.

If you are a local policymaker, make sure that your broadband initiatives support SMEs and take into account "micro-manufacturing" opportunities like those Chapter 9's Njideka Harry supports with her Nigeria-based Youth for Technology Foundation.

4. **Attract human capital:** How easy is it for creative entrepreneurs to live in your region? To meet other creative entrepreneurs? To achieve work/life balance? In Chapters 8 and 10, we discuss many qualities that make regions and communities attractive to creative entrepreneurs. Some of these are beyond the capabilities of even the most creative policymakers—you can't just "install" a beautiful ocean in your town, for example—but plenty of stakeholders can contribute to developing, staging, and promoting cultural, symbolic, and built amenities. Among the most important of these amenities are the assets that allow for creative entrepreneurs to live and work.

 Is there affordable housing in your community for creative entrepreneurs and the talent they employ? Does this housing integrate co-working and maker spaces that promote *symbiotic* relationships? Equally important: do these housing situations

encourage creatives to put down roots and build families if they desire, and do these housing situations avoid perpetuating the cliché of the nomadic creative and instead seek to facilitate synergy with local communities and heritages?

Consider the emergent creativity among taxi drivers facilitated by Sanket Avlani in Chapter 10, or the importance of local heritage to Chapter 2's Kenia Mattis and ListenMi Caribbean. Too many policymakers make the strategic error of thinking about the "creative class" as an autonomous demographic that can be coaxed into existing communities like a traveling circus. In reality, the story in Chapter 4 of an actual circus—Cirque du Soleil—shows how important their symbiotic relationship with Montreal has been to their astronomical growth.

Another idea is for local government to support upskilling and training to help underemployment, as with New Mexico's JTIP program, which has "supported the creation of more than 44,000 jobs" since its inception in 1972.[5]

Instead of courting an ambiguous "class," policymakers can help creative entrepreneurs with global networks engage and embed themselves in their communities. Communities where it's easy for human capital to flow among many diverse groups are communities on their way to healthy creative entrepreneurial ecosystems.

5. **Promote and foster connections between creative entrepreneurs and "management talent":** One concrete example of how policymakers can grease the wheels of human capital flow is to promote and foster connections between

creative entrepreneurs and the people they need to grow their companies from SMEs to major economic forces.

In Santa Fe, Meow Wolf's success has led to an urgent need for C-level employees and middle managers to help sustain and administer their growth. While the task of making an attractive place to work is up to the companies (consider again the successful strategies of Cirque du Soleil in Chapter 4), policymakers and stakeholders can do a lot to help.

First, they can fund entrepreneurial talent scouting: build both local connections and travel to metro areas where managerial talent is often more abundant. These funds don't have to be big for a big payoff. City leaders can redirect funding that has been spent to attract outside companies to instead support local companies' growth and hiring.

They can also spruce up regional attractiveness. The quality of local public school systems, for example, will influence whether middle managers with families might want to take the risk on an exciting new opportunity. This kind of behind-the-scenes ecosystem development is vital for continued company success and feeds into local economic success, as with the stories of LittleBigPlanet and Guildford in Chapter 5 or ChuChu TV and Chennai in Chapter 8.

6. **Facilitate mentor connections:** As we discuss in Chapter 3, we consider our global network of mentors the "secret sauce" to our success. In these stories, you've seen how quality mentorship boosts creative entrepreneurship, especially in critical startup and scaling phases. Recall the comments from

Sydney Alfonso of Etkie and Karen Cuthrell of Feeling Friends about the importance of their Creative Startups mentors.

In Chapter 6, you learned mentor relationships are **mutually beneficial** for creative entrepreneurs and investors, and Chapter 7's Monica Phromsavanh echoes that notion in her advice to aspiring entrepreneurs: "I would tell them to surround themselves with a community of inspirational and intelligent friends and mentors," Phromsavanh told Little Laos on the Prairie. "You'll attract a support system that will become one of your greatest assets."[6]

Local stakeholders and policymakers can help entrepreneurs develop this support system, bringing greater **resiliency** to the ecosystem. Host mixers, conferences, classes, and workshops. Carve out dedicated space for mentors to share their experience and affordable opportunities for entrepreneurs to benefit.

As we said at the beginning of this chapter, coordinating the logistics and ensuring the quality of such events is time and resource intensive, which is why we develop individualized relationships with public and private leaders—as we've done in Albuquerque, Winston-Salem, Kuwait City, Lisbon, and elsewhere—to tailor our expertise to their needs.

Our suite of 110+ mentors stand ready to offer connections to their extensive networks and provide practical guidance. Creative Startups mentors are not "assigned" a startup; the relationships emerge organically. The Creative Startups team provides ongoing connections to the mentor network, investors, and market leaders. As a result, Creative Startups

mentors remain engaged with entrepreneurs for months and sometimes even years.

7. **Attract investment capital:** Investment capital follows entrepreneurial talent. After your entrepreneurship programs start humming and you have some "home runs", your region likely needs to cultivate access to private investment. Cities can help attract investors by marketing their region's startup scene. Investors, like all people, tend to look to familiar places and faces for opportunities. Consider making your region more familiar by inviting investors to visit, to meet with local angels and impact investors, venture capital firms, startups, and higher education. Wondering how to meet investors from regions far away? Start with local and regional angels and investors; their networks often span the region, if not the globe.

Public/private partnerships can support a nascent investment ecosystem through funding regional entrepreneurship competitions with seed funding prizes. For example, we were able to provide Meow Wolf with a small amount of seed funding raised through private donors. These donations to Creative Startups were used alongside city and national funding support for the accelerator program.

Increasingly, impact investors and philanthropies see the benefits of investing in entrepreneurs and the ecosystem as a more sustainable solution to tackling poverty while growing place-based economic strategies. City managers and economic developers can work with local and regional philanthropies

to pilot programs that governments can learn from and then implement for the long term.

As regions compete to attract investment to their entrepreneurial ecosystem, streamlining regulatory pathways is a must. Don't bog investors down in duplicitous and difficult to discern regulations that vary from region to region. Make sure city, state, regional staff know how these processes work, and make sure they're up-to-date on innovative funding structures like crowdfunding. Publish contact information for regulatory specialists who can answer investors' questions easily and accurately. Make it easy for venture funds to operate in your region, and work on making sure entrepreneur-friendly bankruptcy, property, and contract rights exist and are well-enforced.

8. **Investors, step outside your box:** If you are like most investors, you tend to rely first and foremost on your existing network, preferring to invest in entrepreneurs and networks you are familiar with.[7] However, as the venture industry becomes saturated with more and more firms,[8] valuations will become more skewed. Investors engaging across diverse innovation sectors, and with a *diversity* of entrepreneurs stand a stronger chance of attracting unique and undervalued deals. Investors who move beyond the familiar geographies, networks, and industries will be the winners in this brave new economy.

As an old friend says, "Fish where no one else does and you'll likely strike a big one!" Say *yes!* to off-the-beaten path investor summit invitations, do two meetings a month with

entrepreneurs who cold-called you, drop in on startup events most investors skip. Subscribe to blogs and podcasts exploring industries you've only heard a whisper of, and—perhaps most importantly—rethink your assumptions about who looks like a founder of a unicorn.

9. **Fill public calendars and spaces with relevant workshops:** Facilitating mentor-led workshops is not the only way that local stakeholders and policymakers can boost local creative entrepreneurs. Consider Chapter 2's Arnaudville skill-sharing workshops, Chapter 7's British Council Young Creative Entrepreneur of the Year peer networking and business skill workshops, and workshops led by creative entrepreneurs themselves, like ListenMi's creative skill workshops for Jamaican schoolchildren, and Taxi Fabric's participatory design studio Design Fabric.

 All of these workshops require space and planning, which is where local stakeholders can help. Start with workshops for burgeoning entrepreneurs. Relevant and enticing workshops for creative entrepreneurs might include: "Cash Flow Planning for Startups," "Design Thinking for Customer Development," or "Building a Sales Pipeline for Success." We've found the workshops most valuable for entrepreneurs help them tackle a specific startup challenge.

10. **Host dedicated creative economy conferences and invite creative entrepreneurs to tech conferences:** Conferences are another great way to use public space to support creative entrepreneurship. We recommend both conferences

spearheaded by creative entrepreneurs—like Lee Francis's Indigenous Comic Con from Chapter 7 or Audu Maikori's pan-African music industry conference Music Week Africa from Chapter 5—and general conferences to celebrate your local creative economy.

It's important for creative companies to be recognized and celebrated as innovative entrepreneurs and the equal peers of tech startups. If you're considering hosting a tech conference or augmenting an existing conference with a tech entrepreneurial aspect, it's crucial to make sure your definition of tech entrepreneur is sufficiently expansive to include and spotlight creative tech entrepreneurs.

11. **Encourage creative economy tourism:** Do your local tourism agencies encourage development of innovative creative entrepreneurial ventures like Chapter 1's Meow Wolf, Chapter 10's Latest Sightings, or Chapter 8's O Bichinho do Conto?

Do your tourism bureau directors have the insight of Chapter 8's Liu Hsi-lin, who told the Taipei Times in 2014 that "Creativity is … the primary reason the [Taiwanese wedding industry] has been able to make a name for itself"? Do your tourism boosters and promoters recognize the findings we discuss in Chapter 8 from INTELI, who found that the "knowledge spillover" of creative entrepreneurs incites "innovative inputs" for tourism?

If not, your local tourism economy is missing out. Cultivate year-round tourism with creative entrepreneurs. Heed the

lessons we discuss in Chapter 10 about what today's tourists want: authentic, engaging experiences! Work with creative entrepreneurs to offer innovative opportunities for visitors to go "behind the scenes," as with Chapter 4's story of tourists visiting the old movie lots of Ouarzazate in Morocco.

We've leveraged our expertise to provide reports on increasing competitiveness in tourism markets for clients in Colorado to Costa Rica. One of our most important findings is that today's tourists might just be tomorrow's residents. Creative placemaking that spotlights the local creative economy not only attracts tourists, it also appeals to a more highly skilled and talented workforce, which leads to more livable cities with a larger demographic of creative, active, and engaged citizens.

12. **Find outlets to tell stories of local creative entrepreneurs, and remember to frame them as entrepreneurs:** Throughout the book, we've sought to dispel myths about the mindsets of creative entrepreneurs and distinguish artists and cultural practitioners from creative-minded leaders who start companies that solve market problems and scale these companies for competitive growth that boosts local economies.

In Chapter 6, for example, we frame the disruptive potential of creative entrepreneurs like Lynda Weinman from an investor perspective, explaining how the skepticism of labeling creative entrepreneurs as "artists" instead of "business people" ignores the fact that many successful founders didn't start out as "business people," either. For entrepreneurs, creativity

is the key competitive trait that allows them to envision new markets. For creative entrepreneurs, that competitive trait is in natural abundance.

That's why it's so important that local stakeholders—with the power to access the local "megaphones" of public or private media—frame creative entrepreneurs as entrepreneurs. The success stories throughout this book are not simply artists who lucked into marketable ideas. They're driven visionaries with economic mindsets who are highly *adaptable* and learn business tools and techniques to build their vision.

And if you want a robust creative entrepreneurial ecosystem that inspires the leaders of tomorrow's Cirque du Soleil, Etsy, Lynda.com, EA, Pixar, Meow Wolf, Embodied Labs, Flickr, LazyTown, Galpão Aplauso, ChuChu TV, and more—then we need to tell their stories as successes of business *and* creativity.

13. **Campaign to attract your creative diaspora:** In Chapter 7, we discuss how Hala Labaki reached out to the Lebanese diaspora to tackle local infrastructure challenges, convincing the eventual CTO of her company to move back to Lebanon from the U.S. This is a fantastic example of creative entrepreneurial initiative, but creative entrepreneurs shouldn't have to go it alone in these efforts. Local policymakers and stakeholders can mount campaigns to attract their region's creative diaspora.

How many talented creatives leave your region for better opportunities elsewhere? How about talent in other areas that might be interested in transitioning to the attributes of your

creative economy? Are there ways for them to stay abreast of new local startups? Universities benefit significantly from shrewd alumni outreach; there's no reason regional economies can't benefit in the same fashion.

Don't let diaspora outreach efforts stop at reaching potential retirees or welcoming former locals home for holidays and cultural events. Creative entrepreneurial opportunities—with their inherent connections to local heritage and the pride of homegrown innovation (consider Chapter 2's ListenMi outreach to Caribbean diaspora)—fit perfectly into campaigns that seek to alert those who have left your region that exciting things are happening back home.

So communicate with your diaspora. Connect them with local creative entrepreneurs and let them know there are gainful opportunities to get involved with. This will nourish your local creative entrepreneurial ecosystem with relevant human capital, people who already possess a deep understanding—and appreciation—for your unique regional identity.

14. **Establish an Office for the Creative Industries:** One big way to frame these stories effect and successfully is to establish a dedicated office for the creative industries. Though such an office could go by whatever name might be locally relevant, we've highlighted how such initiatives have big dividends, from Chapter 5's look at the enterprise partnership and creative hub efforts of the U.K.'s Department for Digital, Culture, Media & Sport to Chapter to Chapter 10's discussion of the Malaysian state government's role in hiring Joe Sidek to envision a festival

that could take advantage of Penang's 2008 UNESCO World Heritage site designation.

What can a dedicated office for the creative industries do? The possibilities are abundant! Such an office could provide logistical support for creative entrepreneurs both local and distant. For example, they could help the visual media industry scout locations, obtain permits, and coordinate with local unions.

Your creative industries office could also run contests to spur excitement and competition among local creative entrepreneurs and establish a beacon for creative entrepreneurs all over to recognize your region as serious about creative economy ecosystem development.

For example, as we mention in Chapter 11, Creative Startups hosted the U.S.-based wing of the global Creative Business Cup, helping the city of Albuquerque join an elite global roster of other host cities: Copenhagen, Tel Aviv, Tokyo, and more. We're proud to bring such a global event to Albuquerque and show that the U.S. creative economy thrives far from traditional epicenters like New York and Los Angeles.

With an office for the creative industries, your region can also put itself on the map of cutting-edge global creative entrepreneurship.

15. **Develop creative entrepreneurship zones, incubation centers, and clusters:** We spotlight several creative clusters throughout the book: film industries in Vancouver and New Zealand, the video game industry in Guildford, U.K., the

"telenovela production powerhouse" of Bogotá, Colombia, the innovative Taiwan bridal photography industry, and the Atlanta trap music scene.

In all of these clusters, creative entrepreneurs played a huge role in seeding initial success, but smart cluster-friendly local policy is also critical. In Chapter 5, we discuss a Nesta study's tips for successful clusters, which we'll summarize again here:

1. Catalyze latent clusters instead of trying to build them from scratch.

2. Avoid one-size-fits-all, single sector clustering models and instead engage diverse stakeholders in strategic planning. Implement clusters where *symbiotic* relationships form a resilient network.

3. Support universities that interact with and feed local entrepreneurial communities, providing students with applied and interdisciplinary learning.

4. Promote organic networking and collaboration that respects intellectual property protection.

Local policymakers and stakeholders can help their entrepreneurial ecosystem by strengthening regional alliances and connections, and supporting zoning policies dedicated to the creative economy.

Often creativity and collaboration between policymakers, property owners, and private partners is necessary to update historically complex zoning, as we see in Chapter 9's story of

Ivonette Albuquerque joining forces with the InterAmerican Development Bank to convince the federal port authority of Brazil to let her establish Galpão Aplauso in an abandoned "port zone" warehouse. Another example is Chapter 6's story of Mary Stuart Masterson working with upstate New York authorities to establish a film union around the town of Kingston and a boot camp for high schoolers to train for film industry jobs.

Many contributions policymakers and stakeholders can make to creative entrepreneurial clustering might seem more quotidian but are nonetheless imperative for development. Two examples: robust transportation infrastructure (this goes along with facilitating the flow of human capital) and cluster-friendly tax policies (see Chapter 5's story of the British game industry's tax initiative victory in 2014).

Leverage unique expertise and power among your community of stakeholders to pave the way for creative entrepreneurial clusters and zones, and your region will see the benefits we've described throughout the book in regions all around the world.

16. **Integrate creative entrepreneurial ecosystems into your larger entrepreneurial ecosystem:** The dynamism of your broader entrepreneur ecosystem lies in the connections among sectors and elements. When drafting a list of who to invite to economic summits and entrepreneur events, ensure the creative economy is on the list. Consider creative ecosystem leaders as essential economic advisors alongside tech and finance CEOs.

The creative economy is one of the pillars of your entrepreneur ecosystem, it is not décor. Include it as a pillar and it will strengthen other sectors' competitiveness.

17. **Influence national and regional intellectual property policies to support creative entrepreneurs and celebrate their content:** In Chapter 6, we discuss how one of LazyTown creator Magnús Scheving's first steps was to partner with an experienced intellectual property lawyer who understood how to navigate Iceland's IP policies to protect, expand, and repackage Magnús's creative content. Together they "neutralized" LazyTown's core elements to help it easily translate to other cultures and therefore scale the brand to circulate throughout the globe. As a result, LazyTown employed over 1,000 people and kept production centralized in Iceland even after Turner Broadcasting bought the TV show that made up the centerpiece of the brand.

These were brilliant early moves on Magnús's part, moves borne of considerable advance research. Along with making sure this research is easy to conduct, policymakers and stakeholders can do plenty to ensure their local creative entrepreneurs have the same opportunities to scale and circulate their intellectual property.

Participate in conversations and activities that support creative entrepreneurial intellectual property, and actively bring creative entrepreneurs to the table so their voices are represented in these conversations. Connect with international organizations like the World Intellectual Property Organization (WIPO) and

the Public Interest Intellectual Property Advisors (PIIPA), the latter of whom provide "free IP services, training, symposia and support for over 130 clients in 35 developing countries," according to WIPO Magazine.

We recognize that intellectual property policies vary widely throughout the world, and regional leaders often possess a frustrating lack of influence over decisions that take place at national government levels. But united lobbies make a difference. Consider Chapter 5's story of the recession resistant Nigerian music and film industries, which recently won official national "tax holidays" thanks to coordinated lobbying efforts.

While passing national laws that support the intellectual property rights of creative entrepreneurs is important, meaningful change does not have to be limited to the large scale. One small but important thing policymakers and stakeholders can do is connect local creative entrepreneurs with local lawyers and accountants.

Again, leadership in creative economy ecosystems often comes down to putting the right people in touch with each other. If the next Magnús Scheving is starting a company in your region, your local lawyers will want to meet them. It's up to ecosystem leaders to make the introductions that kickstart those meetings. The right handshake in the right room at the right time can mean the difference between boom or bust. In other words, the right meeting can make all the difference between a great intellectual property-based idea that withers for lack of local institutional support—and a thousand new

high quality jobs for your region.

18. **Be as entrepreneurial as the entrepreneurs you want to foster:** Our final two pieces of advice are less concrete, but just as vital to ecosystem success. They involve the right kind of thinking. First, if you want your creative entrepreneurial ecosystem to flourish, you have to make sure you're thinking like an entrepreneur.

Without partners in risk-taking like Óbidos mayor Telmo Faria of Chapter 8, or Rensselaer Polytechnic Institute professor Burt Swersey of Chapter 10, many of the creative entrepreneurs we've profiled would've found it much harder to launch and scale.

That's why it's important for local leaders to embrace entrepreneurial mindsets. Make it as easy as possible for businesses to start in your communities while still respecting the balance and history of those communities. Staff the institutions through which entrepreneurs will do things like obtain business licenses or seek permits with people who are entrepreneurially-aware. This doesn't mean replacement; you can retain the hard-won experience of public employees while training them for entrepreneurial contingencies and toward entrepreneurial agility.

Catalyzing an entrepreneurial mindset in a local economic ecosystem does not require "conversion" of every single stakeholder. Rather, the sea change toward entrepreneurship simply requires a few passionate, visionary agents of change in

strategic locations. Change can ripple into an ecosystem from many origins.

No platform is too insignificant, and no bureaucracy is too complex. With enough creativity, any stakeholder can transform into a leader and spark the connections that seed entrepreneurship.

19. **Celebrate creative process, risk-taking, and failure, regardless of outcome:** Our final piece of advice might seem at first blush a little counterintuitive. After all this talk of success, we remind you not to forget about failure. In fact, we suggest you celebrate failure. Why?

Because without celebrating all aspects of the creative process—and failure is one of the most important—you won't generate an environment that encourages all possible paths to creative success.

Though most all of the stories we've shared have ended well, they've all had plenty of bumps and dips along the way. Compelling narrative arcs are not the only reason we've "left in" the failures. We've left in the failures because the creative process, like the entrepreneurial process, like the process of evolution itself, relies on failure. It relies on failure for adjustment, calibration, and refinement of initial vision. Failure is part of *adaptation*.

LlttleBigPlanet didn't sell well out of the gate. Lynda Weinman was close to swearing off entrepreneurship for good after she closed her Los Angeles punk boutique. Out of a failed

multiplayer computer game, Caterina Fake and her husband created Flickr. It took plenty of failures before Eben Bayer and Gavin McIntyre finally impressed their Inventor's Studio professor with what would later become the innovative mushroom-based building material behind Ecovative Design.

In all of these stories, creative entrepreneurs learned from failure, pivoted, and rebounded into success. That's why one important tenet of your creative entrepreneurial ecosystem should be a cultural endorsement of failure.

In 2010, digital development entrepreneur Wayan Vota founded the Fail Festival to "show that failure is an option and it is acceptable" because it encourages the innovative risks that launch disruptive success. Vota suggests that innovators "fail small, fast, and open." He recommends small funds for experiments that are "too small for logframes or onerous reporting requirements, but large enough to try out an idea" so long as it "honestly, openly test[s] a specific theory of change and document[s] the results."[9]

In addition to celebrating the roadblocks and swerves natural to the creative process, we suggest local stakeholders define success for themselves. As we've documented throughout the book, success looks different in different communities, and it might even look different among different stakeholders within a single community. But once these stakeholders come together to hash out a unified vision for success, they're better able to develop an ecosystem that supports entrepreneurs who embody that success, embracing both innovation and cultural legacy.

Though these acts of collective definition might not seem as material as some of our other suggestions, they are no less important. Consider the soul searching and collective re-definition among stakeholders in Chapter 10's Winnipeg or Chapter 8's Óbidos. Establishing these shared values not only imbues development efforts with clarity and confidence, it also provides a cultural foundation that makes the celebration of risk and failure less scary.

As we explained in Chapter 11, we are excited about the future and the Fourth Industrial Revolution because we know what kind of future we believe in. For communities to establish truly robust creative entrepreneurial ecosystems, they must share a vision for the future and a willingness to celebrate the journey along the way.

ENDNOTES

Chapter 1

1. New Mexico unemployment worst in the nation. (2017, March 13). *Albuquerque Journal*. Retrieved from https://www.abqjournal.com/967904/nm-unemployment-worst-in-the-nation.html
2. Krasnow, B. (2013, May 25). Changing demographics pose challenges to city. *Santa Fe New Mexican*. Retrieved from http://www.santafenewmexican.com/news/business/changing-demographics-pose-challenges-to-city/article_1621df24-3395-5fb1-bbbd-dd1a1f5182d5.html
3. Creative Startups. (2017).
4. Oliveira, A. (2016, March 25). A bowling alley transforms into a 20,000-square-foot trippy art experience. *Hyperallergic*. Retrieved from http://hyperallergic.com/285874/a-bowling-alley-transforms-into-a-20000-square-foot-trippy-art-experience/
5. Kadlubek, V. (personal communication, November 1, 2017)
6. Annual report. (n.d.). Georgia O'Keeffe Museum. Retrieved from https://www.okeeffemuseum.org/about-the-museum/annual-reports/
7. Robinson-Avila, K. (2015, July 13). Accelerator helping jump-start creative industries. *Albuquerque Journal*. Retrieved from https://www.abqjournal.com/611548/accelerator-helping-jumpstart-creative-industries.html
8. Oliveira, A. (2016, March 25). A bowling alley transforms into a 20,000-square-foot trippy art experience. *Hyperallergic*. Retrieved from http://hyperallergic.com/285874/a-bowling-alley-transforms-into-a-20000-square-foot-trippy-art-experience/
9. Bennett, M. (2018, January 4). Meow Wolf announces a $50 million Denver expansion. *Albuquerque Journal*. Retrieved from https://www.abqjournal.com/1114634/meow-wolf-announces-denver-expansion.html
10. The arts and economic growth. (2016, February 16). National Endowment for the Arts. Retrieved from https://www.arts.gov/news/2016/arts-and-cultural-production-contributed-7042-billion-us-economy-2013
11. Feld, B. (2012). *Startup communities: Building an entrepreneurial ecosystem in your city.* John Wiley and Sons, Hoboken, New Jersey.
12. Cultural times the first global map of cultural and creative industries. UNESCO. (2015). Retrieved from http://www.unesco.org/new/fileadmin/MULTIMEDIA/HQ/ERI/pdf/EY-Cultural-Times2015_Low-res.pdf
13. Markusen, A., & Gadwa, A. (2010). *Creative placemaking.* National Endowment for the Arts. Retrieved from http://arts.gov/sites/default/files/CreativePlacemaking-Paper.pdf
14. Association of American Publishers. (n.d.). Retrieved from http://publishers.org/press/119/
15. Kleinhenz, R., & Ritter-Martinez, K. (2014, February). *2013 Otis report on the creative economy.* Los Angeles County Economic Development Corporation. Retrieved from http://www.otis.edu/sites/default/files/2013-

Otis_Report_on_the_Creative_Economy-2.pdf

16. *Impact report 2016: Assessing the effectiveness of the Creative Startups Accelerators.* (2017). Creative Startups. Retrieved from http://www.creativestartups.org/sites/default/files/CreativeStartups_2016ImpactReport_PrintFriendly.pdf

17. *Creative economy report 2013 special edition: Widening local development pathways. (2013.)* United Nations Development Programme. Retrieved from http://academy.ssc.undp.org/GSSDAcademy/Upload/CER13_Report_web_optimized.pdf

18. Trade in creative products reached new peak in 2011, UNCTAD figures show. (2013). United Nations. Retrieved from http://unctad.org/en/pages/newsdetails.aspx?OriginalVersionID=498

19. Liston, E. (2014, April 10). Hello Nollywood: How Nigeria became Africa's biggest economy overnight. *The Guardian.* Retrieved from https://www.theguardian.com/world/2014/apr/10/nigeria-africa-biggest-economy-nollywood

20. Hermansyah, A. (2016, December 8). Creative economic sector grows 62 percent in five years. *The Jakarta Post.* Retrieved from http://www.thejakartapost.com/news/2016/12/08/creative-economic-sector-grows-62-percent-in-five-years.html

21. Trade in creative products reached new peak in 2011, UNCTAD figures show. (2013). United Nations. Retrieved from http://unctad.org/en/pages/newsdetails.aspx?OriginalVersionID=498

22. Santiago, J. (2015, December 22). What is creativity worth to the world economy? World Economic Forum. Retrieved from https://www.weforum.org/agenda/2015/12/creative-industries-worth-world-economy/

23. Trade in creative products reached new peak in 2011, UNCTAD figures show. (2013). United Nations. Retrieved from http://unctad.org/en/pages/newsdetails.aspx?OriginalVersionID=498

24. Howkins, J. (2001). *The creative economy: How people make money from ideas.* Penguin, U.K.

25. The creative economy: It's bigger than you think. (n.d.). Creative Startups. Retrieved from http://www.creativestartups.org/blog/creative-economy-its-bigger-you-think

26. Vilorio, Dennis. (2015, June). Careers for creative people. Bureau of Labor Statistics. Retrieved from https://www.bls.gov/careeroutlook/2015/article/creative-careers.htm

27. O*NET OnLine. (n.d.) About O*NET. *O*NET OnLine.* Retrieved from https://www.onetcenter.org/overview.html

28. O*NET OnLine. (n.d.) Quick Search for: creative. *O*NET OnLine.* Retrieved from https://www.onetonline.org/find/result?s=creative&a=1

29. Loy, A. (personal communication, March 13, 2017).

30. Robinson-Avila, K. (2016, January 22). NM's creative startups wins Kauffman grant. *Albuquerque Journal.* Retrieved from https://www.abqjournal.com/709346/nms-creative-startups-wins-kauffman-grant.html

31. Gray, A. (2016, January 19). The 10 skills you need to thrive in the fourth industrial revolution. World Economic Forum. Retrieved from https://

www.weforum.org/agenda/2016/01/the-10-skills-you-need-to-thrive-in-the-fourth-industrial-revolution/

32. Jobs, S. (n.d.). Steve Jobs quotes. *Brainy Quote.* Retrieved from https://www.brainyquote.com/quotes/quotes/s/stevejobs416925.html

33. Kaufman, S.B. (2014, June 25). The controlled chaos of creativity. *Scientific American.* Retrieved from https://blogs.scientificamerican.com/beautiful-minds/the-controlled-chaos-of-creativity/

34. The American Motion Picture and Television Industry. (n.d.). The economic contribution of the motion picture & television industry to the United States. Retrieved from https://www.mpaa.org/wp-content/uploads/2015/02/MPAA-Industry-Economic-Contribution-Factsheet.pdf

35. Bhargava, J., & Klat, A. (2017, January 5). Content democratization: How the internet is fueling the growth of creative economies. Retrieved from https://www.strategyand.pwc.com/reports/content-democratization

36. Strengthening the creative industries for development in the Republic of Korea. (2017). United Nations. Retrieved from http://unctad.org/en/PublicationsLibrary/ditcted2017d4_en.pdf

37. Schwab, K. (2017, May 16). *The fourth industrial revolution.* World Economic Forum. Retrieved from https://www.weforum.org/about/the-fourth-industrial-revolution-by-klaus-schwab

Chapter 2

1. Tyler Technologies. (n.d.) Expanding access to justice with online dispute resolution. Retrieved from http://modria.com/about-us/

2. Cocco, F. (2016). Most U.S. manufacturing jobs lost to technology, not trade. (n.d.). *Financial Times.* Retrieved from https://www.ft.com/content/dec677c0-b7e6-11e6-ba85-95d1533d9a62

3. Malone, W., Laubacher, R., & Johns, T. (2011, July-August). The big idea: The age of hyperspecialization. *Harvard Business Review.* Retrieved from https://hbr.org/2011/07/the-big-idea-the-age-of-hyperspecialization

4. Bureau of Labor Statistics. (2013). Occupational employment projections to 2022. Retrieved from https://www.bls.gov/opub/mlr/2013/article/occupational-employment-projections-to-2022.htm

5. Schwab, K. (2016, January 14). *The fourth industrial revolution: What it means, how to respond.* World Economic Forum. Retrieved from https://www.weforum.org/agenda/2016/01/the-fourth-industrial-revolution-what-it-means-and-how-to-respond/

6. Worstall, T. (2012, April 29). The productivity/pay gap: Considering the counter-factual, would productivity have grown if the pay gap didn't? *Forbes.* Retrieved from https://www.forbes.com/sites/tim-worstall/2012/04/29/the-productivitypay-gap-considering-the-counter-factual-would-productivity-have-grown-if-the-pay-gap-didnt/#49d13d104a6a

7. The rich, the poor and the growing gap between them. (2006). *The Economist.* Retrieved from http://www.economist.com/node/7055911

8. Leubsdorf, B. (2014, September 4). Fed: Gap between rich, poor Ameri-

can widened during recovery. *The Wall Street Journal*. Retrieved from https://www.wsj.com/articles/fed-gap-between-rich-poor-americans-widened-during-recovery-1409853628

9. Newitz, A. (2017, May 19). An AI invented a bunch of new paint colors that are hilariously wrong. *arsTECHNICA*. Retrieved from https://arstechnica.com/information-technology/2017/05/an-ai-invented-a-bunch-of-new-paint-colors-that-are-hilariously-wrong/

10. What leaders can learn from jazz. (n.d.). *Harvard Business Review*. Retrieved from https://hbr.org/2012/08/what-leaders-can-learn-from-ja

11. Seligman, M.E.P., & Tierney, J. (2017, May 19). We aren't built to live in the moment. *The New York Times*. Retrieved from https://www.nytimes.com/2017/05/19/opinion/sunday/why-the-future-is-always-on-your-mind.html

12. Sundbo, Jon, & SËrensen, F. (2013). *Handbook on the experience economy*. Northampton: Edward Elgar Publishing.

13. Shubber, K. (2013, September 18). UCL students build low-cost, Arduino-powered, Lego atomic force microscope. *Wired U.K.*. Retrieved from http://www.wired.co.uk/article/lego-microscope

14. Goodman, T. (n.d.). Inspired by the lotus leaf: Lotusan paint. *Inventor Spot*. Retrieved from http://inventorspot.com/articles/inspired_lotus_leaf_lotusan_paint_23083

15. Jämtkraft. (n.d.). Retrieved from https://www.jamtkraft.se/privat/

16. Eastman Innovation Lab. Designing an experience. (n.d.). Retrieved from http://www.innovationlab.eastman.com/stories/designing-an-experience

17. Rifkin, J. (2000). *The age of access: The new culture of hypercapitalism, where all of life is paid-for experience*. New York, Penguin Putnam Inc.

18. Kim, E. (2014, April 19). Against all odds, pride of Segou, pride of Mali: The festival on the Niger River. World Music Central. Retrieved from http://worldmusiccentral.org/2014/04/10/against-all-odds-pride-of-segou-pride-of-mali-the-festival-on-the-niger-river/

19. Arterial Network. Meet our members. (n.d.). Retrieved from http://www.arterialnetwork.org/network/member/mamou-daffe

20. Boyd, E. (n.d.). What is an entrepreneur? Earl Boyd: Business Coach PA. Retrieved from http://earlboyd.com/general/what-is-an-entrepreneur

21. Can entrepreneurship be taught? Yes. (n.d.). Creative Startups. Reterived from http://www.creativestartups.org/blog/can-entrepreneurship-be-taught-yes-0

22. Chaston, I. & Sadler-Smith, E. (2011). Entrepreneurial cognition, entrepreneurial orientation and firm capability in creative industries. *British Journal of Management* doi.org/10.1111/j.1467-8551

23. Creative Startups—the world's leading accelerator for creatives such as George R.R. Martin-Funded Meow Wolf—Now open for applications from creative industry companies. (2017). *CISION PR Newswire*. Retrieved from https://www.prnewswire.com/news-releases/creative-startups----the-worlds-leading-accelerator-for-creatives-such-as-george-rr-martin-funded-meow-wolf----now-open-for-applications-

from-creative-industry-companies-300472683.html

24. ListenMi Caribbean Ltd. (n.d.). Linkedin: About us. Retrieved from https://www.linkedin.com/company-beta/3230412

25. Mattis, K.A. (2016, May 17).Meet GES delegate: Kenia Mattis. Global Entrepreneurship Summit. Retrieved from https://medium.com/global-entrepreneurship-summit/meet-ges-delegate-kenia-mattis-47ef2c2a5b21

26. Mattis, K. (n.d.). Sharing Caribbean stories with the world. CNN. Retrieved from http://www.cnn.com/videos/intl_tv-shows/2015/06/22/kenia-mattis-listenmi-p2p-spc.cnn

27. Sylbourne TV (producer). (2016). Kenia Mattis – Exclusive Interview! Jamaica special episode 3 / The Sylbourne Show. Available from https://www.youtube.com/watch?v=6fPBu2LKvrY

28. Jamaican beats field of 10,000 to win U.S. pitch competition. (2016, June 23). *Jamaica Observer.* Retrieved from http://m.jamaicaobserver.com/business/Jamaican-beats-field-of-10-000-to-win-U.S.-pitch-competion_64908

29. Kenia Mattis. (n.d.). *ListenMi Caribbean Ltd.* Linkedin. Retrieved from https://www.linkedin.com/in/keniamattis?ppe=1

30. Kenia Mattis – Exclusive Interview! (2016). Jamaica special episode 3 / The Sylbourne Show. Sylbourne TV (producer). Available from https://www.youtube.com/watch?v=6fPBu2LKvrY

31. Ibid.

32. Mattis, K. (personal communication, n.d.).

33. Howkins, J. (2004). *The creative economy. How people make money from ideas.* New York: Penguin Global.

34. Markusen, A. & Gadwa, A. (2010). Creative placemaking. *National Endowment for the Arts.* Retrieved from https://www.giarts.org/sites/default/files/Creative-Placemaking.pdf

35. Loy, A. (2015, April 20). Azores: An entrepreneurial future in the creative economy. Creative Startups. Retrieved from https://www.slideshare.net/aliceloy/azores-an-entrepreneurial-future-in-the-creative-economy

36. Brasted, C. (2014, August, 19). Arnaudville becomes Louisiana destination through Nunu Collective, experimental creative placemaking. *The Times-Picayune.* Retrieved from https://www.nola.com/living/baton-rouge/index.ssf/2014/08/arnaudville_becomes_louisiana.html

37. Risher, J. (2014, September 17). Arnaudville's Little Big Cup. *Country Roads.* Retrieved from http://countryroadsmagazine.com/cuisine/restaurants/arnaudville-s-little-big-cup/

38. Stoll, A. (personal communication, 2018, January 24).

39. UNESCO. (2015). Cultural times the first global map of cultural and creative industries. Retrieved from https://en.unesco.org/creativity/sites/creativity/files/cultural_times._the_first_global_map_of_cultural_and_creative_industries.pdf

Chapter 3

1. Gartner, B. (n.d.). The entrepreneur as storyteller. Copenhagen Business

School. Retrieved from https://www.cbs.dk/en/knowledge-society/business-in-society/entrepreneurship/media/enter-magazine/enter-2-2014/the-entrepreneur-as-storyteller

2. How start-ups can use storytelling to boost their business. (n.d.). Virgin. Retrieved from https://www.cbs.dk/en/knowledge-society/business-in-society/entrepreneurship/media/enter-magazine/enter-2-2014/the-entrepreneur-as-storyteller

3. Stoll, A. (personal communication, January 24, 2018).

4. Isenberg, D. (n.d.). Five principles for harnessing entrepreneurship ecosystems for rapid regional growth. Babson College. Retrieved from http://www.babson.edu/executive-education/thought-leadership/webinars/archives/Pages/five-principles-for-harnessing-entrepreneurship-ecosystems.aspx

5. Isenberg, D. (2010, June). The big idea: How to start an entrepreneurial revolution. *Harvard Business Review.* Retrieved from https://hbr.org/2010/06/the-big-idea-how-to-start-an-entrepreneurial-revolution

6. Isenberg, D. (personal communication, January, 2018).

7. Anjum, Z. (2014). *Startup capitals: Discovering the global hotspots of innovation.* Dublin: *Random Business.*

8. Loy, A. (2012). *Social-environmental entrepreneurs' communicative actions in communication networks.* (Unpublished doctoral dissertation). University of New Mexico, Albuquerque. Retrieved from http://digitalrepository.unm.edu/cj_etds/36

9. de la Torre, J.J. (2016 January). Vision: The Driver Of Entrepreneurship. *Entrepreneur.* Retrieved from https://www.entrepreneur.com/article/269757

10. Alderson, L. (personal communication, January 24, 2018.).

Chapter 4

1. Lalibert, G. (2016). The circus kid: Guy Lalibert is born. Retrieved from http://www.evancarmichael.com/library/guy-laliberte/The-Circus-Kid-Guy-Laliberte-Is-Born.html

2. Babinski T, Mancester K. (2004). *Cirque Du Soleil: 20 Years Under the Sun.* New York: Abrams Books.

3. Hunter, B. (n.d.) Katherine O'Dwyer KOOZA by Cirque du Soleil interview. Girl.com. Retrieved from https://www.girl.com.au/katherine-odwyer-kooza-by-cirque-du-soleil-interview.htm

4. Cirque du Soleil Press Materials (n.d.) Biography Holger Forterer. Retrieved from https://www.cirquedusoleil.com/en/press/kits/corporate/cirque-du-soleil/creators/forterer-holger.aspx

5. Barmak, S. (2015, October 13). The astonishing second act of Cirque du Soleil. *Canadian Business.* Retrieved from http://www.canadianbusiness.com/innovation/cirque-du-soleil-second-act/

6. Dority, K. (2010, September 14). Career profile: Sarah Mooney technical documentalist, Cirque du Soleil. Retrieved from http://www.infonista.com/2010/career-profile-sara-mooney-technical-documental-

ist-cirque-du-soleil/

7. Drughi, O. (n.d.). Cirque du Soleil's highest grossing shows. *The Richest*. Retrieved from http://www.therichest.com/luxury/most-expensive/10-of-cirque-du-soleils-most-expensive-shows/

8. Ibid.

9. Cirque du Soleil Press Materials (n.d.a) Biography Holger Forterer. Retrieved from https://www.cirquedusoleil.com/en/press/kits/corporate/cirque-du-soleil/creators/forterer-holger.aspx

10. Glassdoor. (2018). Cirque du Soleil reviews. Retrieved from https://www.glassdoor.com/Reviews/Cirque-du-Soleil-Reviews-E7495.htm & Indeed. (2018). Cirque du Soleil employee reviews. *Indeed*. Retrieved from https://www.indeed.com/cmp/Cirque-Du-Soleil/reviews

11. Gross, M. J. (2015, May 29). Life and death at Cirque du Soleil. *Vanity Fair*. Retrieved from http://www.vanityfair.com/culture/2015/05/life-and-death-at-cirque-du-soleil

12. Baghai, M. & Quigley, J. (2011, February 3). Cirque du Soleil: A very different vision of teamwork. *Fast Company*. Retrieved from https://www.fastcompany.com/1724123/cirque-du-soleil-very-different-vision-teamwork

13. Glassdoor. (2018). Cirque du Soleil employee benefits reviews. Retrieved https://www.glassdoor.com/Benefits/Cirque-du-Soleil-U.S.-Benefits-EI_IE7495.0,16_IL.17,19_IN1.htm

14. Wiens, J. & Jackson, C. (2015, September 13). *The importance of young firms for economic growth*. Ewing Marion Kauffman Foundation. Retrieved from http://www.kauffman.org/what-we-do/resources/entrepreneurship-policy-digest/the-importance-of-young-firms-for-economic-growth

15. Barmak, S. (2015, October 15). The astonishing second act of Cirque du Soleil. *Canadian Business*. Retrieved from http://www.canadianbusiness.com/innovation/cirque-du-soleil-second-act/

16. Florida, R. (2015, December 28). The global creative economy is big business. *Citylab*. Retrieved from https://www.citylab.com/life/2015/12/the-global-creative-economy-is-big-business/422013/

17. Ibid.

18. National Assemblies of State Arts Agencies. (2017). *Facts & figures on the creative economy*. Retrieved from http://nasaa-arts.org/nasaa_research/facts-figures-on-the-creative-economy/

19. United States Department of Labor. (2015). Career outlook: Careers for creative people. Retrieved from https://www.bls.gov/careeroutlook/2015/article/creative-careers.htm

20. CiC U.K. to the world. (n.d.). *Economic contribution of arts and culture*. Retrieved from http://www.thecreativeindustries.co.uk/industries/arts-culture/arts-culture-facts-and-figures/the-economic-contribution-of-the-arts

21. van Liemt, G. (2014). Employment relationships in arts and culture. International Labour Organization. Retrieved from http://www.ilo.org/sector/Resources/publications/WCMS_249913/lang--en/index.htm

22. Hearn, Gregory N., Bridgstock, Ruth S., Goldsmith, Ben, & Rodgers, Jess (Eds.) (2014). *Creative work beyond the creative industries: Innovation,employment and education.* Edward Elgar Publishing, Cheltenham, U.K..

23. Cunningham, S. (2014). Creative labour and its discontents: A reappraisal. In Hearn, G. N., Bridgstock, R. S., Goldsmith, B/, & Rodgers, J.(Eds.) *Creative work beyond the creative industries: Innovation,employment and education.* Cheltenham, U.K.: Edward Elgar Publishing.

24. Antal, A.B. (2009). *Transforming organizations with the arts.* TILLTEurope. Retrieved from https://www.wzb.eu/system/files/docs/dst/wipo/researchreport.pdf

25. Craig, W. (2016, February 13). The benefits of horizontal vs vertical career growth. *Forbes.* Retrieved from https://www.forbes.com/sites/williamcraig/2016/02/13/the-benefits-of-horizontal-vs-vertical-career-growth/

26. van Liemt, G. (2014). Employment relationships in arts and culture. (Working paper no. 301). Retrieved from International Labour Organization website: http://www.ilo.org/wcmsp5/groups/public/---ed_dialogue/---sector/documents/publication/wcms_249913.pdf

27. EY and the member firms of Ernst & Young Global Limited. (2104). *Creating growth: Measuring cultural and creative markets in the EU.* Retrieved from http://www.creatingeurope.eu/

28. Bertrand, J. (2017, March 6). *Putting CBC at the heart of a creative Canada.* Canadian Broadcasting Company. Retrieved from http://www.cbc.ca/news/canada/saskatoon/john-bertrand-cbc-creative-canada-1.4010895

29. Creative Startups. (n.d.) *Ready for impact?* Retrieved from http://www.creativestartups.org/expertise

30. Creative Startups. (2017). *Impact Report 2016: Assessing the effectiveness of the Creative Startups Accelerators.* (2017). Retrieved from http://www.creativestartups.org/sites/default/files/CreativeStartups_2016ImpactReport_PrintFriendly.pdf

31. Cirque du Soleil. (n.d.). *Cirque du Soleil-Global Citizen.* Retrieved from https://www.cirquedusoleil.com/en/about/global-citizenship/default.aspx

32. Michael Rushton (Ed.). (2013). *Creative Communities: Art Works in Economic Development.* Washington, DC: Brookings Institution Press.

33. Markusen, A., Gadwa Nicodemus, A., & Barbour, E. (2013). The arts, consumption, and innovation in regional development. In Michael Rushton, ed. *Creative communities: Art. Works in economic development* (pp. 36-. 59). Washington, DC: The Brookings Institution.

34. Florida, R. (2014). The creative class and economic development. *Economic Development Quarterly, 28*(3), 196-205. Retrieved from http://journals.sagepub.com/doi/abs/10.1177/0891242414541693

35. Ibid.

36. European Commission. (2015). *Commission staff working document: Employment and social developments in Europe 2014.* Retrieved from http://www.europarl.europa.eu/RegData/docs_autres_institutions/commission_europeenne/swd/2015/0004/COM_SWD(2015)0004(PAR7)_

EN.pdf

37. Los Angeles County Economic Development Corporation: Institute for Applied Economics. (2017). *Otis report on the creative economy: California*. Retrieved from https://www.otis.edu/sites/default/files/2017-CA-Region-Creative-Economy-Report-WEB-FINAL_0.pdf

38. Edelman Intelligence. (2016). *State of Create Study: 2016*. Retrieved from https://www.adobe.com/content/dam/acom/en/max/pdfs/AdobeStateofCreate_2016_Report_Final.pdf

39. National Endowment for the Arts (October, 2011). Research Note #105 Artists and Arts Workers in the United States: Findings from the American Community Survey (2005-2009) and the Quarterly Census of Employment and Wages. Retrieved from https://www.arts.gov/sites/default/files/105.pdf

40. Cirque du Soleil. (2017). Cirque du Soleil inspires creativity, teamwork and professional growth with 'SPARK': Educate and transform VIP groups and corporate teams by harnessing the magic of Cirque du Soleil. *The Business Journals*. Retrieved from https://www.bizjournals.com/prnewswire/press_releases/2017/03/01/MM18275

41. Iyengar, S. & Hudson, A. (March 10, 2014). Who knew?: Arts education fuels the economy. *The Chronicle of Higher Education*. Retrieved from http://www.chronicle.com/article/Who-Knew-Arts-Education-Fuels/145217

42. Women in the workforce: Female power. (2009, December 30). *The Economist*. Retrieved from http://www.economist.com/node/15174418

43. Ouarzazate of Morocco:The Gateway to Sahara Desert. (n.d.). *Muslim News 24*. Retrieved from http://muslimnews24.com/ouarzazate-of-moroccothe-gateway-to-sahara-desert/

44. Morton, E. (2013, December 3). Ouarzazate, Morocco: The Photogenic Filming Location for Game of Thrones and Gladiator. *Slate*. Retrieved from http://www.slate.com/blogs/atlas_obscura/2013/12/03/atlas_film_studios_in_ouarzazate_morocco.html

45. Ibid.

46. Idean and Work. (n.d.). Dr. Edward de Bobo. Retrieved from https://www.edwddebono.com/ideas

47. Study highlights: work-life is harder worldwide. (n.d*.). EY, a member firm of Ernest Young Global Limited*. Retrieved from http://www.ey.com/us/en/about-us/our-people-and-culture/ey-study-highlights-work-life-is-harder-worldwide#.WVqWZBPys6g

48. Helvey, K. (2016, May 10). Don't underestimate the power of lateral career moves for professional growth. *Harvard Business Review*. Retrieved from https://hbr.org/2016/05/dont-underestimate-the-power-of-lateral-career-moves-for-professional-growth

49. Grasz, J. (2013, January 24). CareerBuilder survey reveals most wanted office perks and what motivates workers to stay with companies. *CareerBuilder*. Retrieved from http://www.careerbuilder.com/share/aboutus/pressreleasesdetail.aspx?sd=1%2F24%2F2013&id=pr735&ed=12%2F31%2F203

50. Hamori, M. (2010, July-August). Managing yourself: Job-hopping to the top and other career fallacies. *Harvard Business Review.* Retrieved from https://hbr.org/2010/07/managing-yourself-job-hopping-to-the-top-and-other-career-fallacies

51. Helvey, K. (2016, May 10). Don't underestimate the power of lateral career moves for professional growth. *Harvard Business Review.* Retrieved from https://hbr.org/2016/05/dont-underestimate-the-power-of-lateral-career-moves-for-professional-growth

52. Weber, B. (2013, September 9). By The year 2020, almost half of the workforce will be made up of these people. Upworthy. Retrieved from http://www.upworthy.com/by-the-year-2020-almost-half-of-the-workforce-will-be-made-up-of-these-people-5

53. Gallup. (n.d.). *How millenials want to work and live.* Retrieved from http://www.gallup.com/reports/189830/millennials-work-live.aspx

54. Cook, N. (2015). Will baby boomers change the meaning of retirement? *The Atlantic.* Retrieved from https://www.theatlantic.com/business/archive/2015/06/baby-boomers-retirement/396950/

55. A conversation with Prem Gill. (2013, November 23). *BCBusiness.* Retrieved from https://www.bcbusiness.ca/a-conversation-with-prem-gill

56. Gill, P. (personal communication, January, 2018).

57. Bailey, I. (2017, March 24). The movie industry in Vancouver is booming once again, thanks to Netflix. *The Globe and Mail.* Retrieved from https://www.theglobeandmail.com/arts/film/the-business-is-booming-in-bc/article30503176/

58. Schaefer, G. (2017, January 19). B.C. film industry players betting good times won't be Trumped. *Vancouver Sun.* Retrieved from http://vancouversun.com/business/local-business/b-c-film-industry-players-betting-good-times-wont-be-trumped

59. Ibid.

60. Bailey, I. (2017, March 25). B.C. film industry booming, but insiders warn it may not last. *The Globe and Mail.* Retrieved from https://www.theglobeandmail.com/news/british-columbia/bc-film/article24462867/

61. Bailey, I. (2017, March 24). The movie industry in Vancouver is booming once again, thanks to Netflix. *The Globe and Mail.* Retrieved from https://www.theglobeandmail.com/arts/film/the-business-is-booming-in-bc/article30503176/

62. Ibid.

63. McLachlan, S. (2017, January 11). What Vancouver's female animators think about the diversity of their industry. *Vancouver.* Retrieved from http://vanmag.com/city/vancouver-female-animators-industry-diversity/

64. Morgan, J. (2015, September 22). The future of work is about flexibility, autonomy, and customization. *Forbes.* Retrieved from https://www.forbes.com/sites/jacobmorgan/2015/09/22/the-future-of-work-is-about-flexibility-autonomy-and-customization/#43a8fb1e7dfe

65. Ibid.

66. Campbell, C. (2017, February 15). Gabe Newell isn't really here, he's

somewhere else. *Polygon.* Retrieved from https://www.polygon.com/ features/2017/2/15/14616192/gabe-newell-interview-vr

67. Rainie, L. & Anderson, J. (2017, May 3). The future of jobs and job training. Pew Research Center. Retrieved from http://www.pewinternet. org/2017/05/03/the-future-of-jobs-and-jobs-training/

Chapter 5

1. Little Big Planet. (2008). Metacritic. Retrieved from http://www.metacritic. com/game/playstation-3/littlebigplanet
2. Simons, I. (2007). *Inside game design.* London: Laurence King.
3. Little big pop up shop. (n.d.) Mm. Retrieved from https://www.mediamolecule.com/blog/article/little_big_pop_up_shop
4. Rag doll kung fu. (n.d.) Mm. Retrieved from https://www.mediamolecule. com/blog/article/rag_doll_kung_fu
5. Guildford town centre hit hard by recession. (2009, January) SurreyLive. Retrieved from http://www.getsurrey.co.uk/news/local-news/guildford-town-centre-hit-hard-4825807
6. University of Surrey staff to decide on pay walkout. (2013, July 2). Surrey-Live. Retrieved from http://www.getsurrey.co.uk/news/local-news/university-surrey-staff-decide-pay-4824172
7. Guildford town centre hit hard by recession. (2009, January) SurreyLive. Retrieved from http://www.getsurrey.co.uk/news/local-news/guildford-town-centre-hit-hard-4825807
8. Wiltshire, A. (2017, March 3). Extended play: How LittleBigPlanet made everyone a game-maker. PlayStation. Retrieved from https://blog.eu.play-station.com/2017/03/03/extended-play-how-littlebigplanet-made-everyone-a-game-maker/
9. Ibid.
10. Nowak, P. (2017, March 26). LittleBigPlanet studio crafting the collaborative future of video games. *The Globe and Mail.* Retrieved from https://beta.theglobeandmail.com/technology/gaming/littlebigplanet-studio-crafting-the-collaborative-future-of-video-games/article13457624/?ref=http://www.theglobeandmail.com&page=all
11. Ettourney, K. (2010). Kareem Ettourney: About. Retrieved from http://www.kareemettouney.com/about/
12. Learning Without Frontiers (2010) Media molecule: Game based learning 2010. [video file] Retrieved from https://www.youtube.com/watch?v=VCW8UcbwCHM
13. Bogle, A. (2016, January 04). For 'LitteBigPlanet' studio head Siobahn Reddy, diversity in gaming is the key to success. *Mashable.* Retrieved from http://mashable.com/2016/01/04/siobhan-reddy-media-molecule/
14. Kikizo Staff. (2008, September 30). LittleBigPlanet: The very big interview. Kikizo Archives. Retrieved from http://archive.videogamesdaily.com/features/littlebigplanet-media-molecule-interview-sep08-p1.asp
15. Simons, I. (2007). *Inside game design.* London: Laurence King.
16. Matthews, M. (2009, January 1). NPD Exclusive: U.S. Sales for LBP, MGS4,

More Revealed. Gamasutra. Retrieved from http://www.gamasutra.com/php-bin/news_index.php?story=21937

17. Lynde, B. R. (2015, January 13). Media molecule. [Web log post]. Retrieved from https://broganlevel6.wordpress.com/2015/01/13/media-molecule/

18. Heritage, S. (2014, June 4). All hail Guildford – the Hollywood of video games. *The Guardian*. Retrieved from https://www.theguardian.com/technology/2014/jun/04/guildford-uk-video-game-industry-ubisoft-little-big-planet-hollywood

19. Heritage, S. (2014, June 4). All hail Guildford – the Hollywood of video games. *The Guardian*. Retrieved from https://www.theguardian.com/technology/2014/jun/04/guildford-uk-video-game-industry-ubisoft-little-big-planet-hollywood

20. Surrey Chamber of Commerce. (2014, May 26). TheChamber: Voice and vision of Surrey business. Retrieved from https://issuu.com/benham/docs/1418tcmj14

21. Luzi, M. & Colombani, L. (2014). Creative U.K.: Overview of the digital transformation of the U.K. creative economy. Bain and Company. Retrieved from http://www.bain.com/publications/articles/creative-uk.aspx

22. Sleeman, C. (2014, November 20). One million new creative jobs in the U.K. economy. Nesta. [web log post]. Retrieved from http://www.nesta.org.uk/blog/one-million-new-creative-jobs-uk-economy

23. Creative Industries UK. (2017, July). Facts and Figures. *Creative Industries U.K.* Retrieved from http://www.thecreativeindustries.co.uk/uk-creative-overview/facts-and-figures/employment-figures

24. Heathman, A. (2018, March). The U.K. games market enjoying record growth thanks to its 'world class content'. *Evening Standard*. Retrieved from https://www.standard.co.uk/tech/uk-games-market-record-growth-gaming-content-a3779706.html

25. Schmidt, B. (2015, June 14). Video games bigger than movies? Don't be so certain. GameSoundCon. Retrieved from https://www.gamesoundcon.com/single-post/2015/06/14/Video-Games-Bigger-than-the-Movies-Dont-be-so-certain

26. Black, E. (2013, January 4). Music, video, book, games markets growing for entertainment industry, study finds. *Forbes*. Retrieved from https://www.forbes.com/sites/edblack/2013/01/24/music-video-book-game-markets-growing-for-entertainment-industry-study-finds/

27. Garside, J. (2014, March 27). EC approves tax breaks for video games industry. *The Guardian*. Retrieved from https://www.theguardian.com/technology/2014/mar/27/ed-approves-tax-breaks-video-games-industry

28. Graham, P. (2017, January 3). TIGA expecting U.K. games industry growth over 2017. VRFocus. Retrieved from https://www.vrfocus.com/2017/01/tiga-expecting-uk-games-industry-growth-over-2017/

29. Creative industries mapping documents. (1998, April 09). Department for Digital, Culture, Media & Sport. U.K. Retrieved from https://www.gov.uk/government/publications/creative-industries-mapping-documents-1998

30. U.K. Government. (n.d.) Invest in Great Britain and Northern Ireland: Creative in the U.K. Retrieved from https://invest.great.gov.uk/us/industries/creative/

31. Invest In Nottingham. (n.d.) *Nottingham investment opportunities.* Rushcliffe Borough Council. Retrieved from http://www.rushcliffe.gov.uk/media/1rushcliffe/media/documents/pdf/businessandlicensing/business/Nottingham%20Investment%20Opportunities%20Brochure%202018.pdf

32. Creative Industries Council. (2014). Create U.K. Retrieved from http://www.thecreativeindustries.co.uk/media/243587/cic_report_final-hires-.pdf

33. Dixon, C. (2010, April 25). *Business Insider.* Retrieved from http://www.businessinsider.com/we-dont-ask-consumers-what-they-want-they-dont-know-instead-we-apply-our-brain-power-to-what-they-need-and-will-want-and-make-sure-were-there-ready-2010-4

34. Pine, J. & Gilmore, J. (1998, July-August). Welcome to the experience economy. *Harvard Business Review.* Retrieved from https://hbr.org/1998/07/welcome-to-the-experience-economy

35. Ibid.

36. Reagan, C. (2015, August 20). Americans spending again but value still reigns. CNBC. Retrieved from https://www.cnbc.com/2015/08/20/americans-spending-again-but-value-still-reigns.html

37. Jones, R. (2010, May 21). Entertainment: Ticket sales booms in the face of recession. *The Guardian.* Retrieved from https://www.theguardian.com/money/2010/may/22/ticket-sales-boom-recession

38. U.K. Film Council. (2009). *2009 U.K. Film Council Statistical Yearbook.* Retrieved from http://www.bfi.org.uk/sites/bfi.org.uk/files/downloads/uk-film-council-statistical-yearbook-2009.pdf

39. Foster, A. (2015, March). Movies, music, and sports: U.S. entertainment spending, 2008-1013. United States Department of Labor Bureau of Labor Statistics. Retrieved from https://www.bls.gov/opub/btn/volume-4/movies-music-sports-entertainment-spending.htm

40. Reagan, C. (2015, August 20). Americans spending again but value still reigns. CNBC. Retrieved from https://www.cnbc.com/2015/08/20/americans-spending-again-but-value-still-reigns.html

41. Sundbo, J., Sørensen, F., & Edward Elgar Publishing. (2013). *Handbook on the experience economy.* Cheltenham: Edward Elgar Pub. Ltd.

42. Le Meur, L. (2009, January 28). Robert Kalin, CEO of Etsy.com. World Economic Forum. [video file] Retrieved from https://www.youtube.com/watch?v=gEkXrUoOfdY

43. Goetz, S., Fleming, D., & Han, Y. (2016, March 7). What makes one economy more resilient than another? *The Conversation.* Retrieved from http://theconversation.com/what-makes-one-economy-more-resilient-than-another-54374

44. Chapain, C., Cooke, P., De Propis, L., MacNeill, S., & Mateos-Garcia, J. (2010, November). Creative clusters and innovation: Putting creativity on the map. NESTA. Retrieved from https://www.nesta.org.uk/sites/de-

fault/files/creative_clusters_and_innovation.pdf
45. Island Facts. (2016, March 4). Public Services, Isle of Man Government. Isle of Man Government Website. Retrieved from https://web.archive.org/web/20160304050532/https://www.gov.im/categories/business-and-industries/iom-key-facts-guide/island-facts/
46. Sparkes, M. (2014, September 20). Creating a bitcoin island just of the English coast. *The Telegraph*. Retrieved from http://www.telegraph.co.uk/technology/11109256/Creating-a-Bitcoin-Island-just-off-the-English-coast.html
47. Isle of Man Government. (2015, October). Enterprise development scheme guidelines (GD. No. 2015/0062). Isle of Man Government Website. Retrieved from https://www.gov.im/media/1349316/eds-guidelines.pdf
48. Pendall, R., Foster, K., & Cowell, M. (2010). Resilience and regions: building understanding of the metaphor. *Cambridge Journal of Regions, Economy and Society*, 3(1), pp. 71–84. Retrieved from https://doi.org/10.1093/cjres/rsp028
49. Leadbetter, C. & Meadway, J (with Harris, M., Crowley, T., Mahroum, S., & Poirson, B.). (2008, December). *Attacking the recession: How innovation can fight the downturn*. NESTA. Retrieved from https://www.nesta.org.uk/sites/default/files/attacking_the_recession.pdf
50. Duckstein, S. (2014, August 04). Nigeria overtakes Africa as the continent's largest economy. DW. Retrieved from http://www.dw.com/en/nigeria-overtakes-south-africa-as-the-continents-largest-economy/a-17551016
51. Akwagyiram, A. (2017, January 20). Sony music seeks Nigeria streaming growth to build on ringback market. *Reuters*. Retrieved from http://www.reuters.com/article/us-nigeria-music-sony-idU.S.KBN1541XK
52. In House Nigeria. (2016, September 26). PwC: Nigeria's music sector to reach $86m by 2016. Music in Africa. Retrieved from https://www.musicinafrica.net/magazine/pwc-nigeria%E2%80%99s-music-sector-reach-86m-2020-0
53. Holden, S. (2017, April 18). Wizkid: Drake always shows me love. BBC. Retrieved from http://www.bbc.co.uk/newsbeat/article/39628061/wizkid-drake-always-shows-me-love
54. Drake, D. (2014, August 01). Pop music's Nigerian future. FADER. Retrieved from http://www.thefader.com/2014/08/01/pop-musics-nigerian-future
55. Akwagyiram, A. (2016, July 07). Nigeria's music scene becomes a cultural export. *Reuters*. Retrieved from http://www.reuters.com/article/us-nigeria-music/nigerias-music-scene-becomes-a-cultural-export-idU.S.KCN0ZN124
56. Abumere, I. (2016, September 12). Nigerian music industry generates $51m in 2016, reports reveal. Music Week Africa. Retrieved from http://www.pulse.ng/buzz/music-week-africa-nigerian-music-industry-generates-51m-in-2016-reports-reveal-id5876009.html
57. NPR Fresh Air. (2011, October 19). The 'informal economy' driving world business. National Public Radio. Retrieved from http://www.npr.

org/2011/10/26/141503411/the-informal-economy-driving-world-business

58. Nihiniola, I. (2016, December 12). Music Week Africa xrays challenges of the Nigerian music industry. Music in Africa. Retrieved from https://www.musicinafrica.net/magazine/music-week-africa-x-rays-challenges-nigerian-music-industry

59. Akwagyiram, A. (2016, July 07). Nigeria's music scene becomes a cultural export. *Reuters*. Retrieved from http://www.reuters.com/article/us-nigeria-music/nigerias-music-scene-becomes-a-cultural-export-idU.S.KCN0ZN124

60. Henry, C. & de Bruin, A. (Eds). (2011). *Entrepreneurship and the creative Economy: Process, practice and policy.* New Zealand: Edward Elgar Publishing.

61. Africa is leading, defining global mobile creativity according to Facebook VP of global business marketing. (2016, August 18). BIZCOMMUNITY. Retrieved from http://www.bizcommunity.com/Article/196/614/149460.html

62. United Nations Department of Economic & Social Affairs. (2015, May). *Population facts: Youth population trends and sustainable development (No. 2015/1)*. Retrieved from http://www.un.org/esa/socdev/documents/youth/fact-sheets/YouthPOP.pdf

63. United Nations. (2010). *Creative economy report 2010*. Retrieved from http://unctad.org/en/Docs/ditctab20103_en.pdf

64. Ibid.

65. Donald, B., Gertler, M., & Tyler, P. (2013). Creatives after the crash. *Cambridge Journal of Regions, Economy, & Society*, 6, 3-21. Retrieved from https://academic.oup.com/cjres/article-pdf/6/1/3/1275503/rss023.pdf

Chapter 6

1. Wired to teach. (n.d.). *Evergreen*. Retrieved from http://www.evergreen.edu/magazine/2008spring/weinman

2. Sorvino, C. (2016, June 5). A Q&A with mother of the internet Lynda Weinman, cofounder of Lynda.com. *Forbes*. Retrieved from https://www.forbes.com/sites/chloesorvino/2016/06/05/a-qa-with-mother-of-the-internet-lynda-weinman-cofounder-of-lynda-com/

3. How to grow your business like Lynda. (n.d.). Lynda.com. Retrieved from https://www.lynda.com/articles/how-to-grow-your-business-like-lynda

4. Lynda Weinman: Queen of the triple win. (2011, October 26). *The Atlas Society*. Retrieved from https://atlassociety.org/commentary/commentary-blog/4863-lynda-weinman-queen-of-the-triple-win

5. Weinman, L. (1996). *Designing Web Graphics: How to Prepare images and Media for the Web: With CD-ROM DISC*. New Riders. Indianapolis, IN.

6. The lynda.com story | Lynda's profile (2013, January 18). YouTube. Retrieved from https://www.youtube.com/watch?v=7oabxru6t10

7. LinkedIn Learning Solutions (Producer). (2013). *The lynda.com story / Lynda's profile*. Available from https://www.fastcompany.com/3045404/

from-near-failure-to-a-15-billion-sale-the-epic-story-of-lyndacom
8. Lynda Weinman: Queen of the triple win. (2011, October 26). *The Atlas Society*. Retrieved from https://atlassociety.org/commentary/commentary-blog/4863-lynda-weinman-queen-of-the-triple-win
9. From near failure to a $1.5 billion sale: The epic story of Lynda.com. (2015, April 27). *Fast Company*. Retrieved from https://www.fastcompany.com/3045404/from-near-failure-to-a-15-billion-sale-the-epic-story-of-lyndacom
10. Lynda Weinman: Queen of the triple win. (2011, October 26). *The Atlas Society*. Retrieved from https://atlassociety.org/commentary/commentary-blog/4863-lynda-weinman-queen-of-the-triple-win
11. Empson, Rip. (2012, May 3). Smart Education: How Lynda.com Hit $70M In Revenue Without A Penny From Investors. *TechCrunch*. Retrieved from https://techcrunch.com/2012/05/03/lynda-70m/
12. lynda.com Ranked No. 1 Job Creator in Education by *Inc. Magazine*. (2012, Decemeber 07). *Marketwire*. Retrieved from http://www.marketwired.com/press-release/lyndacom-ranked-no-1-job-creator-in-education-by-inc-magazine-1735077.htm
13. How does Lynda.com have so many paid subscribers if information wants to be free? (n.d.) *Mixergy*. Retrieved from https://mixergy.com/interviews/subscribers-lynda-weinman/
14. About lynda.com. (n.d.). Lynda.com. Retrieved from https://www.lynda.com/press
15. Martin, E. (2014, January 23). Lynda.com founder dishes details over breakfast. *Pacific Coast Business Times*. Retrieved from https://www.pacbiztimes.com/2014/01/23/lynda-weinman-lynda-com/
16. Empson, R. (2013, January 15). After 17 years, education platform Lynda.com raises its first round of funding, $103M from Accel & Spectrum. *TechCrunch*. Retrieved from https://techcrunch.com/2013/01/15/after-17-years-education-platform-lynda-com-raises-its-first-round-of-funding-103m-from-accel-spectrum/
17. Porter, J. (2015, April 27). From near failure to a $1.5 billion sale: The epic story of Lynda.com. *Fast Company*. Retrieved from https://www.fastcompany.com/3045404/from-near-failure-to-a-15-billion-sale-the-epic-story-of-lyndacom
18. D'Souza, S. (2010). Audio Transcripts: Interview with Lynda Weinman. *Psychotactics Ltd*. Reterived from https://www.5000bc.com/bigkah/pdf-files/lyndaweinman.pdf
19. Empson, R. (2012, May 3). Smart education: How Lynda.com hit $70M in revenue without a penny from investors. *TechCrunch*. Retrieved from https://techcrunch.com/2012/05/03/lynda-70m/
20. Letters from Lynda. (n.d.). *Lynda.com*. Retrieved from https://www.lynda.com/articles/letter-from-lynda
21. Lacy, S. (2013, April 26). Lynda.com's "agonizing decision" to take venture capital. *Pando*. Retrieved from https://pando.com/2013/04/26/lynda-coms-agonizing-decision-to-take-venture-capital/
22. Casserly, M. (2013, July 24). At Lynda.com content is queen, but the

contributor model could be in jeopardy. *Forbes*. Retrieved from https://www.forbes.com/sites/meghancasserly/2013/07/24/lynda-weinman-online-education-human-capital/

23. Singer, N. (2015, January 14). Investors put $186 million into Lynda.com, an online tutorial service. *The New York Times*. Retrieved from https://bits.blogs.nytimes.com/2015/01/14/investors-put-186-million-into-lynda-com-an-online-tutorial-service/?mcubz=0&_r=0

24. Lunden, I. (2014, April 7). E-learning platfor Lynda.com buys compilr to add in-browser coding tools, price around $20M. *TechCrunch*. Retrieved from https://techcrunch.com/2014/04/07/e-learning-platform-lynda-com-buys-compilr-to-add-in-browser-coding-tools-price-around-20m/

25. Kosoff, M. (2015, April 9). LinkedIn just bought online learning company for $1.5 billion. *Business Insider*. Retrieved from http://www.businessinsider.com/linkedin-buys-lyndacom-for-15-billion-2015-4?r=U.K.&IR=T

26. Mithun, K. (2016, June 13). Meet Microsoft's $26.2 billion dollar girlfriend – LinkedIN. What Next!? *LinkedIn*. Retrieved from https://www.linkedin.com/pulse/meet-microsofts-new-girlfriend-linkedin-what-expect-mithun-k

27. Watters, A. (2015, April 14). Data and diiplomats: On LinkedIn's acquisition of Lynda.com. *Medium*. Retrieved from https://medium.com/@audreywatters/data-and-diplomas-on-linkedin-s-acquisition-of-lynda-com-47d87790cb1c

28. MasterClass. (2017), March 28). Education company MasterClass raises $35 million Series C. *CISION PR Newswire*. Retrieved from http://www.prnewswire.com/news-releases/education-company-masterclass-raises-35-million-series-c-300430366.html

29. LinkedIn acquires online education platform Lynda.com. (n.d.). *Adweek*. Retrieved from http://www.adweek.com/digital/linkedin-acquires-online-education-platform-lynda-com/

30. Hibbert, C. (1999) The House of Medici: Its Rise and Fall. New York, New York: William Morrow.

31. Strickler, Y. (personal communication, 2017, November.).

32. Loy, A. (n.d.). *Presentation and discussion*. Creative Startups.

33. US Securities and Exchange Commission. (2012). Jumpstart Our Jobs Act. Retrieved from https://www.sec.gov/spotlight/jobs-act.shtml

34. We.funder.com (n.d.). Retrieved from https://wefunder.com

35. Magistretti, B., & Hensel, A. (2018, January 8). VCs invested the most capital in 2017 since the dotcom era. *VentureBeat*. Retrieved from https://venturebeat.com/2018/01/08/vcs-invested-the-most-capital-in-2017-since-the-dotcom-era/

36. Kosoff, M. (2016, January 3). These 20 VC-backed companies had the biggest exits of the last year. *Business Insider*. Retrieved from http://www.businessinsider.com/the-20-biggest-vc-backed-company-exits-of-2015-2016-1

37. Glantz, A., Martinez, E., & Gollan, J. (2018, February 15). 8 lenders that aren't serving people of color for home loans. *U.S. News and World Re-*

port. Retrieved from https://www.usnews.com/news/best-states/illinois/articles/2018-02-15/8-lenders-that-arent-serving-people-of-color-for-home-loans

38. Hamilton, A. (personal communication, n.d.).
39. Marinova, P. (2018, January 24). This VC is betting on women, people of color, and LGBTQ founders. *Fortune*. Retrieved from http://fortune.com/2018/01/24/arlan-hamilton-backstage-capital/
40. Dickey, M.R. (2017, January 25). Backstage Capital is raising a second fund to invest in as many women of color as possible. *TechCrunch*. Retrieved from https://techcrunch.com/2017/01/25/backstage-capital-is-raising-a-second-fund-to-invest-in-as-many-women-of-color-as-possible/
41. Creative places & businesses catalyzing growth in communities. (n.d.). Calvert Foundation. Retrieved from http://www.upstartco-lab.org/wp-content/uploads/2017/03/170320-CPB-Final-Report.pdf
42. Misak, A. (personal communication, September, 2017).
43. Rasmussen, A. (personal communication, n.d.).
44. Burrows, H. & Ussher, K. (2011). *The lazy assumption that the creative industries are inherently risky is harming Britain's path to growth...* London: Magdalen House. Retrieved from https://www.demos.co.uk/files/Risky_business_-_web.pdf?1320841913
45. Closing the gap between investors and the creative industry. (n.d.). Eciaplatform. Retrieved from eciaplatform.eu/.../closing-the-gap-between-investors-and-the-creative-industry/
46. Burrows, H. & Ussher, K. (2011). *The lazy assumption that the creative industries are inherently risky is harming Britain's path to growth...* London: Magdalen House. Retrieved from https://www.demos.co.uk/files/Risky_business_-_web.pdf?1320841913
47. Expert view / Investing in new creative companies. (2016, July 6). Creative Entrepreneurs. Retrieved from http://creativeentrepreneurs.co/features/expert-view-investing-in-new-creative-companies
48. Creative places & businesses catalyzing growth in communities. (n.d.). Calvert Foundation. Retrieved from http://docplayer.net/48245418-Reativitycreativit-investment-creative-places-businesses-catalyzing-growth-in-communities.html
49. D'Souza, S. (2010). Audio transcripts: Interview with Lynda Weinman. Psychotactics Ltd. Retrieved from https://www.5000bc.com/bigkah/pdf-files/lyndaweinman.pdf
50. Burrows, H. & Ussher, K. (2011). *The lazy assumption that the creative industries are inherently risky is harming Britain's path to growth...* London: Magdalen House. Retrieved from https://www.demos.co.uk/files/Risky_business_-_web.pdf?1320841913
51. Mills, S. (2006, November 24). I am sportacus! *The Guardian*. Retrieved from https://www.theguardian.com/media/2006/nov/24/lifeandhealth.broadcasting
52. Gordon, B. (2006, August 28). Could we move into LazyTown? *The Telegraph*. Retrieved from http://www.telegraph.co.uk/news/health/3342731/Could-we-move-into-LazyTown.html

53. Action man: The world of sportacus. (2007, July 3). *The Independent*. Retrieved from https://web.archive.org/web/20080119174736/http://arts.independent.co.uk/theatre/features/article2730667.ece

54. Hedberg, A. & Stenius-Bratt, H. (2006, April 5). Intellectual Capital Management in the creative industries: From intellectual creations to intellectual property. *Intellectual Capital Management*. Retrieved from https://gupea.ub.gu.se/bitstream/2077/1890/1/200637.pdf

55. Lloyd, R. (2005, August 4). Sporting its own special energy. *Los Angeles Times*. Retrieved from https://www.newspapers.com/newspage/192793000/

56. Hedberg, A. & Stenius-Bratt, H. (2006, April 5). Intellectual Capital Management in the creative industries: From intellectual creations to intellectual property. *Intellectual Capital Management*. Retrieved from https://gupea.ub.gu.se/bitstream/2077/1890/1/200637.pdf

57. Ibid.

58. Gordon, B. (2006, August 28). Could we move into LazyTown? *The Telegraph*. Retrieved from http://www.telegraph.co.uk/news/health/3342731/Could-we-move-into-LazyTown.html

59. Donnelly, L. (2009, December 5). Sportacus goes into battle to save Lazy-Town from massive debts. *The Telegraph*. Retrieved from http://www.telegraph.co.uk/culture/culturenews/6734585/Sportacus-goes-into-battle-to-save-LazyTown-from-massive-debts.html

60. LazyTown wins BAFTA. (2006, Novermber 29). *Iceland Review*. Retrieved from http://icelandreview.com/news/2006/11/29/lazytown-wins-bafta

61. LazyTown awards. (n.d.). *Internet Movie Database*. Retireved from http://www.imdb.com/title/tt0396991/awards

62. Young, B. (2008, November 19). "Bing bang" goes on in Iceland's "Lazy Town." *Reuters*. Retrieved from http://www.reuters.com/article/us-financial-lazytown/bing-bang-goes-on-in-icelands-lazy-town-idU.S.TRE4AJ0D920081120

63. Butler, S. (2010, May 31). Lazytown children's television show becomes latest victim of Iceland's financial crisis. *The Telegraph*. Retrieved from http://www.telegraph.co.uk/finance/financialcrisis/7790666/Lazytown-childrens-television-show-becomes-latest-victim-of-Icelands-financial-crisis.html

64. Turner, M. (2011, September 8). 'Lazytown' founder sells to Turner Broadcasting for $25 million. *The Hollywood Reporter*. Retireved from http://www.hollywoodreporter.com/news/lazytown-founder-sells-turner-broadcasting-232908

65. Sommer, F. (2017). Coronado Ventures Summit, Santa Fe, New Mexico.

66. Kadlubek, V. (personal communication, n.d.).

67. Lopez, T. (personal communication, n.d.).

68. Creative places & businesses catalyzing growth in communities. (n.d.). Calvert Foundation. Retrieved from http://docplayer.net/48245418-Reativitycreativit-investment-creative-places-businesses-catalyzing-growth-in-communities.html

69. Lampert, A. (2015, April 20). Cirque du Soleil sells majority stake to U.S.,

Chinese investors. *Reuters*. Retrieved from http://www.reuters.com/article/us-cirquedusoleil-m-a-tpg/cirque-du-soleil-sells-majority-stake-to-u-s-chinese-investors-idU.S.KBN0NB1AX20150420

70. Lev-Ram, M. (n.d.). If I ran the circus. *Fortune*. Retrieved from http://fortune.com/cirque-du-soleil-show-business/
71. Homepage. (n.d.). *Financial Times*. Retrieved from https://www.ft.com/content/9203e38c-0dab-11e5-9a65-00144feabdc0
72. Young creative entrepreneur awards. (2014). British Council. Retrieved from https://www.britishcouncil.or.th/en/programmes/arts/past-projects/2013-2014/creative-entrepreneur-awards
73. Cohen, D. (2014, December 23). Grounding mobile policies: Ad hoc networks and the creative city in Bandung, Indonesia. Singapore Journal of Tropical Geography. Retrieved from doi.org/10.1111/sjtg.12090
74. Move over Jakarta: Bundung, Surabaya on the rise. (n.d.). *Edelman*. Retrieved from https://www.edelman.id/move-jakarta-bandung-surabaya-rise/
75. Cohen, D. (2014, December 23). Grounding mobile policies: Ad hoc networks and the creative city in Bandung Indonesia. *Singapore Journal of Tropical Geography*. Retrieved from doi.org/10.1111/sjtg.12090
76. Edwin, J. (n.d.). Visual Media in Indonesia. *Video Vanguard*.
77. Populer, A. (2017, March 10). 9 Orang Baik Versi TurunTangan Ini Akan Menginspirasimu Berinovasi. *Turntangan*. Retrieved from http://blog.turuntangan.org/9-orang-baik-versi-turuntangan-ini-akan-menginspirasimu-berinovasi/
78. Nani, J. (2016, February 29). Actress plans to open studio in Kingston. *Record Online Times Hearld-Record*. Retrieved from http://www.recordonline.com/article/20160229/NEWS/160229362
79. Sveikauskas, G. & Platt, F.M. (n.d.). New filmmaking facility is brewing in Kingston. *Stockadeworks*. https://www.stockadeworks.org/in-the-press/2016/10/16/new-filmmaking-facility-is-brewing-in-kingston
80. Ben-Ami, A. (personal communication, n.d.).
81. Sawers, P. (2015, August 27). Y Combinator startups have raised $7B with a $65B total valuation; 8 are $1B unicorns. *VentureBeat*. Retrieved from https://venturebeat.com/2015/08/27/y-combinator-startups-have-raised-7b-with-a-65b-total-valuation-8-are-1b-unicorns/
82. Sommer, F. (2017, March 30). Coronado Ventures Morum.

Chapter 7

1. Entrepreneurship: The big smoke. (2016, August 5). Modaboss. Retrieved from http://www.moda-box.com/blog/2016/08/05/meet-an-innovator/
2. Rodz, C. (2016, May 9). The refugee is taking the fashion world by storm. *Entrepreneur*. Retrieved from https://www.entrepreneur.com/article/272091
3. Ibid.
4. Monica Phromsavanh ModoBox interview. (n.d.). *Femail*. Retrieved from https://www.femail.com.au/monica-phromsavanh-modabox-interview.

htm
5. Daskal, L. (n.d.). How these 4 principles helped one refugee become a successful CEO. *Inc.* Retrieved from https://www.inc.com/lolly-daskal/how-these-4-principles-helped-one-refugee-become-a-successful-ceo.html

6. Ibid.

7. Phromsavanah, M. (personal communication, January 24, 2018).

8. Littlelaosontheprairie. (2015, January 2). Monica Phromasavanh: The Lao New Yorker with Argentinian roots. *Little Laos on the Prairie.* Retrieved from http://littlelaosontheprairie.org/2015/01/02/monica-phromasa-vanh-the-lao-new-yorker-with-argentinian-roots/

9. Nguyen, S.V. (2015, January 21). *Maker's lane: MODABOX founder + CEO.* Available from https://www.youtube.com/watch?v=zxTO6GrCdaY

10. Summit Details. (n.d.). *The United State of Women.* Retrieved from https://www.theunitedstateofwomen.org/summit-details/

11. Modabox. (n.d.). *Owler.* Retrieved from https://www.owler.com/iaApp/9547804/modabox-company-profile

12. Rodz, C. (2016, May 9). This refugee is taking the fashion world by storm. *Entrepreneur.* Retrieved from https://www.entrepreneur.com/article/272091

13. Herman, L. (2015, September 21). She got there: Leona Vasserman and Monica Phromsavanh, co-founders of ModaBox. *Her Campus.* Retrieved from https://www.hercampus.com/career/how-she-got-there/how-she-got-there-leona-vasserman-monica-phromsavanh-co-founders-modabox

14. Brooke, N. (2003). What makes a successful city? *Real Estate Issues.* Retrieved from https://www.cre.org/wp-content/uploads/2017/04/28_4_focus_brooke.pdf

15. Small business creation and growth: Facts, obstacles and best practices. (n.d.). OECD. Retrieved from https://www.oecd.org/cfe/smes/2090740.pdf

16. Bahn, K., Willensky, R., & McGrew, A. (2016). *A progressive agenda for inclusive and diverse entrepreneurship.* Center for American Progress. Retrieved from http://www.astrid-online.it/static/upload/cap_/cap_progressiveagenda.pdf

17. The multiplier effect of local independent businesses. (n.d.). *American Independent Business Alliance.* Retrieved from https://www.amiba.net/resources/multiplier-effect/

18. Women flexing their economic muscle, starting more than 1200 new businesses per day, according to new research. (2014, March 26). *American Express.* Retrieved from http://about.americanexpress.com/news/pr/2014/women-flex-economic-muscle-new-research.aspx

19. Haimerl, A. (2015, June 29). The fastest-growing group of entrepreneurs in America. *Fortune.* Retrieved from http://fortune.com/2015/06/29/black-women-entrepreneurs/

20. Astrada, S. & Rizzo, C. (2016). The new face of small business. *Georgetown Public Policy Review.* Retrieved from http://www.gpprspring.com/

small-business/

21. Kerr, S.P., & Kerr, W.R. (2016, October 3). Immigrants play a dispropor-tionate role in American entreprenurship. *Harvard Business Review.* Retrieved from https://hbr.org/2016/10/immigrants-play-a-dispropor-tionate-role-in-american-entrepreneurship

22. New Kauffman Foundation grant program aims to remove barriers diverse entrepreneurs face. (2017, April). *Ewing Marion Kauffman Founda-tion.* Retrieved from http://www.kauffman.org/newsroom/2017/04/new-kauffman-foundation-grant-program-aims-to-remove-barriers-di-verse-entrepreneurs-face

23. Hunt, V. Layton, D., & Prince, S. (2015, February 2). Diversity matters. *McKinsey & Company.* Retrieved from http://assets.mckinsey.com/~/media/857F440109AA4D13A54D9C496D86ED58.ashx

24. Entrepreneurs have the potential to create 10 million youth jobs in G20 countries, new Accenture research finds. *Accenture.* Retrieved from https://newsroom.accenture.com/subjects/management-consulting/entrepreneurs-have-the-potential-to-create-10-million-youth-jobs-in-g20-countries-new-accenture-research-finds.htm

25. Boffey, D. (2015, February 21). Youth unemployment rate is worst for 20 years, compared with overall figure. *The Guardian.* Retrieved from https://www.theguardian.com/society/2015/feb/22/youth-unemploy-ment-jobless-figure

26. 2017 Global Entrepreneurship Report. (2017). *Global Entrepreneurship Monitor.* Retrieved from http://gemconsortium.org/report/49812

27. Haimerl, A. (2015, June 29). The fastest-growing group of entrepreneurs in America. *Fortune.* Retrieved from http://fortune.com/2015/06/29/black-women-entrepreneurs/

28. Venture capital demographics – 87% of VC-backed founder are white; All-Asian teams raise largest funding rounds. *CB Insights.* Retrieved from https://www.cbinsights.com/research/venture-capital-demographics-87-percent-vc-backed-founders-white-asian-teams-raise-largest-funding/

29. Hunt, V. Layton, D., & Prince, S. (2015, January). Why diversity matters. McKinsey & Company. Retrieved from http://www.mckinsey.com/busi-ness-functions/organization/our-insights/why-diversity-matters

30. Bettcher, K. E., & Mihaylova, T. (2015, May 26). *Economic inclusion: Le-veraging markets and entrepreneurship to extend opportunity.* Center for International Private Enterprise. Retrieved from https://www.cipe.org/wp-content/uploads/2015/05/FS_05262015-Economic-Inclusion.pdf

31. Ibid.

32. Ibid.

33. *Creative diversity: The state of diversity in the U.K.'s creative industries, and what we can do about it.* (n.d.) Creative Industries Federation. Retrieved from https://www.creativeindustriesfederation.com/sites/default/files/2017-06/30183-CIF%20Access%20&%20Diversity%20Booklet_A4_Web%20(1)(1).pdf

34. Why does this bias exist? (n.d.). Creative Industries Federation. Retrieved from https://www.yumpu.com/en/document/view/54833564/cre-

ative-diversity/15

35. Creative Startups. (2017). *Impact Report 2016: Assessing the effectiveness of the Creative Startups Accelerators.* (2017). Retrieved from http://www.creativestartups.org/sites/default/files/CreativeStartups_2016ImpactReport_PrintFriendly.pdf

36. CreativeMornings HQ. (producer). *Lee Francis: Fantasy, dreams, and the building of a new reality.* Available from https://www.youtube.com/watch?v=Zkh3zGIsHb4

37. Rezilience Art Festival, Albuquerque, April 30, 2016

38. Francis, L. (personal communication, n.d.).

39. Bailer, B. (2017, March 31). Native American superheroes get a change to fly! *Arizona Public Media.* Retrieved from https://www.azpm.org/s/46707-tribal-force/

40. Gomez, A. (2016, November 11). Indigenous Comic Con explores influences. *Albuquerque Journal.* Retrieved from https://www.abqjournal.com/886847/native-ingenuity.html

41. Ortega, M. (2017, June 1). Creative Startups graduate opening unique shop up downtown. *Albuquerque Business First.* Retrieved from https://www.bizjournals.com/albuquerque/news/2017/06/01/creative-startups-graduate-opening-unique-shop.html

42. CreativeMornings HQ. (producer). *Lee Francis: Fantasy, dreams, and the building of a new reality.* Available from https://www.youtube.com/watch?v=Zkh3zGIsHb4

43. City Alive (producer). (2016, November 29). *First Ever Indigenous Comic Con Hosted in Albuquerque.* Available from https://www.youtube.com/watch?v=fKjm7W3e13g

44. Logan, P. (2003, July 9). Laguna author Lee Francis was 'example of what a teacher should be'. *Albuquerque Journal.* Retrieved from https://www.abqjournal.com/obits/profiles/francis07-09-03.htm

45. Ibid.

46. Cultural entrepreneurship: At the crossroads of people, place, and prosperity. (2010). Creative Startups report. W.K. Kellogg Foundation. Retrieved from https://www.scribd.com/document/50675158/REPORT-Crossroads-of-People-Place-Prosperity

47. Ibid.

48. Cakaric, D., Roell, W., & Zia, M. (n.d.). *Humanity in Action.* Retrieved from https://www.humanityinaction.org/knowledge-base/677-a-bridge-waiting-to-be-built-rotterdam-s-entrepreneurial-elite-and-ethnic-minority-entrepreneurs

49. Ibid.

50. Zeker zijn in Rotterdam. (n.d.). PvdA *Rotterdam.* Retrieved from http://www.pvdarotterdam.nl/inspirerende-vrouwendag/

51. People. (n.d.). Mahasin Tanyaui. *Salzburg Global.* Retrieved from http://www.salzburgglobal.org/people.html?userID=21653&eventID=7446

52. Cakaric, D., Roell, W., & Zia, M. (n.d.). *Humanity in Action.* Retrieved from https://www.humanityinaction.org/knowledge-base/677-a-bridge-waiting-to-be-built-rotterdam-s-entrepreneur-

ial-elite-and-ethnic-minority-entrepreneurs
53. Ibid.
54. Mujeres que triunfan en el más machista de los mundos. (n.d.). *El Confidencial.* Retrieved from https://www.elconfidencial.com/mundo/2015-06-23/mujeres-que-triunfan-en-el-mas-machista-de-los-mundos_898092/
55. Curley, N. (2012, January 17). 6 Ways a user-genderated recipe site becamse a success in Saudi Arabia. *Wamda.* Retrieved from https://www.wamda.com/2012/01/6-ways-a-user-generated-recipe-site-became-a-success-in-saudi-arabia
56. Curley, N. (2013, May 28). Middle East venture partners invests $1.9 million in three scaling companies. *Wamda.* Retrieved from https://www.wamda.com/en/2013/05/middle-east-venture-partners-invests-1-9-million-in-three-scaling-companies
57. Anderson, B. (2015, May 7). Leading the way in Lebanon, one woman at a time. *BBC.* Retrieved from http://www.bbc.com/capital/story/20150506-lebanons-women-pioneers
58. Ibid.
59. du Liban, B. (2014, January 24). *Hala Labaki – Shahiya – BDL Start-up Workshop 2013 – 33.* Available from https://www.youtube.com/watch?v=zX1qXePIs4E
60. d'Arc Taylor, S. (2013, September 26). How Lebanese recipe portal Shahiya is empowering women in Saudi Arabia and abroad. *Wamda.* Retrieved from https://www.wamda.com/2013/09/lebanese-startup-shahiya-empowers-women
61. Ibid.
62. Curley, N. (2012, January 17). 6 ways user-generated recipe site became a success in Saudi Arabia. *Wamda.* Retrieved from https://www.wamda.com/en/2012/01/6-ways-a-user-generated-recipe-site-became-a-success-in-saudi-arabia
63. Startup Megaphone (producer). (2015, June 12). *Hala Labaki.* Available from https://www.youtube.com/watch?v=IOUhfgyN2FY
64. Ha, A. (2012, August 10). DMD panorama opens API to power panoramic photos in any app. *TechCrunch.* Retrieved from https://techcrunch.com/2012/08/10/dmd-panorama-api/
65. Anderson, B. (2015, May 7). Leading the way in Lebanon, one woman at a time. *BBC.* Retrieved from http://www.bbc.com/capital/story/20150506-lebanons-women-pioneers
66. Shahiya, an investment by Japanese company Cookpad. (2015, March 1). *Executive Magazine.* Retrieved from https://www.pressreader.com/lebanon/executive-magazine/20150301/282033325678647
67. Fielding-Smith, A. (2013, May 15). Start-up Shahiya serves up huge virtual cookbook for the Mideast. *Financial Times.* Retrieved from https://www.ft.com/content/4575fa12-bbde-11e2-a4b4-00144feab7de
68. Ha, A. (2012, August 10). DMD panorama opens API to power panoramic photos in any app. *TechCrunch.* Retrieved from https://techcrunch.com/2012/08/10/dmd-panorama-api/

69. Penenberg, A. (2009, October 12). Flicker co-founder Caterina Fake on the value of viral loops [exclusive Q&A]. *Fast Company*. Retrieved from https://www.fastcompany.com/1402994/flickr-co-founder-caterina-fake-value-viral-loops-exclusive-qa

70. Solon, O. (2016, July 2016). What's next for Flickr after yahoo's sale? *The Guardian*. Retrieved from https://www.theguardian.com/technology/2016/jul/25/yahoo-moves-next-for-flickr

Chapter 8

1. Adrian, B. (2003). *Framing the bride: Globalizing beauty and romance in Taiwan's bridal industry*. University of California Press, Oakland, California.

2. Creativity, competitiveness spice up Taiwan's wedding business. (2011, July 23). *Taiwan Today*. Retrieved from http://taiwantoday.tw/news.php?unit=6,23,45,6,6&post=10384

3. Ibid.

4. Wedding photo in Taiwan. (n.d.). Taiwanholidays.com.au Retrieved from http://www.taiwanholidays.com.au/wedding-photo-in-taiwan

5. Chung, J. (n.d.). Taiwan hopes to lure engaged couples. *Taipei Times*. Retrieved from http://www.taipeitimes.com/News/taiwan/archives/2014/06/26/2003593722

6. Ibid.

7. Creativity, competitiveness spice up Taiwan's wedding business. (2011, July 23). *Taiwan Today*. Retrieved from http://taiwantoday.tw/news.php?unit=6,23,45,6,6&post=10384

8. Taiwan's top court rules in favour of same-sex marriage. (2017, May 24). *BBC*. Retrieved from http://www.bbc.com/news/world-asia-40012047

9. About. (n.d.). *Mighty Vision*. Retrieved from https://www.mightyvision.com.au/about/1/

10. Taiwan zeros in on global wedding dress supply chain. (2016, February 25). *Taiwan Today*. Retrieved from http://taiwantoday.tw/news.php?unit=6,23,6,6&post=12486

11. Creativity, competitiveness spice up Taiwan's wedding business. (2011, July 23). *Taiwan Today*. Retrieved from http://taiwantoday.tw/news.php?unit=6,23,45,6,6&post=10384

12. Flew, T. (2013). *Creative industries and urban development: Creative cities in the 21st century*. New York: Routledge.

13. Reis, J. (2011, June 29). Creative-based strategies in small and medium-sized cities: Guidelines for local authorities. *Issuu*. Retrieved from https://issuu.com/jorgereis/docs/creative-clusters-balance-inteli

14. Ibid.

15. Currid-Halkett, & Stolarck, K. (2013, March 1). Baptism by fire: Did the creative class generate economic growth during the crisis? *Economy and Society*, 6:1, pp 55-69. Retrieved from https://academic.oup.com/cjres/article-abstract/6/1/55/470148/Baptism-by-fire-did-the-cre-

ative-class-generate?redirectedFrom=fulltext

16. Petrov, A. (2007). *A look beyond metropolis: Exploring creative class in the Canadian periphery.* Canadian Journal of Regional Science, 451-474. Retrieved from http://www.cjrs-rcsr.org/archives/30-3/PETROV.pdf

17. Bishop, A., & Han, S.S. (2013, November 29). Growth of the creative economy in small regional cities: A case study of Bendigo. *Analysis & Policy Observatory.* Retrieved from https://apo.org.au/node/59741

18. Bhargava, J., & Klat, A. (2017, January 5). Content democratization: How the internet is fueling the growth of creative economies. *strategy&.* Pwc. Retrieved from https://www.strategyand.pwc.com/reports/content-democratization

19. Ibid.

20. Ibid.

21. Eagle, N.(personal communication, 2018, January).

22. Roberts, E., & Townsend, L. (2015, January 13). The contribution of the creative economy to the resilience of rural communities: Exploring cultural and digital capital. *Sociologia Ruralis* 56:2 Retrieved from http://onlinelibrary.wiley.com/doi/10.1111/soru.12075/abstract

23. Reis, J. (2011, June 29). Creative-based strategies in small and medium-sized cities: Guidelines for local authorities. *Issuu.* Retrieved from https://issuu.com/jorgereis/docs/creative-clusters-balance-inteli

24. Ibid.

25. Willis, J.J. (2016, March 24). Three young labels making old methods new again. *The New York Times.* Retrieved from https://www.nytimes.com/2016/03/24/t-magazine/fashion/jewelry-fashion-labels-etkie-kinsfolk-mataano.html?mcubz=0&_r=0

26. Rogalsky, D.K., Mendola, P., Metts, T.A., & Martin, W.J. (2014, August). *Environmental Health Perspectives.* 122:8, pp. 806-810. Retrieved from https://www.ncbi.nlm.nih.gov/pmc/articles/PMC4123020/

27. Fleming, O. (2015, July 14). Could a $168 bracelet revive the Native American economy? *Elle.* Retrieved from http://www.elle.com/fashion/accessories/a29238/new-luxury-jewelry-label-thats-investing-in-women/

28. Etkie. (2016, March 28). *Kiva.* Retrieved from https://www.kiva.org/about/where-kiva-works/partners/348

29. Allen, L. (2014, June 4). How Etkie beaded bracelets financially and socially empower Native women. *Indian Country Today.* Retrieved from https://indiancountrymedianetwork.com/news/business/how-etkie-beaded-bracelets-financially-and-socially-empower-native-women/

30. Robinson-Avila, K. (2015, July 13). Accelerator helping jump-start creative industries. *Albuquerque Journal.* Retrieved from https://www.abqjournal.com/611548/accelerator-helping-jumpstart-creative-industries.html

31. Kahn, M. (2014, May 26). Etkie jewelry: Investing in women. *Cool Hunting.* Retrieved from http://www.coolhunting.com/style/etkie-jewelry-investing-in-women

32. TEDx Talks. (producer). (2013, December 17) *Social consumerism and its future: Sydney Alfonso at TEDxTUHH.* Retrieved from https://www.youtube.com/watch?v=HW6SpCRY6_w

33. Fleming, O. (2015, July 14). Could a $168 bracelet revive the Native American economy? *Elle*. Retrieved from http://www.elle.com/fashion/accessories/a29238/new-luxury-jewelry-label-thats-investing-in-women/
34. Weinswig, D. (2016, April 14). As fine jewelry moves online, the market sparkles. *Forbes*. Retrieved from https://www.forbes.com/sites/deborahweinswig/2016/04/14/as-fine-jewelry-moves-online-the-market-sparkles/
35. City Alive (2017). Etkie: An Albuquerque business that doesn't just create jobs. Retrieved from https://www.youtube.com/watch?v=D-lu12a50qw
36. Kelly, C. (2016, October 10). How to win (or lose) older women shoppers. *Forbes*. Retrieved from https://www.forbes.com/sites/caitlinkelly/2016/10/10/how-to-win-or-lose-older-women-shoppers/#3d63b-7c7704a
37. City Alive (2017). Etkie: An Albuquerque business that doesn't just create jobs. Retrieved from https://www.youtube.com/watch?v=D-lu12a50qw
38. Alfonso, S. (personal communication, n.d.).
39. Ibid.
40. Robinson-Avila, K. (2015, July 13). Accelerator helping jump-start creative industries. *Albuquerque Journal*. Retrieved from https://www.abqjournal.com/611548/accelerator-helping-jumpstart-creative-industries.html
41. Alfonso, S. (personal communication, n.d.).
42. Meet our alumni. (n.d.). *Questrom School of Business*. Retrieved from https://www.bu.edu/questrom/alumni/community/meet-our-alumni/chan-luu/
43. Finnish embassy supports craft development in Namibia. *Unique Nambian Arts OMBA*. Retrieved from http://www.omba.org.na/index.php/news?start=2
44. Nagada. (n.d.). Retrieved from https://nagada.net
45. Fleming, O. (2015, July 14). Could a $168 bracelet revive the Native American economy? *Elle*. Retrieved from http://www.elle.com/fashion/accessories/a29238/new-luxury-jewelry-label-thats-investing-in-women/
46. Social embeddedness in entrepreneurship research: The importance of context and community. (2014, January). *ResearchGate*. Retrieved from https://www.researchgate.net/publication/298704933_Social_embeddedness_in_entrepreneurship_research_The_importance_of_context_and_community
47. Kahn, M. (2014, May 26). Etkie jewelry: Investing in women. *Cool Hunting*. Retrieve from http://www.coolhunting.com/style/etkie-jewelry-investing-in-women
48. Technological park in obidos / Jore Mealha. *Arch Daily*. Retrieved from http://www.archdaily.com/587677/technological-park-in-obidos-jorge-mealha
49. O fabuloso destino de Mafalda Milhões: A ilustradora que inventou uma livraria. (2016, September 25). *Noticias Magazine*. Retrieved from https://www.noticiasmagazine.pt/2016/o-fabuloso-destino-de-mafalda-milhoes/
50. Ibid.

51. Reis, J. (2011, June 29). Creative-based strategies in small and medium-sized cities: Guidelines for local authorities. *Issuu*. Retrieved from https://issuu.com/jorgereis/docs/creative-clusters-balance-inteli
52. Belanciano, V. (2013, April 23). Uma uptopia ou uma ideia brilhante? Óbidos vai ser uma Vila Literária. Edinburgh City of Literature .Retrieved from https://www.publico.pt/2013/04/23/jornal/uma-utopia-ou-uma-ideia-brilhante-obidos-vai-ser-uma-vila-literaria-26425235
53. Ibid.
54. Reis, J. (2011, June 29). Creative-based strategies in small and medium-sized cities: Guidelines for local authorities. *Issuu*. Retrieved from https://issuu.com/jorgereis/docs/creative-clusters-balance-inteli
55. O armazém das oportunidades. (2014, April 20). *Público*. Retrieved from https://www.publico.pt/2014/04/20/mundo/noticia/o-armazem-das-oportunidades-1632385
56. Belanciano, V. (2013, April 23). Uma utopia ou uma ideia brilhante? Óbidos vai ser uma Vila Literária. Edinburgh City of Literature. Retrieved from http://www.cityofliterature.com/cities-of-literature/cities-of-literature/obidos/
57. Carvalho, L.C. (2017, January). *Handbook of research on entrepreneurial development and innovation within smart cities*. IGI Global. Retrieved from https://www.igi-global.com/book/handbook-research-entrepreneurial-development-innovation/170033
58. Reis, J. (2011, June 29). Creative-based strategies in small and medium-sized cities: Guidelines for local authorities. *Issuu*. Retrieved from https://issuu.com/jorgereis/docs/creative-clusters-balance-inteli
59. Ibid.
60. Ibid.
61. Florida, R. (2003, March). Cities and the creative class. *Cities & Community* 2:1. Retrieved from https://creativeclass.com/rfcgdb/articles/4%20 Cities%20and%20the%20Creative%20Class.pdf
62. Reis, J. (2011, June 29). Creative-based strategies in small and medium-sized cities: Guidelines for local authorities. *Issuu*. Retrieved from https://issuu.com/jorgereis/docs/creative-clusters-balance-inteli
63. Saramago, J. (2002). Journey to Portugal: In pursuit of Portugal's history and culture. *Orlando: Harcourt, Inc.* Retrieved from https://www.amazon.com/Journey-Portugal-Pursuit-Portugals-History/dp/0156007134
64. Choudhury, A.R. (2017, September 6). ChuChu TV: Like a diamond in the sky. *Afaqs!* Retrieved from http://www.afaqs.com/news/story/51268_ ChuChu-TV-Like-a-diamond-in-the-Sky
65. The ChuChu TV. (producer). (n.d.). *ChuChu TV nursery rhymes & kids songs*. Retrieved from https://www.youtube.com/user/TheChuChuTV
66. How much money ChuChu TV makes on YouTube. (2018, January 30). *Naibuzz*. Retrieved from http://naibuzz.com/2016/10/21/much-money-chuchu-tv-makes-youtube/
67. ChuChu TV's new consumer products biz expects 8 to 10 per cent as royalty. *Indian Television*. Retrieved from http://www.indiantelevision. com/mam/marketing/mam/chuchu-tvs-new-consumer-products-biz-

expects-8-to-10-per-cent-as-royalty-161013

68. Balachandran, M. (2017, August 3). An Indian dad turned his daughter's favourite nursery rhymes into a million-dollar business on YouTube. *Quartz India*. Retrieved from https://qz.com/1033031/chuchutv-an-indian-dad-turned-his-daughters-favourite-nursery-rhymes-into-a-million-dollar-business-on-youtube/

69. Census 2011. (2011). Census India. Retrieved from http://www.censusindia.gov.in/2011-prov-results/paper2/data_files/India2/Table_2_PR_Cities_1Lakh_and_Above.pdf

70. Expat Ashok Leyland Nissan Villas. *Economic Times Indian Times*. Retrieved from http://articles.economictimes.indiatimes.com/2009-01-15/news/27663513_1_expat-ashok-leyland-nissan-villas

71. Seetharaman Narayanan. (2009). *Photoshop Hall of Fame*. Retrieved from http://www.photoshophalloffame.com/seetharaman-narayanan/

72. Rajan, T.A. & Kapur, V. (2017, May 22). *The role of ventures in strengthening the fabric of the city*. Coller Institute of Venture. Retrieved from https://www.collerinstituteofventure.org/the-role-of-ventures-in-strengthening-the-fabric-of-the-city-webpost/

73. Mishra, A.K. (2016, July 13). ChuChu TV wields rhyme and reason to conquer YouTube. *Live Mint*. Retrieved from http://www.livemint.com/Consumer/BDaeN0pczcW0HN5dA6ODFK/ChuChu-TV-wields-rhyme-and-reason-to-conquer-YouTube.html

74. How ChuChu TV became one of the APAC's most-watched YouTube channels. (n.d.). *APAC*. http://apac.thinkwithgoogle.com/case-studies/chuchutv-biggest-youtube-channel-apac.html

75. Mishra, A.K. (2016, July 13). ChuChu TV wields rhyme and reason to conquer YouTube. *Live Mint*. Retrieved from http://www.livemint.com/Consumer/BDaeN0pczcW0HN5dA6ODFK/ChuChu-TV-wields-rhyme-and-reason-to-conquer-YouTube.html

76. Bhargava, J., & Klat, A. (2017, January 5). Content democratization: How the internet is fueling the growth of creative economies. *strategy&*. Retrieved from https://www.strategyand.pwc.com/reports/content-democratization

77. Ibid.

78. Creative economy report 2013 special edition: Widening local development pathways. (2013). United Nations/UNDP/UNESCO. Retrieved from https://books.google.com/books?id=XbEaAgAAQBAJ

79. *Creative economy report 2013 special edition: Widening local development pathways*. (2013). United Nations/UNDP/UNESCO. Retrieved from https://books.google.com/books?id=XbEaAgAAQBAJ

80. Galloway, L. (2015, January 21). Living in: 2015's hottest cities. *BBC*. Retrieved from http://www.bbc.com/travel/story/20150116-living-in-2015s-hottest-cities

Chapter 9

1. Wrede, C. (2014, July 20). Ivonette Albuquerque, a economist que só

investee m boas ações. *O Globo.* Retrieved from https://oglobo.
globo.com/rio/ivonette-albuquerque-economista-que-so-in-
veste-em-boas-acoes-13317284

2. Sousa, H.D., Garrido, N., & Almeida, A. (2014, April). O armazém
 das oportunidades. *Público.* Retrieved from https://www.publico.
 pt/2014/04/20/mundo/noticia/o-armazem-das-oportunidades-1632385
3. Chin, C., & Leal, F. (2014, May 28). With opportunity scarce, Brazil's youth
 demand more than the World Cup. *PRI.* Retrieved from https://www.
 pri.org/stories/2014-05-28/opportunity-scarce-brazils-youth-demand-
 more-world-cup-video
4. Sousa, H.D., Garrido, N., & Almeida, A. (2014, April). O armazém
 das oportunidades. *Público.* Retrieved from https://www.publico.
 pt/2014/04/20/mundo/noticia/o-armazem-das-oportunidades-1632385
5. Pereire, R. (2010, April 3). O galpão onde crescem talentos. *EPOCA.* Retrieved from
 http://revistaepoca.globo.com/Revista/Epoca/0,,EMI91477-15228,00-O+GAL-
 PAO+ONDE+CRESCEM+TALENTOS.html
6. Wrede, C. (2014, July 20). Ivonette Albuquerque, a economist que só
 investee m boas ações. *O Globo.* Retrieved from https://oglobo.
 globo.com/rio/ivonette-albuquerque-economista-que-so-in-
 veste-em-boas-acoes-13317284
7. Ibid.
8. Calero, C. Diez, V. Soares, Y., Kluve, J., & Corseuil, C. (2015, March). Can
 arts interventions enhance labor market outcomes among youth? Ev-
 idence from randomized trial in Rio de Janeiro. *Sole-Jole.* http://www.
 sole-jole.org/15528.pdf
9. Motta, R. (2017, January 6). Projeto social que funciona em antigo galpão
 da CSN quer que armazém seja tombado. *Rio Express.* Retrieved from
 http://www.rjexpress.me/raulmottajunior-projeto-social-que-funcio-
 na-em-antigo-galpao-da-csn-quer-que-armazem-seja-tombado/
10. O galpão onde crescem talentos. (2009, September 16). UOL Blogosfera.
 Retrieved from http://365diasqueacalmaramomundo.zip.net/arch2009-
 09-16_2009-09-30.html
11. Wrede, C. (2014, July 20). Ivonette Albuquerque, a economist que
 só investee m boas ações. *O Globo.* Retrieved from https://oglo-
 bo.globo.com/rio/ivonette-albuquerque-economista-que-so-in-
 veste-em-boas-acoes-13317284
12. The MIF and Galpão Aplauso will scale up a successful methodology that
 uses performing arts to help more than 4,000 Brazilian youth obtain
 quality employment. (n.d.). OMIN Multilateral Investment Fund.
 Retrieved from http://www.fomin.org/en-us/HomeOld2015/News/
 PressReleases/ArtMID/3819/userid/28903/ArticleID/3162/The-MIF-
 and-Galp227o-Aplauso-will-scale-up-a-successful-methodology-that-
 uses-performing-arts-to-help-more-than-4000-Brazilian-youth-obtain-
 quality-employment.aspx
13. Encerrada. Contratacão de assessorial de comunicação e imprensa.
 (n.d.). Galpão Aplauso. Retrieved from http://aplauso.art.br/oportuni-
 dade-contratacao-de-assessoria-de-comunicacao-e-imprensa/

14. Ibid.
15. Treasury announces award for exceptional international development projects. (2014, July 23). U.S. Department of the Treasury. Retrieved from https://www.treasury.gov/press-center/press-releases/Pages/jl2576.aspx
16. Bottari, E. (2017, January 6). Projeto social que funciona em antigo galpão da CSN quer que armazém seja tombado. *O Globo*. Retrieved from https://oglobo.globo.com/rio/projeto-social-que-funciona-em-antigo-galpao-da-csn-quer-que-armazem-seja-tombado-21420837
17. Ibid.
18. Pereira, R. (2010, April 3). O galpão onde crescem talentos. *EPOCA*. Retrieved from http://revistaepoca.globo.com/Revista/Epoca/0,,EMI91477-15228,00-O+GALPAO+ONDE+CRESCEM+TALENTOS.html
19. Bottari, E. (2017, January 6). Projeto social que funciona em antigo galpão da CSN quer que armazém seja tombado. *O Globo*. Retrieved from https://oglobo.globo.com/rio/projeto-social-que-funciona-em-antigo-galpao-da-csn-quer-que-armazem-seja-tombado-21420837
20. Sen, A., & Kakar, R. (2017, February 20). Why are we failing 75% of the world's youth at a time of unique opportunity? *The Guardian*. Retrieved from https://www.theguardian.com/global-development/2017/feb/20/failing-75-per-cent-of-world-youth-unique-opportunity-global-youth-index
21. Hanna, A. L. (n.d.). *The global youth unemployment crisis: Exploring successful initiatives and parenting with youths*. Honors Thesis. Durham: Duke University. Retrieved from https://dukespace.lib.duke.edu/dspace/bitstream/handle/10161/9024/Hanna_The%20Global%20Youth%20Unemployment%20Crisis.pdf;sequence=1
22. *Global employment trends for youth 2015*. (2015). International Labour Organization. Retrieved from http://www.bollettinoadapt.it/wp-content/uploads/2015/10/ilo_youth_employment_10_2015.pdf
23. *Global employment trends for youth 2013: A generation at risk*. (2013). International Labour Organization. Retrieved from http://www.ilo.org/global/research/global-reports/youth/2013/WCMS_212423/lang--it/index.htm
24. *Global employment trends for youth 2015*. (2015). International Labour Organization. Retrieved from http://www.bollettinoadapt.it/wp-content/uploads/2015/10/ilo_youth_employment_10_2015.pdf
25. Youth population trends and sustainable development. (2015, May). United Nations. Retrieved from http://www.un.org/esa/socdev/documents/youth/fact-sheets/YouthPOP.pdf
26. The youth labor market in the Mediterranean area. (2014). *MedNet*. Retrieved from http://edu.oxfam.it/sites/default/files/dossier_1_0.pdf
27. Ibid.
28. Impact Hiring. (n.d.). *The Rockefeller Foundation*. Retrieved from https://www.rockefellerfoundation.org/our-work/initiatives/youth-employment/

29. Ighobor, K. (2011, July 7). Africa's economy rebounds strongly, but jobs remain elusive. *Africa Renewal Online*. Retrieved from http://www.un.org/en/africarenewal/newrels/eca-report.html

30. Hanna, A. L. (n.d.). *The global youth unemployment crisis: Exploring successful initiatives and parenting with youths*. Honors Thesis. Durham: Duke University. Retrieved from https://dukespace.lib.duke.edu/dspace/bitstream/handle/10161/9024/Hanna_The%20Global%20Youth%20Unemployment%20Crisis.pdf;sequence=1

31. United Nations ready to partner with young people, Secretary-General tells forum; They always had ideals, now they use social networks to demand change. (2013, March 27). United Nations. Retrieved from https://www.un.org/press/en/2013/ecosoc6565.doc.htm

32. Culture as a vector for youth development. (n.d.). United Nations. Retrieved from https://www.un.org/esa/socdev/documents/youth/factsheets/youth-cultureasavector.pdf

33. Community collection. (n.d.). *dfrntpigeon*. Retrieved from http://www.dfrntpigeon.com/

34. Youthful Cities. (n.d.). Retrieved from http://www.youthfulcities.com/

35. OAS, IDB, and British Council present the study "The economic impacts of the creative industries in the Americas." (2014, January 16). Inter-American Development Bank. Retrieved from http://www.iadb.org/en/news/news-releases/2014-01-16/economic-impact-of-the-creative-industries-study,10735.html?actionuserstats=close&valcookie=&isajaxrequest=

36. Podkalicka, A., Meredyth, D., MacKenzie, D., Rennie, E., Staley, J., Thomas, J., & Wilson, C. (2013). *Youth media and social enterprise as intervention and innovation: The development, establishment and outcomes 2008 - 2013*. Youthworx Media. Retrieved from http://apo.org.au/system/files/38347/apo-nid38347-149546.pdf

37. Ibid.

38. In Argentina, young people are leaving their mark using one single tool: Education. (n.d.). UNESCO. Retrieved from http://en.unesco.org/creativity/8-argentina

39. New training centre helps indigenous youth gain jobs. (n.d.). UNESCO. Retrieved from http://en.unesco.org/creativity/new-training-centre-helps-indigenous-youth-gain-jobs-0

40. Ford, T. (2016, July 26). "I couldn't even pay for the internet": The Cameroonian who built jobs site in his bedroom. *The Guardian*. Retrieved from https://www.theguardian.com/world/2016/jul/26/self-taught-coder-churchill-nanje-building-careers-cameroons-tech-hub

41. Grandison, G. (2010, December 10). Alex Morrissey spreads Jamaican music online. *The Gleaner*. Retrieved from http://jamaica-gleaner.com/gleaner/20101210/ent/ent1.html

42. South, D. (2012). Southern innovator magazine Issue 2: Youth and entrepreneurship. UNDP. Retrieved from https://books.google.com/books?id=Ty0N969dcssC

43. Bloustien, G. Peters, M. (2011). *Youth, music, and creative Cultures: Playing*

for life. (2011). Hampshire: Palgrave Macmillian.

44. Niaah, S.S. (2010). *Dancehall: From slave ship to ghetto.* Ottawa: Universi-ty of Ottawa Press. https://books.google.com/books/about/Dancehall. html?id=wYA9szgUFRAC

45. Wafate 3D printer. (n.d.). Ulule. Retrieved from https://fr.ulule.com/wa-fate/

46. Meet the Togolese inventor who built a 3D printer from electronic waste. (2016, November 14). *The Observers.* Retrieved from http://observers. france24.com/en/20161110-togolese-invent-3d-printer-waste

47. African inventor makes 3D printer from e-waste. (3013, October 10). *3ders.* Retrieved from http://www.3ders.org/articles/20131010-african-inventor-makes-3d-printer-from-e-waste.html

48. Ungerleider, N. (2013, October 11). This African inventor created a $100 3-D printer from e-waste. *Fast Company.* Retrieved from https://www. fastcompany.com/3019880/this-african-inventor-created-a-100-3-d-printer-from-e-waste

49. Meet the Togolese inventor who built a 3D printer from electronic waste. (2016, November 14). *The Observers.* Retrieved from http://observers. france24.com/en/20161110-togolese-invent-3d-printer-waste

50. African inventor makes 3D printer from scrap. (2013, August 10). *Eurone-ws.* Retrieved from http://www.euronews.com/2013/10/08/african-in-ventor-makes-3d-printer-from-scrap

51. Answer to youth unemployment? Making the formal informal. (2016, August 9). *Abacus.* Retrieved from https://abacus.co.ke/newsfeed/an-swer-to-youth-unemployment-making-the-formal-informal/

52. Africa's young future. (n.d.). *Observer.* Retrieved from http://oecdobserver. org/news/fullstory.php/aid/3830

53. South, D. Southern innovator magazine Issue 2: Youth and entrepreneur-ship. *UNDP.* https://books.google.com/books?id=Ty0N969dcssC

54. Ibid.

55. National profile of working conditions in the United Republic of Tanzania. (2009*).* International Labour Organization. Retrieved from http://www. ilo.org/wcmsp5/groups/public/@ed_protect/@protrav/@travail/docu-ments/publication/wcms_119347.pdf

56. Okoroafor, C. (2016, December 30). Youth for technology foundation founder, Njideka Harry, talks inclusivity in tech, entrepreneurship, and 3D printing technologies. VenturesAfrica. Retrieved from http://ven-turesafrica.com/interview-with-njideka-harry-of-ytf/

57. About the program. (n.d.). 3dafrica. Retrieved from http://3dafrica.org/ about-the-program/

58. Harry, N. (2016, January 20). *4ᵗʰ industrial revolution lies at the intersec-tions of education and entrepreneurship in Africa.* GE Reports. Retrieved from https://www.ge.com/reports/njideka-harry-4th-industrial-revolu-tion-lies-at-the-intersection-of-education-and-entrepreneurship-in-af-rica/

59. Ibid.

60. Okoroafor, C. (2016, December 30). Youth for technology foundation

founder, Njideka Harry, talks inclusivity in tech, entrepreneurship, and 3D printing technologies. VenturesAfrica. Retrieved from http://venturesafrica.com/interview-with-njideka-harry-of-ytf/

61. How the program works for women and youth. (n.d.). 3dafrica. http://3dafrica.org/how-the-program-works/for-women-and-youth-entrepreneurs/

62. Success stories. (n.d.). 3dafrica. http://3dafrica.org/success-stories/

63. Youth economic opportunities. (n.d.). 3daftrica. Retrieved from https://youtheconomicopportunities.org/sites/default/files/uploads/resource/3D%20Africa%20-Njideka%20Harry.pdf

64. *Impact report 2015: Progress, milestones, and future focus.* (2015). Youth for Technology Foundation. Retrieved from http://www.youthfortechnology.org/wp-content/uploads/2013/03/YTFimpactreport2015-FinalDraft-1.pdf

65. Rheault, M., & Tortora, B. (2011, June 30). At least 1 in 5 African youth plan to start a business. *Gallup.* Retrieved from http://news.gallup.com/poll/148271/least-african-youth-plan-start-business.aspx

66. Watts, K.N. (2016, May 15). Winston-Salem artist helps adults, children befriend feelings with story, song. *Relish.* Retrieved from http://www.journalnow.com/relishnow/the_arts/winston-salem-artist-helps-adults-children-befriend-feelings-with-story/article_49951cea-a2b0-5ad0-af9c-80aaff485d7e.html

67. Ibid.

68. Ibid.

69. Deutschendorf, H. (2016, May 4). 7 reasons why emotional intelligence is one of the fastest-growing job skills. *Fast Company.* Retrieved from https://www.fastcompany.com/3059481/7-reasons-why-emotional-intelligence-is-one-of-the-fastest-growing-job-skills

70. Kenan Institute helps create momentum for creative startups. (n.d.). Thomas S. Kenan Institute for the Arts. Retrieved from https://www.uncsa.edu/kenan/news/161019-kenan-institute-helps-create-momentum-for-creative-startups.aspx

71. Boonruang, S. (2015, February 4). Multimedia, including YouTube, is now being used by schools to supplement the existing education curriculum. *Bangkok Post.* Retrieved from http://www.bangkokpost.com/tech/local-news/466046/press-play-to-begin-lesson

72. SmartMonkeyTV (producer). (2014, August 14). Adebayo Adegbembo, Genii Games on educational apps to promote Yoruba language and culture. Available from https://www.youtube.com/watch?v=ywagK-GKHyO8

73. Ford, T. (2016, July 26). "I couldn't even pay for the internet": the Cameroonian who built jobs site in his bedroom. *The Guardian.* Retrieved from https://www.theguardian.com/world/2016/jul/26/self-taught-coder-churchill-nanje-building-careers-cameroons-tech-hub

74. Making learning awesome! (n.d.). *Kahoot!.* Retrieved from https://kahoot.com

75. Bain, M. (2017). Game design can bring your whakapapa to life on-screen

FutureFive. Retrieved from https://futurefive.co.nz/story/game-design-can-bring-your-whakapapa-life-screen/

76. Campbell, C.C. (2013, August 21). The first Native American games company. *Polygon.* Retrieved from https://www.polygon.com/features/2013/8/21/4594372/native-american-games

77. Never Alone review. (2014, November 20). *Eurogamer.* Retrieved from http://www.eurogamer.net/articles/2014-11-20-never-alone

78. Narcisse, E. (2014, August 8). The first video game made by Native Alaskans. *Kotauku.* Retrieved from https://kotaku.com/the-first-big-video-game-made-by-native-alaskans-1614648571

79. Kisima Ignitchuna (producer). (2014, August 14). *Never Alone – Iñpiaq perspectives – Ron Brower, Sr.* Retrieved from https://www.youtube.com/watch?v=gTEtK2fwKlE

80. Cohen, M.I., & Noszlopy, L. (2010). *Contemporary Southeast Asia performance.* Cambridge: Cambridge Scholars Publishing. Retrieved from https://books.google.com/books?id=0pQnBwAAQBAJ

81. Nguyen dao, A. (2014, September 19). Explore Vattambang – visual art school founder. *Phare.* Retrieved from https://pharecircus.org/explore-battambang-visual-art-school-founder/

82. Vachon, M. (2017, January 25). Ambitious arts trial seeks to spark Cambodia's creativity. *The Cambodia Daily.* Retrieved from https://www.cambodiadaily.com/news/ambitious-arts-trial-seeks-to-spark-cambodias-creativity-123982/

83. Eaton, K. (2016, February 10). Come One, Come All: A Circus in Cambodia Is Helping Youths Find Work and Joy. *Take Part.* http://www.takepart.com/article/2016/02/10/circus-school-cambodia/

84. Araya, D., & Peters, M.A. (2010). *Education in the creative economy: Knowledge and learning in the age of innovation.* New York: Peter Lang. Retrieved from https://books.google.com/books?isbn=1433107449

85. Jenkins, H. (2006). *Confronting the challenges of participatory culture: Media education for the 21st century.* John D. and Catherine T. MacArthur Foundation, Chicago, 5-7, 19-20, 3-4

Chapter 10

1. Ann, N.S. (2017, January 10). Alena Murang interview. *Timeout.* Retrieved from https://www.timeout.com/kuala-lumpur/music/alena-murang-interview

2. Sun, A. (2016, April 27). Malaysia's George Town Festival staying small but growing up fast. *South China Morning Post.* Retrieved from http://www.scmp.com/culture/arts-entertainment/article/1938593/malaysias-george-town-festival-staying-small-growing-fast

3. Penang's George Town Festival grows up. (2016, August 16). *The Straits Times.* Retrieved from http://www.straitstimes.com/asia/se-asia/arts-baby-grows-up

4. Festivals are roller coaster rides, say organisers. (2017, January 5). *Smart-Investor.* Retrieved from http://www.smartinvestor.com.my/festi-

vals-are-roller-coaster-rides-say-organisers/

5. Mok, O. (2016, April 26). George Town Festival seeks crowdfunding to keep the party going. *Malay Mail.* Retrieved from http://www.themalaymailonline.com/malaysia/article/george-town-festival-seeks-crowd-funding-to-keep-the-party-going

6. Festivals are roller coaster rides, say organisers. (2017, January 5). *Smart-Investor.* Retrieved from http://www.smartinvestor.com.my/festi-vals-are-roller-coaster-rides-say-organisers/

7. Performing arts thrive in Penang. (2012, June 27). *Pressreader.* Retrieved from https://www.pressreader.com/malaysia/the-star-malaysia-star2/20120627/281487863438048

8. Festivals are roller coaster rides, say organisers. (2017, January 5). *Smart-Investor.* Retrieved from http://www.smartinvestor.com.my/festi-vals-are-roller-coaster-rides-say-organisers/

9. Ibid.

10. Maganathan, D.K. (2014, July 20). Penang's George Town Festival returns. *The Star Online.* Retrieved from http://www.thestar.com.my/lifestyle/entertainment/arts/on-stage/2014/07/20/penangs-george-town-festi-val-returns/

11. The ringgit and sen of festivals. (2015, November). *Penang Month-ly.* Retrieved from http://penangmonthly.com/article.aspx?page-id=3976&name=the_ringgit_and_sen_of_festivals

12. *Enabling crossovers: Good practices in creative industries.* (2014, June 27). Asia-Europe Foundation. Retrieved from http://www.culturalfounda-tion.eu/library/enabling-crossovers

13. BizEvents Asia April-May 2017. (2017). Retrieved from https://issuu.com/bizeventsasia/docs/apr-may_2017_issue

14. The ringgit and sen of festivals. (2015, November). *Penang Month-ly.* Retrieved from http://penangmonthly.com/article.aspx?page-id=3976&name=the_ringgit_and_sen_of_festivals

15. Ibid.

16. Sun, A. (2016, April 27). Malaysia's George Town Festival staying small but growing up fast. *South China Morning Post.* Retrieved from http://www.scmp.com/culture/arts-entertainment/article/1938593/malaysias-george-town-festival-staying-small-growing-fast

17. Govers, R., & Go, F. (2009). *Place Branding: Global, virtual and phys-ical identities, constructed, imagined and experienced.* London: Pal-grave Macmillan. Retrieved from http://www.palgrave.com/us/book/9780230230736

18. Messely, L., Dessein, J., & Lauwers, L. (n.d.). *Regional identity in rural development: Three case studies of regional branding.* Budapest: Agroin-form Publishing House. Retrieved from https://ageconsearch.tind.io/record/91126/files/3_Messely%20Regional_Apstract.pdf

19. Ibid.

20. Pine, J. & Gilmore, J. (1998, July-August). Welcome to the experience economy. *Harvard Business Review.* Retrieved from https://hbr.org/1998/07/welcome-to-the-experience-economy

21. Saiidi, U. (2016, May 5). Millennials are prioritizing 'experiences' over stuff. *CNBC*. Retrieved from https://www.cnbc.com/2016/05/05/millennials-are-prioritizing-experiences-over-stuff.html

22. Lauth, I. (n.d.). Survey finds millennials prefer spending money on experiences over 'things'. *Winspire*. Retrieved from http://blog.winspireme.com/survey-finds-millennials-prefer-spending-money-on-experiences-over-things

23. Kiráľová, A. (2016). *Driving tourism through creative destinations and activities*. Prague: University of Business in Prague. Retrieved from https://www.igi-global.com/book/driving-tourism-through-creative-destinations/171016

24. Building local foods sales in retail settings authenticity and success in marketing "local" review and recommendations. (n.d.). Center for Environmental Farming Systems. Retrieved from https://www.ncgrowingtogether.org/wp-content/uploads/2013/09/NCGT-Research-Brief-Retailer-Version-Authenticity-and-Success-in-Marketing-Local-10-2013.pdf

25. Global study from Cohn & Wolfe defines authenticity in the eyes of consumers and reveals the 100 most authentic brands. (2016). Cohn & Wolfe. Retrieved from http://www.cohnwolfe.com/en/news/global-study-cohn-wolfe-defines-authenticity-eyes-consumers-and-reveals-100-most-authentic-bran

26. Eco-trips and travel. (n.d.). *The Nature Conservatory*. Retrieved from https://www.nature.org/greenliving/what-is-ecotourism.xml

27. Kermeliotis, T. (2012, December 31). School boy's wildfire-tracking website helps tourists spot big beasts. *CNN*. Retrieved from http://www.cnn.com/2012/12/31/tech/web/kruger-latest-sightings-nadav-ossendryver/index.html

28. Ibid.

29. Donal, K.A. (2016, June 6). Africa's most promising entrepreneurs: *Forbes* Africa's 20 under 30 for 2016. *Forbes*. Retrieved from https://www.forbes.com/sites/kerryadolan/2016/06/06/africas-most-promising-entrepreneurs-forbes-africas-30-under-30-for-2016/

30. Amanda. (2014, December 17). Meet Nadav Ossendryver, creator of South Africa's most watched YouTube channel: Kruger Sightings. *Books Live Sunday Times*. Retrieved from http://struik.bookslive.co.za/blog/2014/12/17/meet-nadav-ossendryver-creator-of-south-africas-most-watched-youtube-channel-kruger-sightings/

31. Earn cash monthly by uploading your wildlife photos & videos. (n.d.). *Latest Sightings*. Retrieved from https://www.latestsightings.com/film-earn

32. Kermeliotis, T. (2012, December 31). School boy's wildfire-tracking website helps tourists spot big beasts. *CNN*. Retrieved from http://www.cnn.com/2012/12/31/tech/web/kruger-latest-sightings-nadav-ossendryver/index.html

33. Latest sighting: Connecting people to wildlife. (n.d.). *Latest Sightings*. Retrieved from https://www.latestsightings.com/about-us

34. Hill, T. (2016, June 11). How tourists' phones are threatening South Africa's wildlife. *Takepart*. Retrieved from http://www.takepart.com/arti-

cle/2016/06/11/south-africa-parks-ban-wildlife-animal-apps/

35. Reinstein, D. (2016, July 28). Sighting apps a high-tech threat to wildlife, parks official say. *Travel Weekly*. Retrieved from http://www.travelweek-ly.com/Middle-East-Africa-Travel/Insights/Sighting-apps-a-high-tech-threat-to-wildlife-parks-official-says

36. Ibid.

37. Behal, A. (2017, April 18). What does Coldplay have to do with a startup bringing art to taxis? *Forbes*. Retrieved from https://www.forbes.com/sites/abehal/2017/04/18/what-do-taxi-fabric-and-coldplay-have-in-common/

38. Ibid.

39. Miller, M. (2015, July 27). Splashy fabric freshens Mumbai cabs to show-case local designers. *Fast Company*. Retrieved from https://www.fastcodesign.com/3049032/splashy-fabric-freshens-mumbai-cabs-to-showcase-local-designers

40. Why is the designer painting taxis? (2015, November 3). *Rediff*. Retrieved from http://www.rediff.com/getahead/report/achievers-why-is-this-de-signer-painting-taxis/20151103.htm

41. 30 Under 30 Asia. (n.d.). *Forbes*. Retrieved from https://www.forbes.com/30-under-30-asia/2017/the-arts/#52e1d1174bda

42. Mirza, M. (2016, March 19). Taxis get the kitsch of life. *The Hindu*. Re-trieved from http://www.thehindu.com/features/magazine/meher-mir-za-on-how-taxi-fabric-is-giving-mumbais-taxis-and-autorickshaws-a-sassy-makeover/article8374605.ece

43. Joshi, S. (2016, February 10). Mumbai's designer cabs are so stunning that even Chris Martin sat in one. *Mashable*. Retrieved from http://mash-able.com/2016/02/10/mumbai-taxi-fabric-coldplay/

44. Poon, L. (2015, August 5). In Mumbai, taxis are transforming into works of art. *City Lab*. Retrieved from https://www.citylab.com/design/2015/08/in-mumbai-taxis-are-transforming-into-works-of-art/400445/

45. Recinos, E. (2016, January 31). Taxi fabric turns cabs into traveling art. *Creators.VICE*. Retrieved from https://creators.vice.com/en_us/article/qkwnzd/mumbai-taxi-fabric-design

46. Mirza, M. (2016, March 19). Taxis get the kitsch of life. *The Hindu*. Re-trieved from http://www.thehindu.com/features/magazine/meher-mir-za-on-how-taxi-fabric-is-giving-mumbais-taxis-and-autorickshaws-a-sassy-makeover/article8374605.ece

47. Srivastav, T. (2017, May 29). Taxi fabric: Creatives are changing the Indian travelling landscape through art. *The Drum*. Retrieved from http://www.thedrum.com/news/2017/05/29/taxi-fabric-creatives-are-changing-the-indian-travelling-landscape-through-art

48. Why is the designer painting taxis? (2015, November 3). *Rediff*. Retrieved from http://www.rediff.com/getahead/report/achievers-why-is-this-de-signer-painting-taxis/20151103.htm

49. TEDxManitoba. (producer). (2015, January 20). *No such thing as a snow day/Joe Kalturnyk/TEDxManitoba.Available* from https://www.youtube.com/watch?v=x3cQd6fZJyA

50. Ibid.
51. Watt, M. (2013, September 17). Winnipeg's exchange district a growing destination. *CBC News*. Retrieved from http://www.cbc.ca/news/canada/manitoba/winnipeg-s-exchange-district-a-growing-destination-1.1856998
52. TEDxManitoba. (producer). (2015, January 20). *No such thing as a snow day/Joe Kalturnyk/TEDxManitoba.Available* from https://www.youtube.com/watch?v=x3cQd6fZJyA
53. Light, W. (2016, January 27). The hottest dinner is served on a frozen river in Winnipeg. *Munchies*. Retrieved from https://munchies.vice.com/en_us/article/xy7wej/the-hottest-dinner-is-served-on-a-frozen-river-in-winnipeg
54. Master explorer: Joe Kalturnyk. (2017, January 30). *Travel Manitoba*. Retrieved from http://manitobahot.com/2017/01/master-explorer-joe/
55. 2015 Canadian tourism awards winners and finalists. (n.d.). *TIAC AITC*. Retrieved from https://tiac-aitc.ca/2015_Awards_Finalists.html
56. Travel Manitoba. (producer). (2017, January 30). Master Explorer/Joe Kalturnyk. Available from https://www.youtube.com/watch?v=T_mBsWNOzF0
57. Quarterly report on progress: Q4 2016. (2017). Economic Development Winnipeg. Retrieved from https://www.economicdevelopmenttwinnipeg.com/uploads/document/2016_q4_report_on_progress.t1529951649.pdf
58. Ibid.
59. Hear what Jeezy and Gucci Mane's former manager Coach K has to say. (2013, September 17). *XXL*. Retrieved from http://www.xxlmag.com/news/2013/09/hear-what-jeezy-and-gucci-manes-former-manager-coach-k-has-to-say/
60. Carmichael, R. (2017, March 15). Culture wars. *NPR*. Retrieved from http://www.npr.org/sections/therecord/2017/03/15/520133445/culture-wars-trap-innovation-atlanta-hip-hop
61. Hear what Jeezy and Gucci Mane's former manager Coach K has to say. (2013, September 17). *XXL*. Retrieved from http://www.xxlmag.com/news/2013/09/hear-what-jeezy-and-gucci-manes-former-manager-coach-k-has-to-say/
62. Karp, N. (2017, October 27) Here's how women are redefining trap music. *More PLS*. Retrieved from http://moreplsmedia.com/culture/2017/10/29/heres-how-women-are-redefining-trap-music
63. Peisner, D. (2015, January 20). Why the rap veterans behind Atlanta indie label quality control music are the smartest guys in hip-hop. *Billboard*. Retrieved from http://www.billboard.com/articles/news/6443743/quality-control-smartest-guys-in-hip-hop
64. Herrera, Isabelia. (2017, December 6) Cardi B explains why she called herself "the Trap Selena" on "Motor Sport". *REMEZCLA*. Retrieved from http://remezcla.com/music/cardi-b-trap-selena-tweet/
65. Ibid.
66. Petski, D. (2017, January 8). Atlanta's creator & star Donald Glover thanks

Atlanta for Golden Globe comedy series win. *Deadline*. Retrieved from https://deadline.com/2017/01/atlanta-golden-globes-best-tv-series-comedy-musical-donald-glover-1201880929/67. Carmichael, R. (2017, March 15). Culture wars. *NPR*. Retrieved from http://www.npr.org/sections/therecord/2017/03/15/520133445/culture-wars-trap-innovation-atlanta-hip-hop

68. Davis, R. (2017, February 10). Economic group thinks 'West Mass' rebranding will better promote area tourism than 'Pioneer Valley'. *Greenfield Recorder*. Retrieved from http://www.recorder.com/West-Mass-Ho-Pioneer-Valley-adieu-8027108

69. Kinney, J. (2017, June 28). West Mass is dead; long live Western Mass! Mass Live. Retrieved from http://www.masslive.com/business-news/index.ssf/2017/06/edc_tries_western_mass_as_a_slogam.html

70. Govers, R., & Go, F. (2009). *Place branding: Global, virtual and physical identities, constructed, imagined and experienced*. London: Palgrave Macmillan. Retrieved from http://www.palgrave.com/us/book/9780230230736

Chapter 11

1. Hall, S. (2017, May 31). These four technologies will shape the creative economy-for better or worse. World Economic Forum. Retrieved from https://www.weforum.org/agenda/2017/05/these-four-technologies-will-shape-the-creative-economy/

2. United Nations. *Creative economy report 2013 special edition*. (2013). United Nations Development Programme. Retrieved from http://en.unesco.org/creativity/creative-economy-report-2013

3. Bhargava, J., & Klat, A. (2017, January 5). Content democratization: How the internet is fueling the growth of creative economies. *strategy&*. Retrieved from https://www.strategyand.pwc.com/reports/content-democratization

4. Factors for enabling the creative economy. (2016, June). *World Economic Forum*. Retrieved from http://www3.weforum.org/docs/WEF_2016_WhitePaper_Enabling_the_Creative_Economy.pdf

5. Quigley, W. (2016, January 24). ABQ, state hit hard by income inequality. *Albuquerque Journal*. Retrieved from https://www.abqjournal.com/711343/abq-state-hit-hard-by-income-inequality.html

6. United Nations. *Creative economy report 2008*. (2008). Retrieved from http://unctad.org/en/docs/ditc20082cer_en.pdf

7. Tscherning, R. (personal communication, 2016, November).

8. Dahl, M. (2015, September 23). Elizabeth Gilbert on the link between creativity and curiosity. *The Cut*. Retrieved from http://nymag.com/scienceofus/2015/09/how-curiosity-leads-to-creativity.html

9. Using virtual reality to get inside an ailing person's world. *Forbes*. Retrieved from https://www.forbes.com/sites/nextavenue/2017/02/14/using-virtual-reality-to-get-inside-an-ailing-persons-world/

10. Ibid.

11. Hustad, K. (2016, May 20). Embodied Labs see virtual reality as the ultimate tool for empathy. *Chicago Inno.* Retrieved from https://www.americaninno.com/chicago/first-look/uic-startup-embodied-labs-virtual-reality-medical-training/

12. Creative startups announces winners $50,000 in funding. (2016, October 25). *Lioness Magazine.* Retrieved from https://lionessmagazine.com/creative-startups-announces-winners-50000-funding/

13. Madrid, I. (2015, December 14). Bethlehem Tilahun Alemu's sustainable shoes are lifting up her Addis Ababa community. *PRI.* Retrieved from https://www.pri.org/stories/2015-12-14/bethlehem-tilahun-alemus-sustainable-shoes-are-lifting-her-addis-ababa-community

14. Rowling, M. (2016, June 9). Green shoe brand helps Ethiopia walk tall on global stage. *Reuters.* Retrieved from http://www.reuters.com/article/us-ethiopia-business-climatechange-fairt-idU.S.KCN0YV1HA

15. Madrid, I. (2015, December 14). Bethlehem Tilahun Alemu's sustainable shoes are lifting up her Addis Ababa community. *PRI.* Retrieved from https://www.pri.org/stories/2015-12-14/bethlehem-tilahun-alemus-sustainable-shoes-are-lifting-her-addis-ababa-community

16. Rice, X. (2010, January 3). Ethiopia firm recycling tyres into shoes does big business via internet. *The Guardian.* Retrieved from https://www.theguardian.com/world/2010/jan/03/ethiopia-internet-shoe-firm-solerebels

17. In Ethiopia, trading poverty for prosperity provides global success for sol-eRebels. (2012, December 11). *K@W.* Retrieved from http://knowledge.wharton.upenn.edu/article/in-ethiopia-trading-poverty-for-prosperity-provides-global-success-for-solerebels/

18. Rowling, M. (2016, June 9). Green shoe brand helps Ethiopia walk tall on global stage. *Reuters.* Retrieved from http://www.reuters.com/article/us-ethiopia-business-climatechange-fairt-idU.S.KCN0YV1HA

19. Britton, B. (2017, February 2). Ethiopian shoe designer hopes for repeat success with coffee. *CNN Money.* Retrieved from http://money.cnn.com/2017/01/31/smallbusiness/ethiopia-shoes-solerebels-coffee-bethlehem-alemu/index.html

20. In Ethiopia, trading poverty for prosperity provides global success for soleRebels. (n.d.). Wharton University of Pennsylvania. Retrieved from https://global.wharton.upenn.edu/in-ethiopia-trading-poverty-for-prosperity-provides-global-success-for-solerebels/

21. Brown, N. (2017, February 20). Garden of coffee cultivating Ethiopian coffee experience for global growth. *Daily Coffee News.* Retrieved from https://dailycoffeenews.com/2017/02/20/garden-of-coffee-cultivating-ethiopian-coffee-experience-for-global-growth/

22. Le Blog, E. (2017, July 4). From poverty alleviation to prosperity creation. *Programme Eve.* Retrieved from https://www.eveprogramme.com/en/28877/from-poverty-alleviation-to-prosperity-creation/

23. CNN names Bethlehem as 1 of 12 female entrepreneurs who changed the way the world does business. *soleRebels.* Retrieved from https://www.solerebels.com/blogs/news/8044613-cnn-names-bethlehem-as-1-of-12-

female-entrepreneurs-who-changed-the-way-the-world-does-business

24. Rowling, M. (2016, June 9). Green shoe brand helps Ethiopia walk tall on global stage. *Reuters*. Retrieved from http://www.reuters.com/article/us-ethiopia-business-climatechange-fairt-idU.S.KCN0YV1HA

25. Ibid.

26. Trainer, M. (2016, March 23). This woman exports Ethiopian heart and sole. *Share America*. Retrieved from https://share.america.gov/traditional-ethiopian-shoe-inspires-company/

27. Our mission. (n.d.). Ecovativedesign. Retrieved from https://ecovativedesign.com/about

28. Frazier, I. (2013, May 20). Form and fungus: Can mushrooms help us get rid of Styrofoam? *The New Yorker*. Retrieved from https://www.newyorker.com/magazine/2013/05/20/form-and-fungus

29. Ibid.

30. Bayer, E. (n.d.). Evocative. *Green Challenge*. Retrieved from http://www.greenchallenge.info/info/winners/ecovative

31. A growth industry: How Ecovative Design's mushroom-based products are transforming the packaging industry and proving the power of impact inventing. (2015, January 21). *The Lemelson Foundation*. Retrieved from http://www.lemelson.org/resources/success-stories/ecovative-impact-spotlight

32. Ecovative Design. (n.d.). SBIR STTR. Retrieved from https://www.sbir.gov/sites/default/files/SBA_Success_Ecovative.pdf

33. Wollenhaupt, G. (2014, January 6). Self-repairing concrete could be the future of green building. *Forbes*. Retrieved from https://www.forbes.com/sites/ptc/2014/01/06/self-repairing-concrete-could-be-the-future-of-green-building/#353ba22691cc

34. Willard, L. (2017, June 30). Green Island Company awarded $9.1 million contracts to develop living building materials. WAMC Northeast Public Radio. Retrieved from http://wamc.org/post/green-island-company-awarded-91-million-contract-develop-living-building-materials

35. Plasticity Forum. (producer). (2013, June 16). *Ecovative design and how you can "grow" your packaging*. Available from https://www.youtube.com/watch?v=ZSiz2D3GZpI

36. A growth industry: How Ecovative Design's mushroom-based products are transforming the packaging industry and proving the power of impact inventing. (2015, January 21). *The Lemelson Foundation*. Retrieved from http://www.lemelson.org/resources/success-stories/ecovative-impact-spotlight

37. Deleon, N. (2016, Novermber 17). Why your next chair may be made out of mushrooms. *Motherboard*. Retrieved from https://motherboard.vice.com/en_us/article/qkjxg3/why-your-next-chair-may-be-made-out-of-mushrooms

38. Kaufman, S.B. (2014, May 12). The philosophy of creativity. *Scientific American*. Retrieved from https://blogs.scientificamerican.com/beautiful-minds/the-philosophy-of-creativity/

Chapter 12

1. Stoll, A. (personal communication, 2018, January).
2. Carr, A. (2012, August 20). TechStars' David Tisch: Most accelerators will fail, so choose wisely. *Fast Company.* Retrieved from https://www.fastcompany.com/3000561/techstars-david-tisch-most-accelerators-will-fail-so-choose-wisely
3. Cars, A. (2016, October 13). Here is why most startup accelerators fail. LinkedIn. Retrieved from https://www.linkedin.com/pulse/here-why-most-startup-accelerators-fail-andy-cars/
4. Feld, B. (2012). *Startup communities: Building an entrepreneurial ecosystem in your city.* John Wiley and Sons, Hoboken, New Jersey.
5. New Mexico Department of Economic Development. Retrieved from https://gonm.biz/business-development/edd-programs-for-business/job-training-incentive-program/
6. Littlelaosontheprairie. (2015, January 2). Monica Phromasavanh: The Lao New Yorker with Argentinian roots. *Little Laos on the Prairie.* Retrieved from http://littlelaosontheprairie.org/2015/01/02/monica-phromasa-vanh-the-lao-new-yorker-with-argentinian-roots/
7. De Vries, A., Erasmus, P.D., & Gerber, C. (2015). The familiar versus the unfamiliar: Familiarity bias amongst individual investors. *ACTA COMMERCII.* Retrieved from https://actacommercii.co.za/index.php/acta/article/view/366/630
8. Rowley, J.D. (2018, April 5). Q1 2018 global investment report: Late-stage deal-making pushes worldwide VC to new heights. *Crunchbase.* Retrieved from https://news.crunchbase.com/news/q1-2018-global-investment-report-late-stage-deal-making-pushes-worldwide-vc-new-heights/
9. Why. (n.d.). *Fail Festival.* Retrieved from http://failfestival.org/why/

ACKNOWLEDGMENTS

This book was written with significant support and input from people across the Creative Economy movement. Several, however, made significant efforts on our behalf. Thank you to Mike Young, a rising star on the indie publishing and poetry scene. Mike sat through our weekly hashing of ideas and approaches, storylines and statistics, waiting patiently as we reached consensus. He went away each week and translated our conversations into deep research and words that make this book far more interesting and easy to read.

Thank you to the leaders who invested in us when the Creative Startups Accelerator was an idea, a vision of what it could be. Like all entrepreneurs we faced naysayers early on. But there were more believers. Bill Michener and Mary Jo Daniel, leaders at the University of New Mexico believed in us. Albuquerque Mayor Richard J. Berry and his economic development director, Gary Oppedahl, believed in us. Alan Webber, Sandy Zane, Debbie Fleischaker and our entire Board of Directors not only believed in us, they funded us through tough times and tenuous transitions. Phil Marineau, a leading brand expert, led us through a process that ended with our current brand, Creative Startups.

The work we do around the world is made possible by our team of millennials who embody the energy, vision, and determination at the heart of Creative Startups. They defy many of the definitions

of millennials: they are clear-headed internationalists, work-horses with wicked tech skills, futurists with unfettered enthusiasm for new challenges and next level thinking and doing. They remind us each day of what is possible when we bet on big ideas and believe in the power of creative people working together to build what's next.

Alice and Tom
Albuquerque and Santa Fe, New Mexico

INDEX

2017 Otis Report, 78
3-D printing, 221–224
 in Africa, 221–224
 prosthetics, 221–222
accelerators, causes of failure,
 289–290
Acoma Pueblo, New Mexico, 37
adaptation, 20–21, 51, 153
Addis Ababa, Ethiopia, 278
Adegbembo, Adebayo, 231
Adobe, 10
 Photoshop, 200
 2016 State of Create Report, 78
Adrian, Bonny, 172–176
adventurers, 29
Afoma, 225
Africa's future, 222
African mobile ecosystem, 111
African-American women entre-
 preneurs, 152
Afrocentric Afrique, 224
"age of access", 28
"age of possession", 28
Aggestam, Maria, 111
agile development cycle, 108
AI (artificial intelligence), 91
Alaska, 232
Albuquerque, Ivonette, 12,
 206–209

Alderson, Lisa, 61
Alemu, Bethlehem Tilahun, 59,
 278–282
 Garden of Coffee, 280
 soleRebels, 279–282
Alfonso, Sydney, 12, 185–191
Amazon's Alexa, 227
amenities, 196–197
 built, 197
 cultural, 196
 natural, 196
 symbolic, 196–197
animation field, 89
Aplauso, 206
Apple's Siri, 227
Areblad, Pia, 71
Arif, Samya, 254
Arnaudville, Louisiana, 36–37, 39
 leap of faith, 39
Arnold, Steve, 271
arts education, 79
"ask forgiveness, not permission",
 37
Association of Southeast Asian
 Nations investment collective,
 241
Atkinson & Court, 177
Atlanta, 262
Atlanta, Georgia, 259

Atlas Studios, 82–83
Australia, 180
authenticity, 32, 76, 138, 183, 246–249, 264–265
Avlani, Sanket, 251–255
 Taxi Fabric, 253–255
Azzouzi, Alia, 162–164
 Espresso Dates, 163–164

Babson College, 45
 Babson Entrepreneurship Ecosystem Project (BEEP), see BEEP,
"Baptism by fire: did the creative class generate economic growth during the crisis?", 179
Backstage Capital, 126–127
Bain and Company, 98
Bandaul, Srey, 234
Bandung, Indonesia, 144
 creative city pilot project, 144
Banque du Liban Startup Workshop, 166
"barabasso" shoes, 278
Barmak, Sarah, 67
Barrett, Frank, 25
Battambang, Cambodia, 234
Bayer, Eben, 282–285
BEEP (Babson Entrepreneurship Ecosystem Project), 45–46
Before We Were Gamers, 203
Beirut, 165
Belghmi, Mohamed, 82–84
Ben-Ami, Aner, 145
bendy skyscraper, 108
Binder, Melissa, 161
Bishop, Andrew, 180

bitcoin, 107
blerDCon (Black Nerd Con), 160
Bloustien, Geraldine, 220
BlueBay Wedding, 176
Bono, Edward de, 84
boomers, 85–86
Boswijk, Albert, 26
Boswijk, The Handbook on the Experience Economy, 26
Bradley, Patrick, 132
branding, 137, 138, 243
Brazil, 206–211
Brexit, 99
BrightBot, 141
broadband access, 107, 180–183
Brooke, Nicholas, 151
Brower, Ron, 233
Buddies Infotech, 199
Buea, Cameroon, 219, 231
Bureau of Labor Statistics, 21
Burning Man, 241
butterfly wings, 26

Calvert Foundation, 128
Cambodia, 233–234
Cambridge Journal of Regions, Economy and Society, 108
Campbell, Colin, 90
Canada Broadcasting Company (CBC), 73
Canwen, Mai, 174
CAPNOVA, 131
Cardi B, 261
Careers for Creative People, 11
Carmichael, Rodney, 260, 262–263
Cars, Andy, 289
CCIA (Computer and Communi-

cations Industry Association), 98

CDFI (community development financial institution), 140

Center of American Progress, 152

Centrum Catholica, 29

Chackee, Dru, 187

challenges, 42–62, 209

Chandar, Vinoth, 198–203

Chennai, India, 198–203

Chicano Con, 160

Ching-hua, Tsai, 173, 176

ChocolateCity record label, 110

ChuChu TV, 198

Church of Santiago, 193–194

CIPE (Center for International Private Enterprise), 155

Cirque de Soleil, 5, 11, 39, 63–69
 20 Years Under the Sun, 64
 funding, 139, 141–143
 Kooza, 66
 Spark job training program, 79

civic entrepreneurs, xviii

clardic fug, 25

Coach K. See Kevin Lee

Cohen, Dan, 144

Coldplay, 254

collaboration and collectives, 113

Coller Venture Review, 200

Colorado Enterprise Fund, 130

communities, 19

community entrepreneurship, 164

company towns, 104

competition, 174

Compilr, 121

conferences, 301–302

connections, 177, 178

between creative and management, 296–297

mentors, 297–298

consumption to experience, 246

Contemporary Southeast Asian Performance: Transnational Perspectives, 234

Cook Inlet Tribal Council, 233

Cook Lebonese, 169

Cookpad, 169

Cookpad MENA, 169

Coronado Ventures Forum, 31

Coulter, Jim, 41

Country Roads magazine, 37

Craig, William, 72

"Creative After the Crash", 112–113

Creative BC, 86

creative class, 77, 178, 179

creative clusters, 106–107, 108, 112

Creative Communities: Art Works in Economic Development, 74–75

creative economy, 7, 69, 104
 and local economies, 74–76
 and youth, 212–217
 challenges of, 267
 clusters, 183
 tourism, 302–303
 definition of, 9–10
 export, 9
 future of, 177, 215–217, 220, 266–267
 global, 8–9
 growth of, 32, 69, 112, 178
 job production, 7, 74–75

local, 152
not a silver bullet, 39, 40
outlook, 132–133
revenues, 7
tourism, 247–248
U.K., 98
Creative Economy: A Feasible Option, 112
creative ecosystem, 180
creative education, 79
creative embedding, 71
creative entrepreneurs, xviii, 6, 28, 113
 a sense of place, 37, 50
 actions of, 31–32
 and job creation, 41, 73
 and support, 38
 challenges of, 267
 golden ticket to the future, 178
 importance of label, 303–304
 qualities of, 30, 61
 structural barriers, 38
creative entrepreneurship, 269
 defined, xviii–xix
creative exports, 17
creative industries, 11, 70
Creative Industries Mapping Document, 99
creative industry investment, 131–132
creative occupations, 10
creative pride, 133–135
Creative Startups, 39–40
Creative Startups Accelerator, 2, 13–14, 39–40, 47, 73, 186
 founding, 13–14
creative thinking, 26

Creative Work Beyond the Creative Industries, 70–71
creatives, 70–72
creativity, 16, 27
 as wizard, 25–28
 definition of, 16, 84
 for resilience, 92–114
 future of, 286
 vs. data, 26
crises and reaction, 109
critical thinking, 16
crowdfunding, 123–126
cultural entrepreneurs, xviii
Culture as a Vector for Youth Development, 215
Cunningham, Stuart, 71
curiosity, 149, 275–278
Currid-Halkett, Elizabeth, 179
Cuthrell, Karen, 226–229, 230
Cuthrell, Lana, 226, 229, 230
cyclicality, 72

Daffe, Festival on the Niger, 28
Daffe, Mamou, 12, 28
Dancehall: From Slave Ship to Ghetto, 220
DC Comics, 161
Deadpool, 88
Decrop, Véronique, 234, 236
Deer + Almond, 256
democratization of finance, 123
Demos, 131
Denmark, 180
Design Fabric, 253
Designing Web Graphics, 117
Dessein, Joost, 245
Destiny's Child, 110

Det, Khuon, 234
developing economies, 155
Dfrntpigeon, 217
digital natives, 86
disruption, 49, 51, 118
disturbance, 49
diverse talent, 19
diversity, 104, 151, 245
 struggle to integrate, 162–164
 unleashing, 51, 68, 81, 147–171
Diversity Matters, 155
DJ Toomp, 261
Djemaa el Fna festival, 162
DMD Panorama, 169
Donald, Betsy, 197
Dos Santos, Edna, 269
Driving Tourism Through Creative Destinations and Activities, 247
drones, 20
Duke University, 212
 Sanford School of Public Policy, 212

E-Line Media, 232
E. M. Kauffman Foundation, 14, 69, 272
EA Criterion, 97
Eagle, Nathan, 181
Eastman Chemical Company, 26
 Innovation Lab, 26–27
Eat, Pray, Love, 275
ecology concepts, 51–52
 adaptation, 51
 disruption, 51
 diversity, 51
 endemic species, 51
 interdependence, 51
 keystone species, 51
 mutually beneficial, 51
 resiliency, 51
 resource flows, 51
 substrate, 51
 symbiosis, 51
economic base jobs, 18
economic challenges, 18–19, 40
 base jobs, 18
 local economies, 18
economic diversity, 104, 105
economic ecosystems, 40
 seven key challenges of, 18–19, 40
economic future, 19, 43, 266–287
economic monocultures, 104
economies 155
 developing, 155
 experience, 246–248
 informal, 155
 transitional, 155
ecosystems, 42–62
 activating, 44
 building, 156
 building tips, 291–313
 cultures , 288
 definition of , 44–45, 48
 fluidity of social capital, 48–49
 gaps, 154–155
 relationships between, 49
 self-regulating, 46
 steps toward, 288–316
 substrates of, 49–50, 51
 see also entrepreneurial ecosystems
ecotourism, defined, 249

Ecovative Design, 282–285
EDC (Economic Development Council) of Western MA, 264
Elemide, Bukola, 110
 "Asa", 110–111
embeddedness, 190
Embodied Labs, 40, 130, 275–278
emotional intelligence, 40, 226–227
 top-10 market skill, 227
 via VR, 276
Enabling Crossovers: Good Practices in Creative Industries, 242
encore careers, 86
Endangered Wildlife Trust, 249
endemic species, 51, 76
energy storage solution, 26
Entertainment Arts (EA), 10
entertainment spending, 102
entrepreneurial capacity, 58–59
entrepreneurial diversity, 153–154
entrepreneurial ecosystems. See ecosystems
entrepreneurial orientation, 29–30
entrepreneurial talent, 147
entrepreneurs, 16
 common qualities of, 52–53
entrepreneurship, xviii
 barriers to, 154–157
 defined, 29
 ecosystem, 43–48
 education, 59–60
 growth of, 153
 zones, 306–307
Entrepreneurship and the Creative Economy, 111
equity financing, 133, 134

equity in labor, 81. See also diversity
Etkie, 12, 40, 128–129, 185–191
Etsy, 10
Etsy founder, Rob Kalin, 103
Ettouney, Kareem, 93, 95
European Creative Industries Alliance, 131
Europen Union Employment Committee Indicator Group, 78
Evans, Alex, 93, 9
evocative startling, 26
experience economy, 101, 103, 246–248

Fab10, 221
Facebook Connect, 165
Faia, Telmo, 194, 195
Faith, Mpara, 231
Fake, Caterina, 169–171
Falcão, Flávia, 211
Fast Company, 271
Feeling Friends toys, 226–229
Feld, Brad, 7, 292
 startup communities, 7
Fender, 141
Festival on the Niger, 12, 28
film industry, 16–17
financial revolution, 122–126
find entrepreneurial leaders, 291
Fireproof Studios, 99
 The Room, 100
first steps, 274
Fleming, David A., 105
 The Conversation, 105
Flickr, 10, 131, 169–171

Florida, Richard, 77, 178, 197
fluidity of social capital, 48
Fólio, 193
Föterer, Holger, 66
Fourth Industrial Revolution, 18,
 20–23, 85
 cyber physical, 22
*Framing the Bride: Globalizing
 Beauty and Romance in Tai-
 wan's Bridal Industry*, 172
Francis, Lee III, 157, 160
Francis, Lee IV, 127–128, 130,
 157–161
 Indigenous Comic Con,
 157–161
 Native Realities, see Native
 Realities
Fuller, Simon, 132
 Pop Idol, 132
funding opportunities, 133
fungi renewable materials,
 282–285
future of work, labor, and work-
 force training, 23

Galileo, 123
Galpão Aplauso (the Applause
 Shed), 12, 207, 209–211, 235
Gamefroot, 232
gap between creators and inves-
 tors, 131–135
Garden of Coffee, 280
Gartner, Bill, 42
GCCE (Global Center for Cultural
 Entreprenership), 267
 becoming Creative Startups,
 267–273

GDPs, 24
GEM (Global Entrpreneurshp
 Monitor), 153–154
George Town Festival, 239–243
George Town, Penang, Malaysia,
 238–243
 UNESCO World Heritage site,
 240
Georgia O'Keefe Museum, 4
Getúlio Vargas Foundation, 210
GIIN (Global Impact Investor
 Network), 128
Gilbert, Elizabeth, 275
 Eat, Pray, Love, 275
Gill, Prem, 86–87
 "Youth Raap", 86–87
Gilmore, James H., 101, 103, 246
 *The Handbook on the Experience
 Economy,* 103
Girls of Morocco, 162
GIY (grow-it-yourself) kits, 284
Gladiator, 82
global consumers and local, au-
 thentic experiences, 55
Global Entrepreneurship Summit,
 33, 34
global income levels, 24
global middle class, 177
global networks, 56, 189–190
globalization, 24–25
Gnikou, Kodjo Afate, 221
Goetz, Stephan J., 105
 The Conversation, 105
GoPro, 10
Govers, Robert, 243, 264
gratitude, 149
Great Recession, 40, 73, 96, 98, 99,

101–102, 112–113, 267
Green, Kendall, 88
Growth of the Creative Economy in Small Regional Cities: A Study of Bendigo, 180
Gruber, Lee, 270
Gucci Mane, 260
Guildford, U.K., 94, 97, 100, 103
　Borough Council, 97
　Hollywood of video games, 97

Hackers: Heroes of the Computer Revolution, 203
Hall, Kwanza, 263
Hamilton, Arlan, 126
Hamilton, Backstage Capital. See Backstage Capital
Han, Sun Sheng, 180
The Conversation, 105
Han, Yicheol, 105
Handbook of Research on Entrepreneurial Development and Innovation, 194
Harry, Njideka, 223–224
Harvey, Larry, 241
Healy, Mark, 93, 95, 96
Heavin, Bruce, 117–118, 120
Hedberg, Anna, 137
Henry, Colette, 111
　Entrepreneurship and the Creative Economy, 111
Hertfordshire film studio, 99
Herzog, Werner, 121
high skill/high pay workers, 24
hip-hop as economic growth engine, 263
His-lin, Liu, 175

Hitzer, Mandel, 255–259, 292
Hollywood North, 86
horizontal growth, 72, 85
House of Eternal Return, 2, 287
How Millennials Want to Work and Live, 85
Howkins, John, 9, 269
　creative economy, 9, 35
　The Creative Economy, 269
　twelve rules for creative success, 35
Hudson Valley, 145
Hudson, Phil W., 260, 262–263
human talent, 293, 295–296
　repurpose and advance, 91
Humanity in Action, 164
hunsha sheying gongsi, 175
hyperconnected knowledge, 23

IDB (Inter-America Development Bank), 209
ILO (International Labor Office), 70, 212–215, 222
immigrant entrepreneurs, 152
impact funders, 128–133
Indian Country Today, 186
"indiginerd" (indigenous nerd), 157
Indiegogo, 123
Indigenous Comic Con, 128, 130
indigenous people's stories, 159
industrial revolutions, 22
　cyber physical, 22
　digital, 22
　electrical, 22
　mechanical, 22
industry clusters, 56

inequality, 24
informal economies, 155
innovation, 20–21, 100, 108, 161,
 174, 178
innovative investment, 115–146
Institute for Security Studies, 214
INTELI, 178, 183–184, 195
interdependence, 51, 97, 290
*International Journal of Consumer
 Studies*, 247
International Space Apps Chal-
 lenge, 221
investment capital, 60–61,
 299–300
 deep connections, 60
 public leadership investment,
 60–61
 diversify, 300
 private, 123
investor sexism, 168
Isenberg, Daniel, 45, 46
Isle of Man, 107–108
Italian fashion, 112

Jackson, Peter, 259
Jamaica, 32, 33–35, 220
Jamaica Film and TV Association,
 34
Jamaican diaspora, 34
Jamaican fashion, 112
Jämtkraft, 26
Jana, 181
Jansen, Theo, 238
Jeezy, 260
Jenkins, Henry, 236
job quality, 77–82
JOBS Act, 125

Johannesburg, South Africa, 249
*Journey to Portugal: In Pursuit of
 Portugal's History and Culture*,
 197

"kaalk peelis" (yellow black taxis),
 253
Kadlubek, Vince, 5, 31
Kahoot!, 231
Kalin, Rob, 103
Kalturnyk, Joe, 255–259, 292
Kamil, Ridwan, 144
Kauffman Foundation, 38
Kaufman, Scott Barry, 286
kazalik silk wire, 185
key economic challenges, 19
 globalize local economies, 19
 private investment, 19
 talent, 19
 youth, 19
keystone species, 50–51, 83
Khmer Rouge, 234
Kickstarter, 123
Kikizo, 96
Kingston, Jamaica, 219
Kingston, New York, 145
Királ'ová, Alžbeta, 247
Kisima Innitchuna (Never Alone),
 232–233
Klaus Schwab, 21–23
Knowledge@Wharton, 279
Kosciuszko, Stefan, 134
Krishnan, B. M., 201
Kruger National Park, 249
Kuo, Alex, 175–176
Kupchan, Charles, 24
La Plata, Argentina, 219

Labaki, Hala, 12, 165–169
Laliberté, Guy, 11, 39, 63. See also
 Cirque de Soleil
Lashbrook, Time etc., 42
Lashbrooke, Barnaby, 42
Last Temptation of Christ, 82
lateral career growth, 84–85
lateral thinking, 84
Latest Sightings, 249–251
Laura & Wolf, 131
Lawrence of Arabia, 82
Layton, Dennis, 155
 Diversity Matters, 155
Lazy Town, 135–139
Le Meur, Loic, 103
Lebanon, 165
Lee, Kevin, 259–264
 Quality Control, 259
LEGO microscope, 26
Lemelson Foundation, 283
Leonardo Da Vinci, 123
Ler Devagar, 193–194
Lévesque, Premier René, 65
Levy, Steven, 203
Lewis, Nathaniel M., 197
Lex Luger, 261
Li, Lin, 174
Lil Yachty, 261
LinkedIn, 121
Lionhead, 97
Liremt, Gijsbert van, 70, 72
ListenMi Caribbean, 32, 34
Little Big Cup, 36, 37
Little Laos on the Prairie, 150
Little Penang Street Market, 241
LittleBigPlanet, 92–97
local branding, 76

local content, 181,
local economies, 18, 35, 183, 253
 failure, 203
 globalized, 19
 going global, 172–205
local identities, 254
Lomé, Togo, 221
Lor, Lon, 234
Lord of the Rings, 259
Los Alamos National Laboratory
 Venture Acceleration Fund,
 189
Lotusan paint, 26
low skill/low pay workers, 24
Luu, Chan, 189
Lynda.com, 10, 115

Maddin, Guy, 257
Made by Ethiopia initiative, 280
Maia, Pedro, 193
Maikori, Audu, 110
Mala, Dy, 234
Mali, 28,
 Festival on the Niger, 28
Māori youth, 232
Market Insights, 101
markets, 55–56
 demand for local, authentic ex-
 periences, 55–56
 global networks, 56,
Marks, George, 36–38, 39
 Town Market, 36
Markuen, Ann, 75, 77
Maroons, 34
Martin, Chris, 254
Martin, George R.R., 2
Marvel Comics, 161

MasterClass, 121
Masterson, Mary Stuart, 145
Mathieu, Benoît, 142
Mattis, GreaterCakes, 32
Mattis, Kenia, 32–35
 League of Maroons, 33
 ListenMi Caribbean, 32, 33–35
Maureen, 224
McIntyre, Gavin, 282–285
McKinsey Global Institute, 222
McLachlan, Stacey, 89
Mealha, Jorge, 192
meaning making, 25
Medder, Donald, 34
Media Molecule, 93, 97–98, 99, 103
 LittleBigPlanet, see *LittleBigPlanet,*
 Rag Doll Kung Fu, see *Rag Doll Kung Fu*
Medici family, 123
Mehrnoosh, Azin, 141
memories, 101
MENA region, 166
mentorship, 54–55
mentorship ecosystem, 224
Meow Wolf, 2–6, 31, 40, 73, 132
 funding, 139–140
 House of Eternal Return, 287
Messely, Lies, 244
Meyer, Ilyssa, 133
Michaels, Patricia, 270
Migos, 261
Mihi Maker, 231–232
Milhões, Mafalda, 191–195, 198, 292
millennials, 85

job change rate, 85
"Ministry of Fun", 99
minority entrepreneurs, 153
Misak, Anne, 129
Mitchel,l, Peter, 88
ModaBox, 147–151
Molyneux, Peter, 97
Morgan, Jacob, 89–90
 The Future of Work, 89
Morrissey, Alex, 219
Motion Picture Association of America, 16
"Mrs. Suzuka", 174
multi-sensory engagement, 101
Mumbai, India, 251–255
Murang, Alena, 238
Music Week Africa, 110
mutual benefit, 51
mycelium insulation, 282–283

Nagada, 189
Nak, Rin, 234
Nanje, Churchill, 219
nanobot drugs, 20
Naranjo, Norma, 270
Narayanan, Seetharaman, 200,
National Endowment for the Arts, 69
Native Realities, 40, 157
Navajo Nation, 129, 185
NEET (Not in Education, Employment, Training), 214
Nesta, 98, 105, 109, 131–132
Netflix, 10, 109
networking and collaboration, 53–54
new work that works, 63–91

New Zealand, 231–232, 259
Newell, Gabe, 89–90
Neuwirth, Daniel, 165
Nicodemus, Anne Gadwa, 75, 77
Nigeria, 109
 creative industries, 110
 music industry, 109–111
 Wizkid, 110
NM EP-SCoR (New Mexico's Established Program to Stimulate Competitive Research), 270
Nooney, Laine, 203
Norway, 180, 231
Nottingham creative industries, 99

O Bichinho do Conto, 191–195
O'Dwyer, Katherine, 65
O'Neill, Gloria, 232
O*Net, 11
Oakhurst, California, 203
Óbidos, Portugal, 191–198
 Óbidos Creative Strategy and Local Action Plan, 195
OECD, 214
Ojai, California, 117
Omba, Namibia, 189
Ormschool, Thailand, 230–231
Osorio, Néstor, 215
Ossendryver, Nadav, 249
 Latest Sightings, 249–251
Ouarzazate, Morocco, 82–83
OutKast, 260
 ATLiens, 260
outpatient healthcare, 21

Panh, Rithy, 241

participatory design, 254
Patreon, 131
patronage, 123, 268
pattern-crunching, 25
pay gate, 119
Penang, Malaysia, 238
"pepeha", 232
Personette, Sarah, 111
Peters, Margaret, 220
Petiot, Bernard, 142
Petrov, Andrey, 179
Pew Research Center, 91
PFI International, 176
Phromsavanh, ModaBox. See ModaBox
Phromsavanh, Monica, 147–151
Pine, Joseph II, 101, 103, 246
 The Handbook on the Experience Economy, 103
piracy, 108
Pixar, 10
Place Branding: Glocal, Virtual and Physical Identities, Constructed, Imagined and Experienced, 243, 264
platforms, not silos, 58–59
"Pochahotties", 159
Podkalicka, Aneta, 218
policy, 56–57
 intellectual property support, 57–58
 recognition of the creative economy, 56–57
Pop Idol brand, 132
portfolio careers, 70, 86
Portland, Oregon, 217
Postcode Lottery Green Challenge,

283
PPSA (Phare Ponleu Selpak),
 234–236
Prenowitz, Eric, 234
PriceWaterhouseCooper study, 17,
 180–181
private investment, 19
problem-solving, 16
progressive cultural heritage, 238

Q4 2016 Economic Development
 Winnipeg Progress Report, 258
Quality Control, 259
quality of life, 178
Quinnlan, Sarah, 101

radically inclusive art, 5
Rag Doll Kung Fu, 94
Rantanen, Matt, 160
Rasmussen, Ian, 131,
Rataczak, Waldemar, 177–178
RAW:almond, 255–259
RAW:Gallery of Architecture and
 Design, 256
recessions, 100
recreation services, 102
Red Planet Books and Comics,
 160
Reddy, Siobhan, 93, 95
regional economies, 176–184
regional identities, 238, 244–246,
 259
 defined, 244–245
 developing, 238–265
resiliency, 51, 92–114, 175
resource flows, 51, 106, 126, 161,
 292

Rezonate Art, 158
Rifkin, Jeremy, 28
Rio de Janeiro, Brazil, 206
Roberts, Elizabeth, 182
robots, 21
Rockefeller Foundation, 214
Romania design industry, 112
Rotterdam, 162–163
Roy, Serge, 64
RPI (Rensselaer Polytechnic Insti-
 tute), 282

Sackboy, 92
Sacson, Leslie, Dr., 276
Sahara Desert, 82
Samuels, Harmony, 110
Santa Fe, New Mexico, 1–2
sape, 238
Saramago, José, 197
Sareth, Svay, 234
Say, Jean-Baptiste, 28–29
Scheving, Lazy Town. See Lazy
 Town
Scheving, Magnús, 135–139
 Sportacus, 135
Schweizer, Luciano, 210
Scientific American, 16
Scotland, 182–183
Scott, Steven "Sash", 227
Seamless, 10
Seligman, Martin E. P., 26
Seoul, South Korea, 143
Series A funding, 121
Series C funding, 122
Shahiya (appetite), 12, 165–169
Shane, Janelle, 25
Shaw, Carrie, 130, 275

The Alfred Lab, 277. See also VR, "Alfred"

Shawty Red, 261

Sidek, Joe, 239–243

Sierra On-Line, 203

"Silicon Mountain", 203

Silva Lanes, 1

Simons, Iain, 93

 Inside Game Design, 93, 96

Sims, Jonathan, 37

skepticism, 167–169

skill gap to skill innovation, 216

skill of meaning, 23–25

small business growth, 152

small community amenities, 196–197. See also amenities

SME, 17

Smith, Dave, 93, 95

social electricity, 105

social entrepreneurs, xviii

"soft skills", 208

soleRebels, 279–282

solutions for uncertainty, 20–41

Sommer, Francine, 138, 146

South African National Parks, 249–250

South Korea gaming industry, 17

Southern Innovator, 219

Southside, 261

Spark job training program, 79

Spark the Fire Award, 33

Stanley-Niaah, Sonjah Nadine, 220

stargoon, 25

Starkey, Daniel, 233

Starr, Arigon, 159

 Tales of the Mighty Code Talkers, 159

startup capitals, 47

startup culture, 52–53

 networking and collaboration, 53–54

 vision, 52–53

startup ecosystem, 6

Ste-Croix, Gilles, 11, 39, 63. See also Cirque de Soleil

Steam, 90

STEM to STEAM, 235

Stenius-Bratt, Hedvig, 137

Stolarick, Kevin, 179

Stoll, Andy, 38, 288

stories, 42

Strandbeest, 238

Strickler, Yancey, 123

substrate, 53, 110

 definition of, 57

Sugarhill Gang, 260

 "Rapper's Delight", 260

support education, 293

Swersey, Burt, 282–283, 286

symbiosis, 51, 113, 130

Taiwan bridal photography, 172–176

Tales of the Mighty Code Talkers, 159

Tanyaui, Mahasin, 162

 Girls of Morocco, 162

Taxi Fabric, 253–255

TEA (Total Early-stage Entrpreneurial Activity), 154

Tech4Africa, 249

technological proficiency across all demographics, 236

technology

as a spell, 25–28
meets heritage, 58
telenovela, 105
Tendopro, 250
Thaitham, Nuttaya, 230–231
The Alfred Lab, 277
The Contribution of the Creative Economy to the Resilience of Rural Communities, 182
The Conversation, 105
The Creative Economy, 269
The EVE Project, 280
The Fader, 110
The Flash, 87
The Global Youth Unemployment Crisis, 212
The Handbook on the Experience Economy, 103
The Role of Ventures in Strengthening the Fabric of the City, 200
The Room, 100,
The Sylbourne Show, 34
themes, 42–62
think globally, act locally, 56
Third Industrial Revolution, 22
Thompson-Drew, Corliss, 227
Thompson, Ashley, 234
Tierney, John, 26
TIGA 2017 Business Opinion Survey, 98–9
TILLT, 71
Time etc., 42
tips for developing ecosystem, 288–314
Tisch, David, 289
To'hajiilee Navajo reservation, 185
Torre, Juan Jose de la, 53

Towns in a Rural World, 176, 184
Townsend, Leanne, 182
TPG Capital, 121, 141–143
transitional economies, 155
trap music, 259, 260–264
 bubblegum trap, 262
trubnyy klyuch (pipe wrench), 66
TV Maya, 219
TwoFoldTwenty, 134

U.K. Creative Council, 99
U.K. creative economy, 98–99
U.K. Film Commission, 102
U.K. game development industry, 98
U.S. Bureau of Economic Analysis, 80
UN Youth Forum, 215
UNCTAD, 269
unemployment of young people, 153
UNESCO, 267
 2015 Cultural Times Report, 40
 City of Literature, 194
 Creative Economy Report, 202
United Nations Economic Council, 215
University of New Mexico, 161
University of Surrey, U.K., 29
Upper One Games, 232
Upstart Co-Lab, 128
urban entrepreneurs, xviii
USC Center for Body Computing, 276

Valve, 89–90
Vancouver, 89

Vancouver Film Studios, 88
Vancouver, B.C., 86, 88
 film and TV production activity,
 88
venture capital, 126
 few women or minorities fund-
 ed, 126, 154
vertical growth, 72
Vertigo, 115
Video2Brain, 121
Vin, Makara, 236
Virgin.com, 42
vision, 52–53
 definition of, 53
visionary entrepreneurs, 17
VR (virtual reality), 276
VR software, 130, 276
VR, "Alfred', 276
Vutha, Tor, 234, 235
Vuttouk, Chan, 234

wages, 78–79
Watters, Audrey, 121
Webber, Alan, 271
Wefunder, 123, 125
Weiner, Jeff, 122
Weinman, Lynda, 115–122, 134
 Designing Web Graphics, 117
 Lynda.com. See Lynda.com
"West Mass," Massachusetts, 264,
White House Summit, 150
Williams, Ken and Roberta, 203
Williams, Michelle, 110
Williams, Serena, 122
Winnipeg, Manitoba, Canada, 255
 The Forks, 254, 256
 Winterpeg, 256

Witshire, Alex, 95
Wizkid, 110
women-owned businesses, 152
Wordcraft Circle of Native Writers
 and Storytellers, 160
working conditions, 80
workshops, 301
World Conservation Union, 249
World Economic Forum, 15–16,
 18, 21, 103, 267, 268
World Fair Trade Organization
 certification, 280

Y Combinator, 145
YCEY (Young Creative Entrepre-
 neur of the Year), 143
Yoa, Chea, 234
Yoruba diaspora, 231
Yoruba101, 231
Young African Leaders Initiative,
 281
youth, 19
youth education, 229
youth employment, 217
youth engagement, 206–237
youth population growth, 213
youth unemployment, 212–213
youth, empowering, 206–237
Youth, Music and Creative Cul-
 tures: Playing for Life, 220
YouthfulCities Index, 217
Youthworx Media, 218
YTF (Youth for Technology Foun-
 dation), 223–225

Each week, investors, ecosystem leaders, and entrepreneurs from across the globe reach out and ask us about working with Creative Startups. We hope you will, too. If you are interested in learning more about our accelerator programs, our ecosystem building initiatives, and our research and consulting work, please contact us at: info@creativestartups.org.

CreativeStartups.org

@createstartups

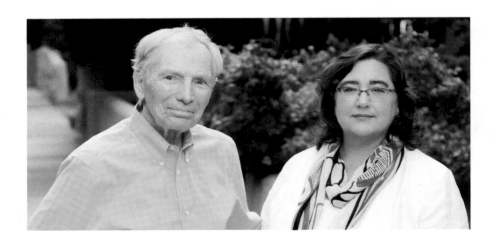

Alice Loy is Co-founder and CEO of Creative Startups. Beginning her career as a cultural ecologist, today Alice is widely considered a leading authority on entrepreneurship in the creative economy. A sought-after speaker on topics ranging from developing creative economy ecosystems to investing in the creative economy, Alice frequently travels to the Middle East, Asia, and Latin America to work with entrepreneurs and economic development leaders. Alice has lived and worked in Mexico, Costa Rica, Spain, and China. She holds a PhD in Strategic Communication and Entrepreneurship and an MBA. Alice lives in Santa Fe, New Mexico, U.S. with her family.

Tom Aageson is a Co-founder of Creative Startups. He previously served as Executive Director for the Museum of New Mexico Foundation. Since coming to Santa Fe, Tom has launched several successful startups including New Mexico Creates, and the now famous Santa Fe International Folk Art Market. Previous to that he was at the Mystic Seaport Museum where he created the innovative Mystic Maritime Gallery, which created new markets for maritime artists and spawned for-profit gallery enterprises across the U.S. Tom holds an MBA from Columbia University and a BFT from the Graduate School of International Management at ASU (Thunderbird).